AN ILLUSTRATED JOURNEY

Inspiration from the Private Art Journals of Traveling Artists, Illustrators and Designers

DANNY GREGORY

HOW
BOOKS

Cincinnati, Ohio
www.howdesign.com

For more excellent books and resources for designers, visit www.howdesign.com.

19 18 17 16 15 8 7 6 5 4

ISBN-13: 978-1-4403-2025-5

Distributed in Canada by Fraser Direct
100 Armstrong Avenue
Georgetown, Ontario, Canada L7G 5S4
Tel: (905) 877-4411

Distributed in the U.K. and Europe by F&W Media International, LTD
Brunel House, Forde Close, Newton Abbot, TQ12 4PU, UK
Tel: (+44) 1626 323200, Fax: (+44) 1626 323319
Email: enquiries@fwmedia.com

Distributed in Australia by Capricorn Link
P.O. Box 704, Windsor, NSW 2756 Australia
Tel: (02) 4560-1600

Edited by Scott Francis
Art directed by Ronson Slagle
Production coordinated by Greg Nock

Danny Gregory is the author of several successful books on creativity, including *An Illustrated Life* and *The Creative License*, and two illustrated memoirs, *A Kiss Before You Go* and *Everyday Matters*. He has a worldwide following of people who are inspired to develop their own creativity through illustrated journaling. He was born in England, grew up in Australia, Pakistan, Israel and New York, and graduated summa cum laude from Princeton University. He is Executive Creative Director and Managing Partner of a leading advertising agency and lives in New York City.

www.dannygregory.com

Contents

"THE WORLD IS A BOOK, AND THOSE WHO DO NOT TRAVEL READ ONLY A PAGE."

— SAINT AUGUSTINE

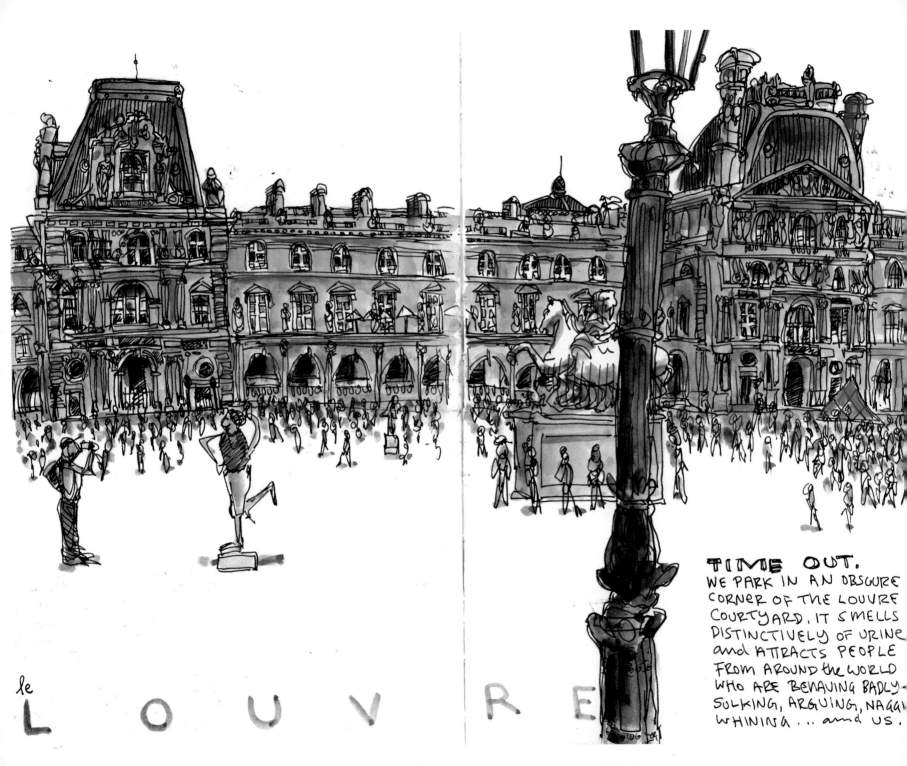

TIME OUT.
WE PARK IN AN OBSCURE
CORNER OF THE LOUVRE
COURTYARD. IT SMELLS
DISTINCTIVELY OF URINE
and ATTRACTS PEOPLE
FROM AROUND the WORLD
WHO ARE BEHAVING BADLY
SULKING, ARGUING, NAGGING
WHINING . . . and US.

le

L O U V R E

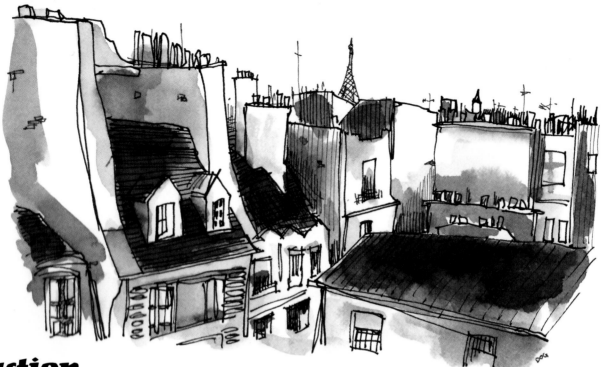

Introduction

When I was fifteen, I visited Paris with a group of other teenagers. Everyone had an Instamatic camera and snapped pictures of the Eiffel Tower, the Louvre, Notre Dame. Being a snotty and contrarian teenager, I complained that all we were doing was taking the same snapshots as every tourist since the dawn of photo-graphy. If we were going to have such a cookie-cutter experience, I would just buy postcards. After all, they were better photographs than my companions were taking anyway.

Like most travelers, I wanted to be able to see the great sights of Paris from my own particular vantage, to have my very own experience rather than a prepackaged, generic tour. I didn't want to read the same paragraphs in the same guidebooks, listen to the same canned narration from droning tour guides, plunder the same souvenir stands as billions before me. I wanted to be like Lewis and Clark, like Marco Polo, like Neil Armstrong—the first stranger in a strange land.

The wonderful artists in this book have solved the problem that irked my younger self. They, too, want to see the world through their own eyes, whether it be a Burmese temple, a Tuscan palazzo or the parking lot of the local Costco. They want to stop and drink it in, refresh their eyes and minds, dismiss preconceptions and replace them with wonder. They know that to truly *see* the places one has traveled so far to see, one need only pack along a pen and a sketchbook.

The travelers I have assembled in the pages that follow have voyaged all over the world, and they have embarked from every corner of it, too. Frenchmen who love New York, New Yorkers who visited China, San Franciscans in Rome, Italians in Africa, small town folks who enjoy being overwhelmed by big cities, and day trippers and long-distance adventurers. Some are professional animators, designers, illustrators and artists, but equally many are happy amateurs with no loftier ambitions, for whom drawing is a passion and a companion. And no matter where they hail from or where they're headed, no matter how they earn their airfare, there's remarkable similarity in their experiences and passions.

When we document a journey in a sketchbook, we discover the difference between vacationing and traveling; we become adventurers, discovering new worlds through a thousand tiny details. Unlike those who hide behind a pudgy mystery novel and a piña colada while plopped in a poolside lounge chair, the travel journal keeper clears his mind, refreshes his eyeballs and builds a cache of enduring memories.

Almost everyone in this book agrees.

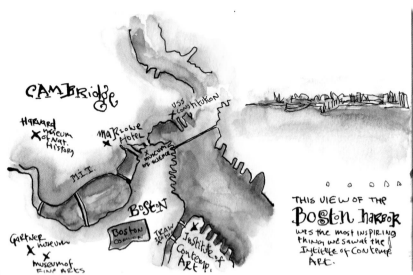

CAMBRIDGE

Harvard
Museum
of Nat.
History

MIT

Marlowe Hotel

USS Constitution

Museum of Science

Boston

Gartner Museum

Museum of Fine Arts

Boston Common

Train Station

Institute of Contemp. Art.

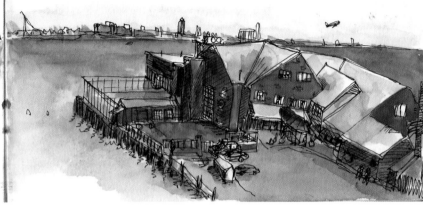

THIS VIEW OF THE
BOSTON HARBOR
Was the most inspiring thing we saw at the Institute of Contemp. Art.

Drawing while traveling has made them more deeply in love with both, has rekindled their love of sketching and has made travel something they plan for and look forward to for years.

They discover the differences and particularities of each destination through drawing: the unique flow of every city, the specific lines that make up each city's signature, the way people dress and park and eat and shop. They record thoughts and overheard conversations, as well as maps of their personal paths, phone numbers for hotels, restaurant recommendations, airline flight numbers.

Eventually, they travel because they draw, rather than vice versa. They learn that drawing is like an excited travel companion who rouses you out of bed at dawn, waving a map in your sleepy face, insisting you get up and start drawing breakfast right away.

For some, drawing is a solitary absorb-ing activity. Most of us have understanding spouses who are used to leaving us for an hour to squat on a stool and sketch a cathedral or a bus stop while they visit the shops and museums. Drawing is also a great icebreaker, a wonderful way to meet locals who are used to ignoring the busloads of indistinguishable tourists. They want to know how our fresh eyes see their world, made all too familiar and unexceptional to them by routine.

Drawing is also a great group activity—as so many in the so-called "urban sketcher" community have discovered, traveling around their hometowns with a group of new friends to draw and capture familiar neighbor-hoods made new again.

I intend for this book to welcome you into this community.

I have asked this book's contribu-tors to open their journals and share themselves, their personal histories, their trade secrets, the contents of their art supply bags. In turn, they have been enormously honest and generous.

They have come to art through many doorways. Most remember drawing incessantly as little children. All too many lost the pleasures of art in adolescence, only to rediscover it when they grew older and more contemplative. Many were dissuaded from following their calling by concerned parents or cynical teachers but then discovered fresh sprouts of creativ-ity emerging as they embarked on more conventional career paths. The drive to create could not be utterly extinguished. Art became an affair on the side that soon grew into an obsession, one that called them to the romance of faraway places.

This book is full of memories, of autobiographies, of souvenirs. It has few recommendations about where to eat, to stay, to visit, but lots of advice on the brands of paint and pens and paper you should pack in your bags. I discovered in interviewing people for the book that to talk about art and travel is to talk about life—to learn people's stories and their loves. Sketchbooks reveal that though we may travel to the same points on the map, we are each actually visiting very different places. These pages show how all of our accumulated experiences make different impacts upon us, create different windows through which we look. Two artists sitting side by side with their sketchbooks produce very disparate records of the experience. And even the same person, returning to a place visited long ago, produces a new impression as time passes. Our sketchbooks become records of these changes and perspec-tives—invaluable slices of personal history that we can revisit and look deeper into time and again.

The collection of filled-up sketchbooks becomes the most valuable of souvenirs,

sitting on a shelf in a place of honor. And the act of filling these travel journals continues to have an effect on the artist when she returns home. Suddenly she sees her mall or her sidewalk as she saw those in foreign climes, her eyes are opened to the everyday things, she becomes an explorer in her own hometown.

Every artist I spoke to concluded his or her part with a variation of the same advice: Join us. Keep a travel journal and draw the things you see every day on your trip. The point is not to create works of art that will hang in galleries or museums but to form a permanent record of your experience, one that you can return to when you want to recapture the nuance and the revelations you discovered on your trip. Don't worry about the quality of the drawings. Don't be intimidated by the many lovely images you will soon discover within the pages of this book. Make your own images, and you will make your own memories. If you persevere, your persistence will result in a lifelong habit that will take you on many adventures to come.

Let me tell you about some of mine:

I was born a traveler. I traveled across oceans on a ship when I was two years old. I lived in Lahore, Pakistan, and I spoke Urdu when I was four. I traveled to Swat, to Queensland, to Pittsburgh, and I went to three different schools in Australia—all before I was eight. I lived on a kibbutz; I rode a bullock; I slept on a Kashmiri houseboat. I took transcontinental flights alone and switched at the

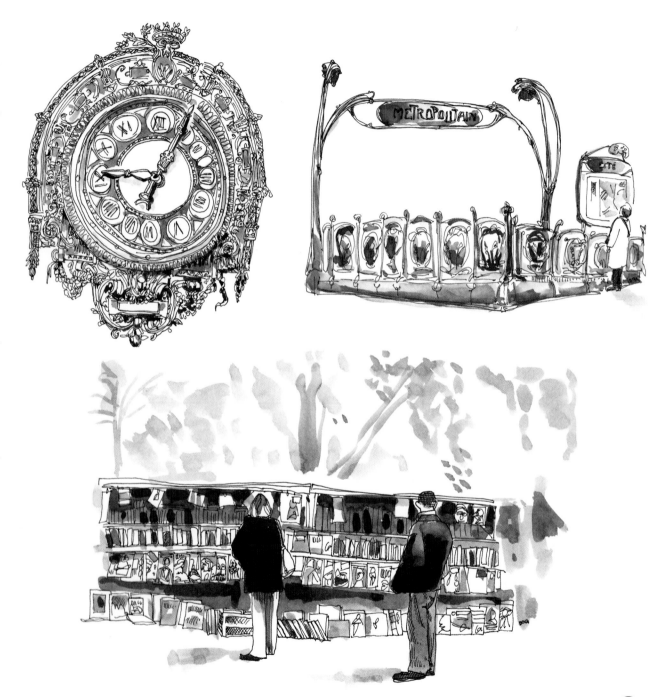

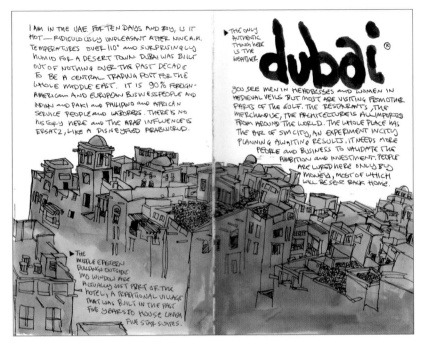

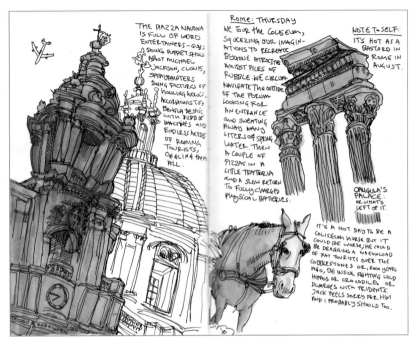

Bangkok airport before I was ten. I wore out passports. Then, when I was thirteen, I came to New York City on the SS Rafaello and hung up my travel bags. My peripatetic youth was behind me and I was determined to become an American.

In college, in search of America, I rode a Greyhound bus down to Charlotte and Atlanta, across to Galveston, back up through Nashville—and was bored at every stop. From then on, if I had to travel somewhere on vacation, I chose a place with a nice beach, a nice lounge chair and a regular supply of cold beer. I lost all interest in things foreign, in seeing how the other half lived.

My job in advertising forced me to travel quite often. I shot commercials in Japan, Sydney, LA, San Diego, San Francisco, Chicago, Miami ... and all I could think of the whole time was the drive back from JFK to my home in Greenwich Village.

And then in my mid-thirties, I began to draw. I discovered the enormous pleasure of recording my life in a sketchbook. I drew the contents of my house, my breakfast, fire hydrants, the benches in the park. Through drawing, I discovered the beauty of the ten thousand things around me. I really saw them for the very first time. I got to know New York in ways I hadn't in the twenty years that I'd lived here.

I discovered that when I drew something, I remembered it in deepest detail. I remember the way the light fell on the building, the sounds birds made as they flew overhead, every item in a shop window, conversations I overheard, and life all around me became richer and more vivid because I was doing this simple thing: drawing with a pen in a book.

After a year or two of recording my life at home, I brought my sketchbook with me on my business trips. I started to draw the other people on the plane, the airports and the cities I visited. Soon I was not only recording the things I came across, I was actively seeking things to draw. I would go on adventures, visit new neighborhoods, see the sights—all in order to record in my little book with my pen. Instead of rushing for the first plane available after the meeting ended, I started to take my time. I got to know the cities I was visiting, and I discovered that drawing made the experience richer and etched it deep in my memory.

I was blessed with a patient wife who was willing, even happy, to come with me on rambles through Paris and London and Florence and beyond in search of things to draw. We would sit together and I would draw the canals of Amsterdam, the palms in Santa Monica, the sex shows in Berlin. Now I can flip open any one of these books and suddenly find myself reliving those adventures.

Over the years, my ambitions began to expand. I'd started with a simple ballpoint pen and an inexpensive sketchbook but eventually wanted to color and vary my lines to suit the places I was visiting.

On my first trip to Florence, I decided to draw with brush markers. I looked

through pictures of Tuscany and went to the art store to buy every kind of yellow and orange and red and dark green marker I could find. I discovered that each place has its own palette, and the moods that each evoked in me determined the way that I drew and painted. When I painted Dubai, I brought very intense colors—not because the city is particularly colorful but because the intense heat made me want to express myself intensely. One Easter we spent a long weekend in Paris and I captured the mist and the light drizzle entirely in shades of gray Sumi ink.

I became a more practical traveling artist. Tired of sitting on stone sidewalks in the blazing sun, I visited camping stores to buy a folding stool and collapsing cups. I started buying guidebooks. I wanted to see what it was that other people found so interesting about the places I visited before I went off on my own adventures. I exhausted myself, springing out of bed at first light and marching back and forth across Rome until the moon was rising, the shadows were long and I could barely see my sketchbook page. When I'm drawing, I drink deeply from the places I visit.

Ever since my son was able to pick up a pen, he drew alongside me. It was a wonderful way of bonding and appreciating the sites together. Unlike other kids, Jack would never get bored visiting cathedrals or museums. He'd just haul out his pad and his pen and draw the wonders in front of him.

Every so often, while I drew on location, I saw a kindred spirit hunched over his or her sketchbook. I always wondered if they were having the same experience that I was. This book proves that they were.

It contains pages that contain the world. It's so interesting to see the similarities and differences in what we capture in the places we visit. There are those who focus on architecture and buildings and those who draw food. Some draw unusual cars, strange fire hydrants, street signs, cafés, fashion … Travel opens different eyes to different things, shows things we've never seen before, shows the world from entirely new angles. That's the power of drawing and the power of travel. They both make the familiar unfamiliar and vice versa. They show what we all have in common and they show what we may have missed thanks to preconceptions that have marred our vision.

I learned an enormous amount putting this book together. It inspired me and challenged me. I hope it does the same for you. And I hope that the next time you travel, alongside your camera and your guidebook, you'll pack a trusty sketchbook and pen.

Danny Gregory

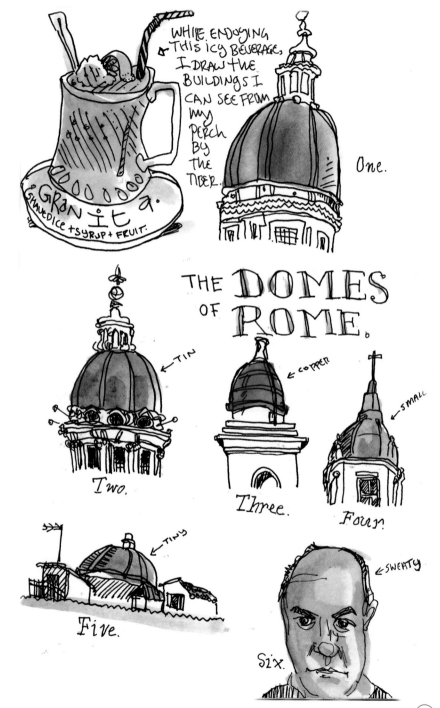

WHILE ENJOYING THIS ICY BEVERAGE, I DRAW THE BUILDINGS I CAN SEE FROM MY PERCH BY THE TIBER.

GRANIta. SHAVED ICE + SYRUP + FRUIT.

One.

THE DOMES OF ROME.

TIN

Two.

COPPER

Three.

SMALL

Four.

TINY

Five.

SWEATY

Six.

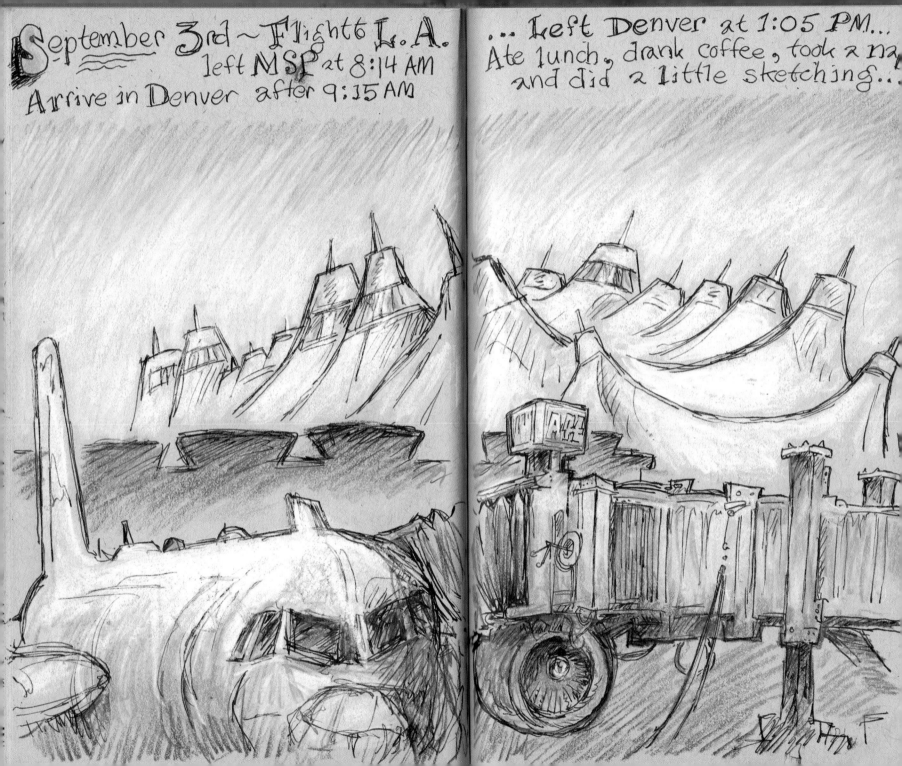

September 3rd ~ Flight6 L.A.
 left MSP at 8:14 AM
Arrive in Denver after 9:15 AM

... Left Denver at 1:05 PM...
Ate lunch, drank coffee, took a nap,
and did a little sketching...

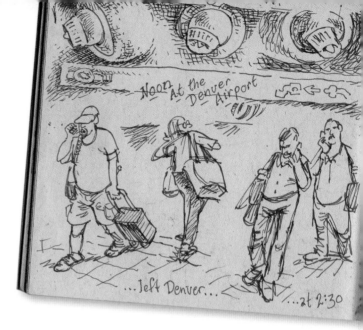

Ken Avidor

Professional artist **Ken Avidor** and his wife Roberta recently moved to a loft in the Union Depot train station in Saint Paul, Minnesota. Roberta and Ken are planning many sketching adventures from the new home. **www.avidorstudios.com**

I was born in Brooklyn, New York, and I grew up in Westchester, New York, a suburb north of NYC. I moved to Manhattan in the 1970s. I live with my wife, Roberta, and two daughters in Minneapolis, Minnesota. My genius wife brings home most of the bacon. I am also a freelance illustrator, occasional courtroom sketch artist, blogger and co-author of *The Madness of Michele Bachmann* (2011, Wiley).

I always drew pictures. My mom and dad were not artists, but they were avid museumgoers. My dad collected art books, mostly about old masters. Those books influenced me a great deal, but my brother introduced me to *Mad Magazine* and underground comics so you will

likely see a greater influence there. My artwork sometimes got me in trouble at school; the teachers and authorities at my school were not too keen on satire. I remember getting sent to the principal's office for sketches.

My first travel journal was more a sketchbook for a trip to Florida in the 1980s. I did it in ballpoint pen on crappy bond paper. My journaling guru Roz Stendahl was horrified when I showed it to her. I use much better paper and ink now, mainly because I don't want to incur the wrath of Roz … and my stuff looks better. Before 2000, I sketched in spiral-bound notebooks with pencils and ballpoint pens. In 1999, Roberta and I were invited to participate in the

Minnesota Journal 2000 Project. Under the tutelage of Roz, Linda Koutsky and Mark Odegard, I learned to combine my sketching and writing into a narrative and my life became an open book. I continued to keep a journal for each year, with an entry every day.

I think sketching makes me notice things simply because I spend a lot of time looking at them. Also, I like showing my journal to the locals because they usually enjoy seeing how an artist views the place they live. It certainly helps to sketch during the boring parts—I have a lot of sketches of airports, trains and buses.

I am always looking for things to sketch. What I look for are subjects that

are unique for artistic reasons that make me want to draw them—shape, color, texture, etc. I also look for subjects that are interesting not just for me but also for readers of my journal. Naturally, if I visit a place with landmarks, I will sketch the landmark, but I will try to document the landmark as it existed for me at that moment; with food vendors, litter, tourists, guides, bored kids, warts and all. A lot of people sketch buildings and streets without people. What a mistake. People, particularly tourists, are way fun to draw. If I have time, I'll add text to explain what I drew. I sometimes include a pictorial map of the journey. My maps are particularly useful for bike trips because I include useful stuff like mileage and

Friday 24th Nature's Nest continued A sheep watched as from the dark barn.

Gas tank

Cabin that way

Big house

slingshot tree

Hobbit house

TRENCH →

where to get food and water in case we bike the route again or recommend the trip to someone else.

My travel journaling is in my annual journal. It helps to know which year the trip was and what happened before I left on the journey and what happened when I returned. I have a terrible memory, and my journals not only help me with the who, what, where and when, but also how I felt at the time. Since I carry my annual journal nearly everywhere, I am able to explain visually to someone who says, "How was your trip?" When I travel, I have more time to sketch. One problem is I tend not to sketch when I'm having fun or doing something exciting. I sketch more when I'm waiting for a plane or a train. I have to make sure I have time to sketch interesting things, or it will look like I had a boring trip. Sometimes that means telling my traveling companions to go ahead without me while I sketch something. I then have to catch up with them (or search for them) after I finish the sketch. My friends and family are used to it. It helps that my wife does the same thing.

I volunteered to be the administrator for the local Twin Cities Urban Sketchers blog. Sometimes we have "sketch-outs." I participated in a recent sketch-out at a favorite tourist attraction, the Stone Arch Bridge, an old railroad bridge built in 1883 and now restricted to pedestrians, bicyclists and the occasional police car and faux trolley. I had less than three

hours to sketch, but I was determined to sketch as much as possible—the bridge, the people and the views from the bridge. It helped to have a bicycle to zip from one spot to the other. I got it all on two facing pages. When I want to get a lot of sketching done, I start with a rough plan and add stuff as I go along. It's fun when it works out.

The thought that often occurs to me is *I am the first person to sketch this*. If it's a well-known site, the challenge is to portray it a different way—my way. It's kind of territorial, like a dog marking a tree.

When I sketch, I like to jump right into the ink instead of ink over pencil, which is how I do my comics and illustrations. I use India ink in my comics and illustrations and color with Photo-Shop. I use water-soluble, fountain pen ink (Parker) so I have to be careful about moisture—no sneezing or drinking beverages allowed while looking at my journals. I color my sketches with colored pencils. I hand letter my journals. I sometimes hand letter my comics, but mostly I use a font created by a friend using my lettering. I'm very conscious of design. I want my journals to look like an illustrated book. The challenge is to arrange the sketches and text on facing pages in a readable and interesting composition. Of course, I don't know what will happen in the future. It's a fun challenge.

There are certain things I draw time and again. I sketch cell phone towers and security cameras. I like to sketch

...sino!

King of the Grill Slot

After I drew these two sketches a security Guard came over and told us we couldn't do it and insisted we show our identification.

...another incident where are art is a "suspicious activity" "The landscape of Fear."

Thursday 23rd~

The landscape outside the Comfort Inn with Wal★Mart in the near distance... We drove along the old Lincoln Hwy. Stopped in Colo... Arrived in Clear Lake 1:15 for lunch at the Coffee Cabin.

We arrived back in Mpls. at about 4 or 5 The temperture is 100°... We went Yummy for dinner.

Clear Lake

People ride bikes in clear lake

Monday August 14th ~ It's a rainy day in Luddington... The beach...

...later after it cleared up... cold water, big waves and wind die down by 4pm... GULL studies...

...in the evening we ate corn on the cob and brats, we rented the DVD of "V for Vendetta" on the big screen T.V.

Tuesday 15th ~ Luddington State Park

Lost Lake

Luddington State Park Death March!

Bert and I hiked the trails to Lost Lake where we ate our subway sandwiches. We decided to hike up to the lighthouse. It was a long hike. It was hot and it was tough hiking in the sand. It was easier hiking back through the beach...

Big Sable Point lighthouse

HOT and DRY Here

Hamlin Lake

CAR

Monday 25 of August ~ Cloudy morning Brad and Sal leave for Nashville. I did some work in the notebook and took the kids to the beach and played shuffleboard.

TOO MUCH VACATION!

Celia pushed the Panic Button on the Car keychain while I was watching T.V. and I blew up at her.

Tuesday 26th ~ Thunderstorms kept me up all night (I did get enough sleep between the storms) We boarded the Badger at 7:00 with a bunch of 'Geriatric' Harley Davidson Bikers.

Last chance to use the Cell Phone

ANYBODY SEE MY FRIEND? He's wearing a black shirt!! HAW HAW

Tuesday 26th continued~ More Harley Studies (100 Anniversary of the Company)

"Motorcycle Club "Colors" on a Resin Deck Chair.

Sleeping on Deck

STURGIS 2002

The Bridge

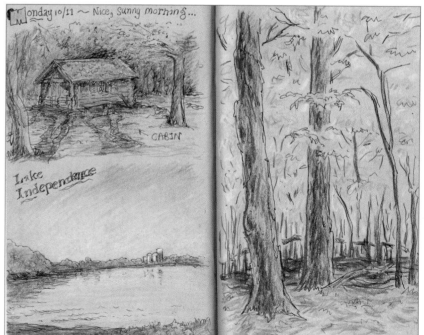

Monday 10/11 ~ Nice, Sunny morning...

CABIN

Lake Independence

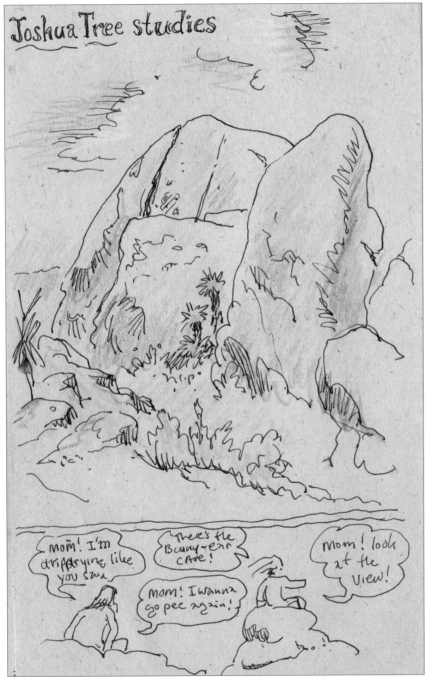

Joshua Tree studies

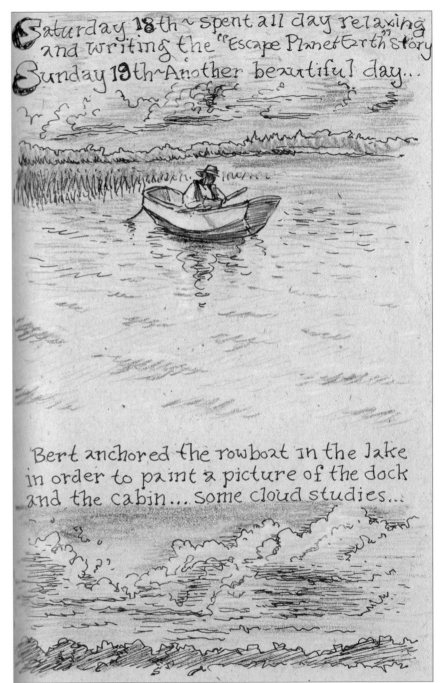

Saturday 18th ~ spent all day relaxing and writing the "Escape Planet Earth" story
Sunday 19th ~ Another beautiful day...

Bert anchored the rowboat in the lake in order to paint a picture of the dock and the cabin... some cloud studies...

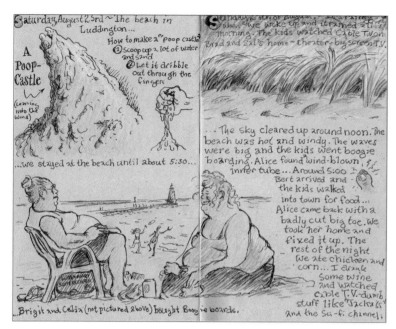

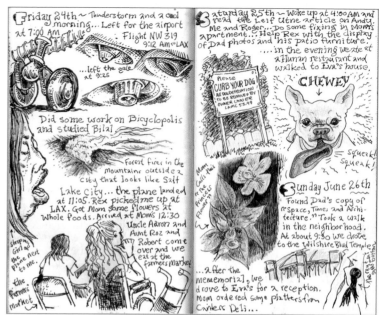

manufactured things that people take for granted, such as clothes, cars, cell phones. The design of these kinds of things changes over time. I also occasionally sketch the signs outside of gas stations to record what the gas price was that day. When I look at my older journals, even those that are only a few years old, that's the kind of detail that really records the passage of time.

I pack a leather shoulder bag with my journals wrapped in plastic to protect them from moisture. I have several fountain pens—I use a Rotring pen with an extra-fine nib. I carry two Rotring pens with siphon cartridges. I keep disposable cartridges in case I run out of ink. I have colored pencils, mostly Prismacolor, in a zippered case. I use a single-edge blade to sharpen the pencils (except when I

sketch in court or travel by plane). I pack binoculars and a book light for low-light situations such as bars. I recommend bicycling—you notice more when you bike and you can usually stop and turn around whenever you want.

I like to work from a brown midtone so I use Cachet "earthbound" recycled sketchbooks by Daler-Rowney. I sometimes use Strathmore sketchbooks when I need white paper. My favorite art store is Wet Paint in Saint Paul.

My journals have that lived-in look— they start out neat and clean and end up beat-up, dirty, stained and ragged. I glue some things into my journal: tickets, stickers and other stuff that relates to the places I've sketched. I sometimes write phone numbers and other info in the back because I carry the journal every-

where. A lot of stuff accidentally finds a way into my journals. I have more than a few squashed bugs. Raindrops indicate what the weather was at the time. My Mom once spilled orange juice over one of my journals in a very artistic way.

I keep all my journals on a bookshelf in my studio, except for my 2000 journal, which is stored in the Minnesota History Center. I hope my journals will find a nice, safe place after I'm gone. I think there's some historical value to some of them.

I tell people not to worry about making mistakes: Most people won't see the mistake. Sometimes mistakes become a different

way of drawing something—the artist's unique way of drawing something. Also, I think it's better to draw what I feel about the object or person instead of "eyeballing" it. We're not cameras. When I see a painting or drawing that conveys what another artist feels, I get goose bumps.

Ken Avidor

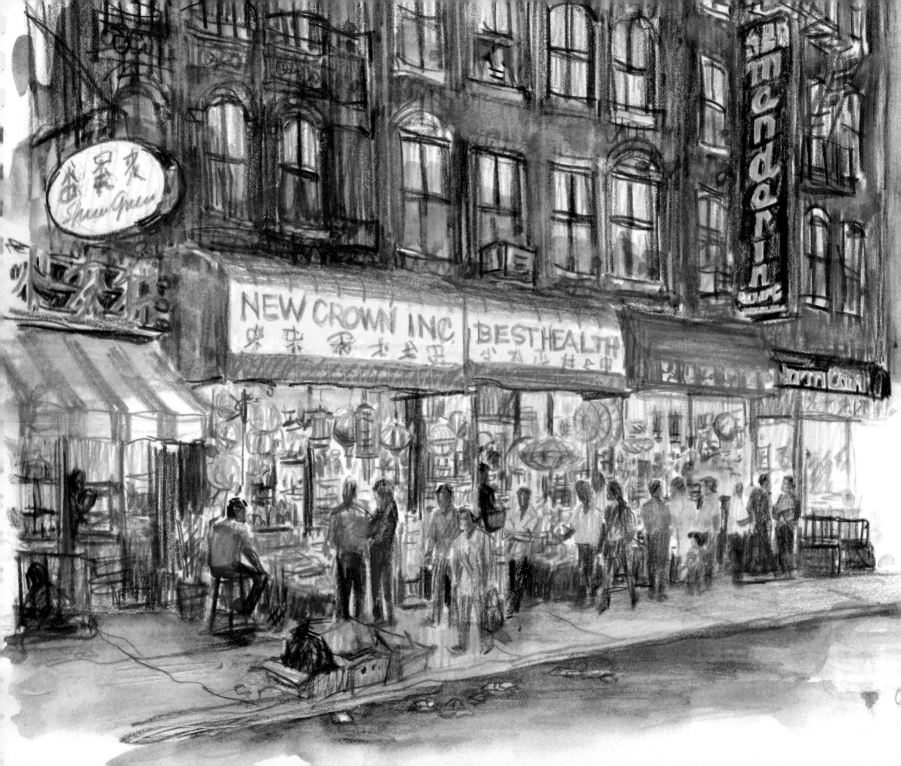

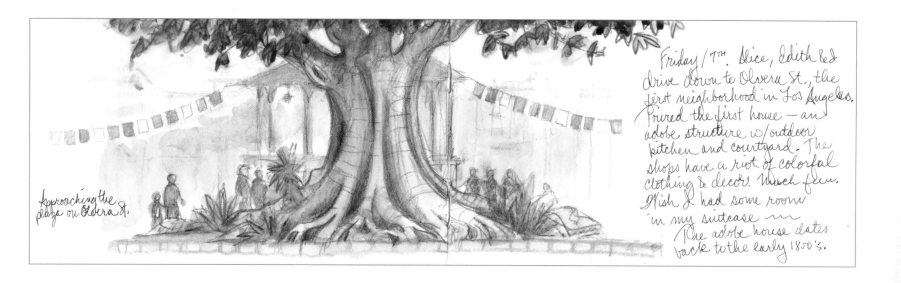

Approaching the plaza on Olvera St.

Friday / 7TH. Alice, Edith & I drive down to Olvera St., the first neighborhood in Los Angeles. Poured the first house — an adobe structure w/ outdoor kitchen and courtyard. The shops have a riot of colorful clothing & decor. Much fun. Wish I had some room in my suitcase. The adobe house dates back to the early 1800's.

Roberta Avidor

Professional artist **Roberta Avidor** and her husband Ken recently moved to a loft in the Union Depot train station in Saint Paul, Minnesota. They are planning many sketching adventures from the new home. **www.avidorstudios.com**

I grew up mainly in Kalamazoo, Michigan. I moved to New York City to go to art school one year after graduating high school. I lived there for thirteen years, then I moved to Minneapolis, Minnesota.

I started drawing about the same time that I could pick up a pencil. My first memory is of drawing the horses down the street. My urge to draw came mostly from the fascination with horses and secondarily from an urge to make art.

The only place that I drew on vacation was in New York City. After the workday ended, my aunt would let me sit at her drawing table and use her materials. I remember visiting the Guggenheim Museum back in 1959, shortly after it opened. I was so inspired by the kooky architecture (I was five years old) that I went back to the apartment and did a drawing of the inside. I came across it many years later and laughed because I realized that I had also captured the fashion of the day: In the foreground was a lady with white gloves and a mink stole! Unfortunately, that drawing has been lost.

I attended Parsons School of Design, which was grueling but fun. We were expected to attain the skills of the famous illustrators of the day, which means that we had to learn to draw realistically with special emphasis on drawing the human figure. That emphasis has made me strive to capture the "look" of today's people when I draw them in my journals.

Currently I work as a freelance illustrator in Minneapolis. I do quite a bit of marker art for Target for their various catalogs. My illustrated map projects have become more numerous in the past year, much to my delight.

All places seem much more interesting when you draw them. It can be a good challenge to try to make more out of a scene than what's really there. Some places are just chock-full of material, though. I love drawing in Chinatown, New York, for instance.

Once I draw something, it's etched in my mind, more or less. If I need to draw a brownstone building in New York, for example, I can pretty much draw a decent representation of one from memory because I've previously taken the time

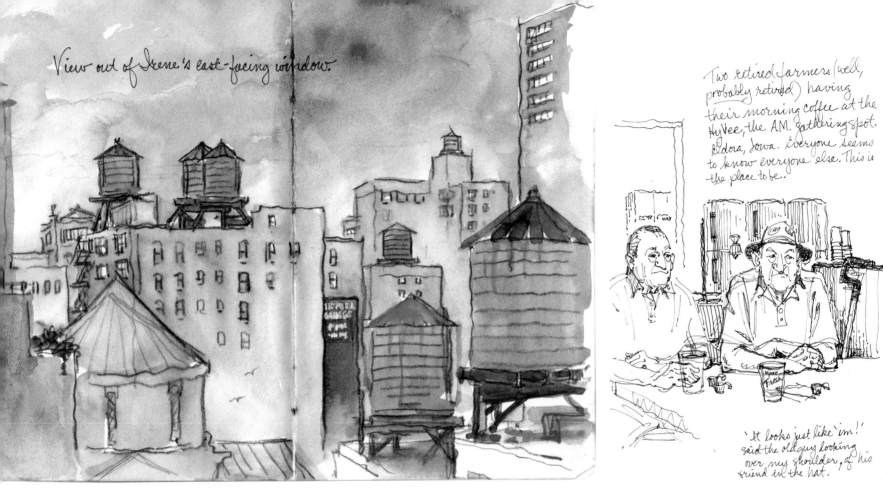

View out of Irene's east-facing window.

Two retired farmers (well, probably retired) having their morning coffee at the HyVee, the A.M. gathering spot. Eldora, Iowa. Everyone seems to know everyone else. This is the place to be.

'It looks just like 'im!' said the old guy looking over my shoulder, of his friend in the hat.

to sketch one on the spot. Journaling seems to solidify memories of a trip. You're recording all sorts of things when you're drawing: the light at that moment, the look of the people, the scale of the surroundings. I love looking back on my drawings. I can almost feel the intensity of the sun, the breezes, the annoying bugs and even the smells.

I have frequently referred to my journal drawings in the course of creating artwork for a job. One of my professional specialties is creating illustrated maps. These maps can require all sorts of subject matter, so I've referred to my journals for animals, buildings, people, trees. There's a close relationship between my journal drawing and the maps because they both deal with sense of place.

The one rule I have in my sketchbook is that a drawing has to be as well composed as possible. It could be many little vignettes or one big drawing, but I try to accommodate the writing into it as well. It's not always as well composed as I think it could be, but it is spontaneous, so I can't be too critical. And that's one of the big challenges—to have the spontaneity but still be well composed. I've been inspired by fellow sketch journal keepers who are very good at that.

I've been editing down my travel kit. I don't have tolerance for excess materials, probably because, for the most part, I'm on foot, bike or mass transit and don't want to be schlepping any excess any-thing. I bring a couple of good pens (I like the waterproof Microns, sizes 5 mm and 8 mm), about four or five watercolor pencils in different colors (I like the Derwent brand), the Van Gogh travel-ing watercolor set of twelve pan colors, an empty 10 oz. plastic jar for water, and three or four favorite watercolor brushes (sizes 3, 8 and 10). And the journal, of course. If I have room, I'll take the little three-legged folding camping stool so I can sit wherever I need to.

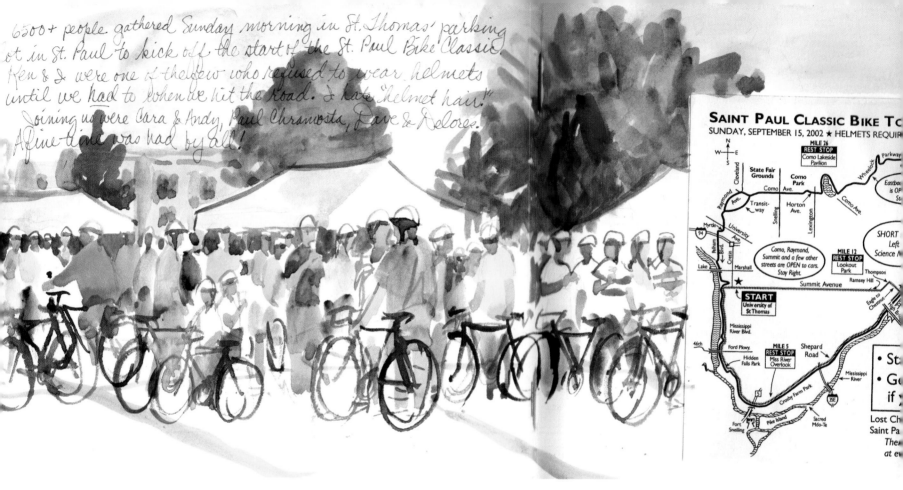

6500+ people gathered Sunday morning in St. Thomas' parking lot in St. Paul to kick off the start of the St. Paul Bike Classic. Ken & I were one of the few who refused to wear helmets until we had to when we hit the road. I hate "helmet hair." Joining us were Cara & Andy, Paul Chramosta, Dave & Delores. A fine-time was had by all!

SAINT PAUL CLASSIC BIKE TO[UR]
SUNDAY, SEPTEMBER 15, 2002 ★ HELMETS REQUIR[ED]

I really like the Moleskine books. I've just finished one with the 5" × 8" horizontal format. It's perfect for doing panoramic scenes. And the paper stands up to multiple watercolor layers. Moleskines can be bought at any good art store.

The book format keeps the work organized and gives it a flow. I don't have to think about what I'm going to do with the drawings after I get home. They're all there, one right after another. They

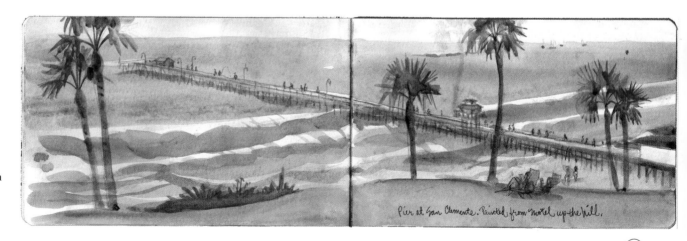

Pier at San Clemente. Painted from motel up the hill.

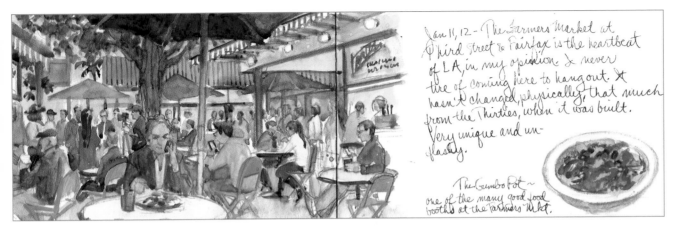

Jan 11, 12 – The Farmers' Market at Third street & Fairfax is the heartbeat of LA in my opinion. I never tire of coming here to hangout. It hasn't changed, physically, that much from the Thirties, when it was built. Very unique and un-flashy.

The Gumbo Pot ~ one of the many good food booths at the Farmers' Mkt.

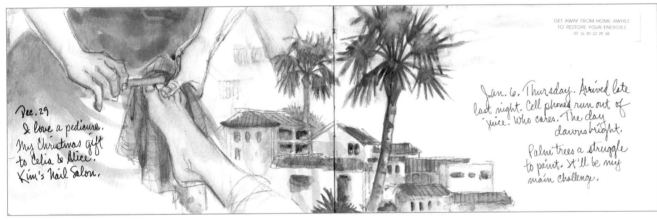

GET AWAY FROM HOME AWHILE TO RESTORE YOUR ENERGIES 07 15 20 23 29 38

Dec. 29 I love a pedicure. My Christmas gift to Celia & Alice. Kim's Nail Salon.

Jan. 6. Thursday. Arrived late last night. Cell phones run out of juice. Who cares. The day dawns bright.

Palm trees a struggle to paint. It'll be my main challenge.

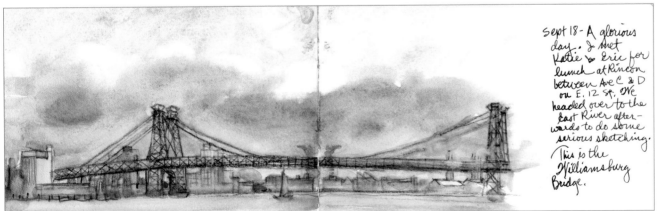

Sept 18 – A glorious day. I met Katie & Eric for lunch at Rincon between Ave C & D on E. 12 St. We headed over to the East River afterwards to do some serious sketching. This is the Williamsburg Bridge.

may not be all wonderful, but I don't care so much about that anymore.

I like to occasionally glue in a ticket stub, business card or some other such piece. It adds historical interest, especially if there's a price printed on it. I glued a list from a grocery store in one of my older journals, thinking that this would be a good snapshot of prices of the day, but unfortunately it was one of those thermal printed receipts and now all the items and prices are faded and practically illegible.

My journal sketchbooks occupy a shelf in my studio. I try to keep them in good shape, but I kind of like the bent corners and fraying edges. They're more or less in order and are accessible to anyone who wants to look at them.

Two bits of advice: (1) Put your name and phone number on the inside cover! I never would have gotten one of my journals back if I didn't have that info in there: (2) Don't let perceived lack of skill or experience keep you from starting a sketch journal. It's one of the best ways to witness your own growth as an artist. It will help you become a keener observer and add more meaning to your travels.

Roberta Avidor

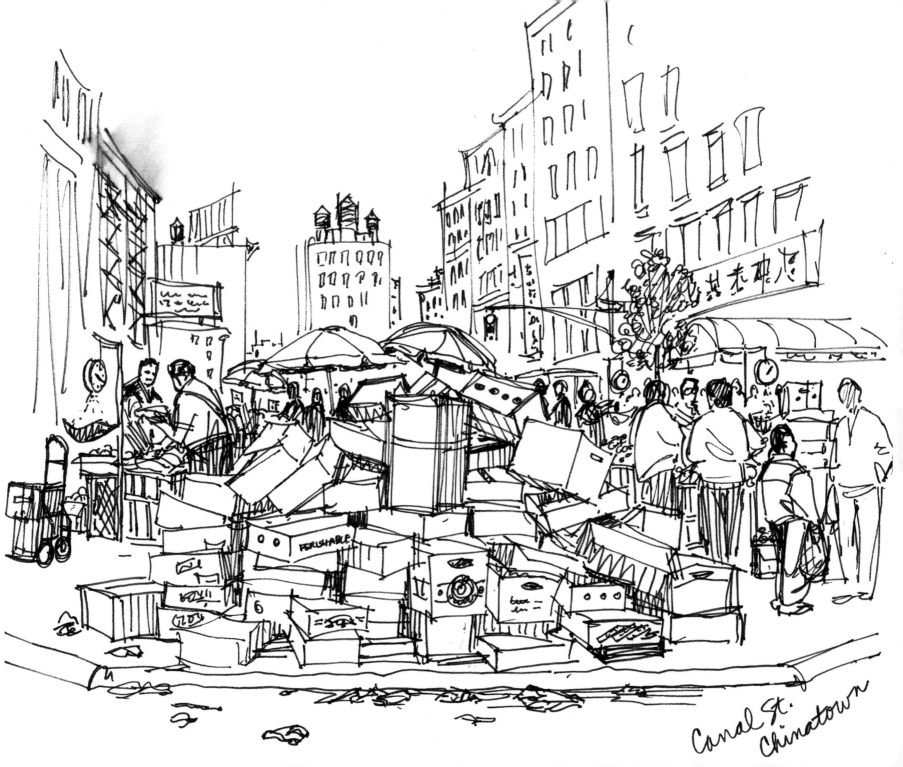

Canal St.
Chinatown

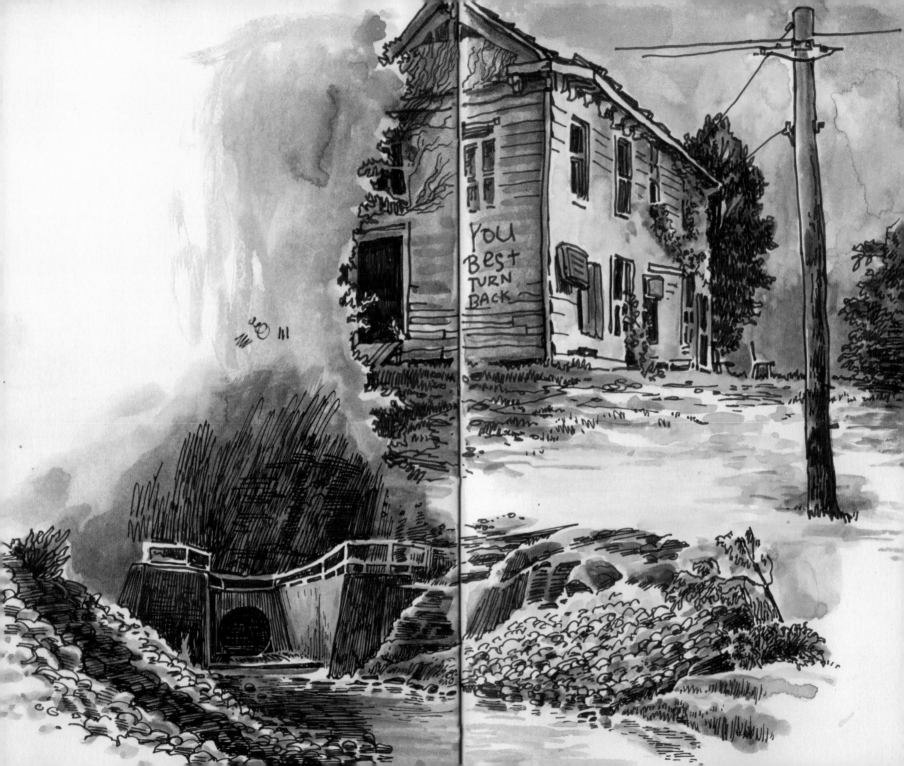

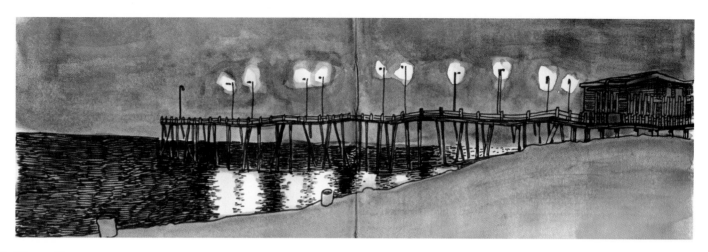

Chris Buchholz

Chris Buchholz studied graphic design at a small community college in Pennsylvania, worked in the design field for several years and then decided to pursue another career as a missionary. He currently lives and works in the Dominican Republic where he met his wife.
www.sketchbuch.blogspot.com

For me, my sketchbook is the ultimate passport. When I'm traveling with my sketchbook in hand, I seem to slide easily into cultures and conversations. When I'm drawing, the locals let me into their world, accepting me as if I were one of them. This self-issued passport, the sketchbook, is what gets me into the heart of the place—into the dining rooms, front porches, hidden alleys and into the most fascinating conversations.

There's something about drawing that makes a person approachable, and I love that. How many times have you taken a digital photo and had a complete stranger come up and peer at the camera's screen in order to see the photo you took? It never happens with photography, but it happens all the time when I'm drawing in my sketchbook. What's interesting, too, is that when people come up to look at a drawing, they seem to understand that they are looking at a piece of your soul, and they want to reimburse you with a piece of theirs. They might offer up a piece of personal information that they would rarely share with any old stranger, or they might tell you about their uncle who has experimented with watercolors, or they might even show you their own art.

A sketchbook is also the ultimate souvenir. In my sketchbook, I'm able to capture the colors and feelings, the speed and confusion or the slow lull of the journey. In my sketchbook I can pinpoint what I really like about a place. Sometimes it might be something really insignificant, such as the pattern on the curtains, the streetlights or even the trash cans. If I draw a beautifully designed and architected building from another era or a tropical beach lit by the setting sun, I own it. And I don't mean that in a selfish way, as if it's property that only I can own, but rather it's as if I were a shareholder of everything I see and draw. It always feels like time well spent.

I usually select a blank sketchbook for the sole purpose of starting and finishing it on the trip. For that reason I like using somewhat smaller books on trips, depending on the length of the trip. If I go on a trip and bring a sketchbook that I know I can't fill, I end up drawing less. I simply like the idea of a whole book dedicated to one trip, as short as that trip may be. I once filled one of the credit card-sized Moleskine notebooks on a two-day trip to the beach. I selected the theme "Things found on the beach," and I spent the whole two days crouched over washed up seashells, cigarette butts, bottle caps and other various beach objects. Sometimes I like to work with a really narrow focus, just one specific theme. For example, right now I'm working on a book filled with Dominican motorcycles and their riders. I find that working this way opens my eyes to things I hadn't noticed before.

My pen of choice is the Faber-Castell PITT pen in various sizes. I use black mostly, but I also love the brown and the sanguine color. I've been thrilled lately with the fact that I just recently figured

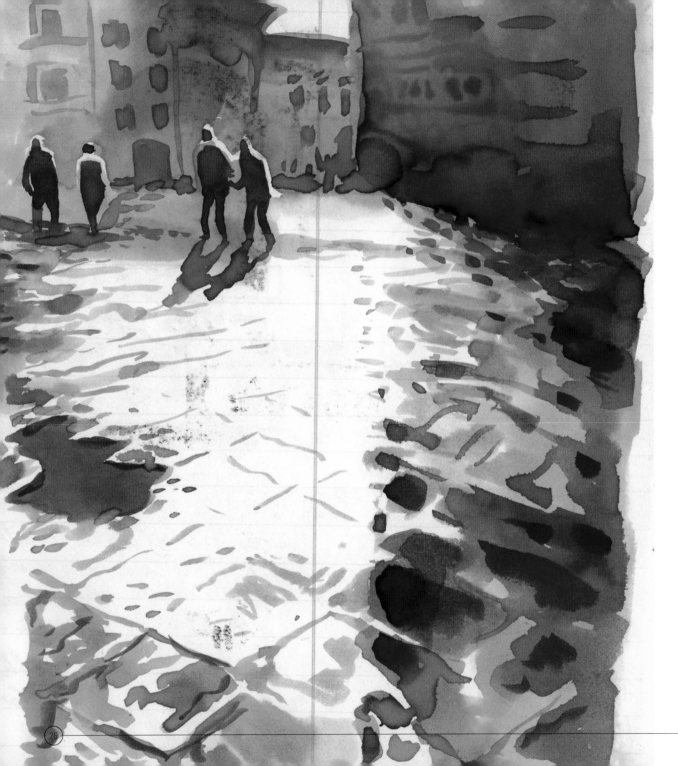

out that you can refill PITT pens with the ink of your choice. I've been filling them with different colored inks, and I've even been experimenting with filling them with Dr. Martin's. I generally use Winsor & Newton artist brand watercolors for the coloring, although lately I've been experimenting with colored pencils and I love the results. I predominantly use the Niji Waterbrush for the brushwork, and I love the fact that I can fill it up with water from the place I'm drawing. There's something cool to me about being able to fill your brush with water from a beautiful fountain in Italy and then paint that fountain. I would say that my favorite travel journal would be the Moleskine pocket-size sketchbook. I really like the yellowed pages and the way the paper seems to slightly resist the watercolor to produce unexpectedly interesting results. I love finding old books to paint in as well. One of my favorite travel sketchbooks is an old register book that my great-aunt owned. It has entries in it that date back to the late 1800s. I was shocked by how well the old yellowed paper handled the strong tones of Dr. Martin's inks. That particular book was also filled with beautiful lightly penciled handwriting from another era; I just drew over top of it and it added a wonderful quality to my drawings.

I felt compelled to include a sketch I did while sitting in a restaurant at the beach. At the time I was reading something by John Steinbeck and I copied

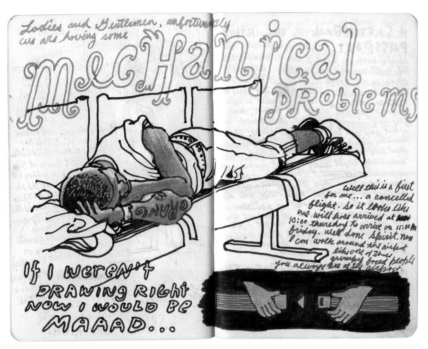

Ladies and Gentlemen, unfortunately we are having some

meCHanical problems

well this is a first for me... a cancelled flight. So it looks like we will have arrived at 10:00 thursday to arrive on 11:10 friday. well done Spirit. now I can walk around the airport like one of these grimy bored people you always see at the airport

If I weren't DRAWING RIGHT NOW I WOULD BE MAAAD...

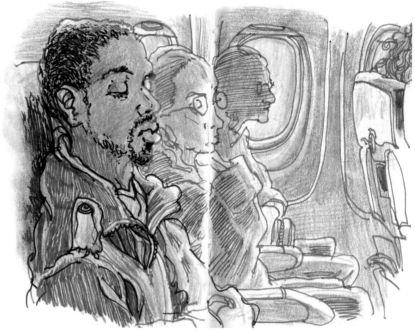

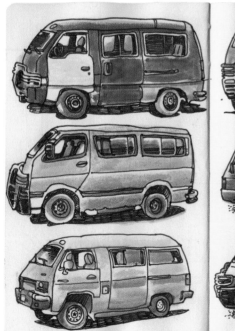

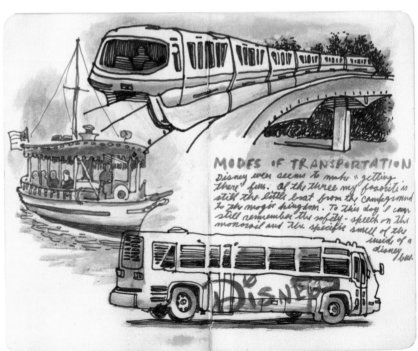

MODES OF TRANSPORTATION

Disney sure seems to make "getting there" fun. Of the three my favorite is still the little boat from the campground to the magic kingdom. To this day I can still remember the safety-speech on the monorail and the specific smell of the inside of a disney bus.

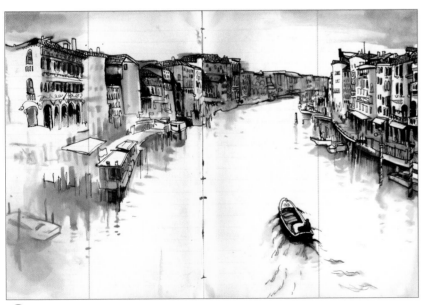

in the sketch something he said, which seems quite relevant now. He said, "... that we do not take a trip; a trip takes us." He then compared a journey to a marriage, adding, "the certain way to be wrong is to think you control it." I think those words in many ways apply to a sketchbook as well. Sometimes I have certain preconceived ideas of how my travel sketchbook should look even before I've taken the trip. But I've learned over the years to just go with the flow of the journey and let the journey alter my book however it will. It used to really bug me when I'd start to draw something only to have it suddenly move or change.

But now I think that the best spreads come out of trying circumstances like that. If I have a page that I really don't like, I just keep drawing until I like it. If I really don't like it, I sometimes put a light white gauche over top and let it serve as a muted backdrop for another drawing. I've gotten some really interesting results doing that.

Chris Buchholz

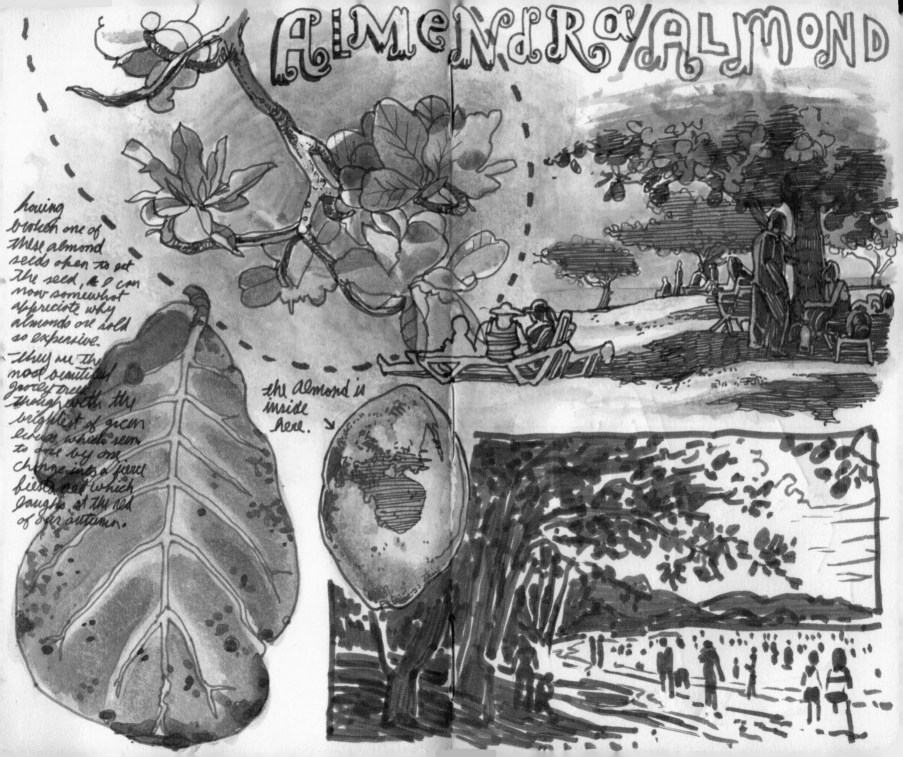

ALMENDRO/ALMOND

having broken one of these almond seeds open to eat the seed, & I can now somewhat appreciate why almonds are sold so expensive.

they are the most beautiful gnarly trees though with the brightest of green leaves which seem to one by one change into a fierce fiesta red which laughs at the red of her autumn.

the almond is inside here. →

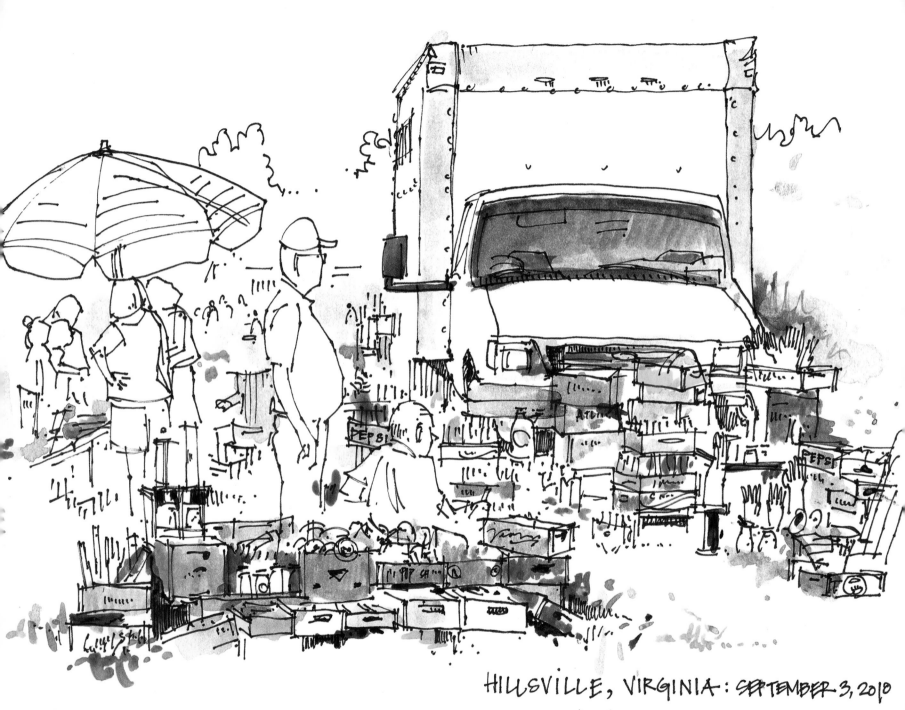

HILLSVILLE, VIRGINIA : SEPTEMBER 3, 2010

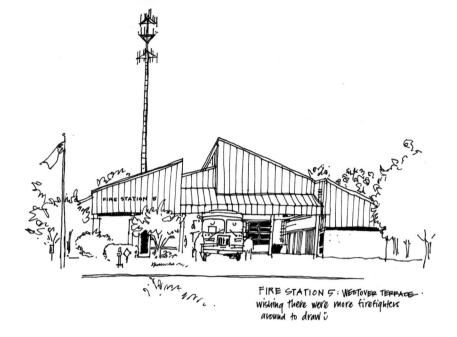

FIRE STATION 5: WESTOVER TERRACE.
wishing there were more firefighters
around to draw ü

Suzanne Cabrera

Suzanne Cabrera grew up in the mountains of North Carolina. Today she lives in Greensboro where she and her husband run a small illustration and design firm called Cabrera Creative. **www.anopensketchbook.com; http://suzannecabrera.com**

As a child, I drew my first picture, a turkey, at eighteen months. I must have fallen in love immediately, as this is my first real memory. I feel like drawing was always something that made me feel special. My parents always encouraged this passion. They even found humor in the way I drew the backs of peoples' heads during church services.

In the past I've traveled whenever an opportunity presented itself. The same holds true now, but I have a little more luggage. As a new mother to twin baby boys, my excursions are fewer and far between. However, I still have a little sketchbook packed in my diaper bag, just in case.

If I am by myself, drawing takes over. It dictates where I eat, where I rest, what I do and what I don't. If I'm with someone else, I try to incorporate it into whatever we're already doing. However, I do gravitate to the seat with the view.

When I bring a sketchbook with me on a trip, the experience is much more intimate than if I don't. I'm able to see a place more vividly, focusing less on the noise and more on the details. Drawing encourages me to slow down. When I draw, I'm living in the moment. I'm nowhere else, just in a zone, soaking in my surroundings. With each line that goes down on my page, I'm connecting with my subject matter, exploring it in a way

that I never would otherwise.

When I was little I wanted to be a detective, an artist or an archeologist.

I feel like I get to experience each of these professions when drawing on location. When visiting a new place, I look forward to investigating what makes it interesting, recording these moments the most beautiful way I can and preserving them for the future. It's the best of all three worlds.

Not only does the careful observation of a place help me as a designer, but I also love the fact that I can look back on a drawing and remember every last detail of the moments in which I was constructing it. (Ask me what I did this time last week

and I may not have the slightest clue. Ask me what was going on in any drawing I've included here—even one that dates back years ago—and I can tell you everything.) The background music, the smell of coffee, the conversation of the couple on a blind date sitting near me: My drawings allow me to travel in time.

My travel kit is pretty basic: a sketchbook, a few water-resistant felt-tip pens (right now I'm enjoying Sharpie pens) and a small Winsor & Newton watercolor set. I travel lightly because I want to be able to bring the supplies with me wherever I go.

I'm not loyal to one particular brand when it comes to my choice in sketch-

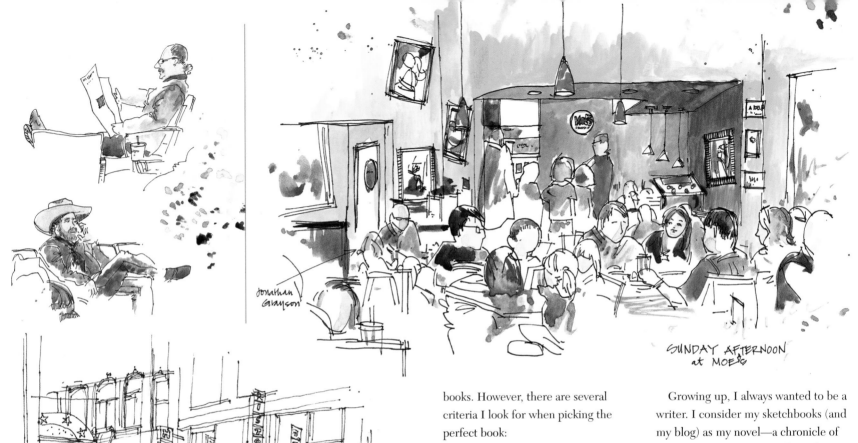

Jonathan Grayson

SUNDAY AFTERNOON
at MOE'S

books. However, there are several criteria I look for when picking the perfect book:

- Smooth paper that my pen can easily glide across, but at the same time, the paper must accept water-color without too much buckling

- Quality paper that is thick but not so much so that making a mistake on it seems like a sin—if the paper is too precious, there is too much pressure for perfection

- Large, preferably 8 ½" × 11" so I can "stretch out" when drawing

- Perfect-bound so it feels more like a novel

Growing up, I always wanted to be a writer. I consider my sketchbooks (and my blog) as my novel—a chronicle of my existence, an illustrated autobiography. Each time I finish a bound book I feel an immense sense of accomplishment. Seeing the books lined up on a shelf in my studio produces an equally satisfying feeling.

I find that many people become discouraged when they start out drawing because they compare what they do with others' work. Recognize that this is where being different is a great thing! In your sketchbook, you have the freedom to develop your own hand and your own voice. This is not an opportunity that readily presents itself in other aspects of

2008 Winter Graduation
GREENSBORO COLISEUM · DECEMBER 18
Congratulations Edgar!
I'M SO PROUD OF YOU.
MAGNA CUM LAUDE

TATE STREET COFFEE: I LET MY STUDENTS OUT OF CLASS EARLY TO GO DRAW. I SAID I WOULD DO THE SAME. THIS IS THE FIRST TIME IN WEEKS THAT I HAVE FELT LIKE I CAN BREATHE. LIFE HAS BEEN SO BUSY. JANUARY 22 2009

FLOW MINI - WINSTON-SALEM, NC - 11.9.08

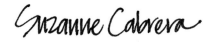

life, so take advantage of it. Ignore the inner critic and listen to your intuition. At its core, drawing is a form of storytelling. Your sketchbook is your chance to tell your own story.

There are no rules in my sketchbook. Life has enough restrictions and expectations.

I value the principles and elements of design in all things. However, I find that when I purposefully "design" a sketchbook page, it feels overdone.

Having found this to be the case, I give myself permission to forgo a plan, but rather allow my hand and intuition to lead the way. I'm certain that most designers would say that the work they do for clients differs from work they do for themselves. With clients, there are always expectations, and even if a client has given free reign on a project, artists feel it must meet certain criteria. As a result, some level of stiffness always occurs in client work. This is not the case

with my personal journals: I find them to be outstanding expressions of the artist I *want* to be rather than the one I feel I'm *expected* to be.

When I'm away from home, more often than not, I do not have any looming deadlines, any laundry waiting to be folded, any dogs banging their bowls to be fed. As a result, I feel free. I believe this inner peace is reflected in the more fluid and spontaneous pieces I draw when I am away from home.

When I draw in my sketchbook, I seek to both live in the present and preserve the moment for the future. I know the value of enjoying every moment as it passes, but I also recognize the importance of good memories. Drawing slows me down. It allows me to live in the moment. It provides me with confidence. In drawing, I've found my voice.

Suzanne Cabrera

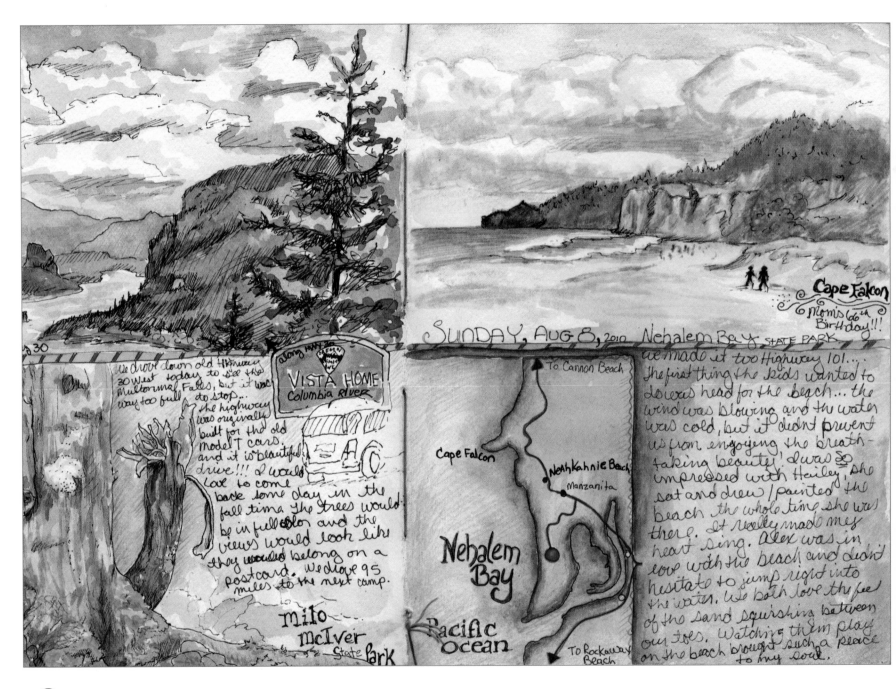

Cape Falcon

Mom's 66th Birthday!!!

SUNDAY, AUG 8, 2010 Nehalem Bay STATE PARK

30

Along HWY VISTA HOME Columbia RIVER

We drove down old Highway 30 West today to see the Multnomah Falls, but it was way too full to stop... the highway was originally built for the old Model T cars and it is beautiful drive!!! I would love to come back some day in the fall time the trees would be in full color and the views would look like they would belong on a postcard. We drove 95 miles to the next camp.

milo McIver State Park

To Cannon Beach

Cape Falcon

NeahKahnie Beach

Manzanita

Nehalem Bay

Pacific Ocean

To Rockaway Beach

We made it too Highway 101... the first thing the kids wanted to do was head for the beach... the wind was blowing and the water was cold, but it didn't prevent us from enjoying the breath-taking beauty! I was so impressed with Hailey, she sat and drew / painted the beach the whole time she was there. It really made my heart sing. Alex was in love with the beach and didn't hesitate to jump right into the water. We both love the feel of the sand squishing between our toes. Watching them play on the beach brought such a peace to my soul.

Lisa Cheney-Jorgensen

Lisa Cheney-Jorgensen grew up in Eastern Idaho. She currently freelances as a graphic designer/illustrator and teaches bookmaking and art journaling workshops throughout the Northwest. Her visual journals have been published in *1000 Artist Journal Pages*, *Art Journaling Magazine*, and *1000 Artists' Books*. **http://lisacheneyjorgensen.blogspot.com**

I grew up in rural Southeastern Idaho, surrounded by farmers' fields and my father's growing collection of antique car parts. I am the only female of five children. My family is full of creative minds. I came to realize, later in life, that even though we each use very different methods and media to express our creativity, we are each artists/craftspeople in our own right.

I recall drawing at a very young age, sitting on a little stool out in my neighbor's driveway drawing the old barns, trees, fields and an occasional outhouse. I have a vivid memory of sitting on the stump of a tree my father had recently cut down, attempting to draw the moon as it rose from behind the mountain peaks. I could smell the sticky, sappy scent of the freshly cut bark the whole time I was drawing. Now I am transported back to that moment every time I smell freshly cut wood.

I didn't really think about being an artist when I grew up. I just liked to record the shapes and textures of the world around me. I very clearly remember the first time I heard the title *artist* in relation to myself. I was about seven or eight years old and at a friend's Halloween party. A fortune-teller told all the kids their fortunes. She told me I was going to grow up to be a famous artist and that I would know because of a beautiful waterfall that I painted. Now, looking back at the event with my adult eyes, the fortune-teller was probably a neighbor dressed for the part and having a grand time with the kids. However, in my young, impressionable mind, she was authentic and knew what was in my heart. So of course I was supposed to be an artist. Wasn't I?

I took every art class available to me in junior and senior high schools and wanted to apply to a nearby art school after graduation. However, my art teacher at the time discouraged me from applying to the school, saying, "It is just so competitive. You don't want to put yourself through that." Being the young, naïve, shy girl I was back then, I tucked my tail and put the dream out of my head. After graduation, I didn't draw anything for almost three years. In my second year of college, I had to choose an elective class, and, of course, I chose Drawing 101. This spring-boarded me back onto my path. I recall very clearly the advice my father gave me when I was being discouraged not to follow my dreams once again. He said, "Honey, do what you love to do. Because you are going to do it for a long damn time! You may not be rich or famous, but you will

have enough money to be happy and will love waking up each day." I keep that nugget of inspiration with me even now. I promptly moved to Boise, Idaho, and received my BFA in graphic design a few years later. I have worked as a professional graphic designer for eighteen years and for the last seven as a freelance designer and illustrator.

What is the point of drawing while I travel? Gosh, that is easy. Drawing allows me to truly see everything around me. Drawing forces me to slow down and to really look at and appreciate the world. Drawing connects me to the places I visit; it creates a very intimate bond. Sure, it would be so much easier to take a snapshot and keep moving—I'd sure get to see a lot more that way! But the memory would be just that, fleeting. I would look back through the snapshots and say, "Oh yeah. I remember seeing that … where was that again? Hmmm, I don't remember. Oh well." And so it goes. This is not true when I have taken the time to draw the places I visit. When I look back through my visual journals, I recall the sounds, the smells, the feel of the breeze or the heat of the sun. I recall everything about those moments. When I draw something, I create a relationship with it.

I enjoy sharing my journals with others. In many ways, it is a very personal gift I want to share with the viewer: the gift of knowing more about me, my thoughts and the world through my eyes. Years from now, I hope my visual journals will

provide my family with a glimpse into my life and those places and people who have touched my life. My travel journaling is usually incorporated into my daily visual journals. This helps to create a chronological order of adventures as they occurred.

The style and media I use in my traveling journals differ from some of my other journals. I mainly use ink, watercolor and colored pencil in these books because it makes traveling with my limited tools easy. I have tried different types of carrying cases over the years, from fanny packs to soft book bags, but recently fell in love with a small antique suitcase. It is the perfect size to hold my book, pens, pencils, inks and watercolors. I prefer to use Faber-Castell PITT pens to capture the moment. The Indian ink is waterproof and permanent. Using the pen can be very liberating. It forces me to really look at and see the scene. It also forces me to accept and live with imperfections in my drawings. Most often I do not have the time to add color to the drawings while I am sitting in front of the subject, so I take a reference photo. Later that day, or sometimes weeks later, I come back to the drawing and apply watercolor, then punch up the colors with Prismacolor colored pencils. I love the waxiness of the Prismacolor pencils; they lay over the top of watercolor beautifully.

Being a graphic designer, I have a tendency to interject basic design aesthetics in my journals. I love to crop images off the page or play with scale. When I

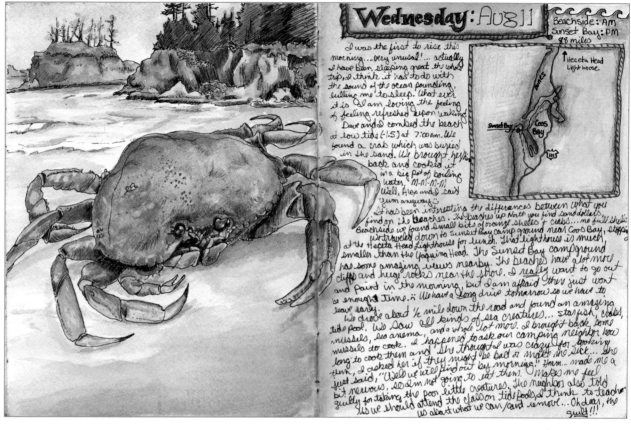

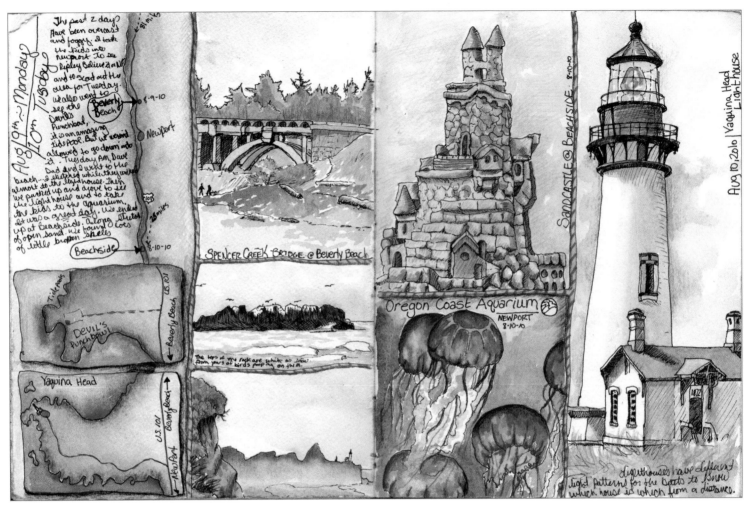

The past 2 days have been overcast and foggy. I took the kids into Newport to see Ripley Believe It or Not, and to scout out the area for Tuesday. We also went to see the Devil's Punchbowl, it is an amazing tide POOL. But we weren't allowed to go down into it. Tuesday AM, David, Dad and I went to the beach... I sketched while they walked almost to the lighthouse. Then we packed up and drove to see the lighthouse and to take the kids to the aquarium. We ended it was a great day. We ended up at Beachside. Along stretch of open sand. We found 2 toes of little broken shells.

Aug 9th Monday / 10th Tuesday

~81 miles
8-9-10
Beverly Beach
Newport
101
25 miles
Beachside
8-10-10

Tide pools
DEVIL'S Punchbowl
US 101 Beverly Beach

SPENCER CREEK BRIDGE @ Beverly Beach

The tops of the rock are white as snow from years of birds pooping on them.

Yaquina Head
Beverly Beach
U.S. 101
Newport

SANDCASTLE @ BEACHSIDE 8-10-10

Oregon Coast Aquarium
NEWPORT
8-10-10

Aug 10, 2010 | Yaquina Head Lighthouse

lighthouses have different light patterns for the boats to know which house is which from a distance.

visited the Oregon coast, it was helpful to include maps as a reminder of where I had been. I rarely include people in my traveling pages. I don't feel I work fast enough to capture them accurately; people are so wiggly and in almost constant movement, and I just want to tell them to hold still, which of course would ruin the moment and compromise the feel of the page.

Also, I keep in mind that I need to leave some areas on the page open for my journaling. Writing does not come naturally to me; jotting down my thoughts on the page can at times be mentally painful. Yet continuing to force the pen to the page has quieted the critic in my head and helped me come to terms with my writing style. I'm not writing for an audience, I'm writing for myself. For the most part I try to record thoughts, observations and/or information about the places I visit.

When I first started working in my visual journals, I used a basic hardbound black sketchbook. The pages were very thin so I only worked on one side of the page. Now I love making my own books with heavy, smooth watercolor or print-making papers that will hold up to any medium I throw at them. I really enjoy the Coptic bound books that lie flat in my lap when I draw. I also work front to back in chronological order. When I kept sketchbooks in college, I rarely filled them cover to cover before I started a new

sketchbook. Now I have multiple visual journals, each with its own theme and/or style, and I have to fill each one cover to cover before I make a new one for that particular theme. I have tried working on loose pages, but I never seem to finish them and find the pages scattered about my studio, so I stick to a bound book.

Now when I travel I have my book and supplies on my "list of things to pack." It is the last thing I do before heading off on my adventures. I also schedule time to draw while I am traveling. My family and friends know that it is very important for me to take this time for myself. I generally like to sneak off on my own, even if it is only for fifteen to twenty minutes. I don't care to have someone peaking over my shoulder the whole time or making me feel like I am holding them back from seeing something. At the end of the day, my travel companions usually want to see what it was I ended up drawing.

I have gotten to the point that I don't notice passersby and become very focused on what I draw. Listening to music helps focus my mind. From time to time, I have had brave individuals approach me and ask questions and, of course, I am always happy to talk with them. I figure if they are going to stop and take the time to talk and appreciate what it is I am doing, I need to reciprocate by sharing my time with them.

In recent years, I have traveled alone to locations and spent entire afternoons drawing in both touristy and off-the-

beaten-path locations. I usually decide beforehand where to go but when I get there I wait until I find the little nugget that piques my interest enough to record in my book. Sometimes it is something as mundane as a power pole. Other times it is a well-known monument or landmark.

My travel journals are very personal and some of my most prized possessions. Once completed, they are displayed in a hutch in my studio. They are all worn with age and use, some of the spines are starting to give way, some need to be rebound, but they are all loved the same.

I firmly believe that anyone can relearn to draw. We all began life drawing, some of us just kept on doing it. To relearn this skill, one need only to make it a priority. Perhaps treat yourself to a class or workshop on basic drawing skills. Buy a sketchbook and begin drawing in it every day, even if the picture is just a little something. Take the book with you everywhere you go, and draw in it instead of flipping through magazines at doctors' appointments or waiting for your kids to finish up soccer practice or during lunch breaks. Don't judge the outcome, just put pencil or pen to paper. Make sure you work in your book every day until it becomes a habit that you look forward to. There will come a day when you don't even have to think about it and your authentic voice will emerge on the page before you.

TRAVEL KIT

Fabio Consoli

Fabio Consoli lives and works in Acitrezza, Italy. He studied at University of the Arts London and at School of Visual Arts of Manhattan. He teaches graphic design at the ABADIR Academy of Arts and is the creative director of FBC Graphic Design Studio.
www.fabioconsoli.com; www.idrawaround.com.com

At six, I already knew that I'd be an artist or illustrator when I grew up. I hadn't understood the difference between the two and I didn't know how I'd manage to pay the rent, but I knew I'd do it with a pencil in hand.

I loved playing in the streets, though I preferred plastering my neighborhood with drawings to kicking a ball around.

As an adolescent, I was passionate about art and knew that many of the great artists died penniless, so I lowered my aim, from the immortality of the museums to something that resembles a job. I discovered graphic design—not bad—certainly the street walls won't be like the ones of the MOMA in New York, but at least someone will see what I do.

At seventeen, I started working as a graphic designer, what a big title. When my grandmother asked, "What do you do?" I replied proudly, "I'm a graphic designer!" She answered, "What?" and I repeated "I do graphics, make brochures and logos … well, Gran, I draw!" Irritated for being treated like an idiot, she said, "I understand that you draw, but what's your job?"

At nineteen years old, I got my degree at art college and already regretted my school years. At twenty-two, and after years of endless English lessons, I was ready for the London University of the Arts. Meanwhile, I came to Catania, where I continued to work in a studio as a graphic designer.

At twenty-five, I wanted to see the world. Not in a picture book, but with my own eyes, so I started traveling the world on my bike. During the trips, I kept a visual journal where I drew what I saw (or what I thought I saw). I wrote recollections and I took photos. In eight years' time, I'd have a blog where I'd publish all this material. In the meantime, I limited myself to treasuring my Moleskine as if it were the Holy Grail.

At twenty-nine, I had my suitcase packed and ready with a nice one-way ticket to New York. A few months later, I found myself attending continuing education courses at the School of Visual Arts in Manhattan.

Now I'm thirty-four years old and I live and work in Catania as an art director, graphic designer and illustrator.

I do two long trips each year, plus I travel on the weekends around Europe. One of these trips is on my bike and another is backpacking. I'd say that travel is a fundamental part of my life, both from a personal and professional point of view. I don't choose the places because they are interesting to draw. In reality, it's the places that choose me. In the beginning, it's just intuition, then coincidences make everything happen. After a short while, I find myself on my bike saddle in some remote place. My drawings create a strong link not only with the place that I'm visiting but with the adventure that I'm having. My sketchbooks are also an exploration tool I use to experiment with new styles.

In Alaska, I sheltered in my tent while storms raged and rivers overflowed, not

having much creative inspiration, scribbling and doodling on my Moleskine just to overcome boredom and tension. In Patagonia, in the Argentinian pampas, I drew while seated on dry guanaco dung. It was very comfortable—the only object that wasn't prickly for kilometers.

While in a "Taxi Brousse" in Madagascar, I put pen to Moleskine and, like a seismograph, I recorded all the vibrations on my Moleskine while the jeep drove at full speed across the sand dunes.

In Uganda, I drew a hut in the Savannah while baboons rummaged around my bike bags. During the day I rode under a tree where some lions were lying on one of its branches (it's forbidden to go into the parks without a jeep with an armed driver).

Maybe the most beautiful place to draw was Southeast Asia. I backpacked so I could carry more material. It was fantastic drawing the Angor Wat carvings in Cambodia, the beautiful Bangkok dragons, the floating village huts and the floating market in the delta of Mekong in Vietnam. Some of the characters that I draw today are inspired by the Angkor Wat carvings and the Asian statues. When I travel abroad, I like to study the traditional art and visual communication systems that are used, the statuettes, the posters, the lettering. I get passionate about African art, the commitment to details of Asiatic art and the minimalism of Swedish design.

I like going around my town and collecting snippets of Sicilian life. I have a notebook where I draw while at the beach every Sunday, quick sketches done with a Sakura 03 and color pencils made into watercolors with sea water. I use a slightly different style there, more narrative.

Drawing facilitates contact with reality and creates a strong bond with places. The stronger the emotion, the deeper it will be remembered in your mind. Because drawing creates intense emotions, the link with places where it was made is even stronger. When I look at an old notebook full of drawings I made in Madagascar, I'm almost able to smell the aroma of Africa. Yes, for me, Africa has its own smell and forest sounds. I'd like to imprint them in my notebooks forever; this is why I often use food or fruits like coffee, wine, soy sauce, some fresh herbs, berries or tomatoes for coloring. This is some way, even for a short time, I can infuse the smells into my drawings; this gives my Moleskine a nice garbage smell.

My travel drawings are created mainly for personal need, as a way to remember events and to explore the world. It also allows me to express myself without the stress and restrictions of assigned work. Over the last year, my drawings have also become tools for solidarity. In February 2011, I made a book of the visual journey of my bike trip in Alaska. The project is called "Cycling for Children" (www.fabioconsoli.blogspot.com), which I set up to raise money for children in need, through my adventures around the

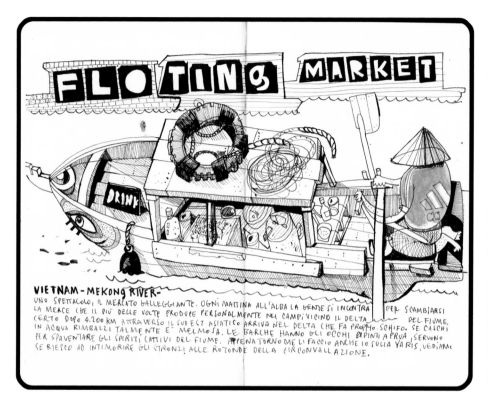

FLOTING MARKET

VIETNAM - MEKONG RIVER -
UNO SPETTACOLO, IL MERCATO GALLEGGIANTE. OGNI MATTINA ALL'ALBA LA GENTE SI INCONTRA PER SCAMBIARSI LA MERCE CHE IL PIÙ DELLE VOLTE PRODUCE PERSONALMENTE NEI CAMPI VICINO IL DELTA DEL FIUME. CERTO DOPO 4.200 KM ATTRAVERSO IL SUD EST ASIATICO ARRIVA NEL DELTA CHE FA PROPRIO SCHIFO. SE CASCHI IN ACQUA RIMBALZI TALMENTE È MELMOSA. LE BARCHE HANNO GLI OCCHI DIPINTI A PRUA, SERVONO PER SPAVENTARE GLI SPIRITI CATTIVI DEL FIUME. APPENA TORNO ME LI FACCIO ANCHE IO SULLA YARIS, VEDIAMO SE RIESCO AD INTIMORIRE GLI STRONZI ALLE ROTONDE DELLA CIRCONVALLAZIONE.

GANESH
④ UNA SOLA ZANNA INDICA LA CAPACITÀ DI SUPERARE OGNI DUALISMO ① IL VENTRE OBESO CONTIENE INFINITI UNIVERSI

world, that then get documented in the drawings and recollections in my blog.

When I draw during my travels, I have only one rule—that there are no rules. Freeing the mind and trying to think "laterally" instead of using vertical thinking to solve logic problems, as described by Andrew De Bono in his book *Lateral Thinking*.

I feel free to explore new avenues, new styles, letting intuition lead me instead of logic. I might begin drawing an object and then finish the drawing by inserting some cartoon characters or something that comes to mind but has no apparent connection with what I'm

looking at. This allows me to express how I'm feeling in the moment. Being mainly an art director and graphic designer, I'm careful that the result works from a visual point of view, and I treat my Moleskine as a unique project. For me, the pages must look good in sequence. This organization comes naturally to me, without thinking much about it.

When I travel by bike, with bike bags on the back, I have to be very careful about how much weight I'm carrying, so I carefully choose what to carry. For a bike journey, I usually carry just a small Moleskine or a Canson A5 ring binder sketchbook, a Staedtler 2B pencil, a

Micron 03 Sakura pencil and a Stabilo Watercolor pencil, which I dilute with a finger and saliva in emergencies. I also like to have something to color with locally. In the Moroccan Souk, I bought some pigment used to paint the mud huts and diluted it with water. The pigment had a very interesting texture and my fingers were stained for two days afterwards. For backpacking, I carry a Pelikan ink pen with an F nib that I bought in Paris. It was expensive and is the only costly tool I have. (I don't like expensive things.) Then I use a Pentel brush for Japanese writing that I bought in London; it has an excellent nib and

can make both very thin and very thick lines. A Staedtler mechanical pencil, an eraser, a paintbrush and a pack of Windsor & Newton watercolors round out my perfect kit.

I mainly use a small Moleskine for drawing. I find them easy to carry and they aren't obtrusive when I want to draw without being noticed. I also use Canson ring binder sketchbooks that have soft plastic colored covers. I can't get them where I live, so I stock up on them when I'm in Paris. I have always loved books. I like the format of books, the fact you can carry them easily and the fact that they have a precise reading

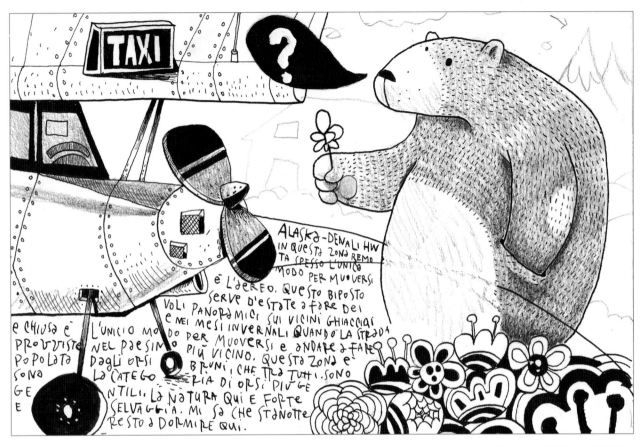

order. I always like carrying my sketchbooks and using them in strange ways: Sometimes I open them and eat on them, I might lay my head on them like cushions while at the beach or use them as drink mats. If I could, I'd sleep on top of them like Basquiat, but I find them quite uncomfortable. I like the fact that my notebooks are worn. Some of them are in a terrible condition. One got completely soaked in a tropical storm while I was riding through a primary forest in Madagascar. All of the drawings have a huge red stain because the first drawing has a background colored in with watercolor pencil, which bled through to other pages. Now I like those drawings even more.

I have a love-hate relationship with my travel journals. They are material objects that I'm very attached to. Sooner or later, I'd like to burn them to force myself to understand that the sketchbooks aren't the end, but just a means. Energy doesn't come from the pride of having a nice drawing but from the act of drawing it, the act of doing and living in the present, the here and now.

LONDON
in black and Red

J'ai toujours aimé imaginer qu'une ville puisse être identifiée par deux couleurs : L'ocre des façades ~~pour~~ et le vert des pins maritimes pour Rome, le gris bleu des toits de zinc allié au vert des bus pour Paris, le jaune des "cabs" et le brun des gratte-ciels pour New-York.

Sans conteste possible, c'est le rouge et le noir qui s'imposerait pour Londres.
Si les façades des bâtiments se sont débarrassées de leur pellicule de suie, le noir persiste — taxis, grilles, réverbères — et lutte pour résister à la montée du rouge vermillon : bus, cabines téléphoniques, boîtes postales, signaux, etc.

PHNOM PENH - 27 déc 2008

Aux abords de Psar Thmay, le grand marché central, les conducteurs de rickshaws guettent le client. Le regard rivé sur l'allée centrale, ils hèlent le chaland, s'épongeant régulièrement le visage ruisselant de sueur.

Jean-Christophe Defline

Jean-Christophe Defline grew up in France in Paris. He is the cofounder and associate VP of Copilot Partners, a strategy company in the digital industry. He is also the illustrator of half a dozen youth books. Largely influenced by Belgian and French comics, he always brings with him a tiny watercolor box and a few pens, filling travel sketchbooks and pastiches of comic books covers. **www.flinflins.com**

As a kid, I almost never left France with my parents. Instead, I traveled through books (I was amazed by the wonderful diaries of David Roberts in Egypt) and magazines where I used to cut out and draw images of places I wanted to go later. Since then, travel has become a passion. I usually travel twice a year: a one-week stay in France and a three-week trip abroad, mostly with my family.

Discovering new countries is a privileged experience where all senses are awakened and stimulated by new landscapes, colors, light, clothes, animal and vegetal species, fragrances, so many things you're unfamiliar with. Asian trips are my favorite travel experiences. There are so many amazing subjects to draw on the continent that I feel like an oversexed guy in a harem, as Warren Buffet would say.

But traveling with five kids doesn't give you much time for drawing. You will never get bored by drawing, but you can easily weary the people traveling with you, who may not be pleased to wait for two hours until you're done with your sketch. So I often draw at lunchtime or execute a ten-minute sketch that I'll complete back at the hotel. I also take a lot of snapshots so that I can wake up very early each morning and finish the drawing quietly in my hotel room.

I draw mainly because I need it: It makes me happy and it's a way to absorb intensely all feelings while away from home, a way to record them. It's also a way to better understand life in a different country. Drawing things pushes you to analyze details and understand why life is different here. It tells you a lot of things you wouldn't even notice at a simple glance or with a snapshot. If you are drawing a rickshaw, you'll see that under different layers of blue paint an old rusted framework hides. You'll notice the old wooden pedals handcrafted, the patched hood and the worn towel on the handle bar to wipe sweat. You immediately understand how much love and effort are needed to run this heavy engine on a daily basis.

Drawing is also a superior experience because you can get rid of unaesthetic details or restore things as no camera could do, depicting scenes from impossible perspectives.

Finally, drawing is also an easy way to get in touch with people. While people often react badly when you pull out a camera, as if you were "stealing" their

SINTRA

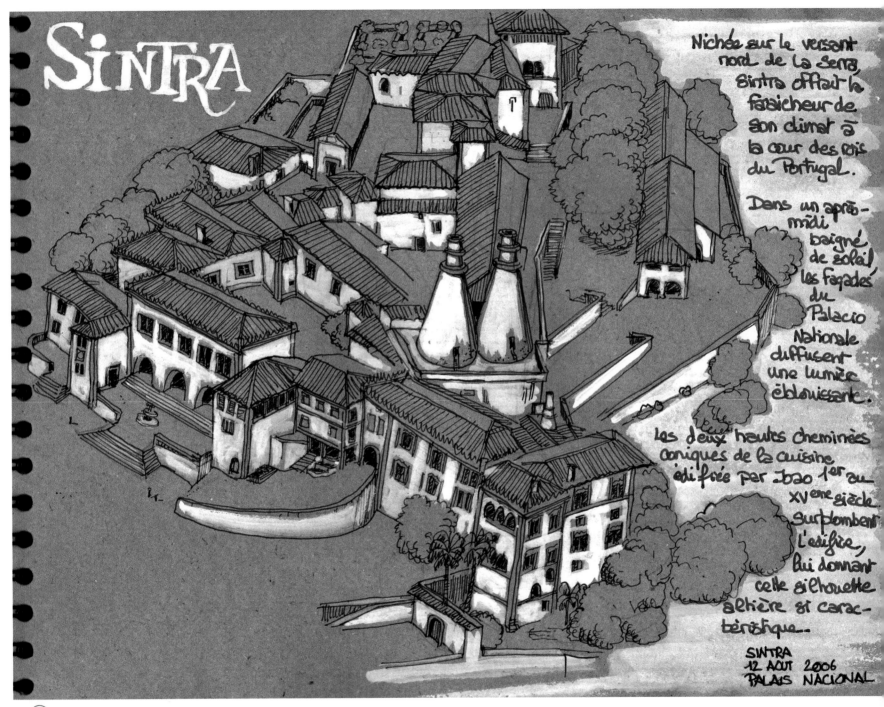

Nichée sur le versant nord de la Serra, Sintra offrait la fraîcheur de son climat à la cour des rois du Portugal.

Dans un après-midi baigné de soleil les façades du Palacio Nationale diffusent une lumière éblouissante.

Les deux hautes cheminées coniques de la cuisine édifiée par Joao 1er au XVème siècle surplombent l'édifice, lui donnant cette silhouette altière et caractéristique.

SINTRA
12 AOUT 2006
PALAIS NACIONAL

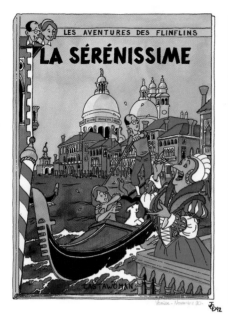

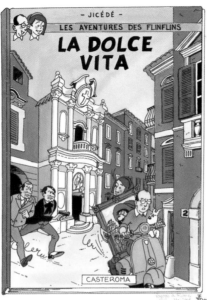

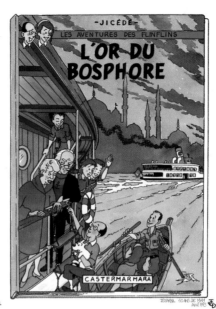

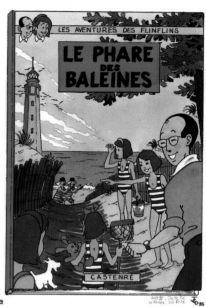

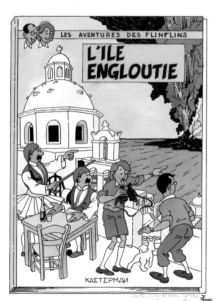

image, drawing brings curiosity and is often considered an homage. In Brussels, in a freezing evening of December, my wife and I entered in a café. There was a gypsy guy singing with his guitar, the face of whom I started to draw on the paper tablecloth. The owner of the restaurant loved it and asked me if he could have it. I gave it to him readily. He came back with a bottle of champagne, then offered us dinner in his café with the gypsy. We stayed and talked until very late about how much life recently changed in Brussels and which hidden spots we should go to.

Portugal was one of my most surprising drawing experiences. I was fascinated by the fact that this country (at least the architecture) seemed to be a two-tone land: brown from stone and white from lime on the walls. Unusually, I had also

taken with me a notebook with brown pages. So, rather than allowing empty spaces on my sheet of watercolor paper to figure the white walls as I would have normally done, I decided to reverse things. I bought a tube of white gouache and loved playing in dual tone.

While traveling, I always have my drawing kit with me. Though I do not always sketch, I feel more secure knowing I have everything to draw, if needed. In Ireland, for instance, though the landscape and the people were gorgeous, sadly I didn't draw at all. With all of its small winding roads, I had underestimated driving times, plus driving a minibus in such narrow lands drove me almost crazy. I was so exhausted I could not even draw.

I have a strong tendency to draw very

meticulously. Travel journaling forces me to draw quicker, which implies sometimes hasty minor mistakes. It took me a while to understand such imperfections add charm to the overall drawing.

Back home, I usually spend a few weeks polishing my sketchbook, completing drawings, adding commentaries here and there. Looking back at those drawings is always a strange experience. I can hear sounds, recall smells or remember very precise things I wouldn't have noticed otherwise.

The by-product of all these travel journals is that I use elements of each one to draw a pastiche of a Tintin comic book cover. It has become a family game to choose the most striking event of each of our travels to illustrate the family adventures with all the gang portrayed.

A room in our home is filled with these framed covers. It has become our family museum. Our friends love it: It's a summary of all our travels.

For years, I have traveled with far too many supplies: tubes of gouache, watercolor, various types of felt-tips and pens, rapidographs, color pencils. Now I travel rather light. I always take with me a drawing refill pencil (2B), Faber-Castell artist pens (thin and medium, both in sepia and black), a Pentel Brush Pen and a tube of gouache (permanent white).

I also have a very tiny watercolor box with twelve half pans of colors (I've been loyal to Winsor & Newton since the age of fifteen). The box has a very convenient tank inside for water, but as it ages it has begun to leak. So I have added to my drawing kit a small plastic gin bottle filled with water, which makes people look at me very suspiciously in some countries.

I use two Da Vinci travel brushes (Kolinsky Red sable hair only No. 8 and No. 5). I love those pocket brushes where you can twist the hair part into the body of the brush to protect it.

I also had many love affairs with various fountain pens until I got tired of seeing them leak on airplanes. I finally adopted a couple of Lamy Safari with larger pens for writing.

While I'm rather constant in my drawing and painting materials, I have been chasing the ideal notebook for the past twenty years, trying different papers, formats and brands. I am a great fan of the plain Moleskine notebook. It's very resistant and comes with a lot of pages (192 pages) in a rather small volume, though its paper warps because it is not really suited for watercolor. I also love the watercolor Moleskine, though it's less convenient for writing. I never understood why you can't find it in portrait format. I recently discovered D&S–Hahnemüle (A5 Landscape eighty sheets) notebooks with a rather polyvalent paper that can be used for china ink, watercolor or even gouache, though it's primarily intended for pencil and charcoal.

On one of my trips, I found an old leather satchel at a flea market. It is big enough to contain a notebook and all my drawing and painting materials, while small enough to force me to travel light.

I usually work chronologically because it forces me to work on a daily basis. Work daily, by the way, is the usual advice I give to anyone who asks me how to deal with sketchbooks: Regularity is key!

I also always take a pair of scissors (with which I play hide-and-seek with airport security) and a stick of glue. I use them mostly to add intermediary sheets of paper in another material (brown or watercolor paper) or to extend the

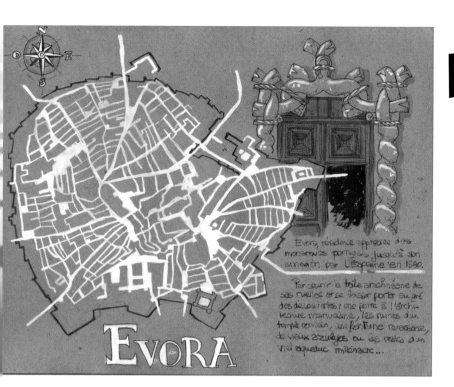

EVORA

Evora, résidence appréciée des monarques portugais jusqu'à son annexion par l'Espagne en 1580.

Parcourir la toile arachnéenne de ses ruelles et se laisser porter au gré des découvertes : une porte à l'architecture manuéline, les ruines d'un temple romain, une fontaine renaissance, de vieux azulejos ou des restes d'un viel aqueduc millénaire...

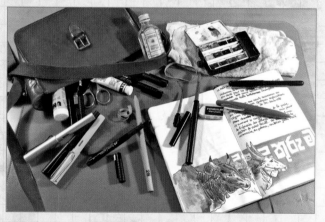

format to draw in a landscape format, though I may also add old banknotes, newspaper headlines, bottle stickers, restaurant bills or tickets, though I'm usually crazy enough to redraw them.

As a result, once I get them back home, my travel notebooks always look very thick and rather worn. That's how I love them to be: worn objects of daily life rather than luxury objects.

Sometimes there are things I really want to draw (somebody passing by on a motorbike with coconuts or pigs, an ox-cart, a fruit shop), but I can't always stop. So I write them down as a list at the very end of my travel book with the hope I'll have a chance to find it again later on. If

not, I may chase photos on the Internet once back home to add to it.

Since I am perpetually dissatisfied with my drawings, I used to share my travel books only among my family. With the rise of the Internet, I discovered a lot a very high-quality works, which stimulated me and helped me make progress (though sometimes it makes me feel like I should simply stop drawing). I also saw a lot of other more unexceptional works that helped me feel more confident with my sketches until I decided I could share them on social networks.

Jean-Christophe Defline

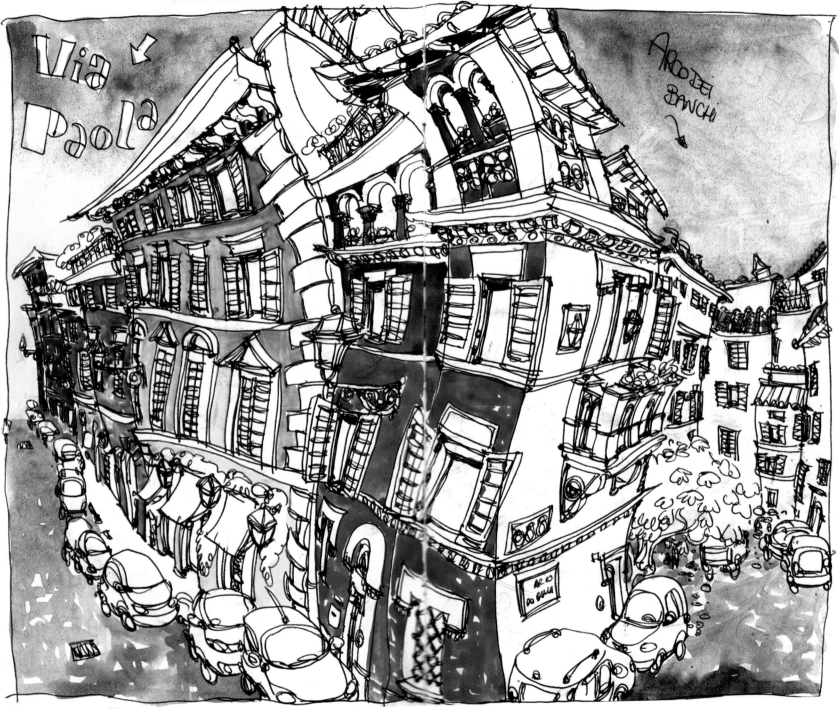

Benedetta Dossi

Benedetta Dossi was born in Trieste, Italy, and now lives in Rome. She is a concept and character designer for RBW-CGI animation. She is also a caricaturist and an urban sketcher. **www.365onroad.blogspot.it; www.benwithcappuccino.blogspot.it**

I started to draw as soon as I was able to hold a pencil. I copied every character I saw—Lion King, Marmalade, Aladdin, Beauty and the Beast—from the stickers I collected. When I was a child I was infatuated with Ariel and her beautiful hair—I loved her freckles. I read *Topolino* magazine and *Il Giornalino*. My eyes were captured by certain styles rather than the stories and, later, I discovered that the strip *Gli Aristocratici* was drawn by Sergio Toppi, a great Italian illustrator. Animation made me fall in love with art.

In school, I learned more from my colleagues than my professors. Some of them were creative and they taught me to use many techniques, but I particu-larly liked to draw from the model.

Every trip I've done gives me some-thing. I've learned to draw only when I'm in a creative mood, to build anticipation until my hand can't stand still any longer and has to draw. Drawing is something inside me, a need that I feel to create a special connection with the surrounding, a method to express my mood. I feel like a child that wants to see everything, and one pair of eyes isn't enough! Drawing affects the way I see the things around me—some particular effects of light, the details of a place, how the people move and speak, everything creates a store of experience from which I draw for my creativity. It makes me feel exhausted and happy! I always try to balance the time when I draw and when I don't, because I need also to observe only with my eyes.

I just look around me and if I dis-cover something that has a good design and stimulates my creativity, I draw it. Sometimes I want to study the design of a movement or just draw the detail of a place, cars or shop signs to create a mental archive.

When I first saw Naples, I realized it was the ideal place for my current style. When I saw New York, I felt a sense of uprightness. When I saw Paris, I fell in love with the beauty of the line, and when I draw in Rome, I feel the words of the stone, the past, our forebears who lie in the underground, brought to glory by the contemporaries.

When traveling, I pay more attention to the differences I find in comparison with my own culture. I'm especially interested in the little differences, like the order of the plates in a menu, how people eat, the way people act in a metro. When I travel, my book fills with notes about things. If I don't draw on a trip, I return home with a sense of fullness, which leads me (after a time) to draw more freely, maybe because I have a lot of things to say! For example, when I was in Neuschwanstein with my boyfriend, I went on a quick guided tour and saw a fantastic and rich castle. After

the trip, my hands quivered because of everything I wanted to draw.

In my work, I learn new techniques or methods to create fast and interesting designs. It's a continuous search to improve my skills, and all this is done in digital ways. Drawing is introspective. I want to speak and play by myself, with the buildings. I want to dance with them, with the people around me, I want to steal their movement, a part of their reality.

I've a very simple travel kit. I use a normal Bic pen and a Moleskine sketchbook. Sometimes I sew my own sketchbook with wrapping paper. I like to add color with Caran d'Ache felt-tip pens or watercolor (Cotman by Winsor & Newton, I also use their brushes) or acrylic color (brand: Maimeri). I also like to use a Tratto Pen that works very well with ink because the line can be watered down. My kit changes with the landscape I have in front of me. Sometimes I feel that a landscape needs colors, sometimes not.

The book form gives a sense of importance and continuity to the sketches. The single piece of paper gives me a sense of solitude; it is detached, a single moment I live. It's important, for the psychology of the sketches, to give them a legitimate place.

Lately I've discovered a kind of sketchbook built with continuous folded pages that fits me well because I want to create continuity from one drawing to the other. Most of the time a single drawing doesn't have a relationship with the others. It is a single moment, but sometimes every drawing is a continuation of the drawing before. I might take notes about some place, or I may add some balloons with a nice dialogue, or I give a title to the drawings, but I don't glue things because they create a depth in the Moleskine, and it's difficult draw in the following pages.

My travel journals are repositories of experience. I consider them precious things in as much as they preserve memories of the trip. They tell about my life and about how I see the world, and they are objects that I love to share when people ask me to. They allow me to tell my history complete with illustrations.

Deri Benedetto

Le barche della casa del Mare

Ore 11:30

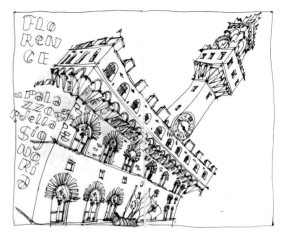

FLORENCE ...Palazzo della Signoria

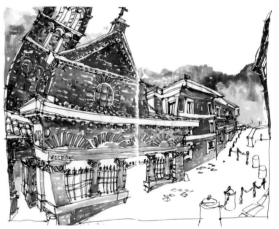

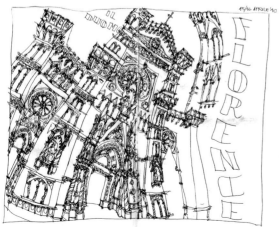

IL DUOMO

FLORENCE

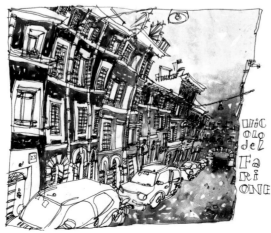

VICOLO DEL FARIONE

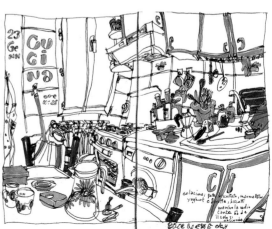

23 Ge giu CUGINA

DIVE BOAT CAPTAIN QUOTE OF THE DAY
"ALL DEM HEROES
DIE QUICK."

"WILL"

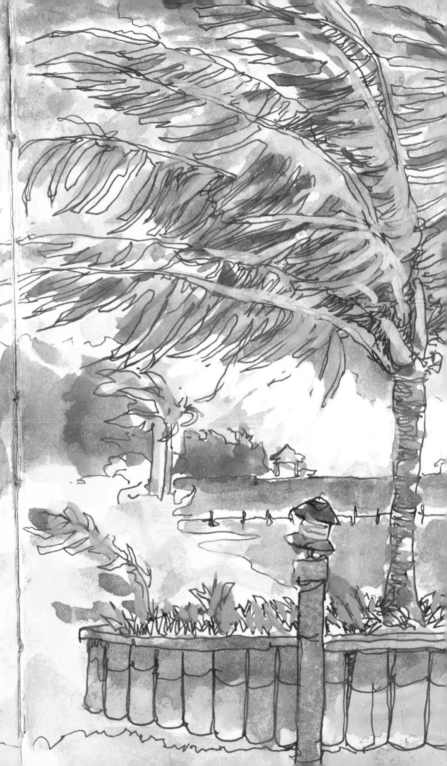

07 MARCH 06: WAKE UP EARLY, 6AM-ISH,
TO BRIGHT SUNLIGHT AND LOUD BIRDS. TRY
TO SQUEEZE IN A BIT MORE SLEEP — THE
NIGHT WAS A BIT RESTLESS — ~~BUT~~ TO NO AVAIL.
BEAUTIFUL WEATHER FOR A BREAKFAST
ON THE GREEN PARROT BALCONY. OFF TO
THE DOCK TO MEET THE DIVE INSTRUCTOR —
TANNED, WHITE ZIMBABWEAN/SO.
AFRICAN/ENGLISHMAN NAMED CRAIG.
SHORT BOAT RIDE TO THE SCHOOL, A
HUT AT THE END OF ~~THE~~ A RESORT DOCK. →

Bob Fisher

Bob Fisher grew up in Ohio but now makes his home outside of Atlanta, Georgia. He earned a BFA in visual art from the Atlanta College of Art, studied illustration and graphic design at the Portfolio Center and got a master's in marketing from Georgia State University. His artwork is focused on the medium of sketchbooks. **http://sketchbob.com**

I was fortunate.

My parents, though not artists themselves, always supported my interest in art. Perhaps they did so because I was a hyperactive child who drove them crazy when I wasn't drawing quietly. Maybe they saw that I lacked more practical skills. Either way, their if-you-can't-beat-'em-join-'em attitude meant that I was free from pressure to become an engineer like my Dad.

I was also fortunate to find an excellent high school art program that provided a strong foundation in the elements of art and principles of design. We learned concepts like line, form, color and composition through a regimen of drawing from life. The training was both traditional and creatively nurturing.

Most important, the teachers required that we keep sketchbooks. We used our books to collect inspiring images, experiment with new materials, work out ideas for assignments and draw things that made our friends laugh. Among my fellow students, keeping a good sketchbook became cool, and we were happy to share our work.

By the time I left high school, I was hooked. I rarely went anywhere without a sketchbook.

After art school, I wound through careers in art, design and business. The regimen of working in a sketchbook kept me grounded, providing a counterbalance to the continual evolution of my professional life.

Now the act of making images and words in my books is an essential part of how I process everything I experience. My books are part of how I see, and keeping a sketchbook is now so fully integrated into my life that it I no longer question why I do it. It's a natural part of who I am and how I live.

My sketchbook functions as a storehouse for inspiring images, a laboratory for experimenting with media and techniques and a playground for exploring and developing ideas. Notable exceptions are my travel pages, which are meant to be chronicles of unique experiences.

I was originally inspired to produce travel pages while working as an art director for Cartoon Network in the early 2000s. One of the designers on our team showed me a few pages of sketches he had done on a recent trip to London. I remember very little about the pages themselves, but they changed the way I looked at travel. I decided to make my sketchbook a central part of my next trip.

I love the transforming power of travel. I go abroad to be influenced by

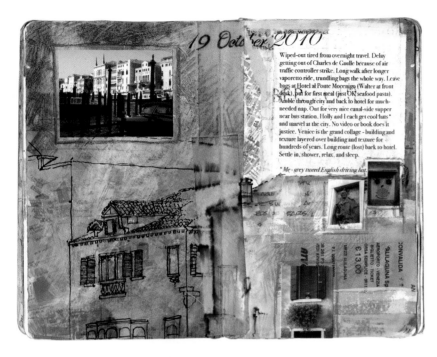

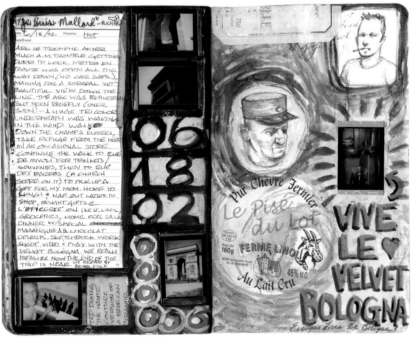

other cultures as much as to see new places. I feel invigorated when I am immersed in an unfamiliar environment, and making art is a natural way for me to process the experience.

I've never been one for merely recording a landscape, so my travel art might not be what people expect. I'm much more interested in the small things that characterize a place: local plants, architectural details, textured walls, graffiti, the shapes of mailboxes and street signs. Most of my travel pages are collages that include small drawings and descriptions of odd things I see.

I spend much of my time observing and collecting bits of my environment through drawings, photographs and written notes. I also collect bits of ephemera that I work directly into my books, often as a background texture. I like the idea of incorporating physical artifacts of a place into the art that I make about it.

Drawing from life while on a trip is always a dicey proposition. I am a bit self-conscious when I draw in front of other people, so I don't like drawing anywhere people can easily see what I'm doing. I have to be very creative about when and where I draw in public spaces in order to feel comfortable.

Some trips I produce a spread each evening about that day's events; other trips I come home with a bag of paper scraps and a bunch of half-completed pages that I finish within a week or two of my return, while my memory of the trip is still fresh. The approach I take depends on who I'm traveling with and whether it is physically possible to work in the place I am visiting, but I try to do as much work as possible while on the trip.

I want each spread in my books to feel finished, so I need a variety of art materials to create the layering and textures I like in my work. I travel with a portable art-making kit that includes a sketchbook, camera, small notepad for written observations, acid-free glue sticks, and a variety of wet and dry media that include markers, colored pencils, and Prismacolor sticks. I modified a toothbrush holder to store watercolor brushes and use a plastic soapbox to hold a few basic watercolor tubes. Most of the materials I use are archival and don't smear easily.

Since beginning my travel pages with a trip to Paris in 2002, I've recorded other trips to Peru, Belize, Spain, Italy and Croatia. I believe that traveling with a sketchbook enriched my experience of those places; I was more aware of my surroundings and now have a unique and meaningful memento of each trip.

Each set of my travel pages presents my own perspective on the places I've seen. As a result, they may be too personal to appeal to anyone else. My hope in showing them is to inspire others to create their own illustrated journeys.

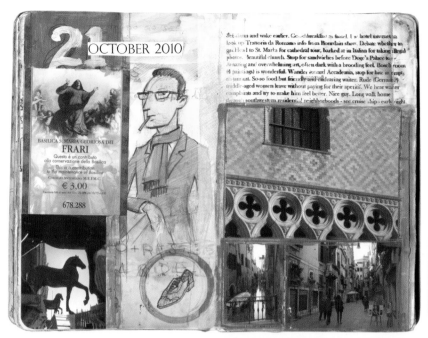

21 OCTOBER 2010

Set alarm and wake earlier. Good breakfast at hotel. Use hotel internet to look up Trattoria da Romano info from Bourdain show. Debate whether to go. Head to St. Mark's for cathedral tour, barked at in Italian for taking illegal photos. Beautiful church. Stop for sandwiches before Doge's Palace tour. Amazing and overwhelming art, often dark with a brooding feel. Bosch room (4 paintings) is wonderful. Wander toward Accademia, stop for bite at empty restaurant. So-so food but friendly and endearing waiter. Rude (German?) middle-aged women leave without paying for their aperitif. We hear waiter complaints and try to make him feel better. Nice guy. Long walk home through southwestern residential neighborhoods - see cruise ship - early night.

BASILICA S. MARIA GLORIOSA DEI
FRARI
Questo è un contributo
olla conservazione della Basilica
This is a contribution
to the maintenance of Basilica
COLLEGI ANTONIANO M.E.F.M.C.
€ 3,00
678.288

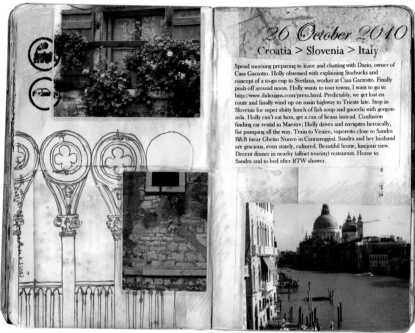

26 October 2010
Croatia > Slovenia > Italy

Spend morning preparing to leave and chatting with Dario, owner of Casa Garzotto. Holly obsessed with explaining Starbucks and concept of a to-go cup to Svetlana, worker at Casa Garzotto. Finally push off around noon. Holly wants to tour towns, I want to go to http://www.ildesigns.com/press.html. Predictably, we get lost en route and finally wind up on main highway to Trieste late. Stop in Slovenia for super shitty lunch of fish soup and gnocchi with gorgonzola. Holly can't eat hers, get a can of beans instead. Confusion finding car rental in Maestre; Holly drives and navigates heroically, fist pumping all the way. Train to Venice, vaporetto close to Sandra B&B (near Ghetto Nuovo in Cannaregio). Sandra and her husband are gracious, even stately, cultured. Beautiful home, luscious view. Decent dinner in nearby (albiet touristy) restaurant. Home to Sandra and to bed after RTW shower.

ORGANIC
#94011

BELIZE

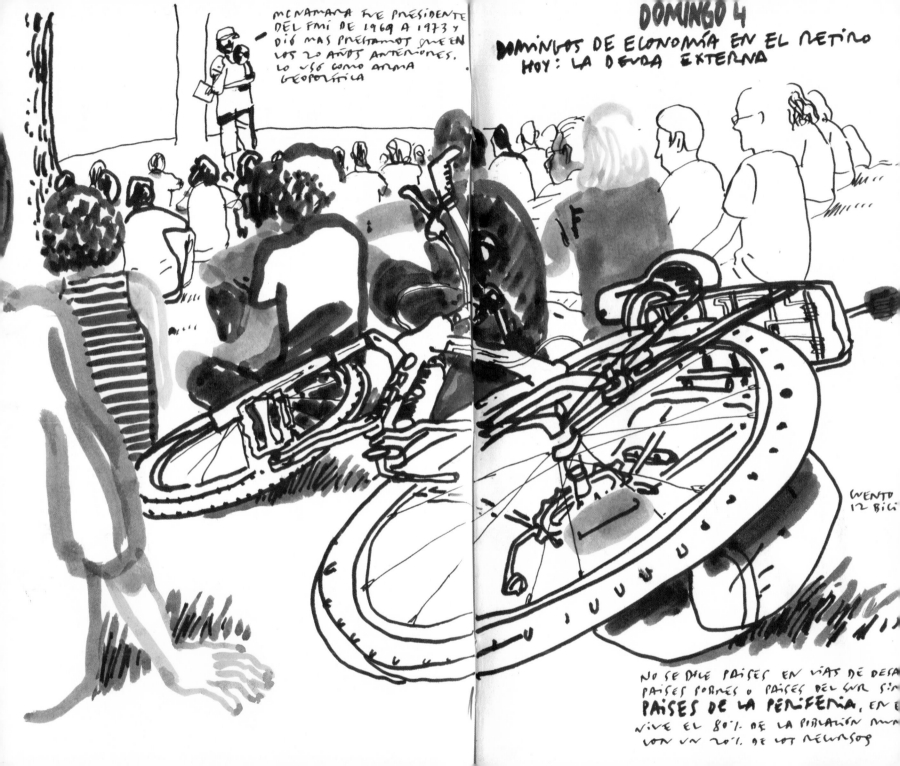

MCNAMARA FUE PRESIDENTE
DEL FMI DE 1969 A 1973 Y
DIO MAS PRESTAMOS QUE EN
LOS 20 AÑOS ANTERIORES.
LO USO COMO ARMA
GEOPOLÍTICA

DOMINGO 4

DOMINGOS DE ECONOMÍA EN EL RETIRO
HOY: LA DEUDA EXTERNA

CUENTO
12 BICI

NO SE DICE PAÍSES EN VÍAS DE DESA
PAÍSES POBRES O PAÍSES DEL SUR SIN
PAÍSES DE LA PERIFERIA, EN E
VIVE EL 80% DE LA POBLACIÓN MUN
CON UN 20% DE LOS RECURSOS

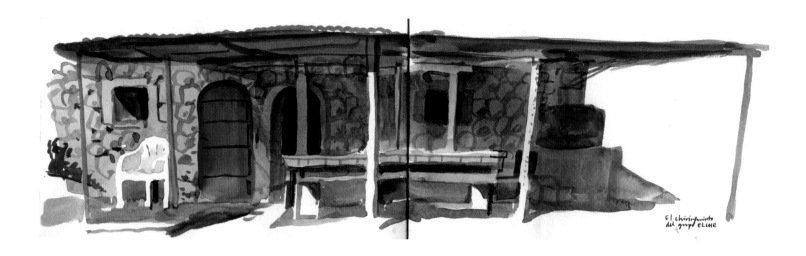

El chiringuito del grupo ELCHE

Enrique Flores

Enrique Flores was born in Spain, studied Fine Arts in Madrid and graphic design in London, worked as an art director for J.Walter Thompson, has published more than 100 books and now collaborates on regular basis in the newspaper *El País*. **www.4ojos.com**

I come from Extremadura in southwest Spain. Magnificent landscape, great people, but zero cultural life, so I moved to Madrid to study fine arts when I was eighteen. I completed my studies with an MA in graphic design in St. Martins, London, where I lived for a while until I realized how I missed the sun.

I remember drawing all the time in my childhood and I guess the reason I keep on doing it now is because I didn't stop at the age most children do. I have to thank my parents for providing me with endless crayons and sheets of paper throughout my childhood.

Now I work as an illustrator for publishing houses and for the Spanish newspaper *El Pais*. My travel sketchbooks and graphic diaries are not part of my professional life, and I like to keep them that way. By doing so, I can preserve them as a space of freedom and experimentation. I wouldn't like the idea of a client telling me what to do in them.

I travel as often as I can but I don't use my sketchbooks only when I'm away. I keep a daily graphic diary where I both draw and write. In it, I doodle and keep track of commissions and appointments. The book is my "second memory," so to speak, and I'm afraid I'm useless without it. I rely absolutely on this object, and it's been ages since I've been without a sketchbook at hand. I live an old-fashioned life, with no car, iPad or mobile phone and an object as fragile as a paper sketchbook ties me to the slow lane.

Of course, life is more intense when traveling and the speed with which I fill the pages when I'm away is always surprising. I'm very fast at drawing and never use pencil prior to the ink and watercolor, so I never have enough pages to fill. That's why I have to compromise when choosing my materials. Thick watercolor paper is bulky and heavy, unsuitable for the kind of trips I like to make (light backpack and public transport), and I prefer carrying quantity instead of quality. I prefer doing ten drawings a day on unsuitable paper rather than one in a state-of-the-art sketchbook. The same applies to watercolors: I carry an inexpensive plastic box I fill with good quality pans (Schminke, Rembrandt or Winsor & Newton, I don't really care). As for sketchbooks, I don't have any preference as long as they are thick. A4 and A5 are sizes I'm comfortable with, and a small A6 is always handy for doing quick sketches of people.

Years ago, I didn't know why I traveled. I invented excuses in order to go to the places that attracted me. Now I can always reply when asked: "I go to places to draw them." That justifies the travel somehow. I don't feel like a loafer anymore but like someone that is doing

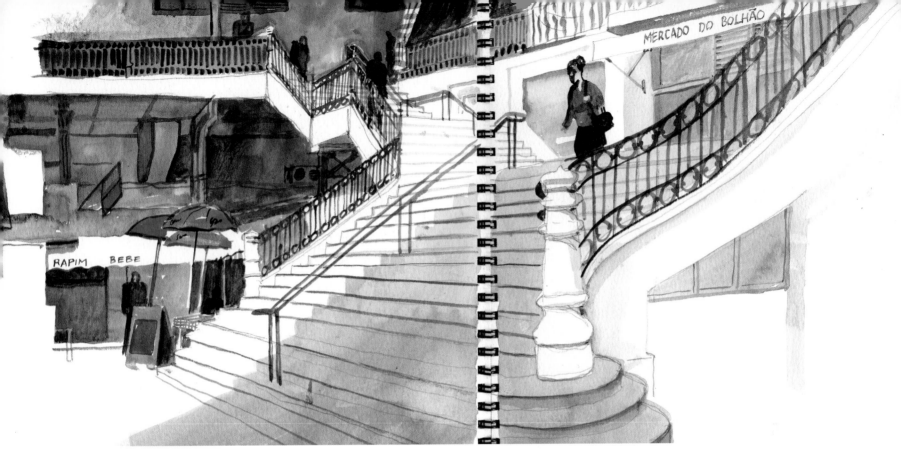

something. I'm aware that's a fiction built for my comfort, but it's like feeling I'm part of the landscape and I give as I receive. I always prefer sketching in public places and love to be seen, asked and criticized. That's perhaps the result of searching for the opposite of my day-to-day surroundings as freelance illustrator working always in the studio. I've always looked with envy to musicians: people who work in close contact with their public and can experience instant feedback; their experience is just the opposite of illustrators. Months can pass between when I submit my work and the day I receive the printed copy of the book.

I'm a creature of habits and I always include in my sketchbooks some hand-drawn maps of the places I visit, a small calendar, a drawing of the plane/boat I'm traveling in and the shoes I'm using. Call it superstition. I also like to fill the pages chronologically. In doing so the book fulfills its ultimate function: helping my memory. It's a process of archiving or classifying my memories.

I like drawing cities. That's perhaps a result of my long years living in Madrid. Streets, squares, cars, people, traffic signs and bars are common subjects in my sketchbooks. I'm good at drawing concerts and I enjoy doing it on foot, sometimes moving with the music. I'm useless at drawing trees and animals, and that's probably the reason I go often to the parks in my city. I draw sometimes as an exercise when I feel I need to improve some skills. You can never practice drawing too much.

Ancient and decadent cities are great places for sketching. Havana is, of course, a paradise to me with magnificent architecture and cars and great bars. The same applies to Algiers, Porto or Rome—places where I draw tirelessly, always thinking of a utopian project of an inventory of my favorite neighborhoods: *Drawing everything* from buildings to traffic lights.

I don't remember any travel I've done without drawing. That's normal, of course, as I only remember what I draw. That's probably my greatest weakness—and the reason I do it.

ENRIQUE FLORES

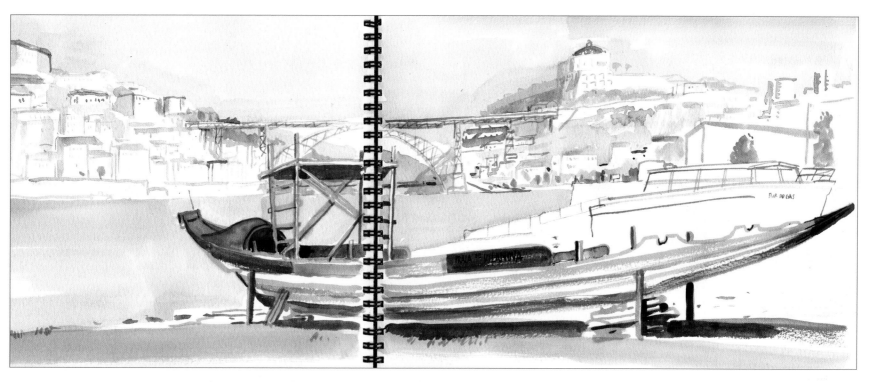

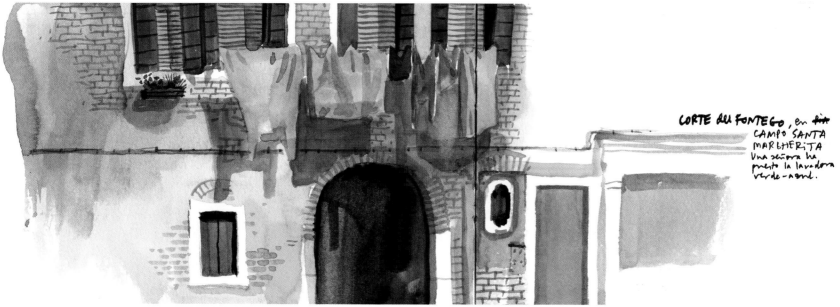

CORTE DU FONTEGO, en ~~fin~~
CAMPO SANTA
MARGHERITA
Una señora ha
puesto la lavadora
verde-azul.

LE VEN BANANAS ECUATORIANAS MARCA "ADRIA", CARAS

UN SEÑOR ME DICE QUE ANTES VENIAN LOS TUNECINOS A ESTUDIAR TURISMO A ARGELIA. HABÍA DOS ESCUELAS, UNA EN TIZI-OZOU, AHORA HAN ATRAÍDO TURISMO A SU PAÍS Y AQUÍ NO LLEGA NADA AUNQUE TÚNEZ "ES TODO FALSO, LO HAN DESTRUIDO Y RECONSTRUIDO AL GUSTO OCCIDENTAL, AL CONTRARIO QUE MARRUECOS, DONDE TODO ES GENUINO"

RESTAURANT DE LA PAIX
CENAMOS LOS DOS POR 800

EL SEÑOR ¿FRANCÉS?, DEL CAFÉ ME INVITA A UNA CONSUMICIÓN

Wil Freeborn

Wil Freeborn was born in Harrow, England, and spent his first few years in Japan before moving to Scotland. He went to Glasgow Art School studying environmental art before becoming a designer and working for various agencies including BBC Scotland. He is currently freelance, spending equal time designing for clients and doing illustration work. **www.wilfreeborn.co.uk**

I was brought up in the southwest of Scotland near a small village called Dunscore. I drew from an early age and fell in love with illustration in books like *The Wind in the Willows*, Snoopy, *Oor Wullie* and the end papers in Rupert Bear books. My family was not very artistic at all, though my aunt did make decorative cakes and spent a lot of time making icing flowers from scratch.

I had always wanted to go to Glasgow School of Art as it had such a strong reputation with painting and had recently produced such artists as Jenny Saville and Alison Watt. By the time I got there it suddenly shifted to concept art, and teaching painting seemed to have disappeared from favor. I studied environmental art and my work shifted from the physical to the intellectual. After graduation, I became a designer doing websites and slowly making the transition to more art and illustration, which is how I make a living today.

I like to travel as often as I can, mostly on weekends. I like to get in the car or on a bike and visit somewhere nearby. When I first moved to Glasgow, I lived there for almost ten years without traveling around Scotland at all. I remember chatting with some visiting Australians who'd seen more of my country in two weeks on holiday than I had in my whole life. It was only when I moved out of the city to a small town on the west coast of Scotland that I really started to appreciate where I lived and started to see it as a place to visit and experience.

There are two aspects of travel drawing: one that's passive and the other active. With the passive, you draw wherever you end up, whether it's waiting on a plane or for a friend in a cafe. Then there are the places and events you actively seek out to draw. I started off drawing in those in-between passive moments, like at meetings, on the train or waiting for appointments. More and more I now like to plan where to draw and turn it into an adventure of finding new places to see and hopefully get some type of narrative into my drawings.

I keep an eye on the local papers and read about upcoming events. I make wish lists and notes of things I'd like to draw (I'm still discovering what I like

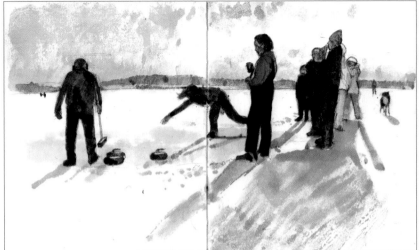

to draw). For example, I don't find museums and galleries especially interesting in themselves, but I do really like places where the audiences interact with the pieces and place. I like seeing how people look at, say, a T-rex skeleton—there's a weird contrast between the two, like two different worlds.

It's great to go into a place and ask if you can draw there. You can often get access behind the scenes and record people at work, which gives a more human aspect to what you're drawing. I've asked permission to draw at my local film theatre. Film is quickly getting sidelined for digital, and I wanted to make a record of a projectionist loading 35mm film before it disappeared. By luck, at the time, there were two generations of projectionists there. I sat and drew them working and had an easygoing chat—I've been tempted to take a recorder with me sometimes so I

can remember everything that's said.

The best drawing trip I ever had was a few years ago, traveling around Spain for two weeks. I learned a lot. Drawing there was such a difference from chilly Scotland. For once, I could spend hours outside on each drawing. The extra time I spent really helped me find my feet and get addicted to something that would last with me.

The worst trip was when I planned to cycle around the coast of Scotland. I took a mini trip around Arran to see how it could go. I fully packed my bicycle for the journey and it was so heavy that as I cycled I got so tired that I wasn't in the mood for drawing. I didn't make the full trip that year. However, I do plan to go back sometime, a bit fitter and more prepared.

I have a really simple kit. It's taken me a while to get the colors I like to use. The colors that you initially get tend to be really basic, and I couldn't understand why

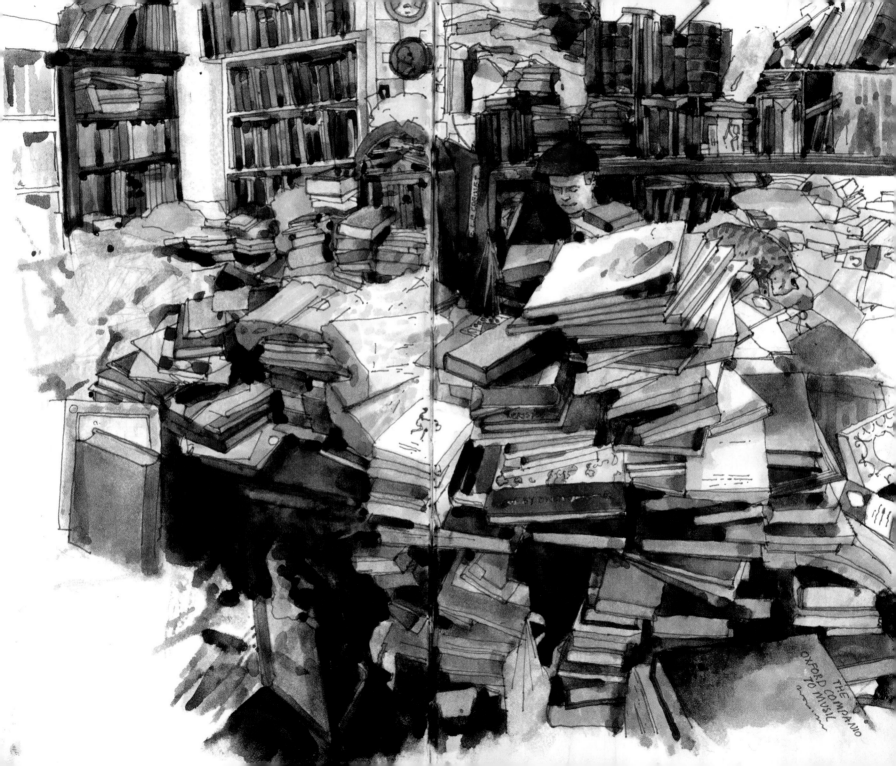

THE
OXFORD COMPANION
TO MUSIC

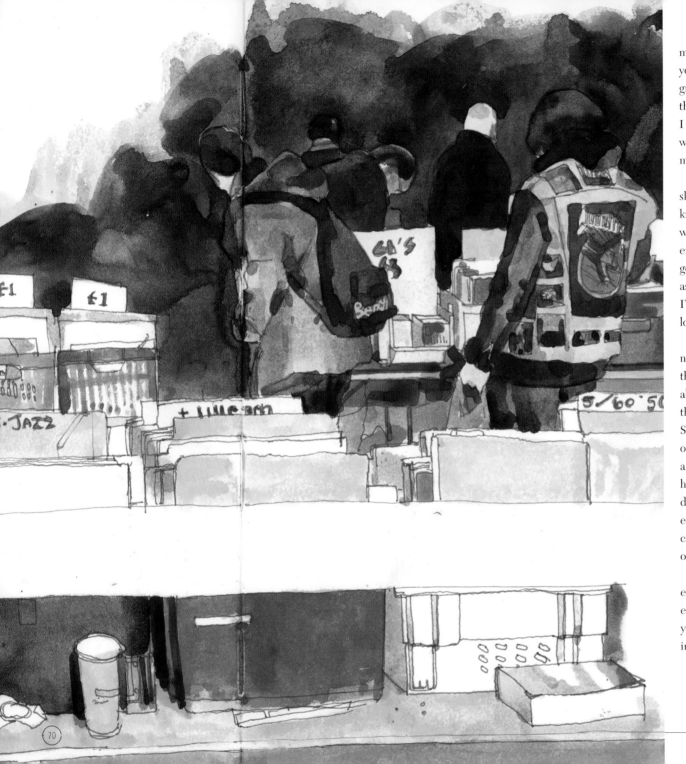

my paintings appeared so garish. What you get is bright red, blue, yellow and green. So over the years I've replaced the colors with ones that suit my palette. I started with black pens but I prefer the way brown lines are less dominant and more equal to the paint.

I've been using the large Moleskine sketchbook for a while now. It's well known for not being ideally suited to watercolor, but I've gotten used to the effect paint has on its pages. I find it good fun to stick with one book at a time as you progressively fill pages. Recently, I've gravitated to larger formats and even loose sheets of paper.

My books are precious, and I'd be annoyed if I lost any of them. While I use them I'm happy for them to get bashed about and develop a sort of patina. When they're full, I keep them on a bookshelf. Sometimes I get asked to supply some of my drawings as hi-res prints, and for a long time I went through each book, hunting for the picture I needed. It drove me crazy, so last year I cataloged each book with the month and year and carefully started to save my scans in an ordered manner.

My advice: Get a sketchbook, label each day and make an effort to draw on each page. I'll guarantee by the time you finish the book you'll see a huge improvement in how you draw.

Wil Freeborn

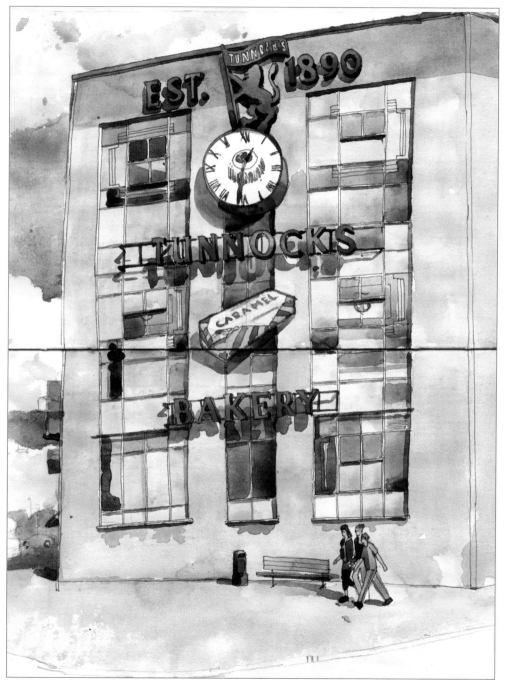

le tour Eiffel

pâtisserie

chocolat

petite jaun

Champagne

l'opera

Savarin

Carol Gillott

Carol Gillott was born in Philadelphia, Pennsylvania. She has worked around the world in Italy, Spain, France, UK, Hong Kong, India and Brazil. She lives in New York but plans to move to Paris. **www.carolgillott.com; www.Parisbreakfast.com**

All I've ever wanted to do was draw and travel, preferably at the same time. I started doodling in schoolbook margins (my first sketchbooks) between intermittent window gazing (early landscape studies). Report cards informed my parents, "If only Carol would apply herself …"

Fashion design took me to Asia and Europe. I've combined drawing, work and travel in one format or another ever since. A side trip to Morocco's souks back then inspired an illustrated guide to Europe's flea markets, *Street Markets*, plus illustrated travel articles for *Mademoiselle Magazine*. Later I traveled for different reasons: for wine companies, for publishing and for designing shoes in Italy/Spain.

Since I started my blog six years ago, at Parisbreakfast.com, I travel to Paris and London two to three times a year. The blog has brought me new foreign clients: a UK chain of pastry shops, Maison Blanc, a Paris online company, I Love Parfums. And I do custom pet portraits set in Paris, plus I sell Parisian-themed still life watercolors on Etsy.

Serious art training began at five at the Philadelphia Museum of Art finger-painting classes and has never stopped. Attending art school has been an ongoing process. Boston University, Philadelphia University of the Arts, Pennsylvania Academy of Fine Arts, plus

I earned a BFA from University of Pennsylvania, School of Visual Arts, The New School, Fashion Institute of Technology, National Academy of Design, N.Y. Academy of Fine Arts, Pratt Institute, plus watercolor workshops with David Dewey in Maine.

My travel kit has always been small—a watercolor box of twelve-plus pans, 6B pencil and Japanese brush pen. It must fit on an airplane tray or train or bus tables. I love drawing the window view while traveling. I still use two Winsor & Newton tiny "jewel boxes" I bought long ago and a classic black Winsor & Newton tin box that belonged to my mother.

My color palette could not be

more basic, made of classic warm and cool colors I've come to know well: Burnt Sienna, Burnt Umber, Payne's Grey, Naples Yellow, Yellow Ochre, Cadmium Yellow, Cadmium Scarlet, Permanent Rose, Alizarin Crimson, Cadmium Orange, French Blue, Cerulean.

A few colors I make myself from raw pigments like cobalt blue pale and an emerald-like green.

Pencils are Staedtler 6B + Paper Mate #2 Sharpwriter, both with pink erasers—I erase a lot. And I'm addicted to Japanese Pentel Brush Pens.

I've used the same paper for years: lightweight Arches Text Laid softbound Moleskine notebooks with graph

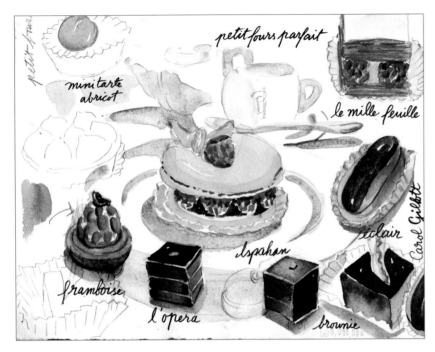

petit fours parfait

mini tarte abricot

le mille feuille

éclair

Ispahan

Carol Gillott

framboise

l'opera

brownie

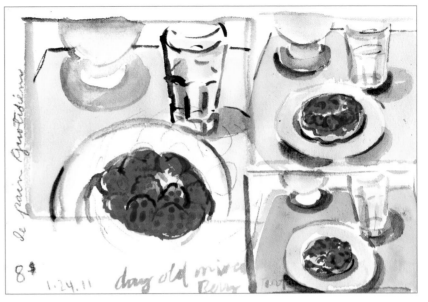

8$ 1.24.11 day old mixed berry tart

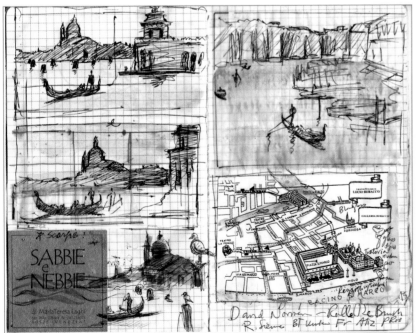

SABBIE e NEBBIE
di MariaTeresa Laghi

David Norden – Raffaello Re Brush
R. Siena BT Umbria Fr Arz PR66

paper or tracing pads I cut up myself.

My sketchbooks are always in book format, more like scattershot scrapbooks with notes, ticket stubs, dates, stickers, ribbons, phone numbers, addresses stuck in with Cellotape, all in one place. It makes it easier to find things later, since stuff gets lost in my chaotic studio. If only I would remember to always date them! Other than that I have no rules or restrictions on format. My handwriting is a nightmarish scrawl even I can't read.

I'm not precious about my sketchbooks. Once a book is used up at the end of a project or trip, that's it—on to the next. I wish I could throw them out. I hate feeling encumbered by things. Often I give them away, if they're presentable enough. Besides you can always get new sketchbooks if you give some away.

Sketchbooks are more like idea scrapbooks. They're related to projects to-do in my head. The last six, seven years they've become records of visits to cafes and tea salons that record potential still life setups, thumbnails and value studies to paint later on for my blog.

I feel more alive when I'm traveling, yet I can't relax or just sit in cafes and watch life go by. I have to be researching, on-the-run gathering visual information for a current or future project. I'm a nonstop workaholic, but it gives me enormous pleasure and satisfaction.

Carol Gillott

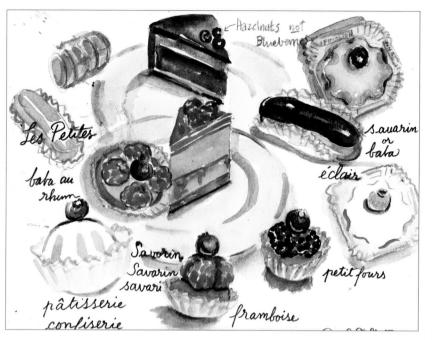

Les Petites

baba au rhum

pâtisserie confiserie

Savarin Savarin savari

framboise

Hazelnuts not Blueberry

savarin or baba

éclair

petit fours

BORDEAUX

TITRE VALABLE 3 JOURS

Poilâne®

8, rue du Cherche-Midi, 75006 Paris - Tél. 01 45 48 42 59

variés — Kinte

Pommes de terre fates à la Bordel

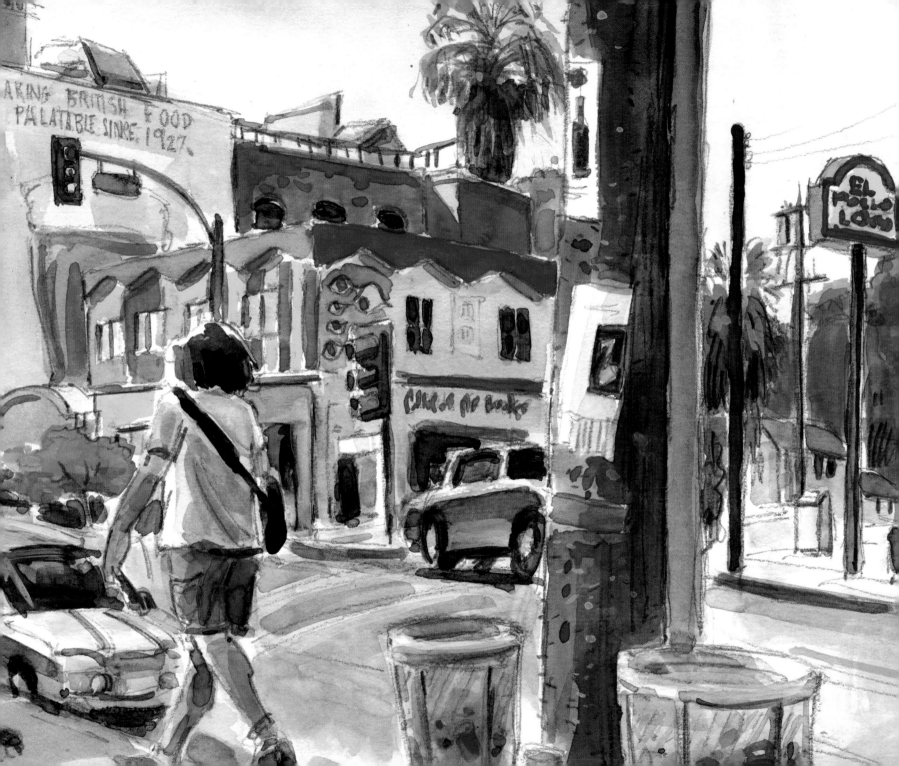

Virginia Hein

Virginia Hein was born in Los Angeles, California, and the city and surrounding area continue to be her favorite subject. She has worked as a concept designer of toys and other products, art director, illustrator and fine artist. Currently she teaches drawing and design and has begun teaching location sketching workshops. She posts regularly on the international Urban Sketchers blog.
http://worksinprogress-location.blogspot.com; http://worksinprogress-people.blogspot.com

I was born in Los Angeles at Queen of Angels Hospital. After living in other Southern California cities, and moving back and forth to San Francisco twice in my life, I now live again in Los Angeles. I fall in love with most every place that I travel to, but Los Angeles really feels like home to me. That has everything to do with what has become the focus of my sketching in the past year—to rediscover old, once-familiar neighborhoods and discover new ones, and to get to know my city of the angels more intimately.

I have been drawing since I could first hold a crayon. I remember how thrilling it was to get a new box of crayons! I still love art supplies like that. I loved the way it felt to put crayon to the paper (or the wall, or other "forbidden" surfaces!). I wanted to draw all the time and make pictures. I was very fortunate to have a mother who really appreciated art and always encouraged me. She was perhaps a frustrated artist herself—I have an early childhood memory of her working on a surreal oil painting of a little girl running in an odd landscape; she became quite frustrated with it and after that she regarded all her various art activities as "play." We always had craft stuff around. A visitor once said that ours was the only house she knew of where you could clear the lunch dishes and there would still be a bottle of glue on the table—that seemed normal to us. Interesting that one of the ongoing themes of my life as an artist is bouncing back and forth between wanting to see what I do as "serious art" and maintaining a sense of play in my work. When I fall into a creative lull, the only way I can really get out of it is to start playing with materials or to make scribbly sketches.

I went to California State University, Long Beach and eventually ended up with an MFA in drawing and painting. I had a truly great life-drawing teacher and mentor, John Lincoln, who taught drawing from rigorous observation, but as he often said, "Sometimes you have to draw what you know." (Drawing from observation is not the same thing as copying what you see.) In my sketchbooks, I may play with observed reality somewhat, and perhaps freely interpret, but it feels important to me to record what I really see and feel in that moment.

In looking for ways to make a living, I eventually became a toy designer and have made my living for many years as a designer, art director and illustrator of toys and other products. I've always felt I lived a sort of artistic double life (I suspect I'm not alone in that). Drawing and painting have always been my first loves, but designing toys has opened a lot of interesting doors—and a lot of it is make-believe thinking: in other words, play! I now spend more time teaching. I preach drawing from life and keeping sketchbooks to my students, and they'll probably do it when it becomes as important to

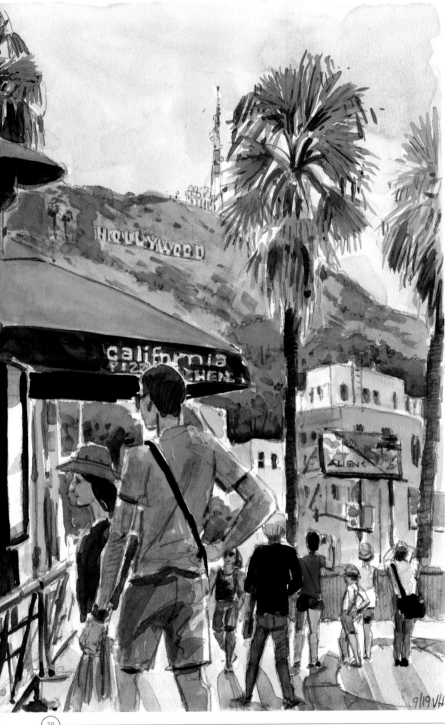

them as it is to me now.

On some trips, I've taken tons of photos thinking they'll be reference for paintings later on or just out of a need to quickly record the moment. But the travel sketches are the things that have the power to bring back a trip so vividly. I'm completely there again, because a drawing records not just the place and time, but how I felt about it (even if the emotion is not apparent to anyone else). To me, sketching on a trip requires a half step back from the crowd to observe and record, not always appreciated by one's traveling companions. I was lucky to travel to Egypt twice in the 1990s. I didn't do a lot of sketching until my second trip, when I experienced an overwhelming desire to spend the day sketching in the great Temple of Luxor—and that meant separating myself from the group I was with. A woman on her own does attract some attention in Egypt, and I had a pack of friendly and curious young boys following me for a while—but I felt that keen sense of being alive, adventurous and completely in the moment that sketching on location gives me.

I have a real passion for travel, though I don't do it as often as I used to. For years, vacations were when I brought along the sketching materials, and it would take days to warm up. That changed a few years ago, when I began sketching all the time, filling up sketchbooks like I never had before. What changed? I hit a major creative dry spell, and I didn't know where to go next with

my painting. I decided to just go out and start drawing what I saw around me. I would use a big black bound sketchbook. One of the first places I went was Echo Park, where I'd gone as a small child and hadn't been back to in many years. I drew the lotuses that famously grew there in the summer. A year or so later, the lotuses mysteriously disappeared! It's very strange to look at those sketches and see that I unwittingly recorded something that no longer exists. This has happened to me more than once and gives me even more of a sense of purpose in drawing what I see wherever I am.

For years, I did not think of sketching as an end in itself. As a designer, I make lots of little thumbnail sketches to work something out. Usually nobody sees those but me. Same thing for working out a painting or illustration—I make compositional sketches. One day, I noticed that I often like my first scribbly, spontaneous sketches more than the finished work. Sketching on location was something I did on vacation, Again, nobody saw those drawings, but I certainly got a lot of pleasure in doing them and looking back on them later.

When I first began filling sketchbooks, I thought it was just for me and that no one would ever see them. I'm not sure when I realized that I was falling in love with drawing in a book; perhaps it was about the time I first discovered the website Urban Sketchers. I thought, "I want to do that!" I began posting drawings on

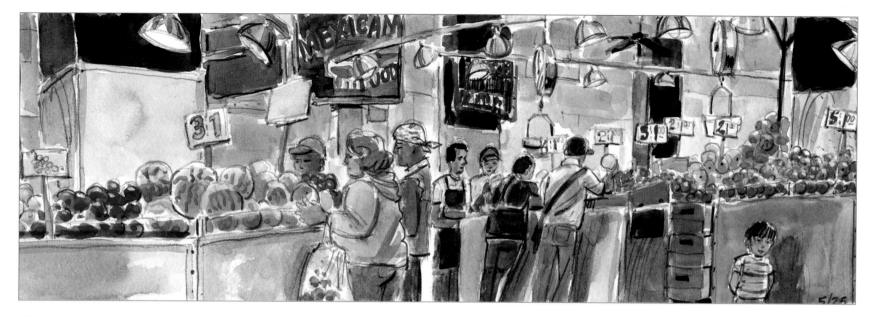

Flickr and discovered an amazing, affirming worldwide community of sketchers. I started as an Urban Sketchers correspondent in fall of 2009, and I began to think of what I did as being part journalist for the first time.

A year or so ago I gave myself the assignment of drawing Los Angeles, and I feel like an explorer, going into neighborhoods that are new to me, or rediscovering neighborhoods that have changed greatly since my childhood. I am finding a deeper connection with this city in which I was born, and I find that I'm documenting life in a city that is changing and evolving all the time. This is hard to explain, but it actually makes me think: *I'm on a mission.* I noticed that those sketches started to get a bit more formal, less spontaneous. I've had to

remind myself to loosen up, to continue to play.

My travel kit varies greatly. I never go anywhere without my 5 inch square Global Art Hand•Book, a few pens and water brushes and a tiny travel Winsor & Newton half-pan watercolor kit stuffed in my purse. (I also add some of my favorite tube colors: Payne's Gray, Quinacridone Gold, Naples Yellow, Holbein Lavender and Verditer Blue. On sketching trips I also take a Schmincke watercolor set, with those same favorites, and a few others: Winsor & Newton Quinacridone Red, Cobalt Violet and Potter's Pink. I've recently discovered Daniel Smith watercolors, which are lovely Quinacridone colors with great transparency. The black bag I take on sketching trips always holds a variety of sketchbooks of different sizes

and shapes. While I'm always searching for the "perfect" sketchbook, I find that different books become interesting for different media and results. I love the Hand•Book since it takes a wash quite well. I like the "beautiful book" quality of a Moleskine, but I'm not as fond of the paper. I'm currently using a Stillman & Birn Beta sketchbook and the Stonehenge spiral pad—both good for mixed media—but I miss "real" binding. I also use a Canson Scrapbook with tan paper—sometimes the mood of a place calls for that—and I use more opaque pigments with it. For watercolor, I haven't found anything quite as good as an Arches Watercolor Journal.

I have tried various fountain pens with Noodler's ink (the most waterproof I've found), such as the Lamy

Safari, and a Hero Calligraphy Pen. I seem to keep coming back to my cheap Pilot VBall Grip pens, because they're pretty waterproof and flow nicely. I also sometimes use a Pentel Pocket Brush Pen and soft, woodless pencils. For most location work, I use Niji Waterbrushes, but I also carry a few big wash brushes in a bamboo roll-up carrier (I need those to make a good sky).

I haven't worried too much about making touristy sketches when I travel. I hope that my drawings will bear my own point of view, even when they depict a well-known place. When I started filling my sketchbooks with views of the Los Angeles area, I specifically wanted to avoid "tourist" Los Angeles. I focused on ordinary neighborhoods and the physical landscape of the scrubby hills, and the

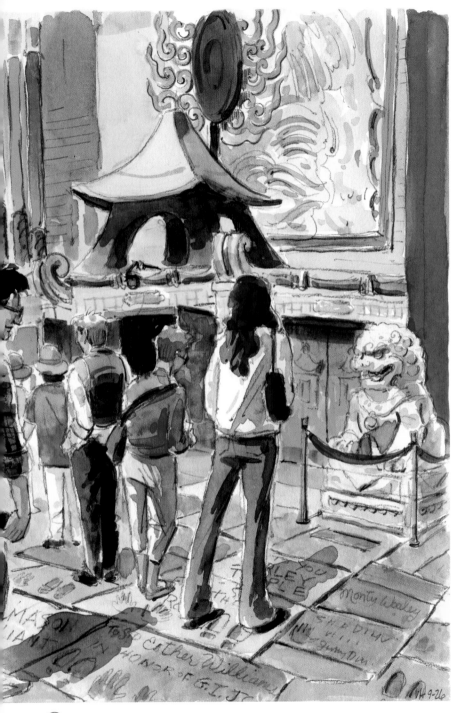

effects of the atmospheric haze (OK, smog) on views of the city. Then I finally just gave in. I just have to draw the touristy stuff and landmarks, too. I draw people: both neighborhood people and the tourists. I love drawing freeways and palm trees, trucks and cars—everything that feels like it's part of a place.

I have sketched sitting on a smooth rock, in a fishing boat, on a small camp stool. Sometimes I draw in my car, but most often I find a café or other available spot to sit or stand. If I'm drawing people, I try to do it somewhat discreetly, but I'm not so shy about that anymore. I am often amazed by comments from passersby—I actually love comments from children. No child has ever been rude to me; usually they are quietly curious and will sometimes offer helpful suggestions like, "You should put a bird in that." Or they tell me what they like to draw. Some want to know if I sell stuff. Adults, well … my favorite question is: "Did you just draw that?" I'm tempted

to give a smart-ass reply, but I haven't so far. Sometimes I sense a real artistic longing in the questioner, and I try to be encouraging. There are days and locations where no one pays much attention (that's fine), and then places, like one of my favorite Los Angeles locations, the Grand Central Market, where I once gathered a curious little crowd. I try to take it all in stride.

I feel it's important to add that I sometimes make lousy sketches. I have to remind myself that it's OK to make bad drawings! If the sketchbook becomes too precious to experiment in, then it's not a good sketchbook. The impulse to scribble should not be ignored. You might even slap on a bravura wash that puddles. It's better to work from that combination of feeling and observation instead of being too careful.

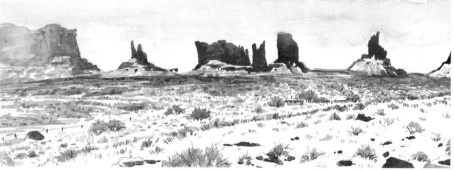

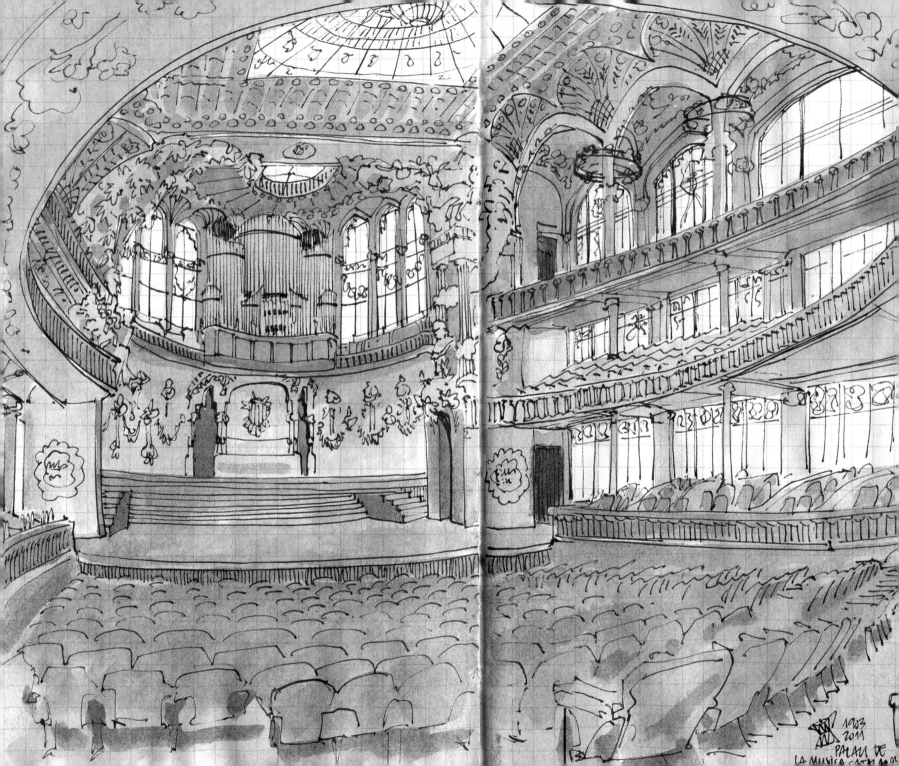

PALAU DE
LA MUSICA CATALANA
1903
2011

Esfinge
masculina
VIBC
Rodas
↕ 8cm

Miguel "Freekhand" Herranz

Miguel Herranz was born in Madrid. He lived nine years in Bologna and now lives Barcelona. He is a freelance illustrator and story-board artist and has published two books with his drawings on location: *Here & There* and *Portraits on the Road.* **http://freekhand.com**

I was born in Madrid in 1960 and I have always loved to draw. I loved comics: reading them, copying them and everything about them. I guess I've never stopped drawing since I was a child.

I started my career in advertising—in those days, art directors still needed to know how to draw. Then I fell in love with typography and devoted myself to graphic design. Finally, in 2006, I went back to illustration. I feel so fortunate to be an illustrator. Even if I don't love all of the assignments I have to do to earn a living, I feel so lucky to be paid to draw. I'm a pen addict!

Traveling is important to me. It's a pleasure, but I don't need to go far overseas to feel amazed by new "worlds." I don't need exoticism to be inspired. I can drive 100 km to a place nearby and see another way of life, other values and, most of all, different stories. There are things and places to discover on every corner. I just look for something that grabs my attention. There are, of course, places with more glamour, but a boring shopping mall can inspire great drawings, maybe better than a special extra-cool place. I am inspired by the sketchbooks of artists like

Damien Roudeau, who try to discover worlds apart in their own hometowns. The journey begins when you close your door behind you and you start walking.

From 2001 to 2010, I lived in Bologna, Italy, then I came back to Spain and settled in Barcelona. After nine years of living in another European country, I'm still trying to understand how and why people and their ways of living have become so different from one place to another and why this often hides the fact that the nature of people is actually more or less the same everywhere.

Drawing completes my pleasure in

traveling. I've often gone to places just to draw them. I'd say that it's the main thing I do when I travel. This can be hard to share with family and people who do not draw. It's why I love trips with fellow sketchers. It's always fun to draw with others, even if drawings I do alone are more focused or intense. It was interesting last year to draw the Clermont-Ferrand Cathedral with a group at 8:30 on a November morning and to almost have my fingers freeze.

Drawing is a quite slow activity if you compare it with, say, photography. So I always remember the place, the people,

the scenes I draw—and I remember the moments I was living. A drawing is at least twenty minutes of your life interacting with that place, those people, a scene.

Drawing is a way of looking at the things/people/environments/buildings/stories that can't be described if you don't draw. I use my sketchbook as a way to try to understand, a way to ask myself and everybody else about everything. Looking and understanding, figuring, imagining, coming up with answers and connecting—that's what drawing in a journal forces me to do. My journals are not just full of drawings but writing too—I love to write down facts, impressions, thoughts.

It's weird the way a sketch becomes a good drawing. A boring street on a cloudy day can inspire you in the moment of the drawing, and the greatest and most inspiring monument may not. I think the way you feel and the questions you ask yourself help your hand to make the drawing.

I've always loved to make portraits in the underground or on the bus, but it can be challenging because people don't always like to be drawn. Until the last couple of years, I hated to draw architecture, and it's still a technical challenge for me. I tend to start running and make a mess with all the windows and columns. I love architecture as a way to identify the place where a human

story is happening. This would be the ideal drawing for me, but I recognize that many times I get hypnotized by the building and I forget the people.

I don't have special travel journals. Each of my sketchbooks just starts on one date and finishes on another one. If I travel on the days in between, it will just be present in the sketchbook, that's all. My approach is always the same. Some years ago I used to throw pages away when I didn't like the drawing. Now the book is the main part of the game—the whole book. With good, bad, quick, slow, from life and from mind pages, all together from the day of the beginning to the day of the end.

My journal work and my professional work are worlds apart. All of my work as an illustrator is some kind of concept art, so it's published as a photo, a film, a TV commercial, an environment; it's never published as a drawing itself. On the other side, I never do any of this work on paper. All of it is digital. This could be the only relationship: The more I draw digitally, the more I miss paper and drawing from life instead of advertising concepts.

In terms of "product," a whole journal is much more difficult to sell than separate drawings. As a result, my journal work is less influenced by commercial issues, so I think it's much more personal and authentic.

I try to do all my journal work on

objetos de los indios ~~nativos~~
(o deberia escribir nativos?)
americani.
Todo esto es del noroeste,
British Columbia, etc.

location. I avoid making a pencil sketch or shooting a reference photo so I can work at home. I might write some caption afterwards or add some touches of color at home, if I didn't have the time to finish on-site. Generally, for me, the drawing must be made from life.

I don't go out of my way to design my pages in advance, but I must admit that almost twenty years of working as a graphic designer have given me some skills in putting together a page.

Sometimes I use a calligraphic fountain pen (Lamy) for the line work or a ballpoint pen (I love the thick 1.4 mm from Pilot). Sometimes my palette is bright and saturated for months. Then I feel the need for more muted colors. For the color, I use watercolors (all Winsor & Newton and Schmincke's Neutral Tint) and eight water brushes (Kuretake) loaded with liquid watercolors (Vallejo, Ecoline) for more saturated tones. I always have two sketchbooks: A big one that I use for almost everything—it's more or less an A5 size (always vertical;

I don't like to work with landscape or squared formats), and a little one (pocket size) that comes with me everywhere just for quick portraits (in this case almost all made with a Pentel Brush Pen). My favorite brands of sketchbooks are Hahnemülle and Stillman & Birn. I don't like Moleskines. They are the worst and most expensive standard sketchbooks in the world, an example of a great marketing strategy selling a poor product.

I used to feel like an artist, but now I feel much like a journalist. Increasingly, I've become very critical of my drawings when they are just "beautiful." I want them to tell a story. I don't care much about posterity, but my sketchbooks are on a shelf, ordered chronologically. They are probably the most important things I own.

Miguel Herranz
freekhand

Esmuinos alli dibrijando el sábado 15 de enero con Lapin, Sagar y Pierre Arnandy

Parece ser que aqui han alquilado en los rodajes de "Vicky Cristina Barcelona" o "Biutiful"

BCN 15.01.2011

Este y el de la página anterior son dibujos hechos en un almacen de alquiler de material para cine que hay al la- do de Els Encants ↑

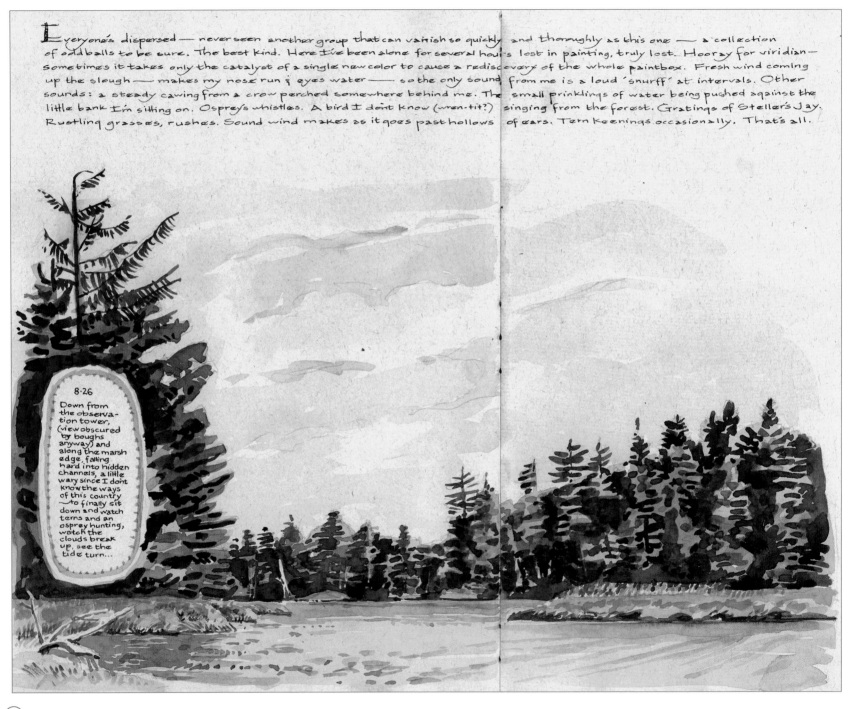

Everyone's dispersed — never seen another group that can vanish so quickly and thoroughly as this one — a collection of oddballs to be sure. The best kind. Here I've been alone for several hours lost in painting, truly lost. Hooray for viridian — sometimes it takes only the catalyst of a single new color to cause a rediscovery of the whole paintbox. Fresh wind coming up the slough — makes my nose run & eyes water — so the only sound from me is a loud 'snurff' at intervals. Other sounds: a steady cawing from a crow perched somewhere behind me. The small prinklings of water being pushed against the little bank I'm sitting on. Osprey's whistles. A bird I don't know (wren-tit?) singing from the forest. Gratings of Steller's Jay. Rustling grasses, rushes. Sound wind makes as it goes past hollows of ears. Tern keenings occasionally. That's all.

8·26

Down from the observation tower, (view obscured by boughs anyway) and along the marsh edge, falling hard into hidden channels, a little wary since I don't know the ways of this country — to finally sit down and watch terns and an osprey hunting, watch the clouds break up, see the tide turn...

Hannah Hinchman

Hannah Hinchman is an artist and writer with deep ties to the Greater Yellowstone Ecosystem. Her three books, *A Life in Hand*, *A Trail Through Leaves* and *Little Things in a Big Country* are about the possibilities of the "illuminated" journal. Her workshops immerse students in the event-worlds of nature and the page.

I live in Chico, California, a genial town at the foot of the Sierras, equidistant from Oregon and San Francisco. I grew up in one of those raw-earth suburbs that swallowed most of the cornfields around Dayton, Ohio. None of the illustrations in my kids' books looked like where I lived. There were no ponies or cows, no lakes, mountains, streams or woods, so I devised miniature landscapes that included toy animals and water and made them realer by illustrating stories about them. As soon after college as possible, I went to the Rockies, land of ponies, cows, lakes, mountains, streams and woods. So the stories came true in a haphazard way.

I went to Maine for four years of art school, where I learned the rudiments of color, but I still struggle with it. We drew from the model for several hours a day in the first couple of years, so I learned the value of constant practice to stay fluent.

Keeping a journal while traveling is the only way I know to really experience a place; at least it's the way that suits me best. What inevitably happens is that I visit fewer places than my traveling companions, who are always up and doing. I usually ask to be parked somewhere while they are hitting all the "must see" spots. I've tried to change that, but my efforts haven't worked. Going from place to place just trying to absorb things leaves me exhausted, as in "museum fa-

tigue." I would rather spend time in one place, or a select few. But I do miss a lot.

Once I'm in the place, I'm not very good at disciplining my attention, either. Rather than trying to select a good view or plan a good composition, I tend to start drawing the first thing that attracts me, which might be a window box instead of Michelangelo's David. My companions wonder how I could have enough patience to stay in one place for so long. Of course from my end of things, three hours is the blink of an eye.

I draw people as often as the attractions of the destination itself. For most of my life I've lived in low-population places, so it's a novelty to be surrounded

by people. I like to speculate about motives or make up life stories for the people I draw, and I also have a tendency to caricature. Overheard conversations are tempting; for writers they can become the germ of a story, and a quick sketch informs later artwork.

Maps have turned out to be a constant feature of my journals, ever since I discovered that the basic concept of a map can be stretched and molded to carry all kinds of information. Sometimes I transcribe maps to study and memorize, using my own visual symbols. Sometimes I invent maps that are less about location and more about sequences of events. One of the many things I'm excited about with

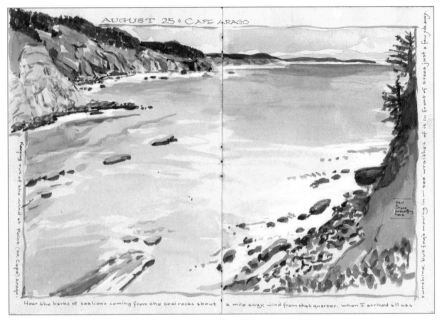

AUGUST 25 & CAPE ARAGO

Hear the barks of sealions coming from the seal rocks about a mile away. wind from that quarter. when I arrived all was sunshine, but fogs moving in—see wraithes of it in front of trees just a few yds. away.

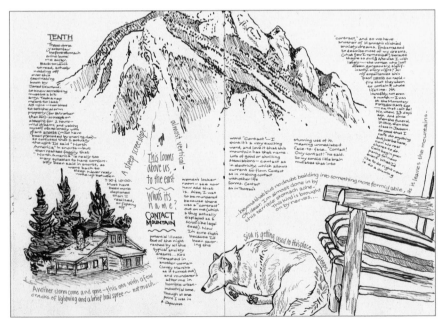

TENTH

Another storm come and gone—this one with a few cracks of lightning and a brief hail spree ~ not much...

the advent of the iPad is the GPS feature. I love being able to trace my exact route on a map and to drop way markers to denote events, as an adjunct to the journal.

The best trip I ever took as an artist goes way back to when I was twelve years old. I wasn't maturing very well and began to have what would now be called anxiety attacks. My grim sixth-grade teacher wanted me to visit psychologists, to be "treated," but my mother had another idea. She removed me from school and took me to the beach in Florida. She gave me a book about drawing birds, a bottle of India ink, a dip pen and a ream of paper. All I did was play in the ocean and draw, and I returned to school healthy and problem-free.

Thirty-odd years later, during a much-anticipated trip to Italy, I worried that Italy's many perfections would be too daunting to respond to. I worried that I'd be too provincial to appreciate the art, and the art of living, as practiced there. My fears were justified: I had no idea what to make of the impeccably turned-out urban Italians and was ashamed of my monolingualism, my comparative oafishness. But when I got to Tuscany and Umbria, the countryside felt very homey and familiar, on a scale I could cope with. My companions went off to visit friends at villas or vineyards. I hung around the inn/farm where we stayed, observing the people doing various jobs and struggling to ask them questions. Where does your wood come from? What's the word for *nightingale*?

When I was artist in residence at the Buffalo Bill Historical Center in Cody, Wyoming, I drew all day in the galleries (on larger sheets as well as in my journal). The people who stopped by were much more mannerly than you would believe; they asked really intelligent questions and gave great critiques. Kids especially pointed out some glaring errors and urged me to take more risks. I like interacting with people when I'm drawing, generally. The most common comment is "I wish I could do that." They can, of course.

I go out with a very nice Osprey day pack. In it is a rolled-up Crazy Creek Chair and a little leather pouch with several pockets that I bought in the Boston airport in 1998. Inside that is a quiver of pens (including Tombows, Pigma Microns, Rotring Sketchpens, Pitt Artists Pens and Prismacolor fine line markers), pencils, brushes, water brushes, spare ink cartridges and a small Winsor & Newton travel palette of watercolors. Also a tube of white gouache, a pocket magnifier, some clips to hold pages flat in the wind and a spare pair of reading glasses.

I'm very particular about my journals since I have to live with them daily for months. A friend usually binds them for me—I can do it myself but am klutzy with needle and thread (right-handed). The perfect paper is yet to be found. Usually I revert to Nideggan, a buff-colored paper with a surface that I love, though colors can be dull on it. The

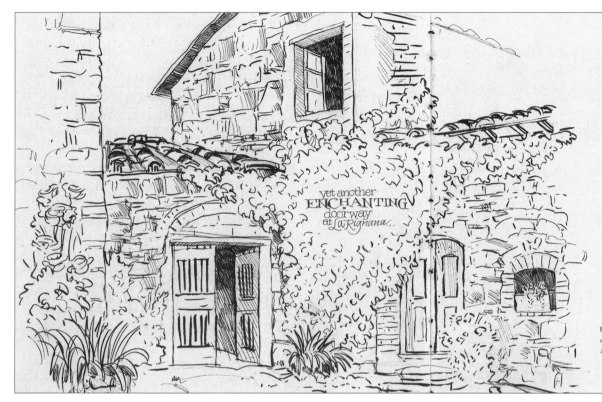

yet another ENCHANTING *doorway at La Rignana...*

are detours. How could you set up an exercise that involved more thinking than writing, paying special attention to the manner of getting from one thought to another? Our burgeoning nest of swallows has fledged, and it's a hell of a lot quieter around here now – we see the babies perched now on windowsills and doorjambs, examining their world, preening as they could not have done in the nest, and thinking about what to do next. Now there seems to be a nest of downy little ones, and one with eggs. After love this morning drowsing, then hearing a mechanical two-beat sound start up – two beats on the same note, maybe doo-doo? No, slowly comes to awareness that this might be a Hoopoe – pronounced, I've learned, hoo-poo. It can be nothing else, I'm convinced, but go out anyway to see, and it is. Continues in monotony for many hours. Comment that it would be a disaster for the nervous system if a hoopoe and a cuckoo were to sing in tandem, and sure enough they do, but surprisingly cancel out each other's syncopation to make a more interesting pattern. hoo-poo hoo cuck oo cuck poop cuck oo oo. The other bird we've been passionately following is the fabled nightingale — and in bird guides the song has never been adequately described. It has a mockingbird quality, yes, but there's really no mimickry— these are invented phrases, and absolutely thrush-like. As we noted, they're like witty conversationalists — animated, and with provocative endings and punctuations.

manufacturer, Zirkall, also makes a white version called Frankfurt, but it isn't the same; it's much softer.

I would love to use Fabriano Artistico soft press, my favorite paper of all, but to my knowledge the manufacturer doesn't make it in bookbinding weight. The journals need to be stoutly bound, and they need to lay flat when open. They get handled roughly going in and out of the pack. I try to cover them with paper that will hold up to friction but welcome the wear as evidence of loving use. I keep them all together on a shelf, shabby as they are. I need them! How else would I know what I was doing in the fall of 1989? I fear they've become a surrogate memory and an uncomfortable one at that.

My journals include nearly everything. I want them to be a good cross-section of my daily rounds and interests. At a stretch, they are word focused: maybe commentary on something I'm reading. Lately, for instance, I've been trying to understand what caused the financial meltdown of 2008. I copy quotes that trouble or inspire me and work out arguments on the pages as if I'm writing an important position paper. It's a way of absorbing complex issues. I try to write well, to get at things, to be funny and clear.

I've been keeping a continuous journal since 1970, so I've learned never to take for granted even the most apparently ordinary things of daily life. Something as obvious and regular as changing seasons reminds us of the flow of a year, but even more happens on subtle timescales that are harder to recognize. Or else occurrences happen abruptly.

For instance, my cats are always nearby, knocking pens off the desk. But many journal volumes have taught me that the nimble Elizabeth will not always be with me, and that I must draw her now, when she eyes the pile of acorns I've laid out on the table.

I share my journals with people, in a sort of supervised way, deflecting them from any chunks of personal writing, usually scribed in 6-point type. I couldn't teach honestly without sharing them. Though I don't keep a separate travel journal, the entries I make when I'm in a new place tend to be less intimate, since I'm concentrating on what's in front of me instead of what's happening in my interior life. In general, like Thoreau, my journals are becoming less personal as the years go by. Less drama/entanglement in my life

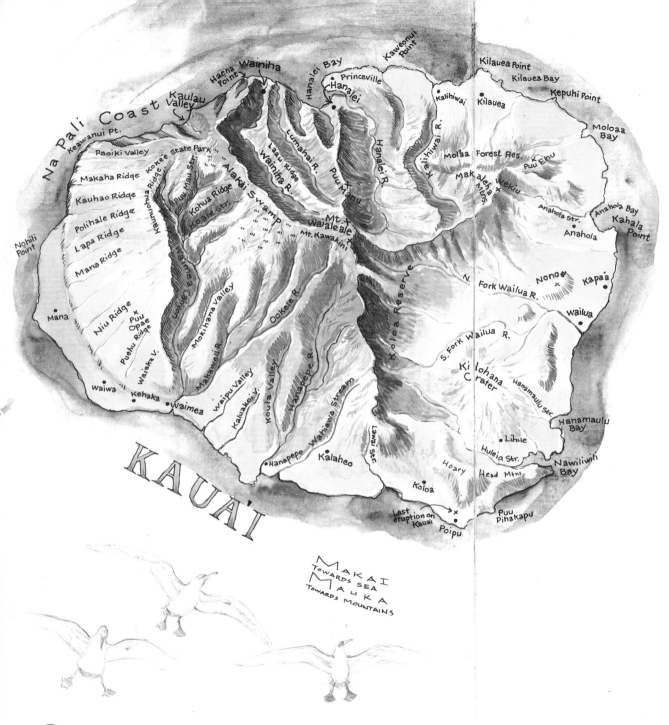

translates into fewer emotionally fraught journal entries.

When I'm working on a project for publication, I concentrate on one medium, like watercolor, because it takes a while to get up to speed with a particular set of tools. The journal is the opposite, I never know what will be the right tool to grab: colored pencils, pen and ink, pastel pencils, brush-pen—until the moment is at hand and the impulse arrives. I like to push the pages in the journal—overdo it, lay it on, make it work.

It's grand when the pages find a beautiful overall design, but that can happen over the course of a couple of weeks. I don't want to remove pages or scratch things out. Bad pages continue to plague me years later, so I keep working on them until they satisfy me.

Finding a prebound blank book was the inspiration for starting my first journal. The fact that it already looked like a real book compelled me. And, oh, what a satisfaction to close the cover on that first volume of the "Little Black Book" series. Here it is forty years later. I would flounder working on individual pages and binding them later, because I need that moment of opening the book to the recently completed page. Seeing the last spread is always a prompt for what comes next. And with loose pages there'd be too much temptation to edit.

Hannah Hinchman

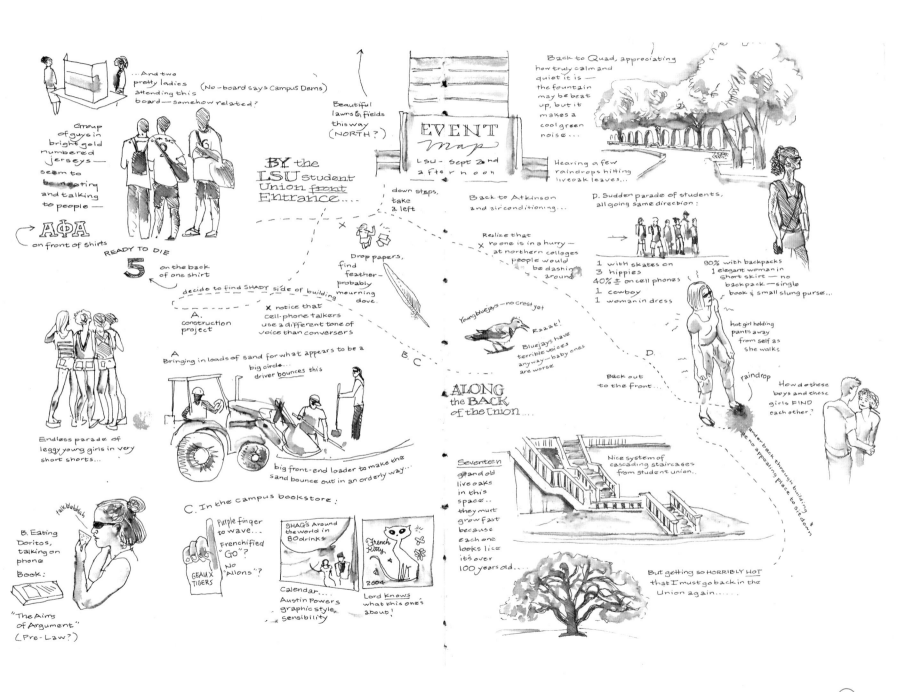

...And two pretty ladies attending this board—somehow related? (No—board says Campus Dems)

Group of guys in bright gold numbered jerseys—seem to be meeting and talking to people—

AΦA on front of shirts

READY TO DIE 5 on the back of one shirt

Endless parade of leggy young girls in very short shorts...

B. Eating Doritos, talking on phone
Book: "The Aims of Argument" (Pre-Law?)

Talk blah blah

BY the LSU Student Union front Entrance...

decide to find SHADY side of building

A. construction project

A Bringing in loads of sand for what appears to be a big circle... driver bounces this

big front-end loader to make the sand bounce out in an orderly way...

C. In the campus bookstore:
Purple finger to wave... Frenchified "GO"? No "Allons"?
GEAUX TIGERS

SHAG's Around the world in 80 drinks
French Kitty 2004
Calendar... Austin Powers graphic style sensibility
Lord knows what this one's about!

Beautiful lawns & fields this way (NORTH?)

EVENT map
LSU - Sept 2nd afternoon

down steps, take a left

Drop papers, find feather—probably mourning dove.

X notice that cell-phone talkers use a different tone of voice than conversers

Back to Atkinson and air conditioning...

Realize that X no one is in a hurry—at northern colleges people would be dashing around

Young bluejays—no crest yet
Raaak!
Bluejays have terrible voices anyway—baby ones are worse

ALONG the BACK of the Union....

Nice system of cascading staircases from student union.

Seventeen grand old live oaks in this space... they must grow fast because each one looks like it's over 100 years old...

Back to Quad, appreciating how truly calm and quiet it is — the fountain may be beat up, but it makes a cool green noise...

Hearing a few raindrops hitting live oak leaves...

D. Sudden parade of students, all going same direction:
1 with skates on
3 hippies
40% ± on cell phones
1 cowboy
1 woman in dress
90% with backpacks
1 elegant woman in short skirt — no backpack—single book & small slung purse...

hot girl holding pants away from self as she walks

Back out to the front...

raindrop

How do these boys and these girls FIND each other?

wonder back through building — no appealing place to sit down

But getting so HORRIBLY HOT that I must go back in the Union again......

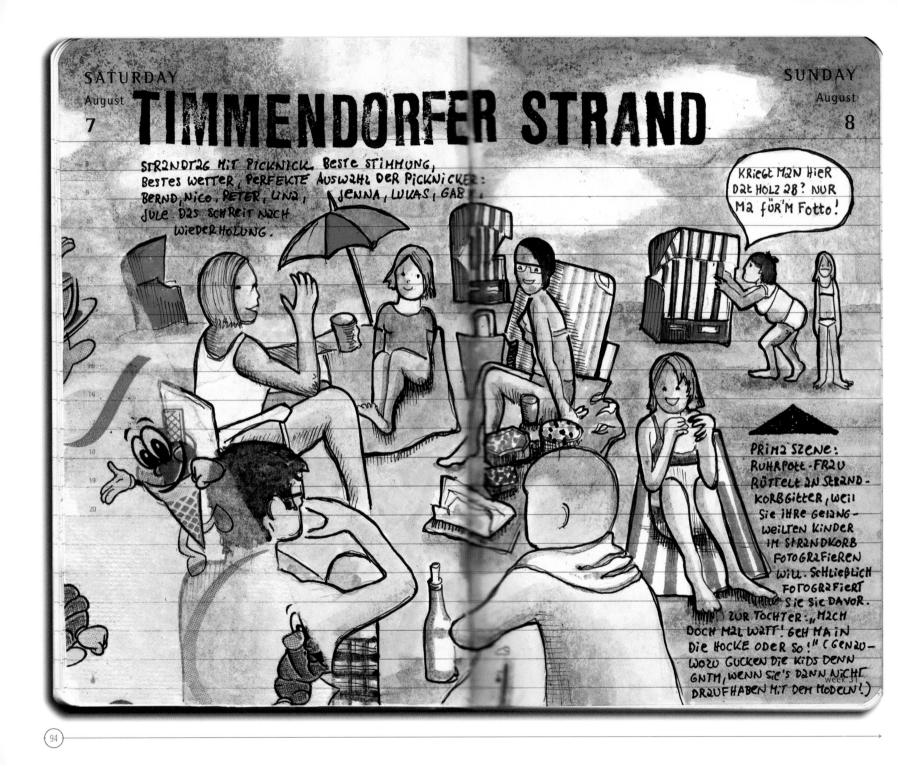

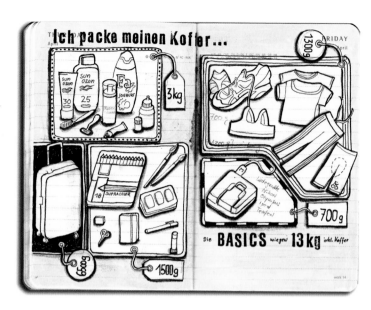

Kathrin Jebsen-Marwedel

Kathrin Jebsen-Marwedel was born in Wolfsburg, Germany. After high school, she apprenticed as a photographer. Then she moved to Kiel and studied graphic design and now runs a small studio. **http://www.flickr.com/photos/98657307@N00/**

I was born in 1965 in Wolfsburg, Germany. After school I did an apprenticeship as a photographer. In 1989, I moved to Kiel in the north of Germany near the Baltic Sea, where I studied graphic design. Now I work as a graphic designer in the marketing and PR department of a medium-sized company in Kiel.

In my youth, I loved to draw animals and landscapes with watercolors or pencil. I spent lots of time drawing, and my endurance in drawing very detailed animal studies and other motives was very high. I worked with watercolors and very fine brushes so I could draw every tiny hair or feather.

When I began to study graphic design I didn't have much free time, so I stopped drawing for a while. In my diploma work, I did some illustrations, but my professor didn't like them. She told me, "If you are not good in doing illustrations you should let it be." Nonetheless, I got my degree.

After graduating, I didn't draw for about four or five years, until I bought my first Moleskine pocket diary in 2001. I used it as a journal, but there wasn't enough room to write down all my thoughts and everyday occurrences, so I began to draw the most important happenings of every day and wrote down only some words.

I noticed that this was a nice way to start drawing again, as nobody could see my drawings, so I did the drawings only for myself. And I noticed that an illustrated journal is better than a written journal, because when I browse through my Moleskines I can see on nearly every page at a glance what I did at that day.

I don't have the patience I used to have. I often get ants in my pants when I want to draw very detailed things. So I like to do quick drawings; at first I sketch with a pencil, after that I like to use fine Copic Multiliners (.05 mm, .1 mm and .25 mm) or a Pilot G-Tec-C4. For coloring, I love the brilliant colors and the smell of Copic markers. A disadvantage of markers is that they bleed through. I put a blotting paper behind the page where I'm drawing, but the back side is always also colored. To cover this, I make a collage on the back side or I use the colored areas that have bled through for a new drawing. I also like watercolors and crayons, and sometimes I use rubber stamps for headlines. Drawing in my Moleskine is a relaxing and important ritual for me.

That's why it's essential for me that I take my Moleskine with me when I'm traveling. I love to travel. As far as possible, I do two journeys a year and a few short trips. Unfortunately I'm not good at drawing on location, so I draw my day in the evening on the balcony. I prefer a good glass of red wine and a really kitschy sunset while doing my notes. When I'm on holiday, I draw landscapes, some funny situations I experienced or some things I bought. While traveling, I get so many new impressions, and drawing helps to assort them. When I browse through my Moleskine, the journey drawings are like a refresher and help to

keep the vivid memory of the journey.

It's easy to travel with a Moleskine, but it's hard to decide which pens and colors are allowed to come along. I love Copics, I love watercolors and I also love colored pencils. Unfortunately the maximum weight limit is 20 kilos (44 pounds), so I cannot pack all my colors. My last few trips I made with very reduced equipment: a very tiny watercolor box, some fine liners and pencils, a little pair of scissors, a glue stick and sticky tape. I need this stuff because I love to cut details from local supermarket offers or other published stuff that brings a local element into my Moleskine. And, if they are not too big, I love to glue tickets into my journal. Sometimes I buy a local stamp and try to get a postmark in the post office. I love all elements that contribute to the special local character of the country or the city I am visiting.

I try to draw every evening during my journey, even if I'm mostly very active in my holidays and I'm tired in the evening. Some drawings or collages I finish when I am back at home. I love my type rubber stamps. I use them for stamping headlines.

When I'm looking through my old journals, I feel really happy that I preserved my memories with my drawings. So I can really recommend to everybody to start an illustrated journal. It doesn't matter if you are an artist or not; just do it.

Kathrin Jebsen-Marwedel

Bis man mal zuhause ist...

8:45 ABHOLUNG AM HOTEL

9:45 LAS PALMAS AIRPORT · CHECK IN

UNSERE KOFFER SIND ZU SCHWER... ENTWEDER 40 EURO ZAHLEN...

SCHLANGE STEHEN...

45 KG

...ODER DAS ÜBERGEPÄCK INS HANDGEPÄCK UMPACKEN.

11:40 ABFLUG
14:50 LANDUNG HH
(ORTSZEIT)

WIR WERDEN BEIM ZOLL RAUSGEWUNKEN - KOFFER FILZEN!

ERST S-BAHN, DANN REGIONALBAHN. INSGESAMT CA. 2:15 STUNDEN.

21:30

ZU FUSS VOM WEDELER BHF NACH HAUSE

UFF!

week 9

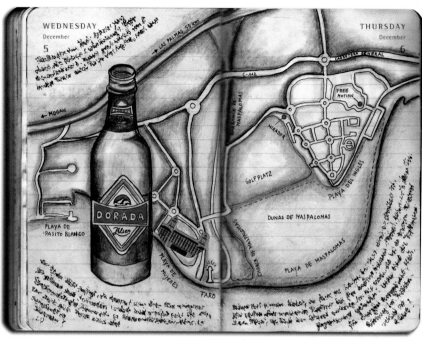

LAS PALMAS 55 km

CARRETERA GENERAL

C-812

FREE MOTION

← MOGAN

DORADA Pilsen

MIRADOR

PLAYA DEL INGLES

GOLFPLATZ

PLAYA DE PASITO BLANCO

DUNAS DE MASPALOMAS

PLAYA DE MUJERES

PLAYA DE MASPALOMAS

FARO

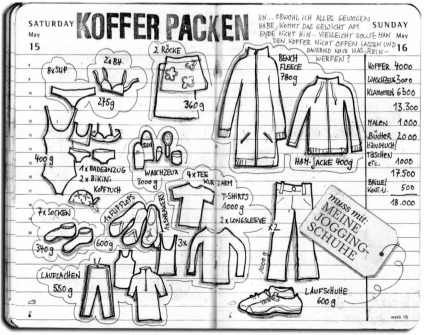

KOFFER PACKEN

HM... OBWOHL ICH ALLES GEWOGEN HABE, KOMMT DAS GEWICHT AM ENDE NICHT HIN... VIELLEICHT SOLLTE MAN DEN KOFFER NICHT OFFEN LASSEN UND DAUERND NOCH WAS REINWERFEN?

2 x BH

8 x SLIP

2 RÖCKE

275 g

360 g

BENCH FLEECE 780 g

H&M - JACKE 400 g

KOFFER 4000
WASCHZEUG 3000
KLAMOTTEN 6300
13.300
MALEN 1000
BÜCHER 2000
HANDTUCH/TASCHEN etc. 1000
17.500
BRILLE/KONT.-L. 500
18.000

400 g

1 x BADEANZUG
2 x BIKINI · KOPFTUCH

SUN

WASCHZEUG 3000 g

4 x TEE KURZARM

7 x SOCKEN

1 x FLIP FLOPS · SNEAKERS

T-SHIRTS 1000 g
2 x LONGSLEEVE
x 2

muss mit: MEINE JOGGING-SCHUHE

340 g

600 g

3 x

1000 g

LAUFSACHEN 550 g

LAUFSCHUHE 600 g

week 19

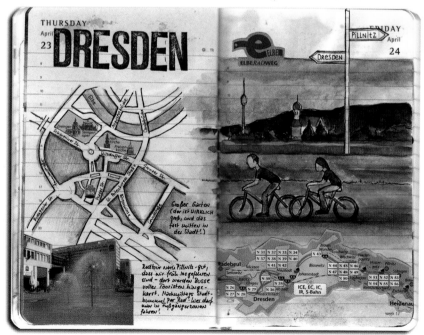

DRESDEN

PILLNITZ

DRESDEN

ELBERADWEG

Großer Garten (der ist WIRKLICH groß, und das fast mitten in der Stadt!)

Radtour nach Pillnitz - gut, dass wir früh losgefahren sind - dort werden busse voller Touristen hingekarrt. Nachmittags Stadtbummel per Rad - hier darf man in Fußgängerzonen fahren!

N 31 N 32 N 33 N 34
N 35 N 36 N 37 N 38 N 39 N 40
Radebeul N 41 N 42 N 43
N 44 N 45 N 46 N 47 N 48 N 49 N 50
N 26 N 27 N 28 N 29 N 30

ICE, EC, IC, IR, S-Bahn

Dresden

Heidenau

week 17

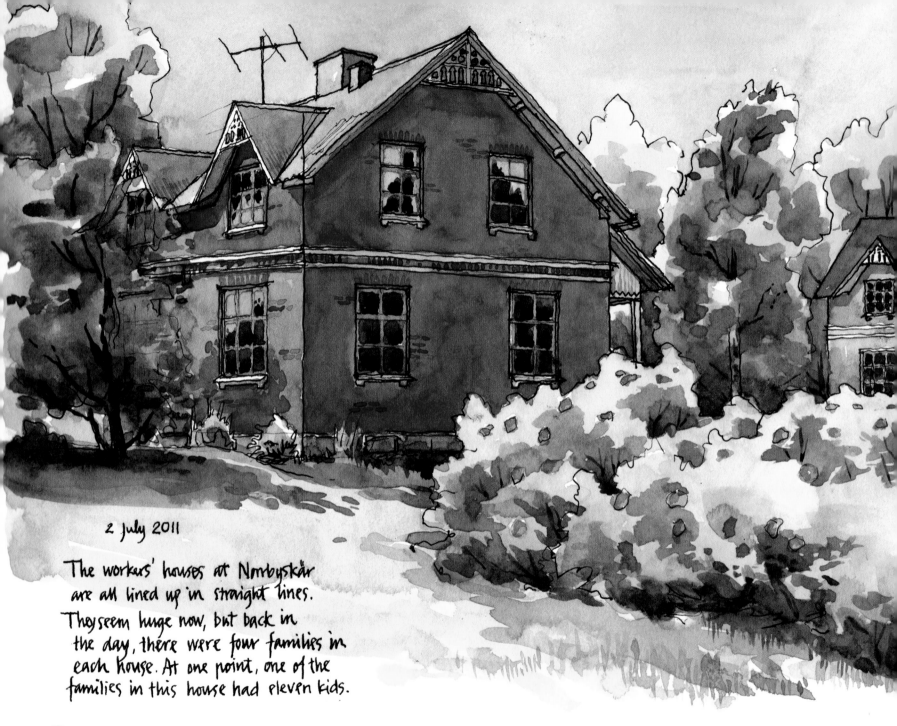

2 July 2011

The workers' houses at Norrbyskär
are all lined up in straight lines.
They seem huge now, but back in
the day, there were four families in
each house. At one point, one of the
families in this house had eleven kids.

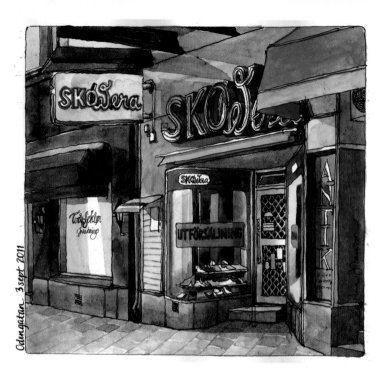

Nina Johansson

Nina Johansson grew up in Northern Sweden and now lives in Stockholm. She teaches arts, photography, design and computer graphics to young creative people. **www.ninajohansson.se; www.urbansketchers.org.**

I have always drawn, for as long as I can remember. I was the kind of kid who had no problem entertaining myself—as long as I had a pencil and some paper. No one in my family made art, but my parents always encouraged me to draw, and friends and family often commented on my drawings and thought they were good. I remember at an early age feeling lucky and a bit surprised that I seemed to have a skill that many others didn't. I was a shy kid and didn't want too much attention. I was quite happy being the observer of what others were doing, but I never minded the attention my drawings got. I guess I felt confident enough with my ability to draw.

I never stopped drawing. My family often drove to our summerhouse, a quite long journey, and I always brought my drawing gear in the car—a safe way to avoid boredom. Throughout my school years, I was constantly doodling and drawing, in regular drawing pads, on loose papers or in the margins of my notebooks at school. I got a watercolor kit from an aunt in the eighties and started painting a bit too.

Now I work in a school south of Stockholm, teaching arts, photography, filmmaking, computer graphics and a few other things. I spend a huge part of my spare time drawing.

I love traveling, but I don't travel more than the next person, really. My sketchbooks are not pure travel journals, they are more "life journals." If I go places, the sketchbooks come with me, so they contain everything from everyday life to journeys to color experiments and whatnot.

I didn't start using sketchbooks until 2004, and the books have really triggered me to draw more. The sketchbooks standing in my bookshelf make me feel like I've really accomplished something, like I have a true body of work instead of some loose papers in a drawer.

I think drawing while traveling definitely changes the way you look at things in a new place, but for me it has also changed how I look at things at home. The first time I seriously attempted drawing while traveling was in 2006, in Paris. I did some drawings there in a sketchbook; they weren't so many, and not so great, but I noticed that when I returned home, the way I looked at my usual surroundings changed. The habit of turning a blind eye to the common things I saw every day almost disappeared, and I started looking at Stockholm in the same curious way as I had looked at Paris. I think that may have

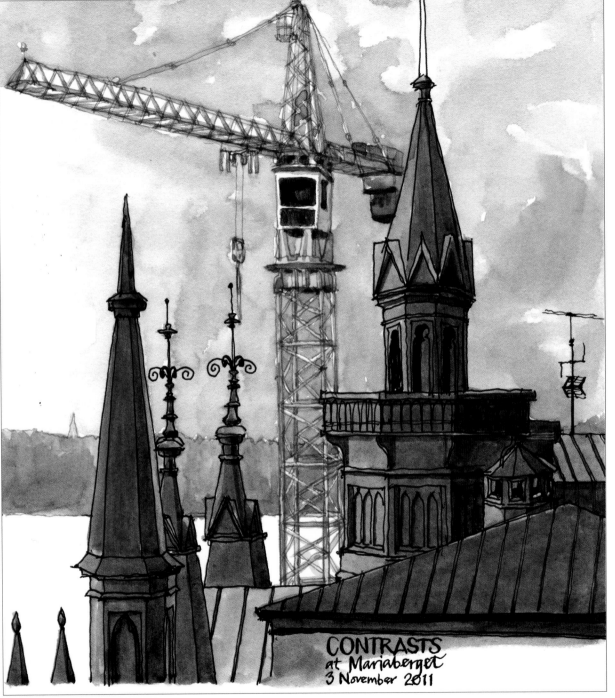

CONTRASTS
at Mariaberget
3 November 2011

been the real starting point of my on-location sketching habit, which I practice both at home and abroad.

Coming to a new location, I always notice the obvious things first. The architecture is different from home, for example, and road signs don't look the same, lampposts and mailboxes are different. But after I sit down to draw for a while, I start noticing other things, such as people's everyday lives, how neighbors say hi to each other, how kids go to school, what people buy in the bakery across the street ... I also notice a lot of tiny details: electrical wiring, doorknobs, brick patterns, curtain styles. I think I get a deeper understanding for a place and its inhabitants because I take the time to sit still and watch it for a while.

The last few years my travel sketching has become even more of a social activity, as a member of Urban Sketchers. Suddenly I have drawing buddies all over the world. Now, whenever I travel somewhere, I am likely to meet up with some other Urban Sketchers and have dinner or coffee and do some drawing with them. This makes a huge difference when traveling to a new location. I get some "inside drawing information" about the place from local people with the same interests that I have. And that's priceless!

I bind my own sketchbooks. I will use an occasional commercial book, but I have never found one with really good paper in it. Also, I like the personality my

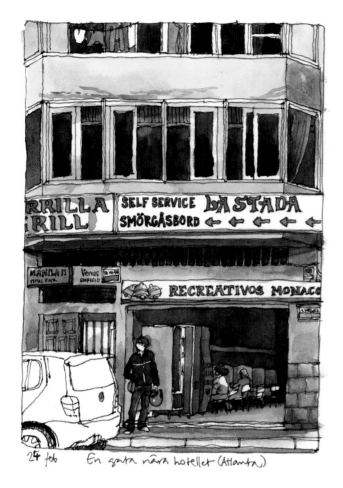

24 feb En gata nära hotellet (Atlanta)

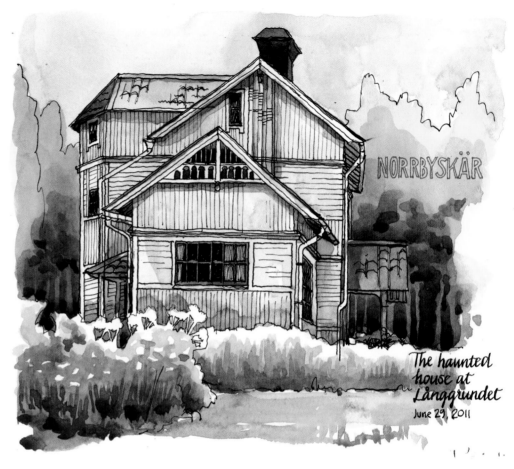

NORRBYSKÄR

The haunted house at Långgrundet
June 29, 2011

hand-bound books acquire. They usually get a random title from an old book, since I often reuse old book covers filled with new pages.

Although I put a lot of work into binding the books, I don't treat them too preciously. They *are* important to me, since they cover large parts of my life, but I don't mind them getting worn and torn. They are meant for heavy use.

I always have my drawing gear with me, usually in a leather pouch. Since ink pen and watercolors are my preferred tools, the kit usually contains some pens (fountain pens and some ordinary waterproof ink pens), a pencil (which I hardly ever use), two or three water brushes, a sable hair travel brush and a watercolor box. Also, I like to have two or three paper clips or hair clips to hold down the sketchbook pages on windy days. Some of the pens and the watercolor box may differ, but the general setup is always the same.

I love trying out new pens, inks and drawing techniques, but I always return to drawing with fountain pens. I have several Lamy Safaris, mostly with extra-fine nibs, and my Rolls-Royce of a pen, a customized Namiki Falcon with a superflexible nib. It produces a fantastic variety in line width that I am very much in love with. Ink-wise, I usually go for Noodler's Lexington Gray, Platinum Carbon Black or Platinum Pigmented Sepia.

I don't bring much else than the drawing kit and a sketchbook when I'm out drawing. If I have room for it in my bag, I may bring a folding stool, but it's not necessary.

When I see something interesting to draw, I just sit down (I prefer sitting, I can't seem to find the proper support for my drawing hand standing up) and begin drawing. I don't think that much about composition, I just begin with the most important item, put it where I want it on the page and continue from there. I often

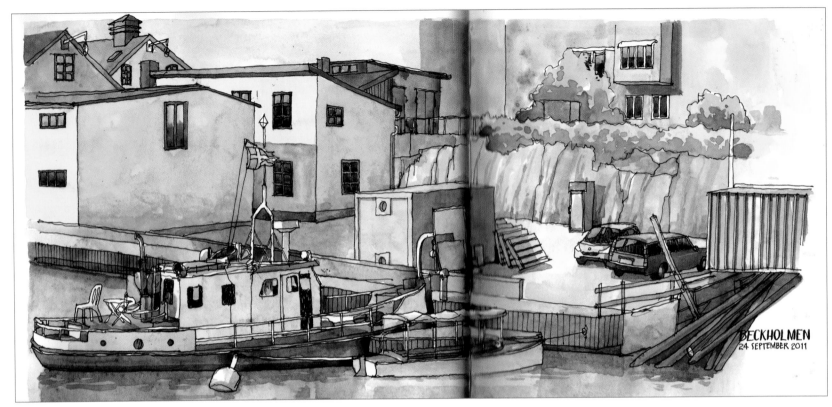

BECKHOLMEN
24 SEPTEMBER 2011

discover when I'm in the middle of a drawing that I should have started further up on the page, or I should have made that main subject a little smaller or bigger or whatever, to make the page look better, but I still don't like to plan the pages too much. I like to just dive in and draw. I have realized that if I don't give up too soon on a drawing, if I just keep working on it for a while, it will probably end up a nice piece of work even if it looks a bit off in the process. It doesn't matter so much how well I planned the page or thought about the composition before I began, it's still going to be my way of telling a story about a place.

I find that drawing a place makes it more mine, no matter where I am or how long I'm staying. When I draw a street corner in my sketchbook, I take a little piece of this place home with me. All these little pieces end up in my bookshelf, as a collection of all "my" places in the world. It's not a greedy kind of "mine"; it's a grateful kind. I feel lucky to have had the opportunity to visit and share all of these places with the people living there.

A journey without drawing is not quite complete to me. Seeing a lot of interesting things and not getting the chance to draw them makes me feel like a kid who's in a toy store but not allowed to play. Drawing is such an important way of experiencing a new location. It's a bit of a shortcut to becoming a part of a place where I don't really belong. It is a bliss to have the opportunity to sit down and observe, draw, lose track of time and just listen, look and feel the place for a while. It makes me a happier person, and I feel enriched when I leave. I don't meditate, but I have a hunch that drawing and meditating aren't all that different from each other.

I have heard a lot of people say that they are worried about using sketchbooks to draw in. They feel intimidated by the pristine empty pages and think they are going to ruin the whole book with drawing mistakes. But listen, sketchbooks are manufactured in the thousands all the time. It doesn't matter if you ruin a few of them. Go ahead and get it over with! You will love these books afterwards, because, mistakes or not, they tell *your* story.

Nina Johansson

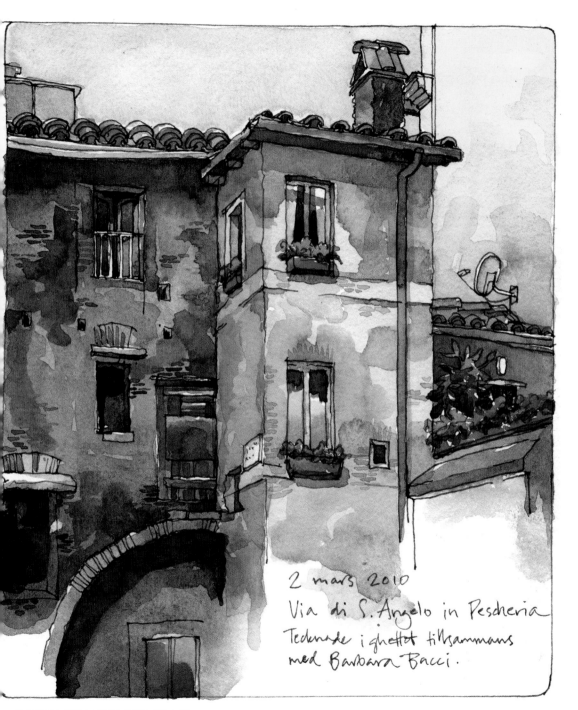

2 mars 2010

Via di S. Angelo in Pescheria
Tecknade i ghettot tillsammans
med Barbara Bacci.

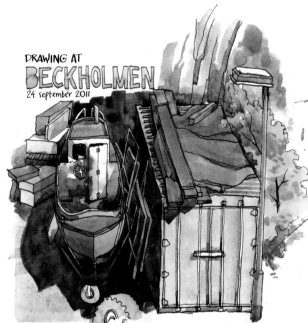

DRAWING AT
BECKHOLMEN
24 september 2011

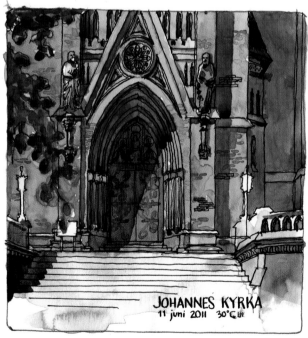

JOHANNES KYRKA
11 juni 2011 30°C ut

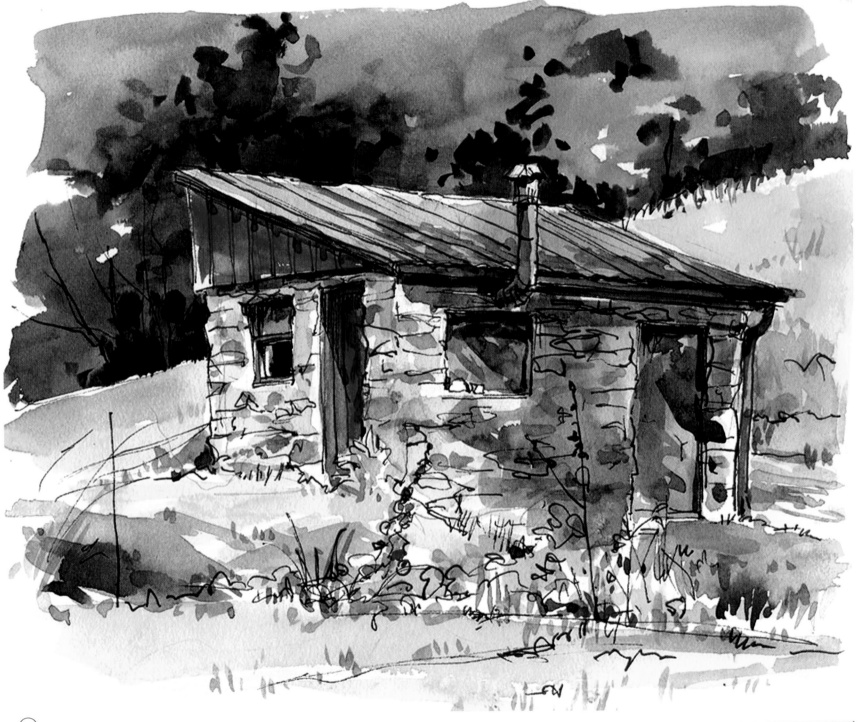

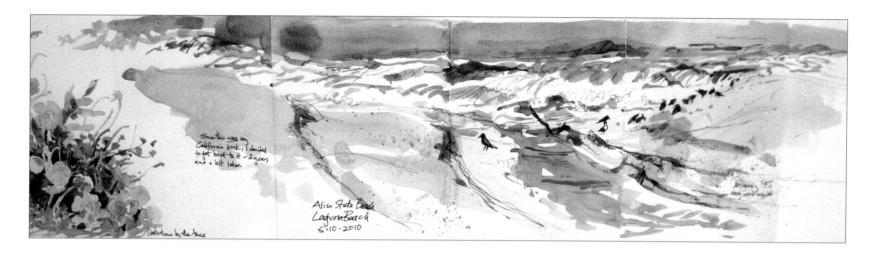

Aliso State Beach
Laguna Beach
5.10.2010

Cathy Johnson

Cathy Johnson is an artist and writer with thirty-four books to her credit. She was contributing editor to *Watercolor Artist*, *Artist Magazine*, and *Country Living* magazines. **http://cathyjohnson.info**

I was born not that far from the geographical middle of the United States, and close to what is now the population center, and still live there ... it's home. I must feel safe with that big buffer around me! I've been to both coasts and the mountains and deserts, as well as the North and South, and love to sketch and paint in all of those places, but this is what speaks to me. Seasons, as well as trees, rivers, farms, prairies, wildlife, cities, towns ... home.

My art education was close to nonexistent. Art classes in high school were hazy at best. I mostly remember making goofy craft projects for a retirement home, not learning about perspective,

media, composition and the rest. After I graduated, I attended weekend and evening classes at the Kansas City Art Institute. I worked (briefly) at Hallmark Cards, and they paid half the tuition. The very best class I ever took was on Chinese/Japanese watercolor, taught by a Mr. Furuhashi. I couldn't understand everything he said, but I could read volumes in his elegant, sure brushstrokes! I can still see the influence in my work, especially in fast watercolor sketches that I do while traveling.

These days, I teach art and art journaling, as well as write books, mostly on art techniques. I'm not much good at anything else, and I'm a dreadful employee.

I live in a small semirural town, so every time I go to Kansas City, I consider it travel—and I sketch accordingly. I once co-authored (and illustrated) a couple of off-the-beaten-path travel books, so even when I'm local I think in terms of travel: what I'd notice if I were new here, what to sketch that's interesting or representative or really unique. I like looking at my town with fresh eyes. I think sketching not only helps me to do that but enforces it, enhances it. I understand exactly what Thoreau was saying when he wrote, "I have traveled much in Concord."

I notice so much more when I take time to sketch. It's almost a symbiotic relationship. I notice more as I sketch,

and I go out deliberately making myself aware of things I *want* to sketch. These two sides to the same coin feed each other and enrich the experience. Some things I *have* to draw, because I wouldn't believe it if I didn't have it down on paper. Some I want to record because I love them. Some I know I am preserving, in my way, because they are crumbling or due for demolition. Paying attention to the details of plants, flowers, seashells, fossils and wildlife teaches me a lot, too, especially when I can take time to draw them carefully, really observe rather than just make a quick, rough sketch.

I love going someplace specifically to sketch. In the past, I might have gone

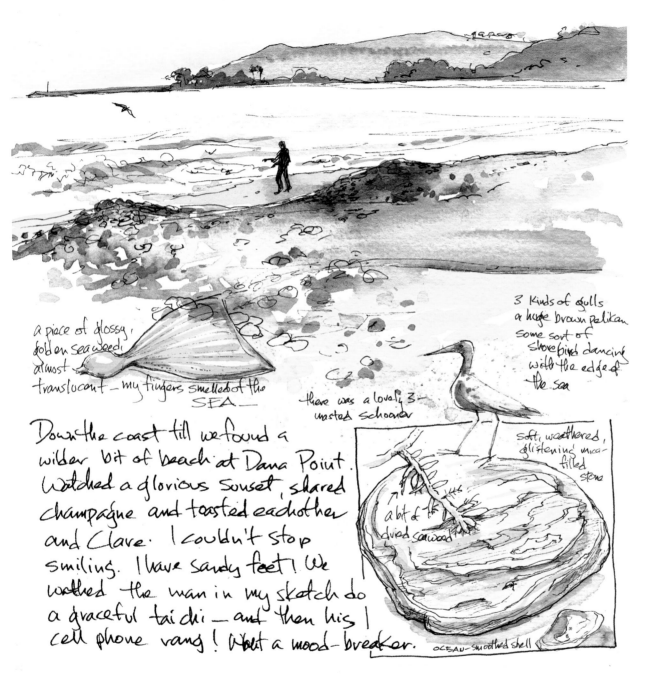

a piece of glossy, golden seaweed, almost translucent — my fingers smelled of the SEA

there was a lovely 3-masted schooner

3 kinds of gulls a huge brown pelican some sort of shorebirds dancing with the edge of the sea

soft, weathered, glistening mica-filled stone

a bit of dried seaweed

OCEAN-smoothed shell

Down the coast till we found a wilder bit of beach at Dana Point. Watched a glorious sunset, shared champagne and toasted each other and Clare. I couldn't stop smiling. I have sandy feet! We watched the man in my sketch do a graceful tai chi — and then his cell phone rang! What a mood-breaker.

to the City Market just for the farmers market on Saturdays, but now I'm *really* wanting to sketch all the people and colorful produce and interesting buildings there, some of the oldest in Kansas City. They're interesting even during the week, when almost no one is there.

I believe my journal is always a tool for discovery, on the road or at home. Especially when I get nose to nose with something, like an unusual mushroom, insect or fossil. When I find an insect nest I don't recognize, for instance, sketching it fixes it in my mind as well as giving me my own "field guide illustration" to compare with a book, online source or to take to an expert in the field. I learn a lot and write what I learn right in my journal. Sometimes I add dimensions, life cycles, habitat or other notes to my field sketches. Sometimes I record snatches of conversation, especially when it's funny or odd.

Weather can play a big part in whether the drawing is fun or not, or works well or not. The first time I sketched in the Angeles National Forest in California, it was so dry and so windy that my watercolors dried almost before I touched the page. Talk about frustrating! So, when I work in the desert or other dry areas, I've learned to mix up more paint than I ever think I'll need and to use bigger brushes. (Or just sketch with an ink pen or pencil, which works, too.)

A few winters ago I came across the still-smoldering remains of an old

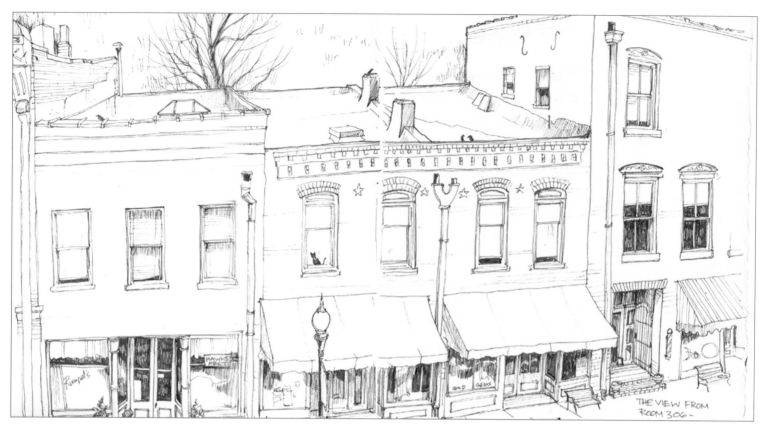

THE VIEW FROM ROOM 306

farmhouse I'd enjoyed sketching a number of times—I used to buy whole milk there back in the 1970s. It was about 10 degrees outside and windy up on that hill, but I was determined to sketch while my anger was still as hot as the embers. Happily, I had a Pentel Pocket Brush with black ink in it. The bold, hurried marks seemed to capture my mood much better than if I'd had time to really work at it. Doing a watercolor in the rain gave me a very interesting, rainy texture in the sky—I just go with the flow! (And of *course* that's a bad pun!)

I think I draw when I travel because I *draw*. Period. Always, whenever, because I have to. I wouldn't know who I was otherwise. If I don't draw for a day or two, I start feeling alien in my own skin and as though I've skipped those days entirely.

I tend to sketch in ink, pencil or colored pencil and then slap in watercolor, most often, in my journal. When I'm painting, it's more likely to be pure watercolor with perhaps a little pencil for a guideline, or an acrylic. I like the freedom of my journal, though. It's fresher and more immediate. Often it's more emotional. Subject matter may vary a lot, too. I've sketched my husband in the hospital, vandalism in the park, people in nursing homes in California. Not my usual subjects for actual paintings.

Everything for the most part goes into one book: people's addresses, grocery lists, notes on the weather, directions, to-do lists are cheek by jowl with sketches. I paste in the occasional ticket stub or business card or some such, as reminders or design elements. The only exception is that lately I'm doing a lot of personal work, sorting things out through writing. So to keep from having to make an issue of what's to be shared and what's not, a lot of the sorting out goes into a separate book. I haven't done that for years, but it's right for me right now. No rules there, either, it's pretty free-form, might be poetry, prose, lists, stream of consciousness, working through what works for me and what doesn't. It actually has some sketches in it, too.

Some days I like to do a more designed page, but often I find that that has become instinctive rather than

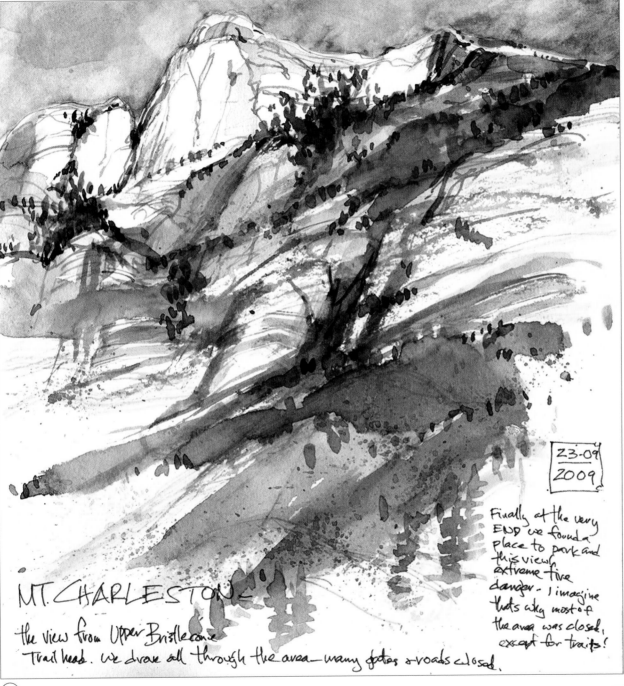

23-09
2009

Finally at the very
END we found a
place to park and
this view,
extreme fire
danger - I imagine
thats why most of
the area was closed,
except for trails!

MT. CHARLESTON

the view from Upper Bristlecone
Trail head. We drove all through the area—many gates & roads closed.

planned. Pages just develop. I like to vary size and placement of elements, and I almost naturally seek a kind of balance. When I add color I might consciously use a touch of this or that for balance, but often the page starts out with one thing on it, then another, then something else. They may or may not be related, and when they're not that's often when I *create* a unity with an overall wash or a repeated or related color.

My travel kit stays roughly the same, with the main change being in the type of palette I pack. Of course, in part this depends on how long I'm going to be gone and if I'm planning to sketch in my journal or do plein-air paintings. For plein air, I'll want a larger palette, in addition to a bigger water container and a few 9" × 12" (23 cm × 30 cm) watercolor blocks. I've discovered, though, that quite often these things come back home with me, unused. Whereas the journal, which is always with me, along with my simpler kit, gets used constantly. I may intend to do larger plein air paintings that I might actually sell, but what happens is that I record the wonderful day by day in my journal, at home and on the road.

Even with my everyday kit, my palette (the box, not the colors) changes according to my mood. My most frequently used one, at home and on the road, is a reloaded kids' Prang watercolor box. I've popped out the tray of inexpensive paints and used rubber cement to stick in full pans I fill myself with my chosen colors.

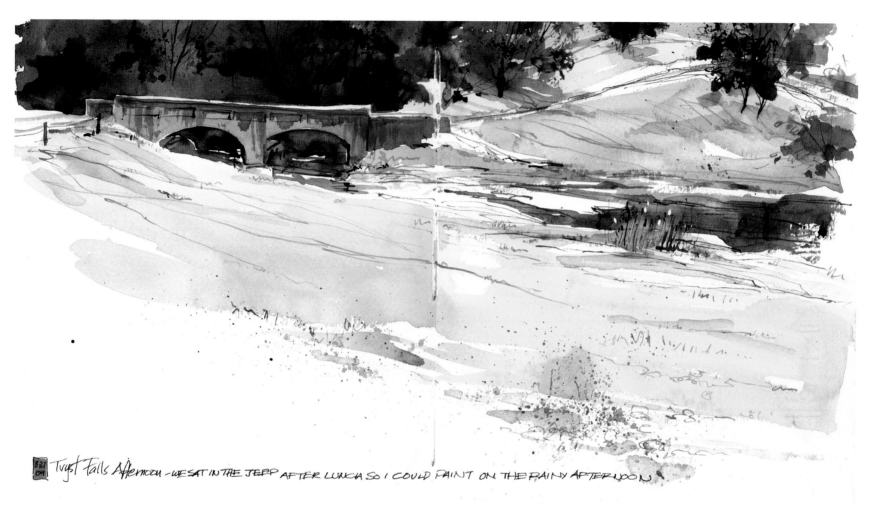

Tryst Falls Afternoon - WE SAT IN THE JEEP AFTER LUNCH SO I COULD PAINT ON THE RAINY AFTERNOON

Usually it'll hold a couple of brushes and a small sponge, too.

Other times I'll take a small Kremer box I've also retrofitted with full pans, or a slightly larger, squarish Schmincke, one that was meant to hold twelve full pans or perhaps eighteen half pans. I've done the rubber cement and empty pan trick, and the Schmincke now holds fifteen colors of my choosing, mostly in full pan size.

Like many other artists, I've also played with making my own little kits out of metal candy boxes, plastic cough drop boxes and small metal tins that watercolor crayons came in. They're fun. (One of the candy box kits has only the subdued primaries: Quinacridone Burnt Scarlet, Quinacridone Gold, and Indigo. It's amazing what you can do with that tiny kit!)

I tend to use the same basic colors for most of these palette boxes: a warm and a cool red (currently Quinacridone Red and either Cadmium Red Medium or Pyrrol Scarlet), a warm and cool blue (usually Ultramarine and Phthalo, often with a half pan of Cobalt, Cerulean or Manganese Blue Hue thrown in, if I have room), a yellow or two, and then if I still have room, a few convenience colors such as Burnt Sienna, Raw Sienna, Quinacridone Burnt Scarlet, maybe Indigo or Payne's Gray. Occasionally a green like Sap or Phthalo, and even a Naples Yellow, if I'm really going nuts. For travel, though, I mostly mix my own secondary and tertiary colors, except for

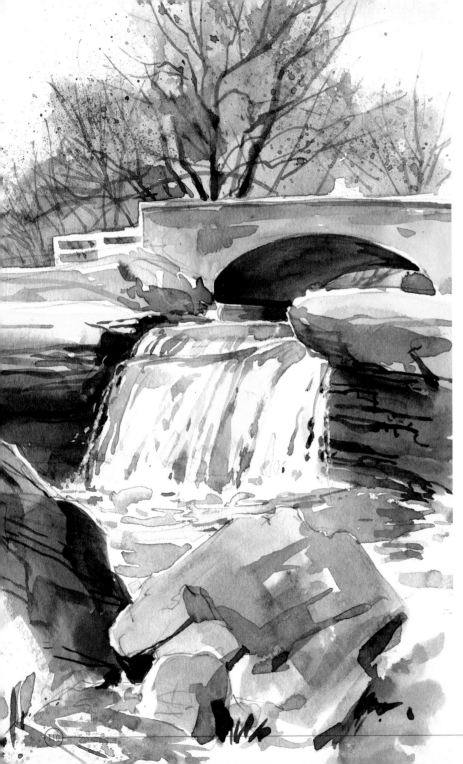

my beloved Burnt Sienna (I much prefer Winsor & Newton's Burnt Sienna; it's much livelier in color and more transparent than many other brands. Same with Winsor & Newton's Indigo.) That keeps it simple and lighter weight.

I normally use Winsor & Newton, Daniel Smith and some Schmincke colors, going for the old tried-and-true ones that I can make do whatever I want. The newest trendy pigments don't seem to be for me. I *know* what the usual will do, and it's fun to put them through their paces.

I usually take a few folding travel brushes by Daniel Smith, Black Gold, Isabey or Connoisseur in the largest size I can afford (or find), but I also carry an old tin pencil box to hold a few larger ones. I like at least a 3/4" (2 cm) flat (for those big washes) and a #8 or #10 round. I'll often cut off the wooden handle of a brush to make it fit the pencil box, and sharpen the end in my pencil sharpener to give me another tool to draw or scrape with. My favorites are Loew Cornell, Winsor & Newton, Princeton and GoldenEdge. I seldom take sable brushes to travel. There's too much chance of loss for such an expensive investment.

In addition, in my purse I carry one or two dark Prismacolor colored pencils for sketching: 90 percent Gray, Black, even Indigo or Black Cherry, plus a White one to make things pop off the page when I'm working on colored paper; a Derwent Blue Gray watercolor pencil; a mechanical pencil; and a few water brushes (the largest I can find, roughly equivalent to a #6 or 8 round, from brands Niji or Pentel Aquash), plus one Niji Flat Waterbrush. These, I usually hold in a bundle with a big rubber band, which is both lightweight and easily replaceable. (A hair band works, too.)

I've got a variety of water containers that I take under different circumstances. My "always" container is a small plastic travel sprayer. I also use a small waterproof plastic freezer container when I can carry more, and my old aluminum Army canteen for big trips.

I often take a couple of Micron Pigma pens in black and sepia (.01 and .03), along with a Lamy Fountain Vista pen with an EF nib, sometimes a Lamy Joy Calligraphy Pen, a Pentel Pocket Brush Pen with waterproof black ink, and a water-soluble fiber-tipped pen. I've tried a variety of other fountain pens. I like the thick and thin lines of the Noodler's Flex Pen (but not so much its tendency to be temperamental), a Waterman pen and, of course, a responsive, wonderful fine-nibbed Namiki Falcon, but it was expensive enough that I find I'm too chicken to take it traveling with me. What if I lost it!? (I know, duh.)

My favored pencil is a Pentel Forte 0.5 mm mechanical, with a big soft eraser. I may replace the HB leads with 2B if I want a softer, darker effect.

If my husband and bearer is along, I might have a folding chair or stool. Otherwise, not. I sit where I can, even

if it's on the ground. I sometimes work from a car, a shelter house, picnic table, café, hotel room window ... wherever. I usually put my paints on the ground or my lap if there's no table or retaining wall or some such handy.

Most often, I make my own sketch journals, so I have a combination of papers I really enjoy working on. I do a traditional case binding, but I also make accordion folders from leftover paper. These are great for keeping in the glove box or dedicated travel books.

If I haven't had time to bind books (or when I want to explore), I'll use Strathmore Visual Journals, Stillman & Birn hardbound journals, Aquabee Super Deluxe or a handmade one a friend gave me or I picked up on Etsy. I'll usually pack along a small Fabriano or Canson Montval watercolor block or some watercolor postcards. And if none of these are available? There are always used envelopes, check stubs, the backs of programs or receipts, paper towels, napkins, whatever! Just draw.

I love the feel of paper, of having a book in my hands. I love having the books fill my bookcase at home, the shelves filling up, one by one, with my life and times. In the winter, when travel is more difficult, I love to leaf through them and take that trip all over again.

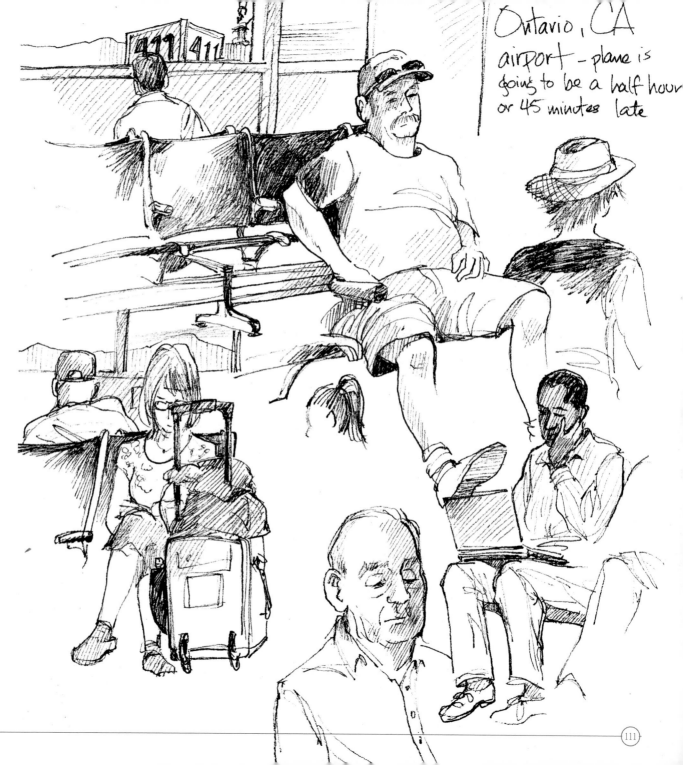

Ontario, CA airport - plane is going to be a half hour or 45 minutes late

Andrea Joseph

Andrea Joseph is originally from Wales and now lives in the North of England. She started drawing about six years ago after finding the Everyday Matters community online. She hasn't stopped since. **www.andreajoseph24.blogspot.com**

I remember the moment I came up with the idea for my travel journal. Until that point I'd never considered journaling. I'd seen some really great travel journals and artists online, but these were people who drew on location. That's what I felt travel journaling was, or should be, and that was not me. Back then, I'd made a couple of attempts at drawing on location, but I didn't feel comfortable with it at all. In fact, it terrified me. It petrified me. You see, I draw things not places.

But, I do love to travel, and I heard about an annual travel exposition in France that I really wanted to go to. And I wanted to go as an exhibitor instead of a visitor. To do that, I had to enter my travel journal; just one problem: I didn't have one. Yet.

So I was sitting in the backyard one summer's evening doodling and looking in through my kitchen window at the shelves that are crammed full of souvenirs, condiments, bits and bobs and odds and sods from my travels, when suddenly it came to me. My travel journal began from the comfort of my armchair drawing all of the souvenirs I'd brought back from around the world.

I spent my twenties traveling and working around the globe—from picking roses in the desert in Israel to washing dishes in restaurants in the Canadian Rockies. Revisiting those times and places through drawing the souvenirs from those trips proved to be an emotional experience. Sitting quietly, at home, filling my sketchbook, I remembered all sorts of things from my journeys. I recalled memories that I would never have remembered if I hadn't been meditating over these drawings—good times and bad.

My thirties saw a different chapter: My backpacking days were over. My travels became holidays or vacations instead of a way of life. For the most part they were closer to home. I got to see more of Europe, which I love.

But no matter where I am, I'm always in search of my next souvenir. I'm like a magpie swooping in all tiny little things (hmmm, is that a Joni Mitchell lyric?), from sugar sachets to tram tickets to religious tat, and filing them away in my suitcase for safekeeping until I get back to my armchair.

These days I'm pretty poor. I live to draw and, as yet, I haven't quite worked out how to make money from that. But as long as I have enough to get by and

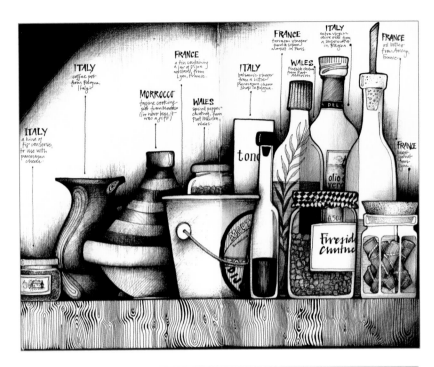

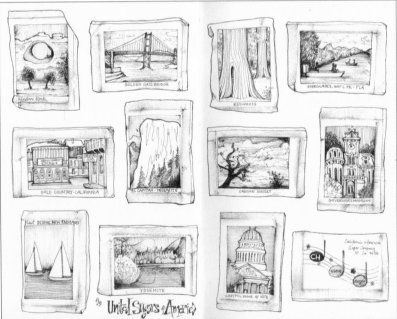

still have the time to draw compulsively, I'll live with it. It means, of course, that there's no money for travels. But, you know, when one has access to the Internet he can always travel.

I become obsessed with journeys I'd like to make and plan them out as if I'd booked my tickets. Recently, I've taken a road trip around mid-America, visiting all the old ghost towns. And, Australia. Yes, I've been traveling around there, too. In winter, of course. My Scottish coloring would mean I'd have to rule out the summer months.

And, speaking of Scotland, there's another road trip I have desire to go on. It's an itch that needs scratching; I want to drive up to Scotland with nothing but Ron Sexsmith's back catalog to keep me company. I have no idea where I get these ideas, but does that really matter?

Of course, whether I actually physically make these trips or not, all this stuff makes its way into my work. Personally, I see anything and everything we create as a travel journal in some way. Even if it isn't about travel in the physical sense it's certainly about our journey—and transience—the transience of life. Well, that's how I see it, anyway.

And back to my drawing, because that wasn't the end of the story. You see, something happened a little while ago. I'd say six months or so. I'm not sure what, or why, or how, but suddenly I couldn't stop drawing. No matter where I was or who I was with. It didn't matter. I began taking my sketchbooks everywhere.

Over the past few years, since rediscovering drawing, people had often told me I should do that (I hate the word *should*). I should loosen up; I should let go more. But I didn't listen. I didn't need to because I knew when the time was right for me I'd do it. You know, it was an organic thing (again very clichéd). It's probably the only advice I would ever give anyone who was discovering his or her creativity: Don't take any advice from anyone! Do everything in your own time.

Now I go on sketch crawls, draw in public and attend life-drawing sessions. All those things I never thought I'd do.

And I get so pissed off with myself if I forget to take my sketchbook with me. But that happens less and less these days.

When it comes to sketchbooks, there is only one for me: the Moleskine. I got my first Moleskine out of curiosity, after hearing so many other online artists banging on about them. I think that it's the mark of a great product—when your customers do all the advertising for you. Anyway, I fell in love straight away. I love the quality of the paper and the classic clean design. Plus, for me, a heavyweight paper is a must. I need a paper that can handle all the crosshatching I will throw at it. That's a lot of crosshatching. The Moleskine has no problem dealing with that. And the cherry on the cake is the pocket at the back of the Moleskine, which can store all sorts of receipts, tickets, bills and other stuff that I pick up

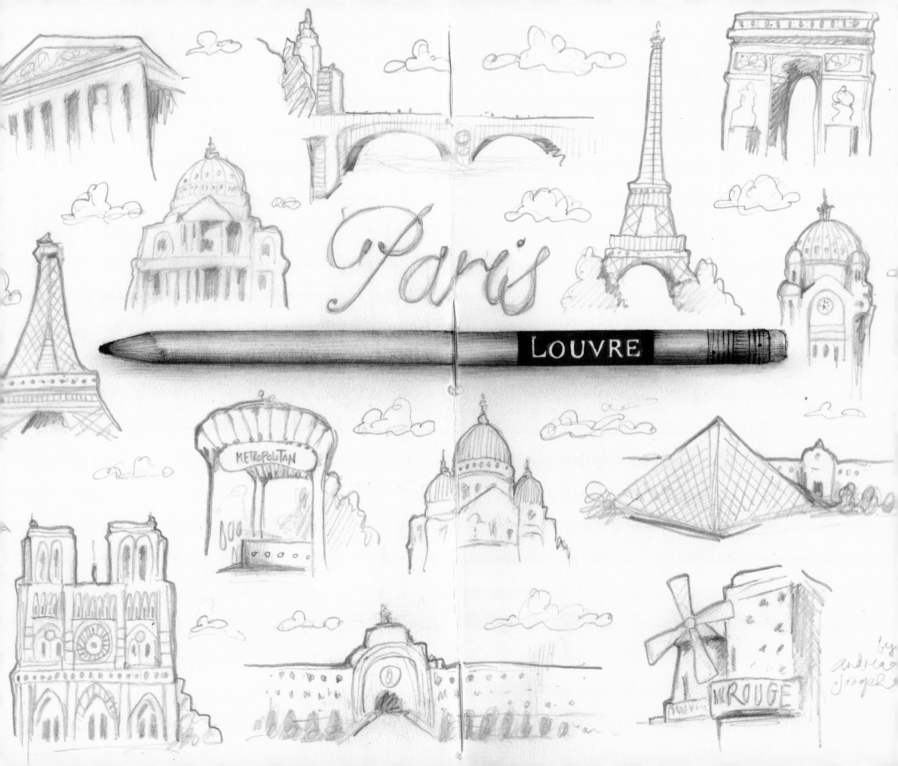

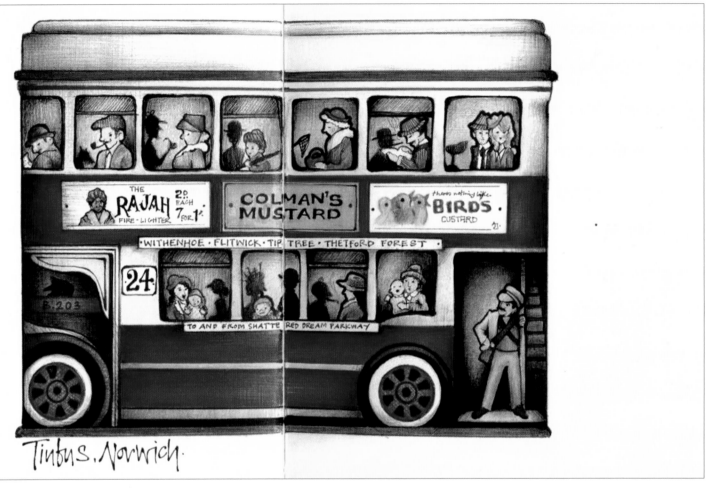

Tinbus. Norwich.

along the way.

As far as pens go, I have no such loyalty. I'm no pen snob. I'll use anything to hand. My pencil cases are filled with pens that range from the cheapest ball-points (some were free) to some rather posh Cross fountain pens. Obviously some suit me better than others, but that's just a process of elimination. Ball-points and fine liners are my favorites. I also like color pencil for, er, color.

I find it difficult trying to explain how I make my drawings, because basically I sit there with my pens and paper and out it flows. It comes naturally. For the souvenir drawings in my travel sketch-books, I guess I have a bit of a technique. I draw around the object; I actually lay the object on the paper and draw around it. My friend says it's cheating but I don't think so. The thing I like about this method is that the drawing is the actual size of your subject. And, in some way, I feel the object and the drawing become even closer. The object becomes part of the drawing, more entwined. It's never a perfect outline, it's always exaggerated in some way, and often there will be some unintended little quirks but I love to work with them. Also the pen follows the nooks and crannies that the naked eye may never have noticed. Then I cross-hatch the hell out of the blank space.

I hope that goes some ways to explaining how I do what I do. I'm not so good with words—that's why I draw.

LONDON BRIDGE

@ Transport for London Reg. user No. 88/6827

Ruler UNDERGROUND

JUST A FEW OF THE THINGS I BROUGHT BACK FROM A TRIP TO LONDON EARLIER THIS YEAR.

TOTAL COST OF LONDON UNDER-GROUND SOUVENIRS: £45.

NO, SERIOUSLY.

AJ 2011

Springfields
FRESH PRODUCE
Daffodil Bulbs
grown at
MANORBIER
DYFED

Canada

VANCOUVER

WELCOME

Portugal

When I go on holiday the thing I look forward to the most is the food. Not the architecture, the nightlife, the art galleries, and certainly not the beaches. It's the food. Trying out all the local delicacies. And I love chillis. Adore them. Spicy is my most favourite. Especially piri piri.

So when we went to Portugal I was extremely excited about trying real authentic piri piri. It turned out that we were, unintentionally, staying quite close to a small town where, a friend & a good food guide had told me, served the very best piri piri chicken that you could wish to taste. And I decided to not try any other piri piri until we visited this town (can't remember the name of it now, sorry).

→ fridge magnet

So we booked our taxi for the last day of the holiday to piri piri town (as it'll now be known). And yep, you might have guessed how this story pans out. True to form, we drive up, with hungry bellies, all excited, and it was like a ghost town. Yes it was the afternoon of the week when the whole town closes down. No piri piri.

Dolls from around the world. And from back in time. Some of these dolls were gifts and others were souvenirs that come from places including Japan, Russia, France, Sri Lanka and Guatemala. And the rest are from my childhood.

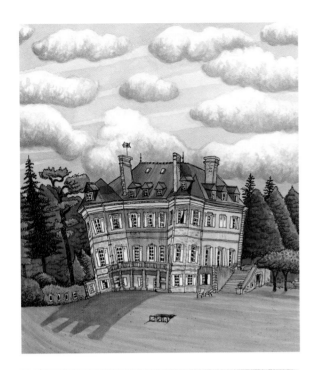

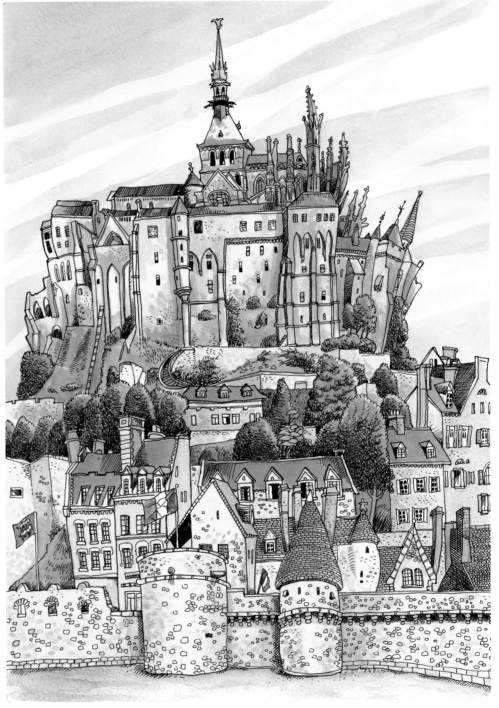

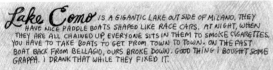

Lake Como IS A GIGANTIC LAKE OUTSIDE OF MILANO. THEY HAVE NICE PADDLE BOATS SHAPED LIKE RACE CARS. AT NIGHT, WHEN THEY ARE ALL CHAINED UP EVERYONE SITS IN THEM TO SMOKE CIGARETTES. YOU HAVE TO TAKE BOATS TO GET FROM TOWN TO TOWN. ON THE FAST BOAT BACK FROM BELLAGIO, OURS BROKE DOWN. GOOD THING I BOUGHT SOME GRAPPA. I DRANK THAT WHILE THEY FIXED IT.

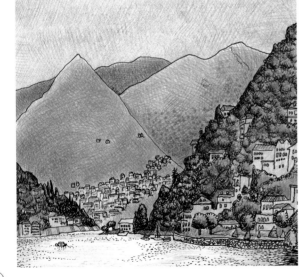

I AM FASCINATED WITH THE DESIGNS OF ORDINARY PRODUCTS IN FOREIGN COUNTRIES.

Tommy Kane

Tommy Kane is a squirrel who grew up on Long Island and now lives in Brooklyn with his wife, Yun. He's worked as a creative director in advertising for a million years. Check out his blog to find out more about this troubled individual. **http://tommykane.blogspot.com**

I have drawn every brick, cinder block and lamppost in all of New York City. Google Earth didn't need to go around and photograph every building in Manhattan. I would have given them all my drawings instead. They could have saved a lot of time, money and effort. All of this has created a dilemma for me. The Big Apple all looks the same to my eyes now. I can even say I'm bored of drawing New York. As I ride my bike around, I whisper to myself, "Did that, drew that, sketched that, painted that." My wife and I discuss moving out of New York someday. Mostly I discuss it. It wasn't until I started to write this that I realized the real reason is that I need something new to act as my muse.

My wife loves to travel around the world. Thank god. She drags me to all kinds of countries I never would have thought of going to. Her thing is food. She watches all the cooking channels, knows every chef and restaurant, she reads every cookbook and studies the best places on earth for foodies to visit. My wife and I make a good couple because she has lots of ideas and I nod my head yes to all of them. She came to me and asked if I'd like to go to Morocco because she heard there were great spices for cooking. I nodded my head yes. How about Bologna for its sauces? I nodded my head yes. Brittany, France, for its oysters? I nodded my head yes.

At first my wife was so excited that we shared this love of world food. It quite rapidly dawned on her that that was not the case at all. In fact, I don't care if I ate a granola bar three times a day while traveling. All I want to do is draw something that is new to my eyes.

As a kid growing up, my family didn't have much money so we never traveled. My family once went to Kentucky to visit my uncle and one time we went to Washington, DC, to visit my mom's cousin. That was what I had seen of the world beyond Long Island. Oddly enough it was my job as an art director in advertising that became the reason for me to travel the world. On someone

else's dime, I might add. I did work in Africa, New Zealand, Australia, London, Amsterdam, Paris and Korea. Up until that happened, I never pictured myself seeing much of the world.

I did my first drawing in a sketchbook only about six years ago. Around the same time, I discovered blogging. Hence my blog about the drawings I do. Everyone and their mother have a drawing blog now. It's a bit ridiculous. In order to stand out from the crowd, you need to have two things: mad skills as an illustrator and stories that aren't boring. That's where travel comes in for me.

My goal is to get myself into crazy situations. Not because I really want to,

THERE ARE AIR CONDITIONING UNITS IN EVERY SQUARE INCH OF EVERY BUILDING IN HONG KONG.

i WENT TO DRAW IN THE BIG MARKET. I SAT ON MY LITTLE STOOL. i ATTRACTED THE USUAL CROWD OF YOUNG AND OLD PEOPLE BUT i WAS SHOCKED TO ATTRACT WOMEN WEARING BURKAHS. THREE OR FOUR DIFFERENT ONES. THEY SPOKE AND JOKED WITH ME. A FEW EVEN TOUCHED ME, i DIDN'T THINK WERE SUPPOSED TO TOUCH A MALE STRANGER, i MUST HAVE MAGICAL POWERS.

13

THIS IS THE LITTLE TOWN OF BELLAGIO ON LAKE COMO. TODAY WAS YUN'S BIRTHDAY. SHE HIT THE BIG HO. SHE DID A BIT OF SHOPPING TO CELEBRATE. IT IS VERY HILLY. WE HAD TO WALK UP AND DOWN VERY STEEP STEPS THAT ARE MADE OUT OF STONES. PLUS WE FLEW SEVEN HOURS THEN TOOK A ONE HOUR TRAIN AND FINALLY A ONE HOUR BOAT.

MY FEET HURT

but just so I will have something interesting to write for my dumb blog. This may seem stupid but it does motivate me. Otherwise, I would sort of be happy staying home when I take a vacation and taking naps on my couch. My insipid blog is always looming over me. "What are you going to draw and write about next, Kane? You bore me." Okay, let me ask my wife if she wants to go climb Everest or spend a week in Bagdad. As I mentioned before, my wife has the ideas of where to go

because my ideas would get us into real trouble. So there is the truth. I am being controlled by my addiction to blogging. If I don't get to some foreign crazy country soon to draw, then what will my five thousand Facebook fans think? Will they desert me? What about my two thousand Tumblr followers? My eighteen hundred twitter disciples? My thousands of Flickr worshippers? The pressure. The insanity.

My wife and I are now travel experts. We have actually traveled with only one

carry-on bag. Not *each*, just one. To travel light takes skill. I am a 140-pound weakling. Therefore I can't carry very much. In the past, I have taken too much drawing equipment with me. Not anymore. I take a Moleskine, a 10" × 14" (25 cm × 36 cm) Canson cold press watercolor block, two black uni-ball pens, a tiny Winsor & Newton watercolor set, a few water brushes, ten Prismacolor pencils and a folding camping stool. I also take my Canon G12 camera. In order to

seem more interesting than I really am, I have started to make YouTube videos of myself drawing in strange lands.

Think about how dumb that is for a second. It takes me about three hours to make a great drawing on the street somewhere. I'm in some foreign place so I'm all jet-lagged. Now throw in the fact that I'm going to film myself. I set up my tripod and camera a few feet away from me after composing a shot. Then I turn the camera on and run to my folding

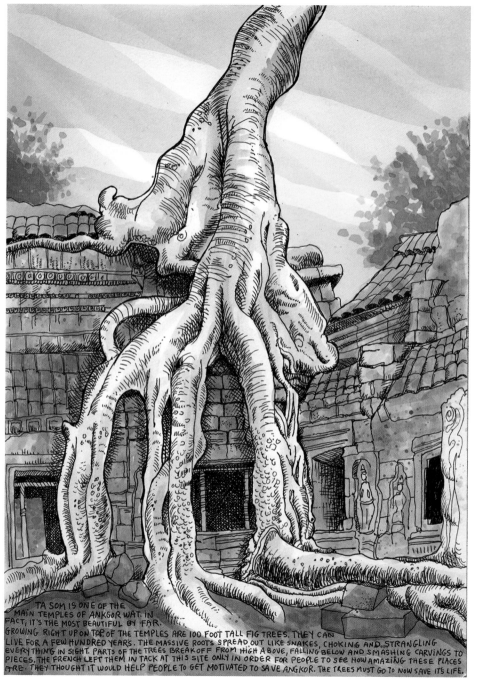

TA SOM IS ONE OF THE MAIN TEMPLES OF ANKGOR WAT. IN FACT, IT'S THE MOST BEAUTIFUL BY FAR. GROWING RIGHT UP ON TOP OF THE TEMPLES ARE 100 FOOT TALL FIG TREES. THEY CAN LIVE FOR A FEW HUNDRED YEARS. THE MASSIVE ROOTS SPREAD OUT LIKE SNAKES, CHOKING AND STRANGLING EVERYTHING IN SIGHT. PARTS OF THE TREES BREAK OFF FROM HIGH ABOVE, FALLING BELOW AND SMASHING CARVINGS TO PIECES. THE FRENCH LEFT THEM IN TACK AT THIS SITE ONLY IN ORDER FOR PEOPLE TO SEE HOW AMAZING THESE PLACES ARE. THEY THOUGHT IT WOULD HELP PEOPLE TO GET MOTIVATED TO SAVE ANGKOR. THE TREES MUST GO TO NOW SAVE IT'S LIFE.

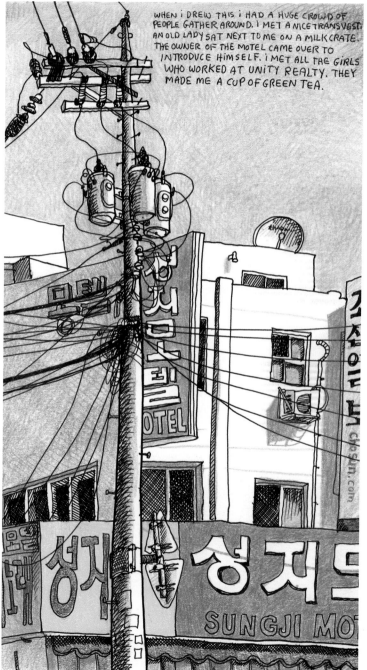

WHEN I DREW THIS I HAD A HUGE CROWD OF PEOPLE GATHER AROUND. I MET A NICE TRANSVEST AN OLD LADY SAT NEXT TO ME ON A MILK CRATE. THE OWNER OF THE MOTEL CAME OVER TO INTRODUCE HIMSELF. I MET ALL THE GIRLS WHO WORKED AT UNITY REALTY. THEY MADE ME A CUP OF GREEN TEA.

YUN WENT INSIDE AND BOUGHT THE MOST BEAUTIFUL BOTTLE OPENER I'VE EVER SE

Souk Tulaa

I SAT ALONE ON A PARK BENCH TO DRAW THIS. AFTER ABOUT 10 MINUTES, TWO RUSSIAN TRANSVESTITES CAME AND SAT NEXT TO ME. ONE WAS SIX FOOT FOUR WITH HOT PANTS AND A JACKET MADE OF WHITE FEATHERS. THE OTHER WAS FIVE FOOT SEVEN WITH RED KNEE HIGH BOOTS ON. BOTH HAD WIGS, FULL MAKE UP AND GIANT WHITE SUNGLASSES. THEY GIGGLED AND CHAINSMOKED NON STOP. MY CINEMATOGRAPHER, YUN LEE, WAS BUSY SHOPPING SO I MISSED MY CHANCE OF GETTING SOME GREAT SHOTS OF ME DRAW- ING NEXT TO MY NEW FRIENDS. DID I MENTION THEY HADN'T SHAVED IN FOUR DAYS.

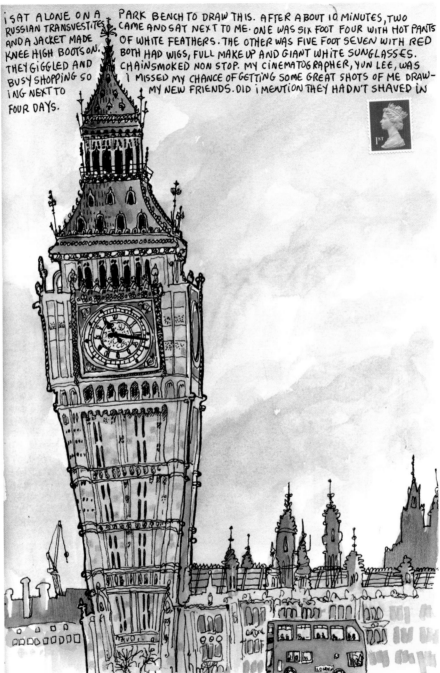

stool and begin drawing. I can't let it film too long because I only need a few seconds for each setup. So now I have to run back and turn off the camera. Then I draw for a while longer. I need to cover quite a few angles. So there's a lot more running back and forth. Plus I have to shoot extra coverage of the streets to show where I was drawing. Imagine how tiring that is. I'm exhausted just having to write about it. All of this nonsense just to feed my World Wide Web addiction.

What I really need is an AA meeting, not for drinking or drugs, but for making drawings that go on my blog. I need help because I don't know how to stop. In the end, it will cause my demise. My ass and balls are always killing me from sitting on that damn camping stool. My eyes are shot. I need a telescope to read a menu. I'm beat up from sitting in the bright sun or freezing cold. Hours of my life wasted away scanning and tweaking colors in Photoshop. Days spent shivering in my study trying to coax iMovie into doing what I need done. It is a dark, lonely existence. I have come to realize I need professional help to kick my habit.

My name is Tommy Kane, and I am a drawaholic.

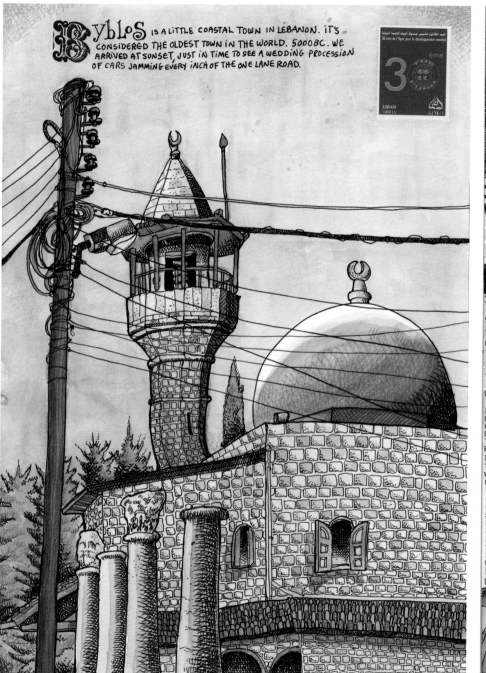

BYBLOS IS A LITTLE COASTAL TOWN IN LEBANON. IT'S CONSIDERED THE OLDEST TOWN IN THE WORLD. 5000 B.C. WE ARRIVED AT SUNSET, JUST IN TIME TO SEE A WEDDING PROCESSION OF CARS JAMMING EVERY INCH OF THE ONE LANE ROAD.

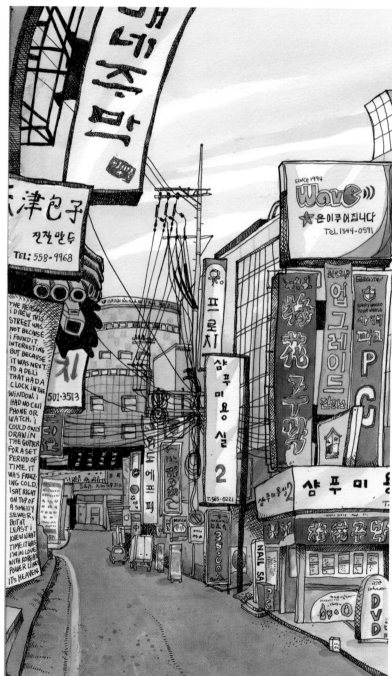

THE REASON I DREW THIS STREET WAS NOT BECAUSE I FOUND IT INTERESTING BUT BECAUSE IT WAS NEXT TO A DELI THAT HAD A CLOCK IN THE WINDOW. I HAD NO CELL PHONE OR WATCH. I COULD ONLY DRAW IN THE GUTTER FOR A SET PERIOD OF TIME. IT WAS FREEZING COLD. I SAT RIGHT ON TOP OF A SMELLY SEWER, BUT AT LEAST I KNEW WHAT TIME IT WAS. I'M IN LOVE WITH KOREA'S POWER LINES. IT'S HEAVEN.

SAN JOSE
MEXICO
07.10

Stéphane Kardos

Stéphane Kardos was born in France where he studied animation and illustration. He lived in London for a few years then moved to Los Angeles where he currently is an art director. **http://stefsketches.blogspot.com/**

I started to draw when I was very young. My Dad and my granddad both painted and drew in their early years, neither was a professional artist as such; they never made a living out of it, but they both loved drawing. One day my mum gave me one day one of my granddad's sketchbooks (I must have been nine or ten years old). It was a sketchbook that he kept with him in Paris during World War II. I was blown away by how detailed the sketches were, and I loved reading his notes along with them.

As a kid, I loved drawing, painting, even doing embroidery with my Mum. I remember drawing a tree with the birds around and doing it as an embroidery with my Mum on a piece of yellow fabric. I also loved painting with my Dad. I remember fondly how he showed me how to paint on glass one day. I was so proud of myself to be able to paint exactly what he was painting, using his technique. I was looking up to him.

I had notebooks at school at a very early age. The teachers made us fill them in every day with a new drawing. We had to write a sentence and then illustrate it.

What a lovely idea it was. My Mum preciously kept them through the years and gave them to me three years ago, when my Dad passed away.

Now I use my sketchbooks as diaries. I remember exactly where and when I did a sketch, why I did it, what the weather was like, the mood I was in. One of the things I haven't lost from drawing as a kid is spontaneity. I really make sure that my drawings are spontaneous and full of life. I never rework my sketches for fear of overdoing it and killing the energy of the first shot. My sketches are all about capturing a moment, whether it's a sketch of a person or a scene, or some buildings, a car—anything really. I'm more about the feeling than trying to draw exactly what I have in front of me ... I want a snapshot of life, something that will touch people because there's a story, not because it's a 'beautiful' well-drawn sketch.

Sketching while traveling is one of the most enjoyable ways to travel, I think— to keep records of everything around. And I love going through those sketchbooks later to remember the places I visited. And it's funny how some drawings

casa
LA
VIENNESE

taormina 26 08 04

that were insignificant at the time mean a lot to me now, because they caught something on paper without me realizing I did it. That is why I never rip off a page from my sketchbooks; who knows what pleasant secret lies in that drawing that I will discover years later?

I never rework my sketches because I want them to be spontaneous and fresh, full of energy, honest. What I drew is what I saw, or think I saw, at this exact moment, good or bad. And this is why I love sketching, because you can't cheat if you stick to drawing on location and that's it. No retouching back in the studio.

I always travel light when I sketch, mainly because I never really prepare for it. I rarely go out and say "I'm going to sketch." I want to be surprised (spontaneity again). So I carry few black ballpoint pens (uni-ball Vision Elite) that I like because the ink is waterproof. I can add watercolor on top, because these pens dry fast.

I also always have two Pentel Brush Pens with me: one completely worn out, filled with grey ink, for dry brush effect, values; the other one in very good condition for nice line weight and black ink. I really love using dry brush effect in my sketches more and more to add values and contrast. It really adds a beautiful organic effect. I also love sketching with a black and gray Tombow pen. They're really good all-around pens.

I also have a very small Winsor & Newton watercolor travel kit, and I use a Pentel water brush pen with it. And that's it. I don't want to waste any time thinking about what I'm going to use to sketch. When I see something I want to draw, it has to be done right now.

I have used a lot of different sketchbooks throughout the years; it's always the same thing, you're always on the lookout for the perfect sketchbook with the perfect paper that can take ink, watercolor, gouache, any kind of medium you might throw at it. And also a sketchbook that looks good. I like having a sketchbook that invites me to draw in it. I had a few of the ones bound in leather, but the paper wasn't good for me. I used the Fabriano sketchbooks for a while. I like the paper very much for ink and watercolor, but they are paperback, so it's difficult to draw in them standing up. Also, when you get toward the end of the sketchbook, there's no support. I used also the Moleskine sketchbooks for a long time, they are very convenient. I like the hardcover, with the pocket inside, but I'm not sure about the paper. The only Moleskine I use now are the Japanese notebooks, I love how you can create a long story line with them.

The sketchbook that I always have with me now is a Seawhite of Brighton, purchased in London, a letter-size landscape format. I absolutely love them. The paper is superb, with the right amount of texture in it, and you can draw, paint, watercolor, do everything you want in them. They're hardcover and not too thick, perfect for

LAKE AVE.
AUGUST 22
2009

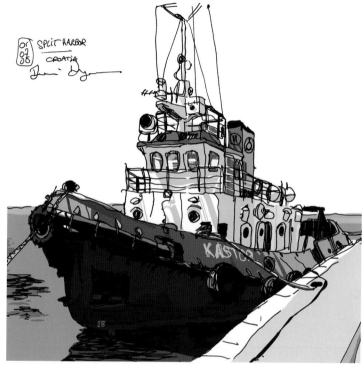

SPLIT HARBOR
CROATIA

me, as I can fill them pretty quickly. I don't like thick sketchbooks. I like starting a new one often.

For a while when I first arrived in Los Angeles, I used to go out every lunchtime and draw the most boring thing around the neighborhood. It was a challenge for me. I did so because when I arrived in L.A., I was disappointed by the look of the city, which I didn't know very well at the time. Coming from Europe, where most of the buildings are a few hundred years old and very intricate designs, L.A. felt a bit boring.

Every building looked like the back of a building in Europe, or the back of a shop. So I thought, it's very easy to do some beautiful sketches in Europe, as most of the buildings around you are beautiful, but what if you draw boring, simple buildings? Can you make them an interesting sketch to look at? I also discovered that it is indeed much harder to sketch in Europe than in L.A. The building designs are so intricate in most cities in Europe, they give you headaches just trying to understand how the doorknob has been designed. In L.A., everything

felt like a rectangle with a door and a window; at least at the beginning. Now that I know L.A. better, I know where the city is interesting. I know what the city has to offer.

Two of the best experiences I had sketching were, first when Jonathan Ross in London invited me to sketch backstage and during the rehearsal of his show *Late Night with Jonathan Ross*. I was working at the time on my first long sketchbook, one of those Moleskine Japanese sketchbooks. I was moving from London to Los Angeles at the time

and wanted to document it on one very long single page that tells a story. So right in the middle of that sketchbook, I got invited to Jonathan's show and was able to sketch the guests, hence Samuel L. Jackson and Quentin Tarantino appear in the sketchbook. The pressure that day was terrible! It's one thing to sketch people on the streets, but to be on the set of a TV show and try to be inconspicuous while sketching Samuel L. Jackson and Quentin Tarantino was an all-different story. For once, I was conscious of what I was doing because I wanted to do well.

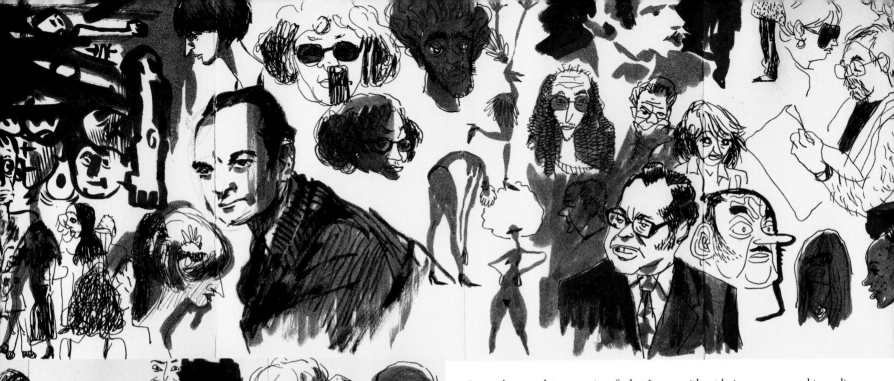

It was the complete opposite of what I would do normally.

The second best experience I had sketching was in August 2011, when my friend Jean-Claude Vannier, who is a French music conductor, invited me to spend an afternoon and evening at the Hollywood Bowl, to sketch the guest stars and musicians on stage and backstage during rehearsal and during his concert in the evening. I decided, for this occasion, to fill a long Moleskine Japanese sketchbook again, only this time I had only twelve hours to do it rather than a month. That, plus the pressure of being onstage during rehearsals next to the likes of Joseph Gordon-Levitt, Beck, Sean Lennon, Mike Patton ... it took me a while before I could start to sketch

without being nervous and to realize where I was. It was also my first time at the Hollywood Bowl—a lot to take in!

I love looking at my sketchbooks collection on the shelves in my studio. I learn from them. I like coming back to them, browsing through the pages. I think about them as a legacy, a trace I leave for my son, for him to go through later in life. And who knows? Maybe he'll get inspired as I did when I looked at my granddad's sketchbook for the first time as a kid.

That, or he'll spread peanut butter and mac and cheese all over the pages—and that will be okay, too.

Stéphane Kardos

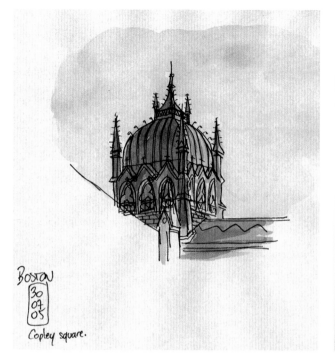

BOSTON
30
07
05
Copley square.

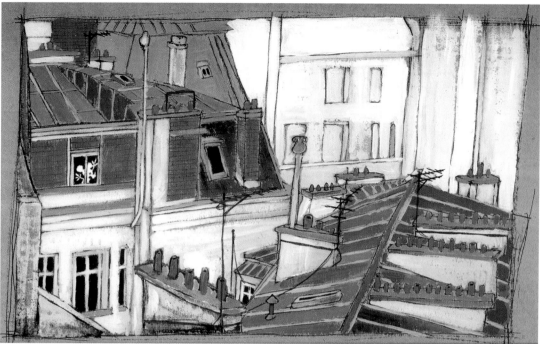

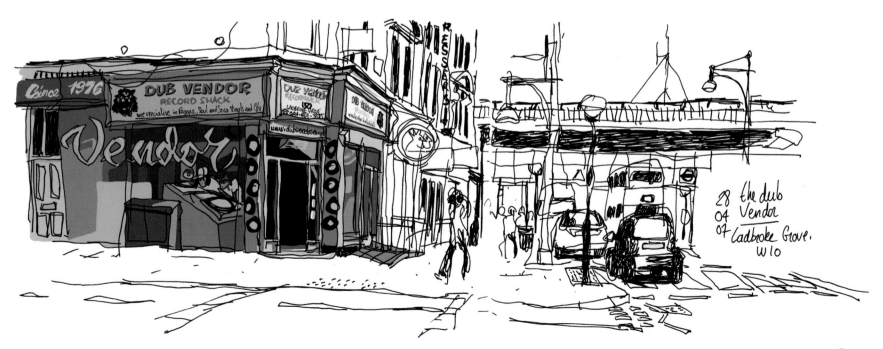

DUB VENDOR
RECORD SHACK
we specialise in Reggae, Soul and Soca Vinyls and CD's

Since 1976

Vendor

DUB VENDOR
RECORDS

DUB VENDOR

28 the dub
04 Vendor
07 Ladbroke Grove.
W10

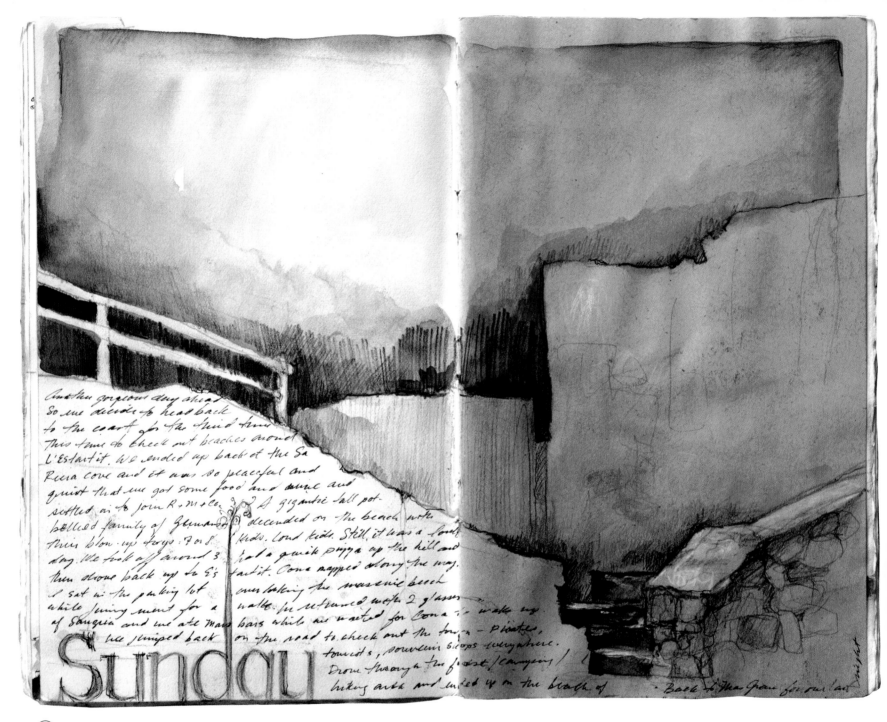

Another gorgeous day ahead
So we decide to head back
to the coast for the third time
This time to check out beaches around
L'Estartit. We ended up back at the Sa
Riera cove and it was so peaceful and
quiet that we got some food and wine and
settled in to join R + M + co. A gigantic tall pot-
bellied family of Germans descended on the beach with
their blow-up toys. For 8 kids. Loud kids. Still, it was a lovely
day. We took off around 3 had a quick pizza up the hill and
then drove back up to E's Startit. Oona napped along the way.
I sat in the parking lot overlooking the masenic beach
while Jenny went for a walk. She returned with 2 glasses
of Sangria and we ate Mars bars while we waited for Oona to wake up
We jumped back on the road to check out the town — pirates,
tourists, souvenir shops everywhere.
Drove through the forest/canyons/
hiking area and ended up on the beach of — Back to Mas Jaine for our last

Sunday

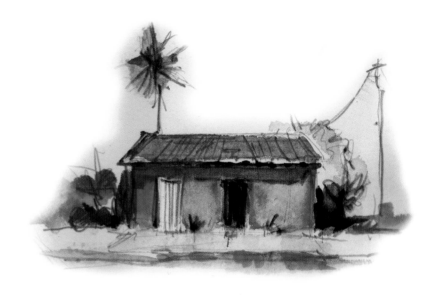

Amanda Kavanagh

Amanda Kavanagh was born in New York City and raised in the lower Hudson River valley. She studied illustration at Syracuse University and currently lives in Brooklyn with her husband and daughter. She splits her time between running her own graphic design business and oil painting. **www.amandakavanagh.com**

I grew up with three older sisters in a very creative family in Dobbs Ferry, New York, a town about 20 miles north of New York City on the Hudson River. My parents were artists and always encouraged us to pursue our creativity. We loved making our own toys. I remember a very intricate circus made from cardboard and clay (we played with it until it disintegrated), paper dolls, dollhouses, a tree house for our Barbies. Although I had always drawn as a kid, when I was twelve years old, I turned some kind of corner and became serious about it. I was very shy and didn't have many friends, so I stayed in every night, every weekend, just watching television

and drawing. It became my constant companion and tween salvation. Drawing got me through those difficult years.

I went to Syracuse University, and it was a given that I would study art (illustration). When I came out of school, I took a job as a production artist in the art department of a marketing firm. That's when the drawing stopped but the traveling began. I would insist on a minimum of three weeks vacation each year, and every extra penny I earned went into my travel fund. My goal was to get to Europe at least once a year.

The production job eventually led to a graphic design position with another

firm. Years later, I started my own design business. So that's my day job. But somewhere along the line I took out my old art supplies and started keeping a journal—which led to more drawing and painting—and soon I was finding the voice I never managed to find in college. And, of course, I continued to travel.

Traveling for me is not just about going on vacation, lying in a coma by the beach (although I can do that, too). It's about getting away from all my stuff and flogging my brain. It's about experiencing new cities, people, culture, architecture. My wings were clipped a bit when I became a mother, but we still try to get

away whenever we can.

I've never taken a trip just to draw, although my dream is to one day take a painting workshop in France or Italy. I see my travel journals as a more intimate way of documenting my trip than just taking photos. Drawing enhances the whole experience by allowing me to focus more on the details around me.

I don't pick places to visit based on journaling, but I do find I prefer drawing bustling cities and old architecture over relaxing beach vacations. Maybe I'm more stimulated by being in a city. Either way, I find it takes a few days to get into the groove of drawing. And the more time I

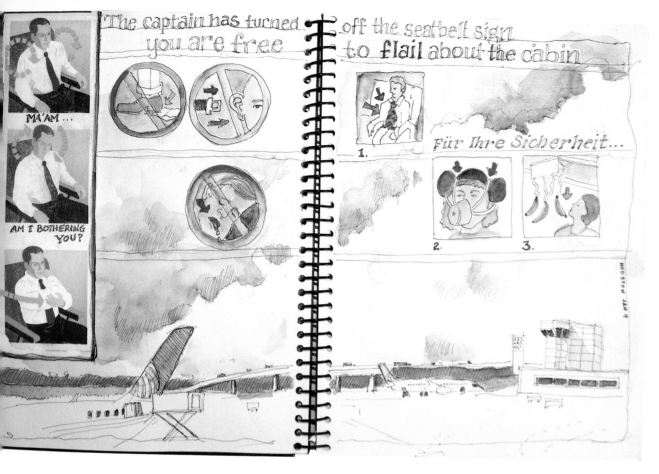

spend with it, the more interesting the pages become. So I try to allow time each day to be alone and just sit with the place. By the end of the trip, I'm usually hitting my stride.

I try to begin each trip with its own new journal. I like to take advantage of a long plane ride to map out the trip—list all the places I'd like to see and where I'd like to eat, sketch out maps and subway lines and bus routes. I also keep important numbers and contacts in the journal, since I know that's one thing I'll always have with me.

Since my first trip with a journal about ten years ago, I've never considered traveling without one. It would be like leaving my camera or passport at home. It's just not going to happen.

Drawing is my way of experiencing a place on a much deeper level. When I draw or paint, I am completely in the moment. It's my form of meditation. Every sense is engaged and enhanced: sight, smell, sound, touch and sometimes even taste (especially in Italy). The rest of the world fades away and I can really focus on what's in front of me.

I don't have any rules about how to approach a new journal page but I do like to spend a few minutes thinking about composition before I start. Time is usually a big factor in deciding how much to include in the drawing. I'll step back for the big view and then pare it down to what I can realistically get done in that time frame. If it's going to be one of those days of racing around, I'll do several small sketches on a spread. I'll figure out how to connect them all later.

As the years go by, I've learned to get my kit down to just the basics. I've come to terms with the fact that oil paints are not practical, so I know I'm limited to watercolor, pencils, ink … and that's fine. I can use the sketches as studies for larger oil paintings later. I know if I keep it simple and limit myself, I am always

happier with the results. If you don't bring it, then you don't worry about having to use it. My usual kit is tiny: 2, 4, 6 and 8B pencils, a Rotring Sketching Art Pen, a rapidograph for small writing, an eraser and sharpener, a white pastel pencil, two Niji Waterbrushes and a small Winsor & Newton Bijou Box. They all fit in one pencil case. And my journal, of course.

Although I can streamline my drawing utensils, I have a very hard time committing to one kind of paper or book. So my work-around is to make my own journals using a variety of papers. The travel journal will serve a number of purposes for me (itinerary, photo album, diary, sketchbook) so I want to have a variety of papers available. I also bind in photo sleeves, envelopes, and other things. I'm a terrible bookbinder though, so they often fall apart over time. I have to tape them up or restitch them. But I like to think that it adds to the patina.

When you're traveling, try to keep your load compact and portable. Pare it down to one book and your favorite tools. I find I get confused when I give myself too many choices. I feel obliged to use everything I brought with me and each time I switch it up, I have to warm up all over again. Sometimes I'm disappointed I didn't try this new pen or those fancy paints. If I don't have the extra tools on me, they won't distract me. Freedom from choice. I can just focus on drawing.

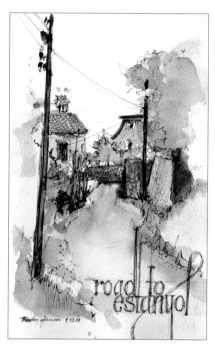

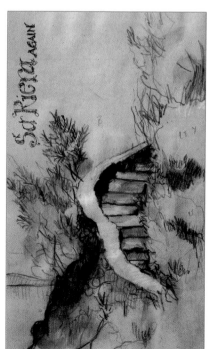

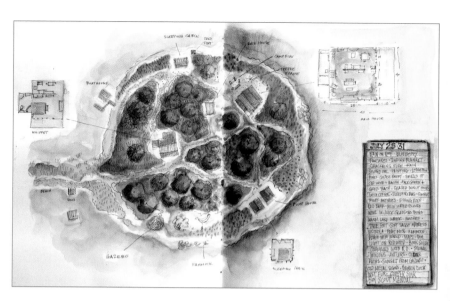

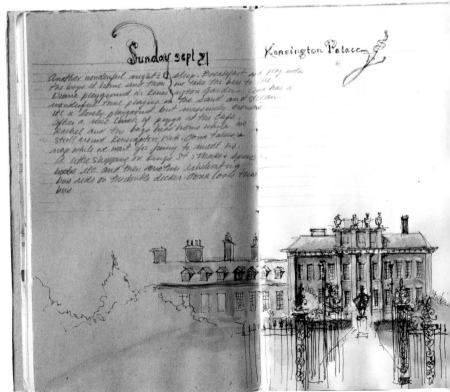

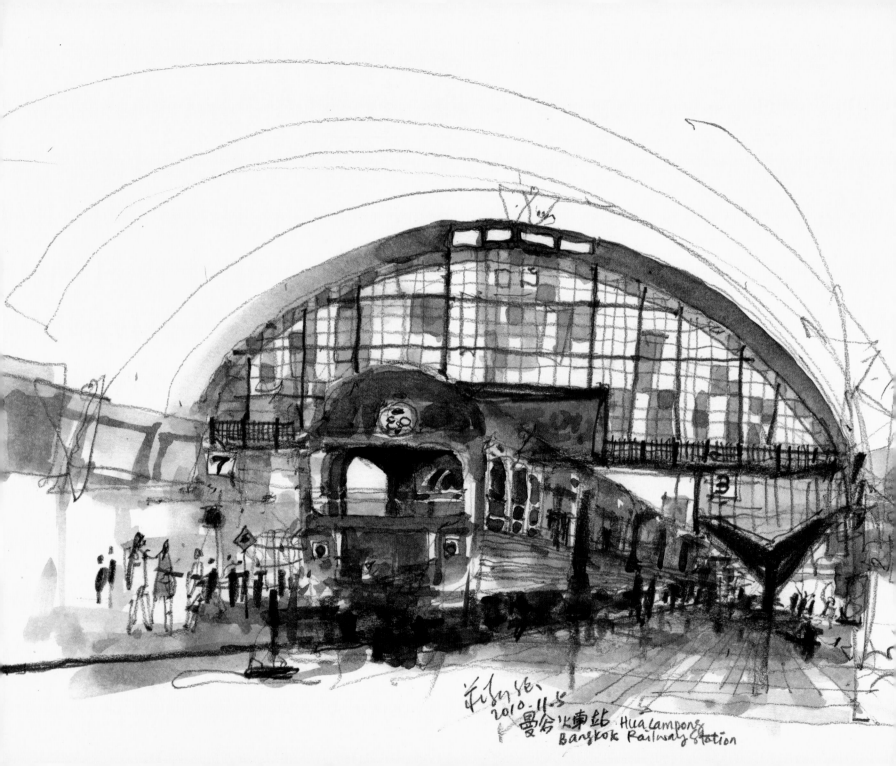

曼谷火車站 Hua Lampong
Bangkok Railway Station
2010·11·5

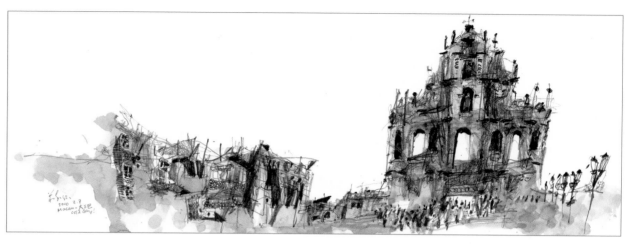

Ch'ng Kiah Kiean

Ch'ng Kiah Kiean was born in George Town, Penang. He is a blog correspondent of Urban Sketchers and also a founding member of Urban Sketchers Penang. He published *Sketchers of Pulo Pinang* in 2009 and *Line-line Journey* in 2011. **www.kiahkiean.com**

I was born in Penang, Malaysia, in 1974 and grew up in the inner city of George Town. I still live and work here in this old city.

I started to draw when I was a child, around the age of seven or eight years old. I fell in love with art and I never stopped drawing. I am surprised to be the only person who draws and loves art in my family, though one of my uncles did practice Chinese calligraphy and I was somewhat influenced by him.

When I was in high school, I would sketch outdoors with my high school's art society. We would travel around Penang Island during school holidays and sketch. After high school, I studied architecture at Universiti Sains Malaysia and began

to focus my drawing on architecture and heritage buildings. My training helped me appreciate the beauty of architecture and expanded my drawing subjects.

After graduation, I worked in architectural design for a couple of years then went into heritage conservation and restoration works. After that, I started my own graphic design studio and I hope soon to be a full-time artist and illustrator.

I travel whenever I have free time; I usually leave the country twice a year. Travel is definitely more fun when I pack along my sketching tools. I love every location that I have sketched and find that drawing gives me many more memories than a camera. Sometimes I will travel

to particular places to draw (usually nearby), and most of the time I discover new things or places as I travel.

I use my sketchbook for exploration and discovery. When I draw on my travels, I like to interact with people, to talk to them and share my experience. I like to listen to the stories they tell and they teach me about the place.

The most challenging drawing situation for me is extreme weather—for instance, drawing under a hot sun. As I live in a tropical country, the cold winter weather is also a big challenge. I remember when I did the aerial view sketch of Monte Fort Macau, the cold wind over there was so strong and I was shivering.

Drawing has become the main pur-

pose of my trips nowadays, other than meeting people and sightseeing. I will not go on a trip without my sketching tools; they are as important as my passport. A trip without producing sketches makes me feel I have missed out on something important. It is not fun.

A trip to another neighborhood is also a good subject matter for my journal, and I always discover great things around the city I live in. I am in love with my city and really enjoy drawing its many faces. The uncontrolled development made George Town change so rapidly over the years, and many heritage buildings and monuments have disappeared. Sometimes the sketches have become a good record for the places that were demolished.

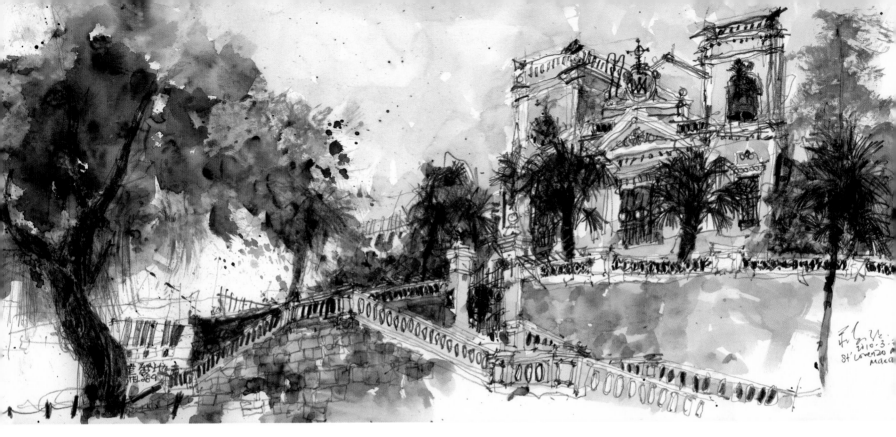

There is not much difference between the process of my travel journals and my professional artworks. If the sketches are done with the sketchbook, then they are not for sale. Normally I only sell loose sheets of sketches, unless the particular piece of work is important or has sentimental value to me.

When I travel abroad, I always bring my watercolor sketchbook together with a smaller version of loose sheet sketching papers. My normal sketch paper is a long vertical format.

I don't have many rules. Basically if I use the Moleskine watercolor sketch-book I will not collage or paste anything to the pages. I always fill the pages with whatever sketching media that I bring along: graphite, watercolor and Chinese ink. I will sign on every page with the full date and the location of the drawing (street, city and country).

My travel kit is quite light: Normally I will bring along a backpack, a folding stool, a drawing board and a bottle of drinking water. I also carry a Winsor & Newton lightweight enameled box, twenty-four half pans watercolor, a Faber-Castell pencil case, a Chinese ink container and calligraphy brush, a Hol-bein water brush, a sharpened bamboo stick and a sharpened dry twig in pencil extender, a range of flat head sketching pencils and nine 4B pencils.

For the time being, I like to use a Moleskine watercolor sketchbook the most, it can be easily obtained from the bookstore in Penang.

Normally I go on sketching trips with my friends who share the same interest, then all of us will have the same time to sketch and whoever finishes drawing first will help the others to take photos. Only my girlfriend has the patience to sit by my side and watch me sketch from start till the end. Sometimes she will draw a cute cartoon of me. I enjoy talking to passersby while sketching and sometimes we will gather crowds.

My travel journals are my most precious things, other than my passport. I keep them nice and safe and I scan every page. My advice: Throw away your digital camera. A journey with sketchbooks is definitely more fun.

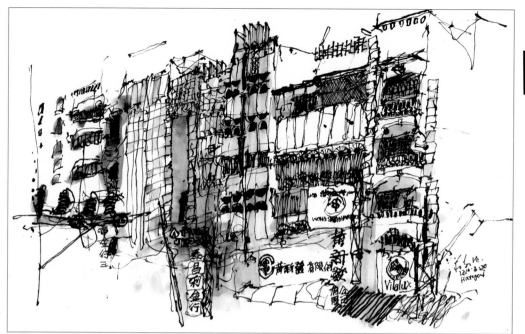

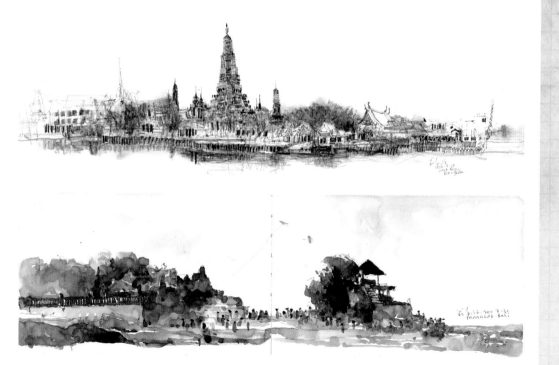

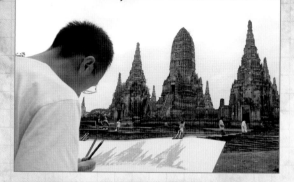

"THE GRANITE THRONE" WAS ONE OF MY FAVORITE CAMPSITES TO NAME. IT WAS A GROUP EFFORT. WELL, ALL OR NOTHING AND I, AT LEAST. SHE SUGGESTED "COZY CAMP." I THOUGHT THAT WAS TOO GIRLY. "IT HAS TO BE MANLY!" CHAINSAW & DETOUR FOUND THE SITE, NESTLED IN A CRAG OF GRANITE. FROM THE TOP OF THE ROCKS, THE VIEWS TOWARD THE SOUTH & WEST WERE STUNNING DURING SUNSET. ALL OR NOTHING & I CAMPED 100 FEET DOWN THE TRAIL FROM THE "THRONE" - ON THE TRAIL, IF I RECALL - BUT WE COOKED & SAT AT A CAMPFIRE IN THE THRONE OF ROCK.
IN THE MORNING WHILE HIKING OUT, I LOST MY BREAKFAST ON THE TRAIL. HIKED TOO QUICKLY & SWALLOWED A BUG, BOTH LEAD TO A COUGH, THEN VOMITING.

JULY 11TH - "HAPPY FIRE CAMP"

HIKED WITH ALL OR NOTHING INTO THE EVENING. TOUGH AFTERNOON FROM DEATH CANYON UP A RIDGE TO A SADDLE NEAR A WATER SOURCE ("WA0736"- M 736.3) WE CAUGHT UP TO CHAINSAW, DETOUR, BUSHWHACKER & TRIPLE DIGITS, WHO HAD PICKED A GREAT SPOT TO CAMP. I HAD NO PROBLEM FINDING A NICE FLAT SPOT ON THIS WIDE SADDLE TO SET UP MY TENT.
"WE HAD BETS ON IF YOU AND ALL OR NOTHING WERE GOING TO MAKE IT HERE."
ME: "OH YEAH? WHO WON?"
"NOBODY!"
TRIPLE DIGITS PACKED IN A THERMOS OF 100% PROOF WILD TURKEY WHISKEY. HAD 2-3 SHOTS. FEELING GOOD.
BUSHWHACKER GAVE THE SITE ITS NAME: "WHEN YOU CAME INTO CAMP YESTERDAY, YOU WERE SO HAPPY TO SEE THE CAMPFIRE." IT WAS TRUE, I DIDN'T EXPECT TO SEE ONE OVER 10,000 FEET.

JULY 12TH - PORTAGEE JOE CAMPGROUND (LONE PINE, CA)

AN UNEXPECTED (BUT MUCH NEEDED) DETOUR INTO LONE PINE FOR PIZZA. BADWATER MARATHON IN PROGRESS SO WE COULDN'T FIND A HOTEL ROOM. CAMPED AT AN OFFICIAL CAMPGROUND JUST OUT OF TOWN WITH: ANT HOO HAO "HOT ROD" (SECTION HIKER), CHAINSAW, ALL OR NOTHING & DETOUR. I ROLLED ONTO MY IPHONE DURING THE NIGHT AND CRACKED THE SCREEN. LUCKILY, IT STILL WORKS. UP AT 6AM. FIRST TO PACK. EXCITED FOR A BIG BREAKFAST IN TOWN. SHAWN SALABERI, A FRIEND FROM LA, SUGGESTED THE ALABAMA HILLS CAFE.

JULY 13TH - CHICKEN SPRING LAKE

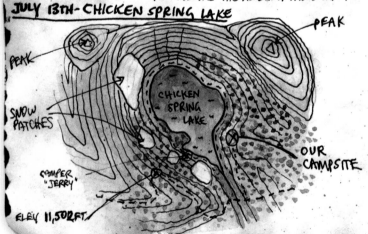

PEAK
PEAK
SNOW PATCHES
CHICKEN SPRING LAKE
CAMPER "JERRY"
OUR CAMPSITE
ELEV 11,502 FT.

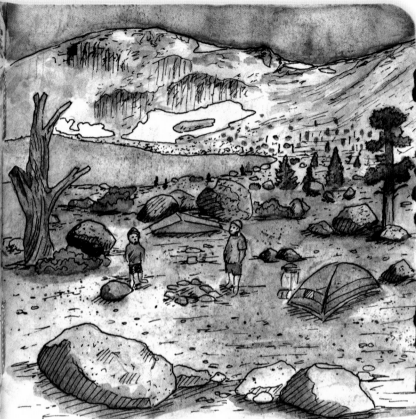

CAME UPON CHAINSAW WRITING "TEAM NAP TIME" AND AN ARROW WITH PINE CONES ON THE SIDE OF THE TRAIL. HE LOOKED DISSAPPOINTED THAT I ARRIVED BEFORE HE COULD FINISH HIS DIRECTIONS TO THE CAMPSITE NEAR THE SHORE OF CHICKEN SPRING LAKE.
THE LAKE SITS DEEP IN AN INDENTATION, A HORESHOE-SHAPE OF ROCK SURROUNDS IT LIKE A FORTRESS WALL. ITS WATER GENTLY LAPS ALONG A GRASSY SHORELINE, WITH GREY BOULDERS SCATTERED LIKE PIECES OF A SHIP WRECK WASHING ASHORE.
CHAINSAW WAS EXCITED TO CAMP HERE. LAST YEAR, HE HAD STOPPED HERE FOR LUNCH. OUR CAMPSITE IS NOT ON THE LAKE'S SHORE BUT BEHIND A SMALL RISE OF BOULDERS, PROTECTION FROM THE WIND IF IT PICKS UP (IT DIDN'T).
MARMOTS & GROUND SQUIRRELS CONSTANTLY SCHEME WAYS TO GET OUR FOOD. TOOK A STROLL AROUND THE LAKE. THERE ARE JUST THREE OTHER BACK-PACKERS HERE TODAY.
CAMPERS WITH US: CHAINSAW, ALL OR NOTHING & DETOUR.
SUFFERED VIOLENT SHIVERING & A PAINFUL LEG CRAMP. SUFFERING FROM DEHYDRATION. REALIZED I DIDN'T DRINK ANY WATER SINCE LEAVING CAMPGROUND THIS MORNING!
SOUND OF FROGS CROAKING FILLS THE NIGHT AIR. SLEPT WELL.

Kolby Kirk

Kolby Kirk is an artist, writer and outdoorsman who enjoys a good ramble in the woods with his journal. In the past decade, he has hiked over four thousand miles of trails and roads in over twenty-five countries. **http://kolbykirk.com; www.thehikeguy.com**

I was born in Eugene, Oregon. I lived there until my family relocated to Duluth, Minnesota, then Sacramento, California, then Southern California. I just ended a nineteen-year run of living in Southern California—I was laid off from a job of six years in April. I took that opportunity to hike the Pacific Crest Trail, which runs from Mexico to Canada through California, Oregon and Washington. I spent five months on the trail and hiked nearly 1,700 miles. I filled over five hundred pages of journals along the way. I am now living in Bend, Oregon, where I hope to settle and start a family. As I look for a new employer, I'm making ends meet by selling my photography.

My first journal, kept on and off through high school and college, was a way of responding to the information I was reading in books and *National Geographic* magazine and a place to share my dreams of exploring the world. After years of dreaming it, I finally got the chance to travel. My first time traveling by myself to a foreign country began on September 11, 2001. I was on the first day of an eleven-week backpacking trip, when terrorists attacked the United States. I realized fairly quickly that this would be a trip that would change my life, and I felt it was important to write about it as it happened.

In 2004, I resolved to celebrate my birthday every year on foreign soil. Since then, I've blown out candles in Africa, Central and South America and New Zealand. Travel—attentive travel—is a very important aspect in my life. I like to step out of my comfort zone into a world of the unfamiliar in order to learn more about the world and myself. I find power in pilgrimage.

I vividly remember sitting in the Temple of Apollo, among the ruins of Pompeii, Italy, sketching an ancient column with Mount Vesuvius looming in the background. I spent enough time sketching there to be visited by multiple guided tours, all of which shuffled in and out of the area within just a few minutes. I could really feel the scene being permanently etched into my memory, as

I etched the scene into my journal.

When I travel, I love to actively get lost and find myself out of the currents of tourism. It is in these backwaters that I truly feel like I'm being adventurous. I draw what I find interesting and want to spend time studying. I recently took a break on my Pacific Crest Trail hike to spend a full forty-five minutes sketching a stump.

Keeping a journal is a way for me to learn more about myself, just as it is to learn more about the place I am in. I like to dedicate at least a page for writing interesting facts about the place: a list of bullet points about the town/country I'm in, stuff I learn on the road or read about while I'm there. Travel

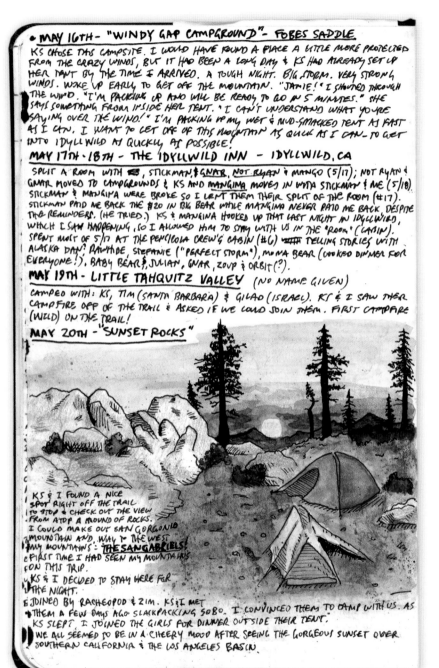

• MAY 16TH - "WINDY GAP CAMPGROUND" - FOBES SADDLE.

KS CHOSE THIS CAMPSITE. I WOULD HAVE FOUND A PLACE A LITTLE MORE PROTECTED FROM THE CRAZY WINDS, BUT IT HAD BEEN A LONG DAY & KS HAD ALREADY SET UP HER TENT BY THE TIME I ARRIVED. A TOUGH NIGHT. BIG STORM. VERY STRONG WINDS. WOKE UP EARLY TO GET OFF THE MOUNTAIN. "JAMIE!" I SHOUTED THROUGH THE WIND. "I'M PACKING UP AND WILL BE READY TO GO IN 5 MINUTES." SHE SAYS SOMETHING FROM INSIDE HER TENT. "I CAN'T UNDERSTAND WHAT YOU'RE SAYING OVER THE WIND!" I'M PACKING UP MY WET & MUD-SMACKED TENT AS FAST AS I CAN, I WANT TO GET OFF OF THIS MOUNTAIN AS QUICK AS I CAN - TO GET INTO IDYLLWILD AS QUICKLY AS POSSIBLE!

MAY 17TH · 18TH - THE IDYLLWILD INN - IDYLLWILD, CA

SPLIT A ROOM WITH [?], STICKMAN & GNAT, NOT RYAN & MANGO (5/17); NOT RYAN & GNAR MOVED TO CAMPGROUNDS & KS AND MANGINA MOVED IN WITH STICKMAN & ME (5/18). STICKMAN & MANGINA WERE BROKE SO I LENT THEM THEIR SPLIT OF THE ROOM (#17). STICKMAN PAID ME BACK THE $20 IN BIG BEAR WHILE MANGINA NEVER PAID ME BACK, DESPITE THE REMINDERS. (HE TRIED.) KS & MANGINA HOOKED UP THAT LAST NIGHT IN IDYLLWILD, WHICH I SAW HAPPENING, SO I ALLOWED HIM TO STAY WITH US IN THE "ROOM" (CABIN). SPENT MOST OF 5/17 AT THE PENSACOLA CREW'S CABIN (#6) TELLING STORIES WITH ALASKA DAN! RAWHIDE, STEFANIE ("PERFECT STORM"), MONA BEAR (COOKED DINNER FOR EVERYONE!), BABY BEAR, JULIAN, GNAR, ZOUP & ORBIT (?).

MAY 19TH - LITTLE TAHQUITZ VALLEY (NO NAME GIVEN)

CAMPED WITH: KS, TIM (SANTA BARBARA) & GILAD (ISRAEL). KS & I SAW THEIR CAMPFIRE OFF OF THE TRAIL & ASKED IF WE COULD JOIN THEM. FIRST CAMPFIRE (WILD) ON THE TRAIL!

MAY 20TH - "SUNSET ROCKS"

KS & I FOUND A NICE SPOT RIGHT OFF THE TRAIL TO STOP & CHECK OUT THE VIEW FROM ATOP A MOUND OF ROCKS. I COULD MAKE OUT SAN GORGONIO MOUNTAIN AND, WAY TO THE WEST, MY MOUNTAINS: THE SAN GABRIELS! FIRST TIME I HAD SEEN MY MOUNTAINS FOR THIS TRIP. KS & I DECIDED TO STAY HERE FOR THE NIGHT. JOINED BY RACHEOPOD & ZIM. KS & I MET THEM A FEW DAYS AGO SLACKPACKING SOBO. I CONVINCED THEM TO CAMP WITH US. AS KS SLEPT, I JOINED THE GIRLS FOR DINNER OUTSIDE THEIR TENT. WE ALL SEEMED TO BE IN A CHEERY MOOD AFTER SEEING THE GORGEOUS SUNSET OVER SOUTHERN CALIFORNIA & THE LOS ANGELES BASIN.

journaling promotes learning and appreciation. One of my favorite ways to learn about my surrounds is to sketch them. I have spent hours sketching a room from the light fixtures to the candles on a table. If I close my eyes, I can still see a room I sketched in a small farmhouse in Romania in 2001.

I record my journeys in different media: photography, writing and sketching. If I stumble upon something visually interesting, I'll capture it in one of these ways, depending on how much time I have. Photography is the quickest way to capture it and sometimes I'll leave room in my journal to sketch the photo I took. If I'm inspired, I'll stop what I'm doing and sit down to sketch and write about it. It's moments like these that end up defining the journey. The sketches become lodestones that connect to the memories surrounding the moment. My journal is an extension of who I am as an artist, a writer and a traveler. The journal is capturing a moment of my life to be reviewed by family (and myself) later in history. I keep a travel journal for myself. I keep a travel journal for my unborn children. However, I do not intend for a travel journal to be anything more than what it is when I bring it home: a book of captured fleeting memories.

I learned a long time ago that a journey cannot be captured entirely, by any means. It's impossible. We're lucky to be able to capture in our heads just a small drop of the waterfall of events that happen to us every day. Just as we choose where to point the camera, we always pick and choose what we write down or draw in our journals.

When I put my pen to paper and try capturing some of the experiences, am I writing down enough? Will I be able to look through my journals years from now and read between the lines, to fill in the picture with details that weren't recorded? I worry about this quite a bit. When I look through my old journals, some experiences I wrote/sketched still feel fresh in my mind while others have gone into a foggy realm of memory. I think a lot about memory, as well. Whether I have a good memory or not. How can one know if one has a good or bad memory? You remember what you remember. How many times have we said, "I had forgotten all about that!" We usually say it just after a memory returned to us. A door in our mind had closed but then a key was presented. If we forget the key, do we forget the door even existed? Journals are these keys that open doors to long-forgotten memories. The more I write in my journal, the more keys I'm creating. I just hope that in the distant future, I'll remember which doors they open.

I wonder, does the act of keeping a journal inspire one to make his life more interesting? Does an interesting life lead to a journal, or does a journal lead to an interesting life? I find that I'm more conscious of living in the moment

with my journals—knowing that the books are precious to me and hopefully outlive me—more so than any other art I make. I sometimes wonder if my journals will outlast my digital footprint. A book seems much harder to destroy than art created in Photoshop or a video. We're getting closer to having a "cloud" of information that we can pull down at anytime from anywhere, but that makes a physical book all the more special to me. It's one of a kind.

I started keeping a travel journal as a way to share my journey with others. The fresh pages are open to anything, which sometimes can be intimidating, like meeting a stranger that you know you're going to spend time with. I struggle with this "phobia of blank pages" as well. Just like a new relationship with a person, some people feel they need to prove themselves worthy to the other. Those first pages of words and sketches are the hardest for me, but I soon realize, just as it is with a human relationship, it's best to just be myself, to let my honesty come through in the words and sketches.

My journals are like a message in a bottle: I hope someone ends up reading them to understand more about me. Honestly my journal writing is horrible, and I'm rarely happy with my art, but the act of doing it helps open myself to the world around me. When I share my work online, I share a page spread like it is a work of art. Sometimes I forget to study

the writing on the page and consider whether it is too personal to share. In some ways, I look at the page as a whole and forget that those printed letters actually are sharing my inner thoughts.

One of the first things I do before starting the new journal is to take a permanent marker and label the book along its fore edge. If I know I'll be filling more than one book on the journey, I'll write "BOOK #X" on the side as well.

I start each new day of the journey on a new page. I'll write the date, the day of the journey and where I am at the top of the page as a title. If I'm on a multiday hiking journey, I'll make up a name for the campsite, if it doesn't already have one. Sometimes I'll take out my GPS and write down the coordinates. As I write in my journal throughout the day, each entry usually starts with the time. I'd say that, on average, I write in my journal more than twenty times a day. Adding a time stamp to start lets me (and future readers) know how much time has passed between entries. This can be helpful when I share my journey with those who want to follow my path. They will be able to figure out how long a train journey takes from one town to another or how long it took me to hike a certain trail.

In the back of the book, I'll use a straight edge to make a spreadsheet. For international trips, these pages would keep track of which cities I visited and when. On a hike, these pages would be

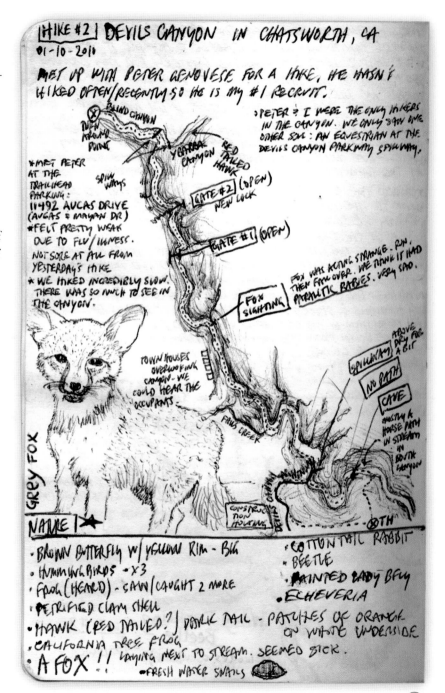

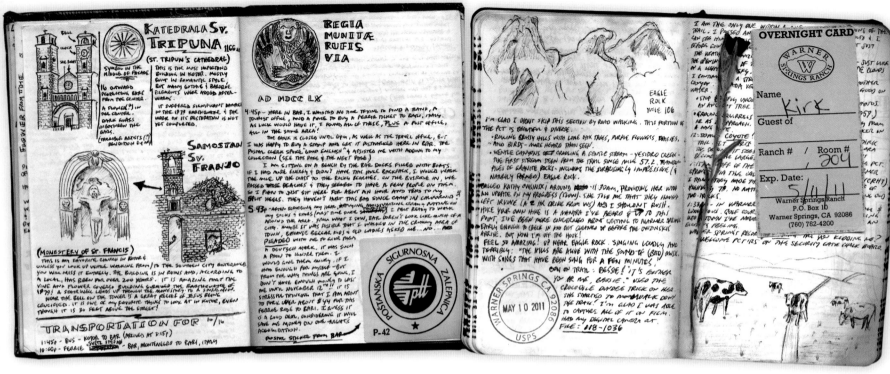

for mileage reports, names of campsites and where they were, and what other hikers joined me at the campsite. I tend to review these back pages more than any other in my journals.

I used to believe that once I got home, the journal was done, that nothing could be added or corrected. It became a time capsule not to be modified. However, I've wanted to record more and more with every journey I take, and not necessarily while *on* that journey. It is easy to fall out of the habit of keeping a journal, and rightly so—I want to *experience* the journey, not just write and sketch it. So I'll spend time after a trip filling in the blanks or adding more details. Just as I would in a published book, I call these added notes and sketches "appendices."

I find it very important to review and recollect a journey after arriving home. Discovering what I've learned requires time for reflection. I'll spend hours at a coffee shop after a journey, reading my journals and writing more details in an appendix, which is usually a separate journal. I try to finish the appendix as soon as I can—within a month or so of my return. I'll never take a pen or pencil to an older journal. If I find something was written incorrectly or inaccurately, I'll write the addendum on a sticky note, date it and add it to the journal over the entry.

My journals are like jazz music: open to experimentation and inspiration. I suppose that's why I don't have rules for my journals but rather just guidelines. I don't want to limit myself in how I capture my journeys. Experimentation in journal keeping has lead me to new ways of keeping them.

My travel "kit" hasn't changed much in the past decade. I carry a pocket-size journal and a ballpoint pen. They are always on me, usually in my breast pocket, within easy reach. I am very specific with the type of pen I use. It has to be black ink and a ballpoint tip. If I find one I like, I'll buy it in bulk and carry a couple with me on a journey, just in case one runs out of ink or is lost.

I've started using black ink Pigma Micron pens (.005 mm to 1 mm), which are quickly becoming my new favorite pens. I've also started adding a bit of color to my journals by using Prismacolor colored pencils, applying the color using a Pentel Aquash Waterbrush. I prefer the hardcover Moleskine Classic Pocket Plain Notebook. It is the perfect size, and the hardcover is durable, yet pliable.

The first pages of my first travel journal are addresses to Parisian Internet cafes, translated titles of U.S. films and notes/messages left at the U.S. Embassy in Paris (my first day in Europe was September 11, 2001). I now reserve a few pages in the back of the book for

addresses/phone numbers that I need, as well as a place for others I meet to share their contact information. I love having people write in my journal. In fact, I insist that they write their name and information in their own hand.

I love collecting "flat items," what I call ephemera. Anything that can fit on the page: stamps, postmarks, stickers, receipts, business cards, mailing labels, postcards, notes, interesting leaves, dead insects. Nothing found on a journey is tossed or left behind before it's considered for my journal. I rarely glue these things down, though. They either sit within the pages, or I use a small roll of fabric first aid tape to secure the items on the page.

I love books. I collect old travel guidebooks from the golden age of travel and have over one hundred books from 1880 to 1950. But my books aren't clean and fresh—they have been heavily used by me, the traveler. I love seeing a book that has been heavily used with marginalia and ephemera within its pages, those glimpses into the person's life and travels. Even the stains of dirt or sweat are clues to their journey.

As long as the ink doesn't smear into an illegible mess, I don't care if the book gets a little wet, either. If I came home from a journey with a clean book, it wouldn't represent the journey. I just finished hiking about 1,700 miles of the Pacific Crest Trail in California through some of the most difficult terrain and weather I've ever experienced while hiking—and the four journals I filled certainly reflect that. On the journey, they get banged up and thrown around no more or less than any other book one would carry on a backpacking trip, like a kid and his raggedy stuffed animal. The worth of the journal grows with every filled page as I approach the back cover. At home, I keep the journals easily accessible for two reasons. First, I review them quite often. I like to mine them for information to share with friends who might be planning a trip of their own. Secondly, I want to have them in a box to grab if my home finds itself on fire. The box of journals is the first thing I'd grab on my way out.

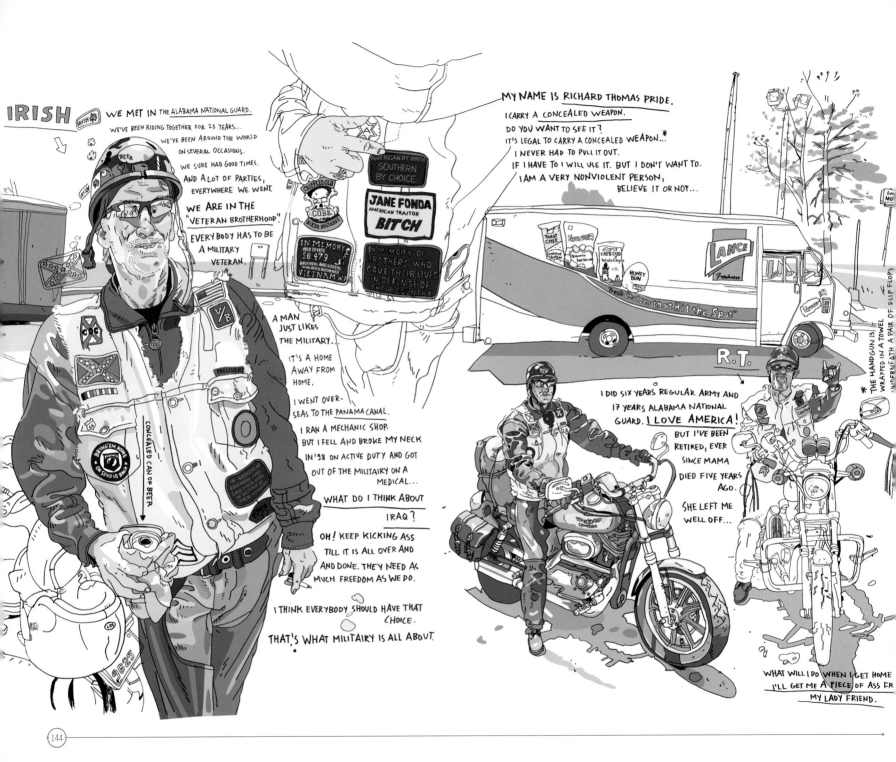

IRISH

WE MET IN THE ALABAMA NATIONAL GUARD.

WE'VE BEEN RIDING TOGETHER FOR 25 YEARS...

WE'VE BEEN AROUND THE WORLD ON SEVERAL OCCASIONS.

WE SURE HAD GOOD TIMES.

AND A LOT OF PARTIES, EVERYWHERE WE WENT.

WE ARE IN THE "VETERAN BROTHERHOOD".

EVERYBODY HAS TO BE A MILITARY VETERAN.

A MAN JUST LIKES THE MILITARY.

IT'S A HOME AWAY FROM HOME.

I WENT OVERSEAS TO THE PANAMA CANAL.

I RAN A MECHANIC SHOP. BUT I FELL AND BROKE MY NECK IN '98 ON ACTIVE DUTY AND GOT OUT OF THE MILITARY ON A MEDICAL...

WHAT DO I THINK ABOUT IRAQ?

OH! KEEP KICKING ASS TILL IT IS ALL OVER AND AND DONE. THEY NEED AS MUCH FREEDOM AS WE DO.

I THINK EVERYBODY SHOULD HAVE THAT CHOICE.

THAT'S WHAT MILITAIRY IS ALL ABOUT.

CONCEALED CAN OF BEER

AMERICAN BY BIRTH
SOUTHERN BY CHOICE

JANE FONDA
AMERICAN TRAITOR
BITCH

IN MEMORY
1959 TO 1975
58,479
BROTHERS AND SISTERS
WHO NEVER RETURNED
VIETNAM WAR

IN MEMORY OF BROTHERS WHO GAVE THEIR LIVES IN DEFENSE OF THEIR COUNTRY

MY NAME IS RICHARD THOMAS PRIDE.

I CARRY A CONCEALED WEAPON.

DO YOU WANT TO SEE IT?

IT'S LEGAL TO CARRY A CONCEALED WEAPON... *

I NEVER HAD TO PULL IT OUT.

IF I HAVE TO I WILL USE IT. BUT I DON'T WANT TO.

I AM A VERY NONVIOLENT PERSON, BELIEVE IT OR NOT...

LANCE
Freshness

TOAST CHEE

Thunder

Boomin barbecue

CAPE COD Potato Chips

HONEY BUN

Fresh Choices that Hit the Spot

R.T.

I DID SIX YEARS REGULAR ARMY AND 17 YEARS ALABAMA NATIONAL GUARD. I LOVE AMERICA!

BUT I'VE BEEN RETIRED, EVER SINCE MAMA DIED FIVE YEARS AGO.

SHE LEFT ME WELL OFF...

* THE HANDGUN IS WRAPPED IN A TOWEL UNDERNEATH A PAIR OF FLIP FLOPS.

WHAT WILL I DO WHEN I GET HOME I'LL GET ME A PIECE OF ASS FR MY LADY FRIEND.

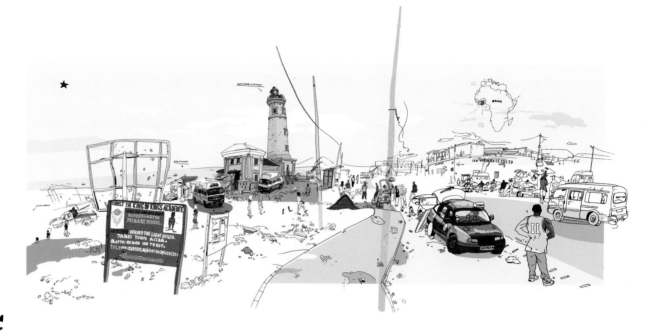

Olivier Kugler

Olivier Kugler was born in Stuttgart, Germany. After military service in the navy, Olivier studied graphic design in Pforzheim and worked as a designer in Karlsruhe for a few years, then got a master's degree in illustration at the School of Visual Arts in New York. He now works in London as an illustrator for clients all over the world. www.olivierkugler.com

I grew up in Simmozheim, Germany, a village in the Black Forest. I live in London now and I am an illustrator doing mainly illustrated reportage and travel drawings.

I fell in love with Tintin when I was about seven or eight. Hergé's work is probably the reason I became an illustrator. My first and possibly most important teacher was my father. He told me the basics and convinced me to draw from life, to draw what is around me. "If you want to learn how to draw, stop copying comic book artists' work!" One of my best birthday presents ever was going to a life-drawing class with my father. I was about sixteen.

After my military service in the navy, I enrolled at the Fachhochschule Fur Gestaltung in Pforzheim in Germany. Even though I studied graphic design, I spent most of my time there in the drawing class. During this course, I spent half a year at the University of Georgia in Athens, Georgia, where my teacher Alex Murawski encouraged me to draw on location and introduced me to the sketchbooks of Alan E. Cober. For my diploma I stayed four months in the city of Hamburg's notorious harbor and red light district where I drew on location day and night.

After I graduated from Pforzheim, I worked as a graphic designer for two and a half years as I couldn't get any illustration work (wasn't good enough, I guess). Also there was no market in Germany for the kind of work I wanted to do so I was a bit frustrated and hardly drew after graduating, until a friend of mine who started to do a master's degree in visual communication at the School of Visual Arts in New York told me about the school's "illustration as visual essay" program led by Marshall Arisman and the school's approach to drawing on location. I started to draw again, and a year later I received a scholarship from the German academic exchange service. The next two years I spent drawing on location all over New York.

While pursuing my master's degree, I spent several days drawing in a barbershop in Spanish Harlem. The barbershop looked quite a cozy/quirky location. I walked past it one day and it looked like a place I would love to draw and document. So I asked the barber, an elderly Italian immigrant, if he would mind me drawing in his shop. It was just a couple of days after the 9/11 attacks, and I soon found out, whilst drawing in the shop, that the barber knew some of the firefighters who were killed in the World Trade Center.

Two years ago I went traveling in Iran. In Tehran I met Massih, a truck driver, who invited me to join him on a four-day journey carrying bottled water down to

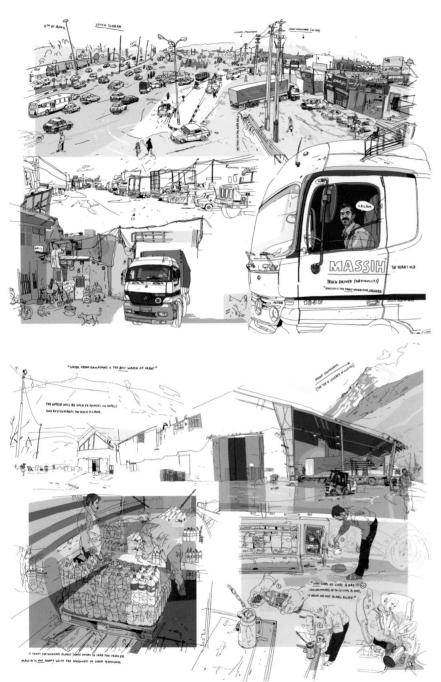

the south of the country, to Kish, a small island in the Persian Gulf. The French magazine *xxi-vingt et un* published my thirty-page illustrated account of the journey, "A Tea in Iran." I enjoyed this trip a lot because it allowed me to get insight into the everyday life of a stranger, and not only a stranger, but a person from a totally different cultural background that I didn't know a lot about. I think doing this trip was quite an educational experience, as it gave me an insight into the daily life of a person I would have under normal circumstances never spent much time with.

I try to do one large trip every year/two years. Several smaller trips in between. I hardly draw whilst I am traveling anymore. I take photos that I use as reference when I am back in my studio. When I am traveling I don't want to spend a lot of time sitting on my bum or standing around sketching—I want to get out there. Explore! And see as much as I can. When I am back in the studio I draw from my reference photos. I love this process. When I draw at my desk, looking at my photos takes me back to the places I visited and the people I met.

It is a quite personal process, as I re-experience the people I met and the places I visited. I guess I put more love and passion into my personal projects than work projects, which doesn't mean that I am not working hard on my illustration commissions, just that I run the extra mile for my reportage drawings.

My drawings are done with an HB pencil. Faber-Castell usually, they are the best. When I draw I press quite hard on the pencil, and you can see the embossed drawing (a ghost drawing) on the next three sheets of my sketchpad. The Faber-Castell pencils are the only ones that don't break when I draw. The sketchpad (a2) lies in front of the monitor and I just draw what I see on the photos. The drawings are quite large (around four times the size they are getting printed in the end). Drawing on such a large scale gives me the chance to include a lot of details. I guess this is the reason my drawings are so large. I love to draw all these details! When the drawing is finished I scan it in and import the digital version of the drawing into Freehand, the program I use for the layout and the coloring of my pages. The colors are done with vectors. I like working in this process as it allows me a lot of flexibility when it comes to exploring different color versions and in laying out my pages.

When I was pursuing my master's in illustration at the School of Visual Arts in New York, I hardly ever used color in my drawings. All of the drawings were done in pencil. They were line drawings. At the end of my first semester, my professor told me that if I wanted to make a living as an illustrator that I should find a way to add color to my drawings. Before joining the program at SVA, I worked for about three years as a graphic designer in a small design agency. All the work

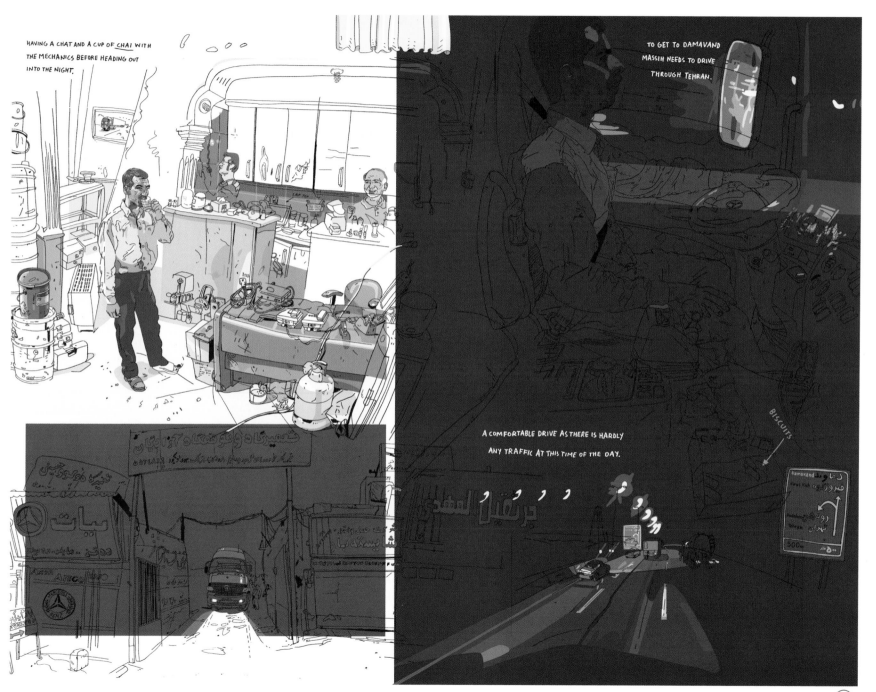

HAVING A CHAT AND A CUP OF CHAI WITH
THE MECHANICS BEFORE HEADING OUT
INTO THE NIGHT.

TO GET TO DAMAVAND
MASSIH NEEDS TO DRIVE
THROUGH TEHRAN.

A COMFORTABLE DRIVE AS THERE IS HARDLY
ANY TRAFFIC AT THIS TIME OF THE DAY.

BISCUITS

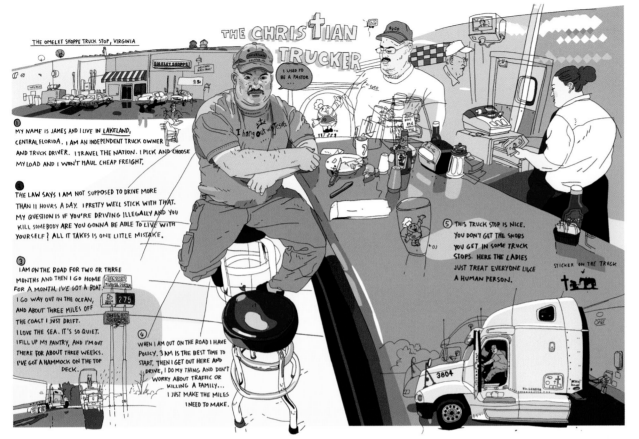

THE CHRISTIAN TRUCKER

I USED TO BE A PASTOR.

① MY NAME IS JAMES AND I LIVE IN LAKELAND, CENTRAL FLORIDA. I AM AN INDEPENDENT TRUCK OWNER AND TRUCK DRIVER. I TRAVEL THE NATION. I PICK AND CHOOSE MY LOAD AND I WON'T HAUL CHEAP FREIGHT.

② THE LAW SAYS I AM NOT SUPPOSED TO DRIVE MORE THAN 11 HOURS A DAY. I PRETTY WELL STICK WITH THAT. MY QUESTION IS IF YOU'RE DRIVING ILLEGALLY AND YOU KILL SOMEBODY ARE YOU GONNA BE ABLE TO LIVE WITH YOURSELF? ALL IT TAKES IS ONE LITTLE MISTAKE.

③ I AM ON THE ROAD FOR TWO OR THREE MONTHS AND THEN I GO HOME FOR A MONTH. I'VE GOT A BOAT. I GO WAY OUT IN THE OCEAN, AND ABOUT THREE MILES OFF THE COAST I JUST DRIFT. I LOVE THE SEA. IT'S SO QUIET. I FILL UP MY PANTRY, AND I'M OUT THERE FOR ABOUT THREE WEEKS. I'VE GOT A HAMMOCK ON THE TOP DECK.

④ WHEN I AM OUT ON THE ROAD I HAVE POLICY. 3 AM IS THE BEST TIME TO START. THEN I GET OUT HERE AND DRIVE, I DO MY THING AND DON'T WORRY ABOUT TRAFFIC OR KILLING A FAMILY... I JUST MAKE THE MILES I NEED TO MAKE.

⑤ THIS TRUCK STOP IS NICE. YOU DON'T GET THE SNOBS YOU GET IN SOME TRUCK STOPS. HERE THE LADIES JUST TREAT EVERYONE LIKE A HUMAN PERSON.

STICKER ON THE TRUCK

3804

HALF THE WORLD IN ABOUT 80 hours

Africa

THE NAME OF THE CANOE IS "NYAME AFENI" IT BELONGS TO MY BROTHER.

WE ARE 10 TO 12 PEOPLE IN THE CANOE. WE SLEEP ON THE SEATS.

N. YAME

JOHN ATEIKU

★ ABOUT FIVE YEARS AGO WE CAUGHT A LOT OF FISH. THE FISH WAS JUST AROUND HERE. NOW FISHING WORK IS VERY DIFFICULT FOR US.

WE ARE GOING TO ABIDJAN WITH THIS CANOE.

THE FUEL FOR THE MOTORS IS VERY, VERY EXPENSIVE NOWADAYS. THE PRICE IS TOO HIGH!

IF YOU GO TO SEA AND COME DOWN, THE FUEL YOU'LL USE AND THE FISH YOU'LL BRING... IF YOU DIDN'T TAKE CARE YOU CAN ALWAYS LOOSE. EVEN IF YOU BRING DOWN SMALL IT WILL NEVER REACH THE FUEL PRICE.

we did was done in Freehand, and I was fluent in this program. So it came to me quite naturally to scan in my drawings and color them using Freehand. I was very happy with the results and haven't really used any other technique to color my drawings.

At the moment, I am at a point where I think my drawings might be a little bit too detailed. It takes me a lot of time to do them. I would like to find a faster approach. So I think to go back and draw on location again would be a challenging and interesting development for me. My drawings would be more raw, less polished, and they would look more immediate. Also, I could hopefully work much faster. I think it would be very interesting for me to go back a step and draw the way I used to draw when I learned how to draw. I'd like to see how it works out.

My advice: Work hard! Draw every day. Invest as much time into your art as you can afford to, especially if you are a beginner and you want to make a living as an artist or an illustrator. You need to be very good if you want to compete with the big beasts. Don't only do short sketches! It is very important that you also work on longer studies/larger, more detailed drawings that require you to look exactly at the subject you are drawing. Have fun!

16.04.06
TÓRSHAVN, FAROE ISLANDS

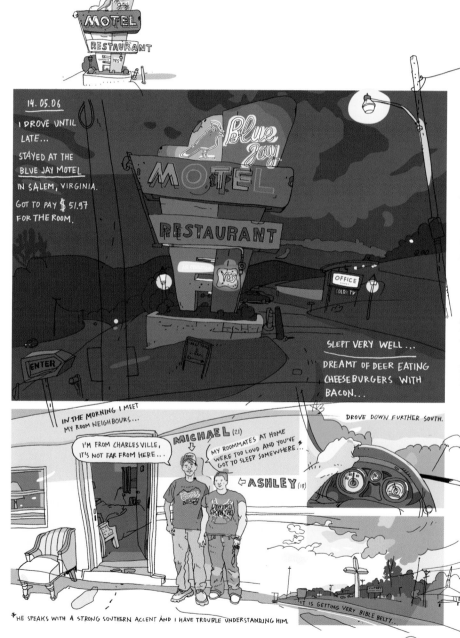

14.05.06

I DROVE UNTIL LATE...

STAYED AT THE BLUE JAY MOTEL IN SALEM, VIRGINIA.

GOT TO PAY $ 51.97 FOR THE ROOM.

SLEPT VERY WELL...

DREAMT OF DEER EATING CHEESEBURGERS WITH BACON...

IN THE MORNING I MEET MY ROOM NEIGHBOURS...

DROVE DOWN FURTHER SOUTH.

I'M FROM CHARLESVILLE, IT'S NOT FAR FROM HERE...

MICHAEL (21)

MY ROOMMATES AT HOME WERE TOO LOUD AND YOU'VE GOT TO SLEEP SOMEWHERE... *

ASHLEY (18)

*HE SPEAKS WITH A STRONG SOUTHERN ACCENT AND I HAVE TROUBLE UNDERSTANDING HIM.

IT IS GETTING VERY BIBLE BELTY...

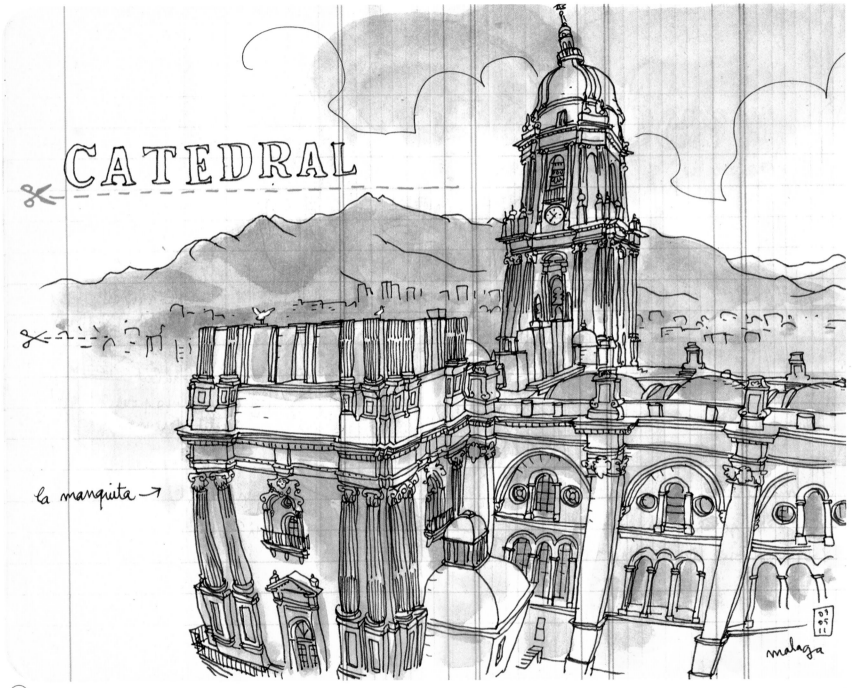

CATEDRAL

la manquita →

09 05 11

malaga

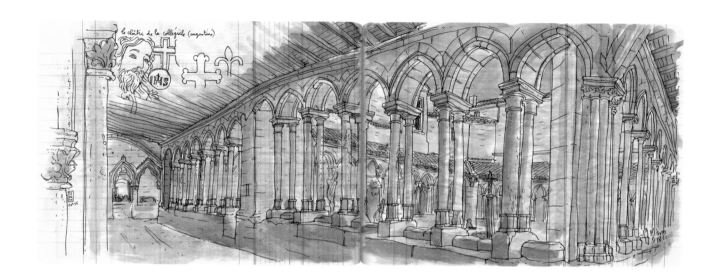

Lapin

Lapin is a French artist working for fashion, advertising and editorial who lives between Barcelona and Paris. He published several of his sketchbooks as "lapin à istanbul," "te quiero bcn" or "expediciones de lapin."
www.lesillustrationsdelapin.com; www.les-calepins-de-lapin.blogspot.com

I grew up in Bretagne near Saint-Malo. I started drawing in my very first sketchbook when I was around four years old. It was a small notebook with penguins on the cover. All of the pages were fully doodled with planes, houses, people, even a "man-house," sketched with only a ballpoint.

Then, as far as I remember, I've always made drawings and caricatures of my teachers in my school notebooks. I sketched some horses to please the girls, some logos for T-shirts, airplanes and comics as well.

Later on, I studied in an old-fashioned, disciplined art school, an academy where I learned all the traditional techniques (perspective, anatomy, hyperrealism paintings). It was where I developed my addiction for sketching. I still remember some good advice I got from my teachers like: "You must practice every day, even if it's a doodle a day." "Be curious about everything and sketch from nature." "Don't sketch a portrait without a neck."

Sketching is a way of living in every sense for me—after three days without sketching, I am in a very bad mood. My wife, Lapinette, can tell.

I sketch in real time and I record every second of that actual moment. Then I turn around and I have all my memories of a city, of my newborn child, of my grandmother, of a feeling, of that big delicious plate I had in such good a company, of the building that fascinated me. All are kept as I remembered during that actual moment.

I decided to work as a freelance illustrator four years ago, and I never regret it. I travel as often as I can, at least once a month, for the inspiration I need for sketching. I just published a book of illustrations called *La Sagrada Familia* by

Treseditores. I created a series of travel books (the last destinations are Carcassonne and Istanbul). I collaborate with a traditional Catalan sketchbook brand, Miquelrius, to produce travel books with covers I design, and I am working on a travel bag collection.

Since the age of twenty, I have never traveled without sketching. For my very first travel sketchbooks, I went alone to Egypt, Mexico and Vietnam. During those travels, I realized that I need nothing more than a sketchbook, watercolor, ink pen and a bottle of water in order to survive. Most of the time, my

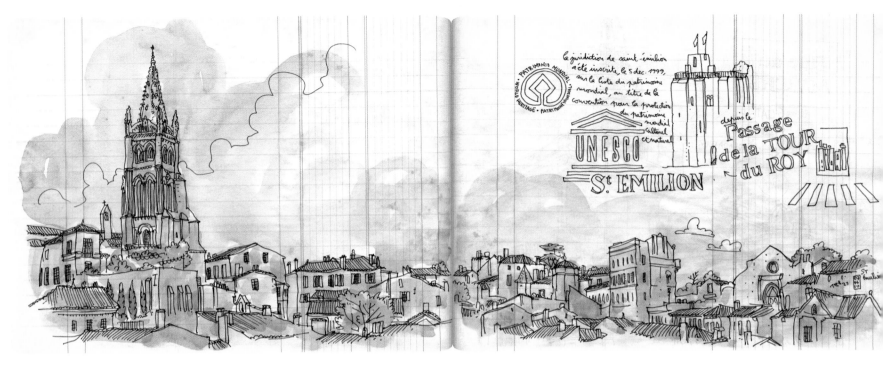

sketchbook organizes my schedule and provokes some unexpected meetings.

Sketching also creates an easy connection with the people around me. While I sit on the floor sketching, people talk to me, and when I propose to draw their portrait, they tell me so many things about their lives, sometimes very personal stuff. I like to write down some of what they have shared with me.

I don't like drawing from a photograph. I like to actually see the object, place or the product that I'm sketching. That way, I can draw the way it makes me feel. For example, I illustrated a book on Ramatuelle, Saint-Émilion and Carcassonne, three historical cities in France, and I developed a new concept for my clients: capturing my vision while spending ten to fifteen days in immersion in a place. So, in a way my travel journals also become my professional projects!

My pages are usually designed to include some typography picked up from a logotype, from some packaging or from a flyer. I make the subject fit into the page, even if I have to make some distortion, but I strive to be honest and to sketch my personal feeling without invention—just from watching and interpreting it, despite any imperfection.

Vintage cars are a recurrent subject for me, and I sketch them sitting on the floor less than a meter away. On the other hand, a portrait has to be made quickly, in less than fifteen minutes, otherwise the person start to feel uncomfortable or to get bored.

I have small sketchbooks for the subway, meals and notes, and I keep one A5 for more elaborated drawings. I have a sketchbook for my daughter, one for my nephew and others for testing different media. I have a big one for models drawings.

The last pages of my sketchbooks are full of random information: e-mails, phone numbers, addresses, exhibitions, titles of books. I do not glue tickets or labels anymore, as I did in my first sketchbooks. I prefer to redraw them.

I don't have any assignments or specific rules when I start sketching—my assignments are the day I face. When I travel for my travel books, I walk around the city, go to a local bar, observe local people and learn more about the city before I start drawing it. After that, I go with the flow. For example, during my last trip to Venice, I was planning to focus on palaces and emblematic perspective of canals for my last day, when my host invited me to sail on a Venetian boat called a *sandolo*. I couldn't refuse and spent hours on the lagoon, enjoying this atypical view of the city.

I always carry my favorite materials

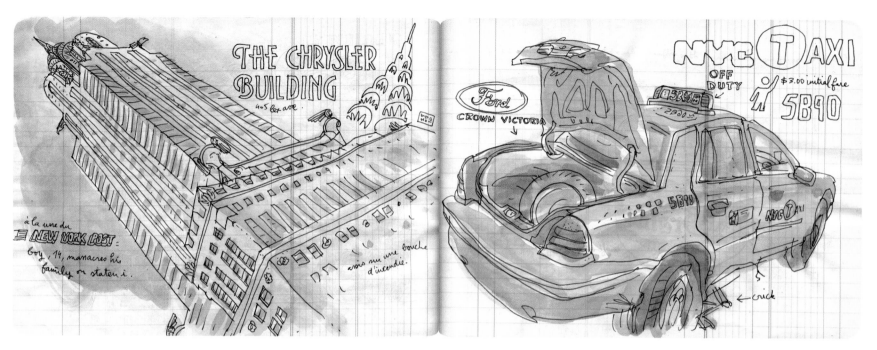

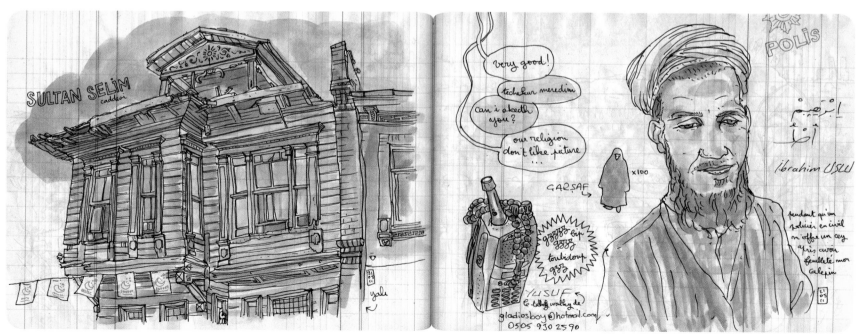

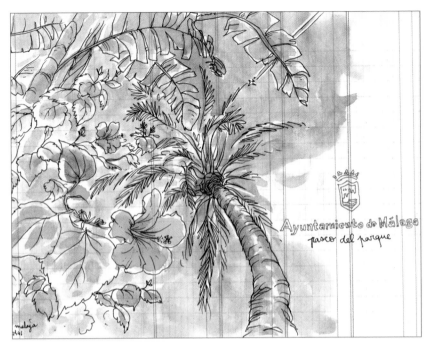

Ayuntamiento de Málaga
paseo del parque

malaga
LAPI

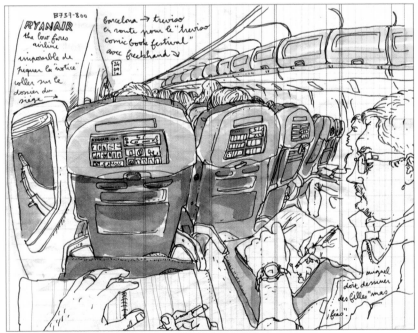

B737-800
RYANAIR
the low fares
airline
impossible de
figurer la "notice"
coller sur le
dossier du
siège

barcelona → treviso
en route pour le "treviso
Comic book festival"
avec freakhand →

24
09

miguel
doit dessiner
des filles "mas
feas"

in my pocket: my pens, water brushes and watercolors, all together in a vintage Texas Instrument case, and I will not exchange it for any other one. It's the perfect size. With a snap hook, I attach it to my coat or my belt. So I have all my stuff ready to use and easy to access.

The two hair clips that I stole from Lapinette are very useful to keep my sketchbook open when it's windy. The pen is my principal tool. I start all my sketches with lines, and the Uni PIN fine line 0.1 mm suits my taste. It's waterproof and the black ink is very dark; I love it. I also carry two color pens: Edding 1800 0.1 mm to copy logotypes or typography and a gray Copic Multiliner.

I have a special travel box, made by Daler-Rowney, England, with eighteen fine arts quarter pans. I fill the brush compartment with transparent red, a very cool green and gold watercolor. My favorites are the Yellow Ocher, the Alizarin Crimson and the Russian Blue. I sketch figures only with those three colors. I've used a Pentel water brush only for a short time, but I'm already addicted to it. I always carry two of them filled with water, to get enough autonomy for the day, and a third one full of Yellow Ochre liquid watercolor so I have a bright and luminous yellow to work with (most of the watercolor yellow pans are opaque).

I also use a few secret weapons: a child's big multicolor pen and eight wax pencils to augment my watercolors.

And when I can't sketch with my usual technique (when it's dark, or when the model has too much contrast), I paint with a black Japanese brush (from Muji).

I like sketching in secondhand account books from the 1940s to the 1970s. I find them in flea markets. I really like the texture and the lines that carry my memories to a different level. I'm still amazed by the quality of the vintage paper. Each time I show one of those sketchbooks to some other sketchers, they can't believe that a paper that fine can support watercolor on both sides.

I rarely draw on a loose piece of paper. A sketchbook and a compact sketching kit can make you feel like you're in your studio wherever you are. It's easy to carry and is chronological. The sketchbook tells the story that a single page doesn't; I love the accumulation of sketchbooks. All of my sketchbooks are very precious to me, and I can't imagine losing one. It would be like losing a part of my memory. Still, I like them to look used, time worn with a rubber band to keep the cover on. I let people read them during festivals and exhibitions. I keep all my memories together at home: the small ones in a drawer, the others on my shelves. Like we all do.

Lapin

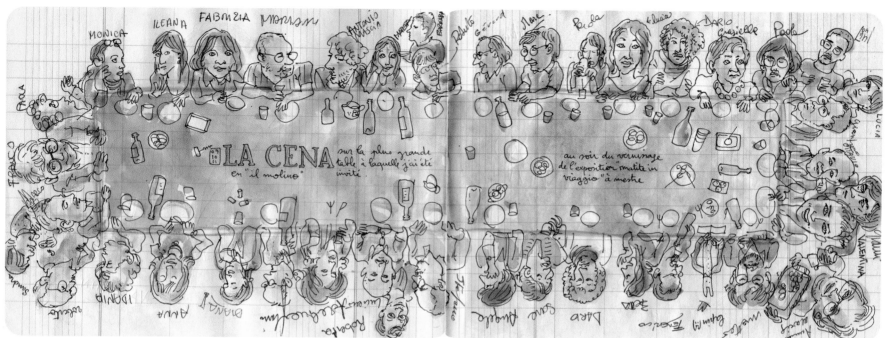

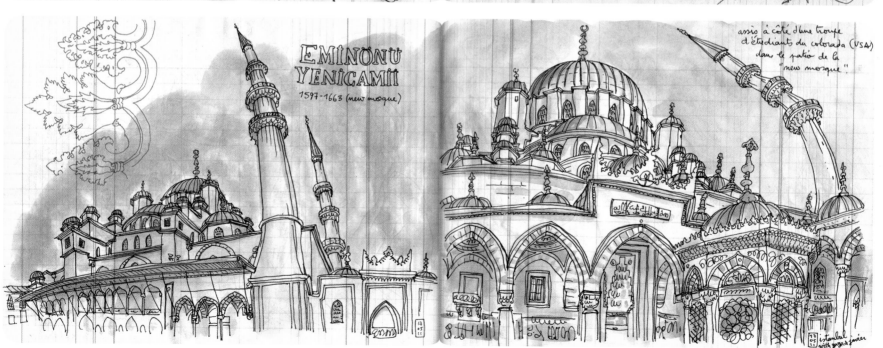

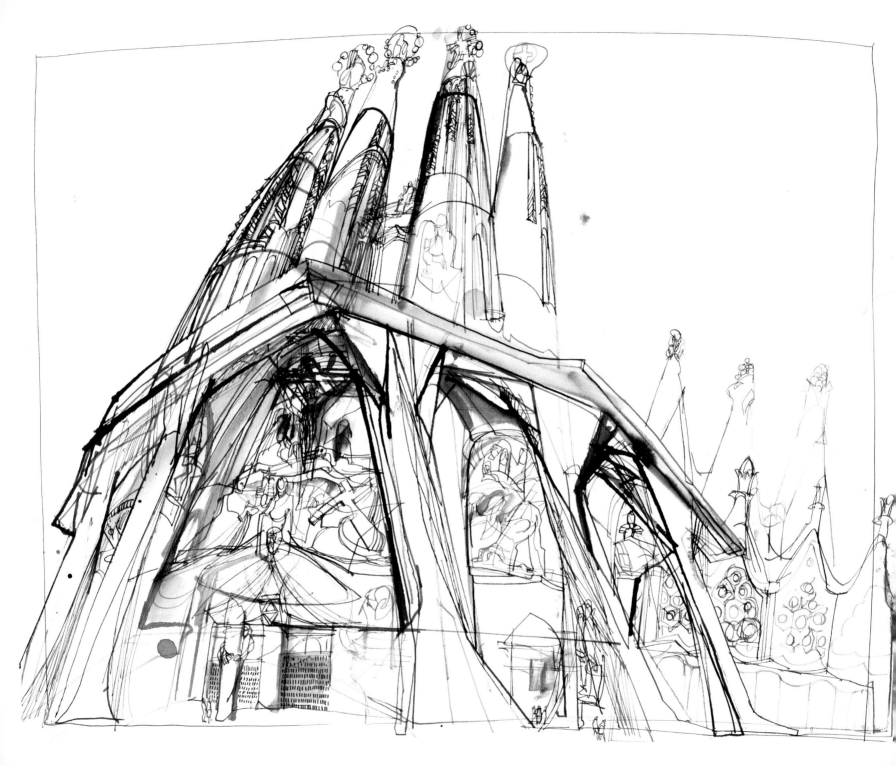

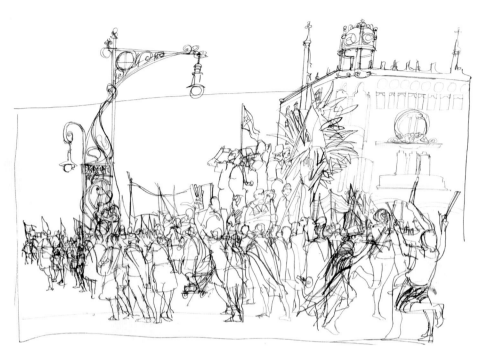

Veronica Lawlor

Veronica Lawlor lives in New York City. She is a freelance illustrator and the president of Studio 1482. She also teaches drawing and illustration at Pratt Institute, Parsons The New School for Design, and Dalvero Academy. She is the author of several books, including *One Drawing A Day: A Six-Week Course Exploring Creativity With Illustration and Mixed Media*.
www.veronicalawlor.com; www.studio1482.com/veronica.

I grew up in New York. I was born on Fifth Avenue in Manhattan and promptly whisked off to a neighborhood in the Bronx called Parkchester, where I lived with my family until the age of nine or ten. I remember the night before we moved, sitting on boxes watching Richard Nixon resign on television. I didn't really know what was happening. I just remember that atrocious seventies yellow color behind his head and that I felt sorry for the sad man on the television. For the next ten years, I lived with my family on Long Island, in a town called

Baldwin. It was a nice suburban town, but I missed the city life. I remember roller-skating in our driveway, missing the nice smooth blacktop of the Bronx. So at the age of twenty-one, I moved back to the city. Brooklyn to be exact, where I stayed for another ten years until I moved to Manhattan.

My mother, my aunt and my grandmother are artists. My mom and aunt draw and paint today, and we all have the fashion drawings my grandmother made in high school in the 1930s. She was good.

I remember drawing at a very early age. I still have two of my earliest drawings: one was an illustration of Sherlock Holmes leaning on a lamppost with the helpful street sign, "London," attached to it. The other is a drawing of my Aunt Marion, who had the most incredible beehive hairdo and always wore these fabulous purple glass earrings that were bunches of grapes. So my passions in life (travel, reportage, people and fashion) showed up early.

I don't remember drawing on vacations with my family until I reached high

school and decided that I was going to become an artist. As a younger child, I did a lot of drawing with my friend Tricia Sheehan. We would take apart the gossip magazines and redraw and rewrite them. We used to imagine the scene at Studio 54 (this was in the 1970s) and draw it for each other. Starstruck, I guess.

I was blessed with some really great art teachers. In high school, I had a teacher named Gordon Heath, who started me on the habit of drawing from life all the time. I went to Parsons The New School for Design on a

partial scholarship (thanks Parsons!) and learned from some wonderful teachers there, like John Gundelfinger and Ivan Powell. But one teacher I met at Parsons had a huge impact on me: David J. Passalacqua. Dave became my mentor and friend and had the greatest influence on my art and career.

He taught me drawing and reportage, and after I graduated from Parsons I went for many years to his private drawing and illustration school in Orlando, Florida. He would take us to Disney World and have us do nothing but draw in the hot sun for twelve hours a day. What a great experience it was! He would sit us down in front of what he called, "the gates of hell," which was the main entrance gate at the Magic Kingdom, and make us draw all the hundreds of people coming in. And Epcot was a great way to draw and experience different cultures without leaving the United States. I still take my students there.

Today, I am a freelance illustrator and have had the good fortune to have had clients who give me illustration and reportage work, which I love doing. And as soon as I'm done with my commissions, I run out to draw what's happening around New York, or I plan art trips to do the same elsewhere.

I also teach drawing and illustration at Pratt Institute, Parsons The New School for Design and Dalvero Academy, my own school which I founded with Margaret Hurst. To be able to make art and

teach art all the time is such a great way to spend my life. I feel truly lucky.

I travel often, usually at least twice a year. It's a big part of my life. I've wanted to travel since I was a young girl. I remember a picture book I had about children who lived in different parts of the world, and I remember deciding back then that I wanted to visit every one of them.

I can't imagine traveling without drawing. You're forced to slow down and really observe a place. What's going on there? How does the place feel? What are the people and customs like? I also find that by drawing a place I can make a connection with the people there, even if I don't speak the language. By sitting and drawing in China, I discovered the emotional quality of the Chinese people that I never would have experienced going through Beijing in a tour bus. I remember one day it started to rain while I was drawing and a young woman held an umbrella over me! Another day, I went to dip my pen in the ink and a little boy reached over and held it up for me. So sweet.

The compulsion to draw will get me out of bed at 4 A.M., bring me out in the middle of a snowstorm, put me in a neighborhood where I am feeling less than comfortable—in other words, put me in situations that without drawing I probably would never find myself in. I've met people through drawing that I would never connect with in my everyday life,

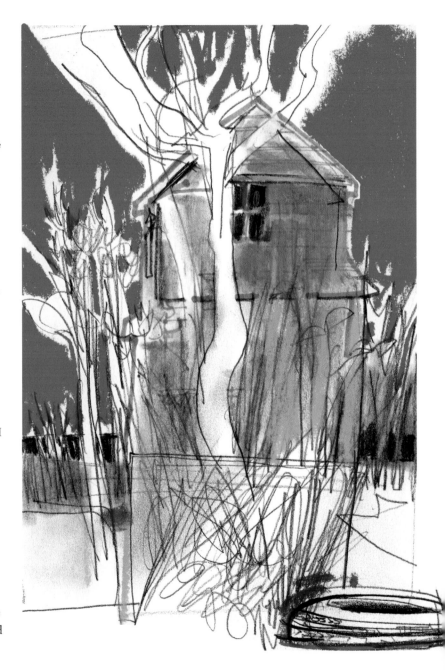

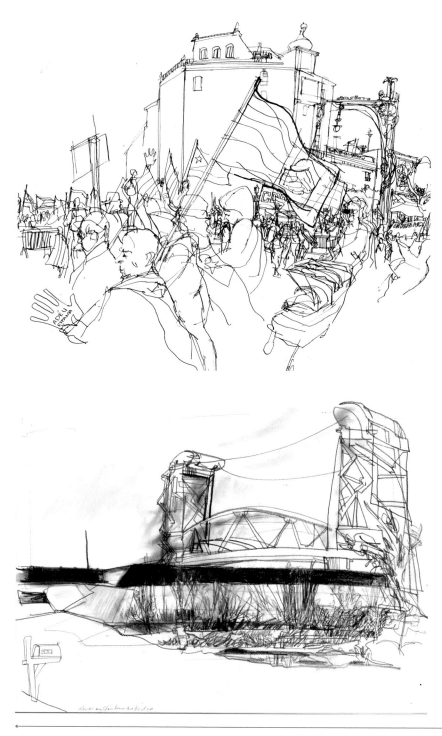

and it's fantastic! Drawing while traveling has brought a lot of adventure to my life.

One of the strangest experiences I've ever had drawing was Semana Santa in Seville, Spain. That's holy week in the Catholic church, and all of the smaller churches around Seville send representative groups of men into the city carrying large sculptures depicting scenes from the Passion. It is very intense. People dress formally—women wear the black mantillas—and line up along the streets to witness the event. (I read that it was only as recent as the 1960s that the city banned self-flagellation by the participants.) On Good Friday, a life-size statue of the skeleton of Jesus in a glass coffin is carried down the street while the Seville police play taps. It's totally silent; you can hear a pin drop. All of the rest of the police force salutes as the glass coffin passes by. Surreal. After the event is over, the streets are covered for days with wax from all the dripping candles. I've never experienced anything even remotely like it.

I usually have quite a lot of interactions with passersby when I'm drawing. A lot of artists don't like that, but I actually love it. I get to meet so many people this way. I've actually made some friends this way. I do sometimes gather groups of people who watch me draw. The most intense experience like that was at the Gate of Heavenly Peace, outside the Forbidden City in Beijing. Many people gathered around me to watch me draw—

and the Chinese people have a very different sense of personal space than I do as an American. They were literally on top of me, leaning on me, touching my stuff. It was a little unnerving. The crowd got so big that the Chinese police came and broke it up! And then, this is the best part, they left a guard standing by me to keep the crowds away. I was initially thinking I might get arrested, but instead I had a personal bodyguard from the Beijing police department!

I like to take an "art holiday" at least once a year, if I can, just to draw, play and experience a new place. When I go on a trip to draw, I revolve the trip around that, and drawing influences my choices of where to visit in any given place. I will sometimes see less of the overall place but more of the parts of it that I do see because I go back to the same places to draw a couple of times during the week. I prefer to explore fewer areas and spend more time in them to rushing through the entire city I'm visiting.

I decide what to draw by doing research of a place before I get there. I knew I wanted to draw the Semana Santa and April Fair in Seville, for example, and I researched what was going to be happening before I arrived. I also often thumbnail a place before I get there, to give myself an idea of what to focus on once I arrive. Of course though, I leave room for things I couldn't possibly know in advance. For example, when I went

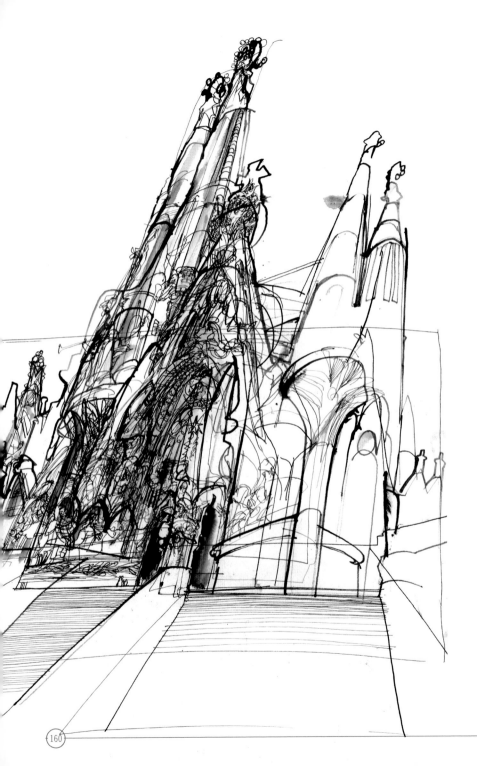

to Barcelona I was dying to draw the Gaudi architecture so I read a biography of him before I went to give myself some understanding. But when I was drawing La Pedrera and a demonstration formed around me, I certainly shifted gears to draw that.

My kit changes and evolves over time. I will typically bring a dip pen, loose black ink, a few brushes, a small pan watercolor set (I like the cheap ones for brilliance), brush pens, a fountain pen, graphite pencils, colored pencils, pastels, a few colored markers and sometimes some oil pastels as well. I will sometimes tailor my materials to a specific place, but usually I just throw all of it into my bag because I never know how a place will feel once I get there. Unless I am going to draw at a place or event where I know I'll have to be mobile, I pack a light stool as well. I also pack a clip to pull my hair back—it gets in the way when I'm drawing.

I used to draw on any kind of paper, but lately I've been doing some work for Canson and I've found that I love their papers. Good paper really does make a difference. Their Pure White Drawing paper and Mixed Media pads are my favorites to work with right now. I usually prefer large pads or will sometimes take a board with a few different kinds of paper clipped to it. I usually keep a small pocket sketchbook with me on my trips for thumbnails and notes, and that pad becomes a real

recording of the trip for me. The little sketchbook has all my thoughts and first impressions of a place, as well as thumbnails and little bits of ephemera from the journey. I write a ton of things down in my sketchbook—especially the little one I carry as my note-taking thumbnail companion. Sometimes I'll tape little ephemera in there, too, things I find interesting. Or I'll put that stuff in a little folder in the back of the little sketchbook.

My travel journals and sketchbooks definitely get banged around—and rained on, snowed on, spilled on. They are well used and well loved. I live in a New York City apartment, so my sketchbooks are kept anywhere they'll fit. Some are on bookcases, some are in boxes in closets, some are stacked on shelves in my studio in Brooklyn and others still are in plastic boxes in a storage space. I have a ton of them stashed everywhere. I opened a closet the other day and one fell on my head.

My advice to people about drawing and keeping a sketchbook is this: Do it every day. Don't judge it or make it precious. Just keep drawing and recording things. The sketchbook is for you.

bench Park Güell

7/9

Construction on Sagrada Familia
1st thoughts - It's got that
drippy wax Catholic feel
that is kind of disconcerting
Picasso vs Gaudi: Bohemian vs Catolico
- Let's see the inside -
outside has a lumpy feel
like it's made of wet sand -
It feels like obsession

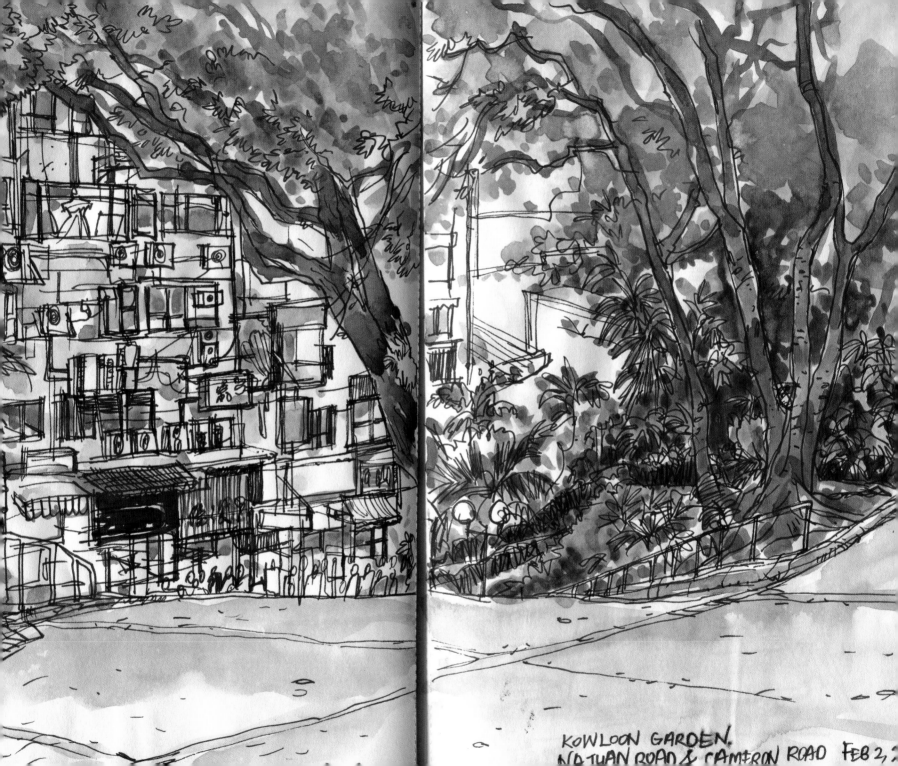

KOWLOON GARDEN.
NATHAN ROAD & CAMERON ROAD FEB 2,

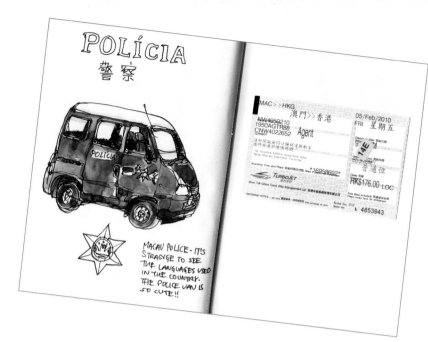

POLÍCIA
警察

MACAU POLICE - IT'S STRANGE TO SEE THE LANGUAGES USED IN THE COUNTRY. THE POLICE VAN IS SO CUTE!!

Don Low

Don Low was born and lives in Singapore. He is a freelance illustrator and designer, teaches part time in two local universities, and is a correspondent for Urban Sketchers. His works are featured in *The Art of Urban Sketching* and *Urban Sketchers Singapore*.

I can't remember how old I was when I fell in love with drawing, but my dad told me he used to keep part of the wall in our apartment white so I could doodle on it as a toddler. As I grew up, I wanted to pursue an art career, but my less than well-to-do family did not appreciate the ambition. Job security and bringing in the dough were more important. My parents preferred doctor, lawyer, engineer or teacher—anything but an artist. They knew I had a flair for art but their encouragement stopped short of developing my talent into anything more than a hobby.

Of course, I made my family proud by eventually completing a bachelor's degree in materials engineering. I even

worked for three years as an engineer before I finally put my foot down to do art full-time.

I got married and moved out of my parents' home and that ended their control over my life and my career. For the next two years, I paid my way through another degree in multimedia design at the Curtin University of Technology by freelancing as a children's book illustrator. When I graduated, I landed myself a job as an art director with a start-up company making web animations and designs. I worked for two years before I joined my church as a graphic designer, churning designs for books, monthly magazines, brochures, all forms of collaterals, CD and DVD cover designs,

greeting cards and so forth. At that time, my church had a membership of about eleven thousand that kept me busy.

Throughout these years working as an artist, my parents had no idea what I did. In Singapore, being an artist is a taboo, especially for my generation, especially when only dropouts were admitted into art schools. Things have changed over the last five years. Our society has accepted the influences of computer arts and designs in the entertainment industries. Industrial partners have been brought in and institutes were encouraged to set up courses to gear students to become digital artists in animation and effects. Many other Asian countries have done it very well so local authorities felt

the need to follow suit. Digital artists are now recognized as a new breed of technical specialists.

When the Media Development Authority was awarding scholarships to prospective media students, I applied successfully, which allowed me to study abroad. I chose Savannah College of Arts & Design, which offered additional scholarships to students who applied to the college with a portfolio. I sent all my past works and the college awarded me a $10,000 annual artistic fellowship. I was elated to go to a country that offered the best in the entertainment industry, with major players like Disney, Pixar and DreamWorks. I was dreaming of working for these studios already. I knew for

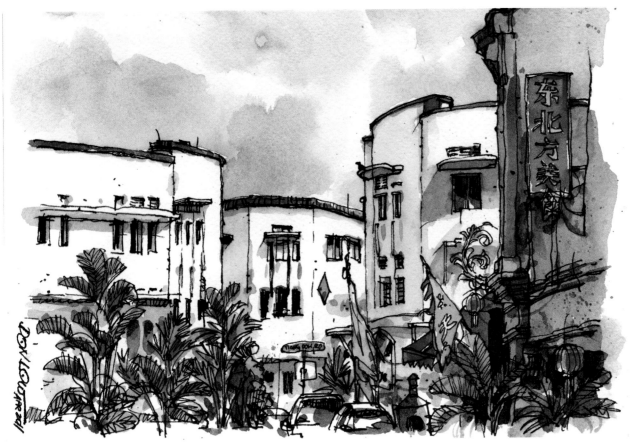

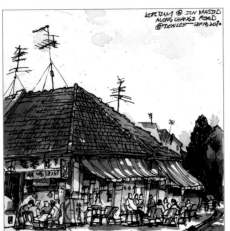

KOPI TIAM @ JLN MASJID
ALONG CHANGI ROAD
@DON LEE — SEP 18, 2010

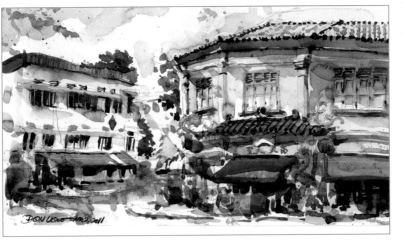

DON LEE — MAR 3, 2011

certain that my life would be different after that.

When I was fourteen or fifteen, I formed my own sketching club by rounding up some of my classmates in secondary school to sketch and draw. Usually we drew indoors, but sometimes we went outdoors to sketch on location. I loved it. The only problem was drawing in the hot, humid climate of Singapore. There are no temperate seasons in our country, just a hot, blazing sun every day the whole year round. Onsets of monsoons occur near the end of the year. I sat and drew in open spaces, but became increasingly self-conscious under public scrutiny. In the end, I let my awkwardness get the better of me and stopped sketching outdoors entirely. Inwardly, though, I believed I would pick it up again.

This came about when I was at SCAD. A professor encouraged every one of us to keep a sketchbook in his class. The sole purpose was to doodle. Each week, he would give us a theme to develop in our drawings, and each week we were to submit at least six pages of doodles, drawings and sketches. To me, it was the best excuse to draw more than usual. I bought an A3 sketchbook (while most of my classmates bought an A4 or smaller so they could draw less) for this assignment just so I could give myself a challenge. I couldn't stop in the end. The exercise reminded me of how I once loved to doodle and draw just for the sake of drawing when I was a kid. Kids

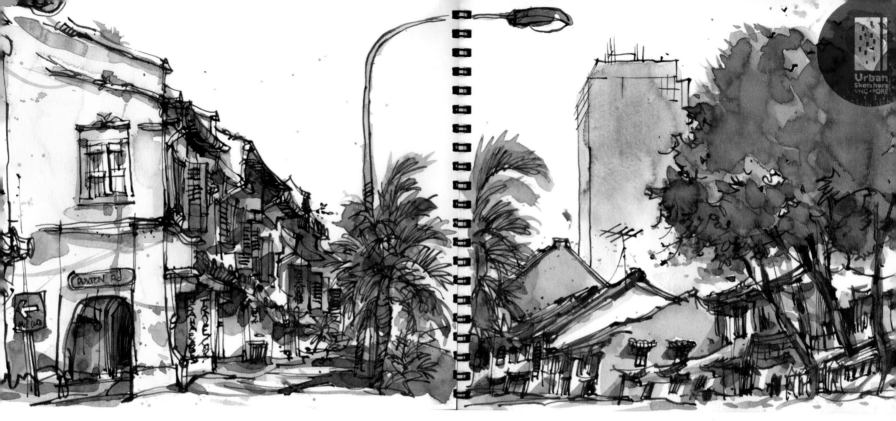

are not mindful of techniques or of how others think; they are just lost in their own dream world, totally immersed with creating something to please themselves. I loved it.

During my second year at SCAD, I read *An Illustrated Life: Drawing Inspiration from the Private Sketchbooks of Artists, Illustrators and Designers*, which blew my mind. Looking at and reading how and why the featured artists sketch and create their visual journal changed how I thought about sketching. For many years as a freelance illustrator and designer, I found sketching to be just part of work or a function. I presented

my sketches to my clients so they could approve an idea or a concept before I churned them into finished art. This saved time and money from correction later.

But the book changed me. Now, I sketch for fun, to enjoy the sheer simplicity of recording things around me and to create a visual journal of what I see and feel daily. Unknowingly, sketching has become a lifestyle I enjoy so much that I wouldn't trade it for anything else. I used to sketch to practice my skills in drawing (that's quite important for anyone who wants to become an artist and I still do that all the time), but I feel something more when I sketch now, especially when

I'm on location outdoors. There is a different reason for sketching.

During my stint in the United States, my wish was to drive at least once across the country. Our landlord in Savannah told us he was planning to retire to California and needed to transport his antique porcelain collection from the East Coast to the West. He proposed we drive his car across country, and he would give us money for the road. I brought along my Winsor & Newton watercolor travel set, an A3 Strathmore sketchbook, a Canson sketchbook, Pen & Ink Fountain Pen and some brush pens. Though it was December, we traveled

through the South, so the weather was relatively amiable. That was, until we arrived in wintry Texas and it only got colder in New Mexico.

Of course, we had to visit the Grand Canyon. We did this on the fifth day of our journey. No snow, but very cold. When we were at one of the vista points, I braved the cold and whipped out my Moleskine to sketch the view. I did not own gloves (I never needed any in Singapore or Savannah!). Just one to two minutes into sketching, my fingers started acting up and refused to move properly. I started involuntarily shivering from head to toe, though I had on a woolly cardigan

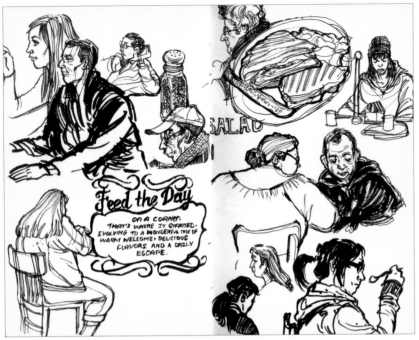

Feed the Day

ON A CORNER.
THAT'S WHERE IT STARTED.
EVOLVING TO A WONDERFUL MIX OF
WARM WELCOME, DELICIOUS
FLAVORS, AND A DAILY
ESCAPE.

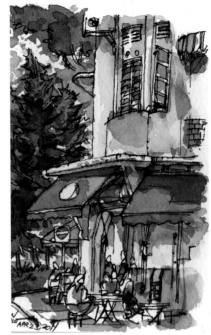

FINALLY, AFTER ABANDONING SKETCHING FOR ALMOST A WEEK, I WAS BACK AT THE NEIGHBORHOOD FOR SKETCHING AGAIN. NO MORE HECTIC MORNING FOR ME. STILL BUSY, BUT THE HIGH TIDES ARE SLOWING DOWN A LITTLE. SO I'M TAKING A BREATHER BY HAVING COFFEE AND SKETCHING. SPOTTED THIS AS I WALKED BY. FRESH COCONUTS FROM THE MARKET. THESE ARE WEDGED ALREADY. WHEN SOMEONE ORDERS A COCONUT DRINK, AN OPENING WILL BE CUT ON TOP & A STRAW STICK IN. ONLY IN ASIA OR THIS PART OF THE WORLD!!

DON LOW

12 NOV 2010

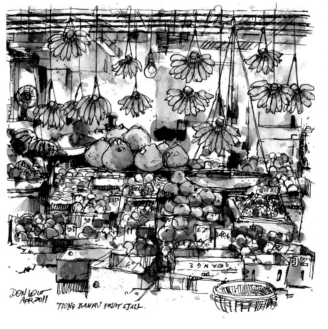

DON LOW
APR 2011

TIONG BAHRU FRUIT STALL.

and a windbreaker. I pressed on to finish the sketch in five minutes, but soon I could not feel my nose! I felt bad my wife had to suffer the cold with me just so I could sketch some icy canyons. So I brought her to a nearby tavern and we warmed ourselves beside a huge fireplace. Needless to say, as I enjoyed a hot cup of coffee, I sketched the fireplace and the giant logs. I believed that would be the last time I sketched in frosted conditions. Incidentally, that was also when my wife insisted I buy my first pair of gloves.

After I graduated, more opportunities to travel along the west coast came about. Almost every weekend, we drove to a new city. We drove along Highway 1 to visit the Big Sur, Carmel-By-the-Sea, Monterey, Point Lobos, San Francisco and down South to attend the annual comic convention in San Diego.

When I got back from trips like these, I found myself thumbing through the sketches instead of looking at the photographs. Looking at each sketch, I could relate much better to the sights and sounds I experienced while I was drawing. I realized the process of sketching actually involved the entire consciousness—all the senses coming together to translate what I saw onto paper.

After three and a half years in America, we returned to Singapore and found that many things had changed. It was as if I was seeing my hometown for the first time.

When I joined a local sketching group

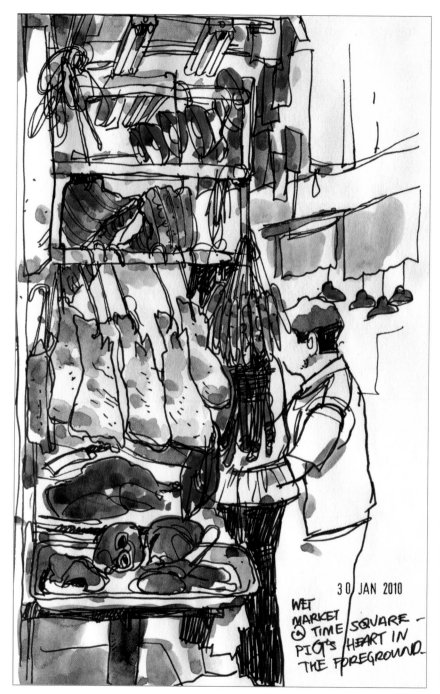

WET
MARKET
@ TIME SQUARE —
PIG's HEART IN
THE FOREGROUND.

30 JAN 2010

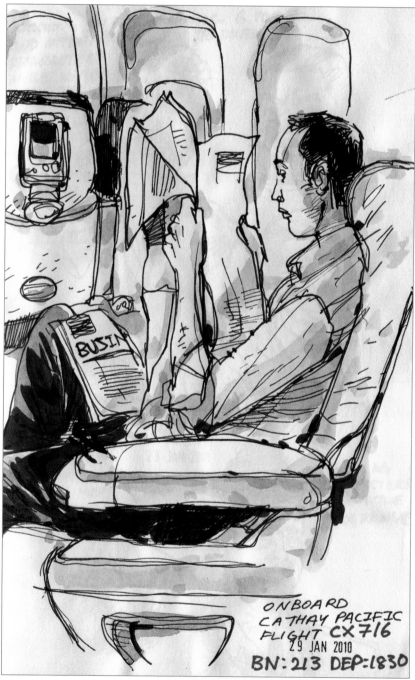

ONBOARD
CATHAY PACIFIC
FLIGHT CX716
29 JAN 2010
BN: 213 DEP: 1830

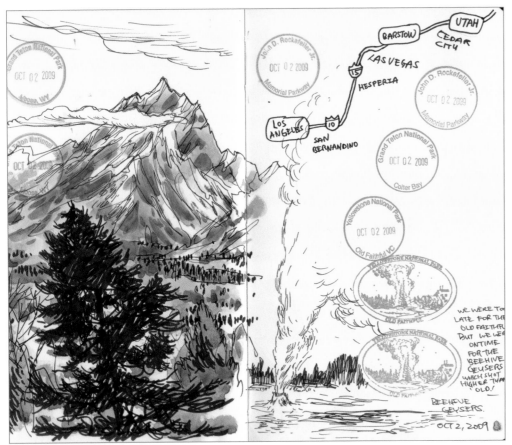

(Urban Sketchers Singapore), I found myself traveling and sketching almost every weekend within the city as a group. We call these trips "Sketchwalks," during which we would scour a location in two to three hours, making quick sketches as we moved. I call it guerrilla sketching. Making quick sketches distracts you from focusing on techniques and tools. Because I have to nail a scene within ten to fifteen minutes, economical use of lines is vital. Such exercises train my eyes to look out for the essence of a place, the light or the cast shadows that attribute to the character of a building or architecture. In the beginning, I found it hard to adjust to drawing buildings; drawings of people still make up the largest part of my sketchbook. But making quick sketches of buildings helps me eliminate unnecessary details and pay more attention to composition and design of the page.

I use a Hero, a Chinese-made fountain pen. The nib of the pen is manufactured to bend upwards slightly so it can produce both very thin and very thick lines. The flow is very good and if you are using the right fountain ink, the lines remain bleed-proof when you apply watercolor washes onto your drawings.

I like posting my sketches on Facebook or on Flickr to share my experience. Facebook has already connected me to many sketchers from all over the world. Being a contributor to the Urban Sketchers blog also brought about much motivation to sketch more and to share my travel sketches with others in another part of the globe. I feel like a documentary producer when I sketch and share the place I sketched. And I love every moment of it.

If I could choose, I would choose to sketch full-time all my life.

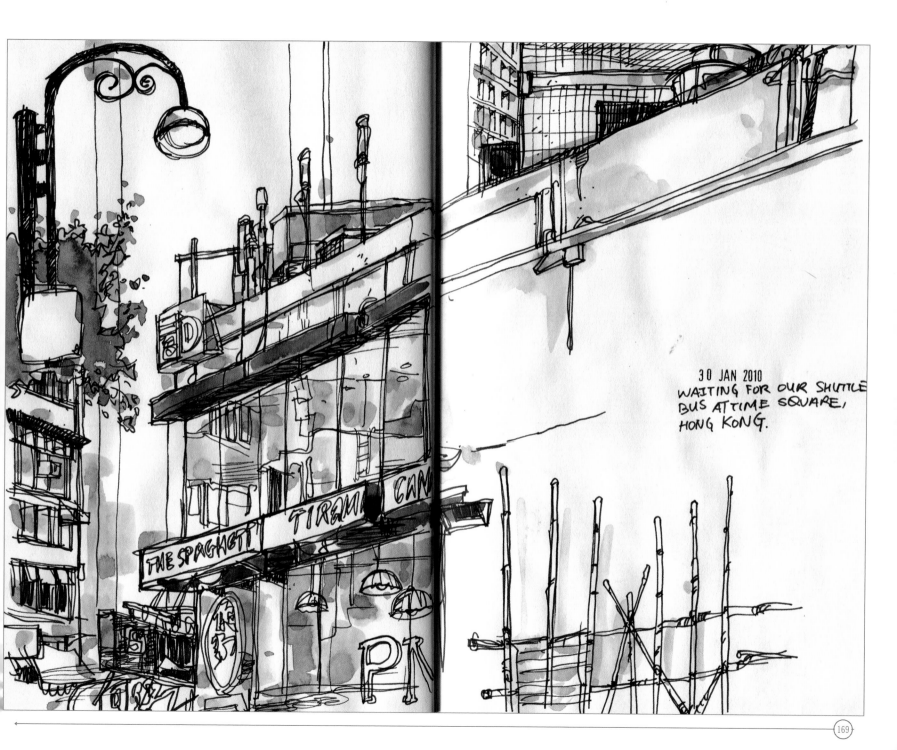

30 JAN 2010
WAITING FOR OUR SHUTTLE
BUS AT TIME SQUARE,
HONG KONG.

Prashant Miranda

Prashant Miranda was born in Quilon, grew up in Bangalore and studied animation at the National Institute of Design, Ahmedabad, India. He moved to Toronto in 1999 and paints and makes animation films. **www.prashart.blogspot.com**

I always drew as a kid. I loved to draw and sing and paint. The individuals in my family are not visual artists, but my parents are artists in their own right. My mom loves to cook, and my dad is a fantastic gardener. I would keep a diary and doodle in it. It was mostly things around the house or the children of construction workers who were in the neighborhood.

I studied for five years at the National Institute of Design, Ahmedabad, India. It is here that I blossomed. It is also here that I really started keeping a visual journal, in 1994. I would bind my own books, reuse paper from old courses and explore all sorts of different styles. Some sketchbooks of my vacations back home in Bangalore are rather special, because they document our home and a time that doesn't exist anymore. I specialized in animation film design, and so keeping a sketchbook really helped in the way I saw and understood things.

These days I paint for a living—mostly watercolors and I also make animation films.

I am a migratory bird. I spend my summers and autumns in Canada, and when it starts to get cold, I travel to India. And within Canada and India, I travel around.

Travel is a very important part of my life because it is a dose of reality. It widens my perspectives and gives me an objective viewpoint of the places where I live. For instance, I have learned not to take for granted that we get fresh drinking water out of our taps here in Canada, and hot water too! When I'm in certain places in India I'm thankful for that.

Often when I draw while traveling, it attracts people and opens up conversations. I might be sitting in a bar and someone will strike up a conversation and buy me a drink. I love painting while I travel, as opposed to the fleeting instance of taking a photograph, because it makes me observe things that I normally wouldn't pay attention to.

Travel journaling takes me back to that very moment years later. It is a transportation device. Watercolors are great for that because I use the water from wherever I am and it infuses itself into the painting. My sketchbooks are definitely a storehouse of memories, the routes

Le cathédrale de Rouen

I've taken and the things I've done and the people I've met during my travels. I feel different when traveling because I'm constantly interacting with new and different people. And so the questions that define me become who I am. I think the energy of the place is reflected through my sketchbook.

My drawings on a trip usually revolve around the pauses. In my last trip to France, in July, I realized that most of my watercolors were done over a beer or when I stopped to have a bite to eat or a coffee or some such thing.

The one time I didn't draw for ten days was during a Vipassana meditation that I did in India. It was a silent meditation retreat where we couldn't draw, read or write for those ten days. It was a different experience because I couldn't remember when I'd been without drawing in the past. But it made me focus on other things: the sounds at night, the way the train whistled when it passed by, the light of the moon, the gorgeous sunrise or the birdsong. When I did get to my sketchbook, all these outpourings came out stronger and more vividly.

Traveling often makes me want to draw more. It's because of all the new things I see that make me want to document them. I get used to the things that surround me at my own home, and it's always the novelty of seeing something new. My sketchbook and I are best friends, and so everything is shared between us.

My sketchbooks are very personal, but I love sharing them with others. They are meant to be looked at, perused through and shared with others.

My travel journals are personal accounts of my journies. They are not hindered by briefs, a particular style or other people's notions of what they should look like. My travel journals are for me alone. They make me explore ways of seeing that I haven't tried before and allow for a clean slate without preconceived notions.

I use watercolor. I love it because it is portable. It can all fit in my bag, can dry quickly and it's very immediate. I also like the fact that I can use the water from the place I'm visiting, be it from the sea, a river, a container of rainwater or beer, wine or tap water from a charming old house.

My sketchbooks dictate the work in it. Some have bad paper, not perfect enough for watercolors, but they provide for very loose, rough drawings that translate into watercolors that are lively and capture an energy I wouldn't have captured otherwise. The size of the sketchbook also steers my drawings. Larger spreads take a longer time to fill and therefore alter the movement within the page.

My bag usually contains drawing pens. Rotring Isographs or Staedtler rapidographs 0.3 and 0.5, are my favorites. Of late, I love soft pencils, EE or 8B. I love

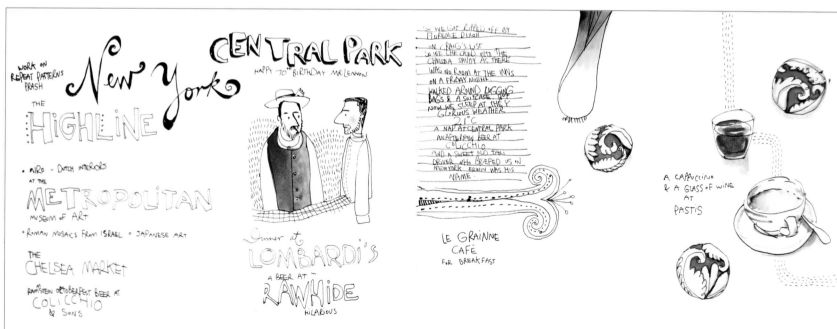

OFF TO
NY

UP
IN THE
DOME
CAR

DAZZLING
FALL
COLOURS

WORK ON
REPEAT PATTERNS
PRASH

New York

CENTRAL PARK

HAPPY 70th BIRTHDAY MR LENNON

THE
HIGHLINE

• AFRO - DUTCH INTERIORS
AT THE
METROPOLITAN
MUSEUM OF ART

• ROMAN MOSAICS FROM ISRAEL • JAPANESE ART

THE
CHELSEA MARKET

RAMSTEIN OCTOBERFEST BEER AT
COLICCHIO
& SONS

Dinner at
LOMBARDI'S
A BEER AT
RAWHIDE
HILARIOUS

SO WE GOT RIPPED OFF BY
FLORENCE DIXON
ON CRAIG'S LIST
SO WE CHECKED INTO THE
CHELSEA SAVOY AS THERE
WAS NO ROOM AT THE INNS
ON A FRIDAY NIGHT
WALKED AROUND LUGGING
BAGS & A SUITCASE BUT
NOW WE SLEEP AT THE Y
GLORIOUS WEATHER
21°C
A NAP AT CENTRAL PARK
AN AFTERNOON BEER AT
COLICCHIO
AND A SWEET OLD TAXI
DRIVER WHO BRIEFED US ON
NEW YORK. ERWIN WAS HIS
NAME

LE GRAINNE
CAFÉ
FOR BREAKFAST

A CAPPUCCINO
& A GLASS OF WINE
AT
PASTIS

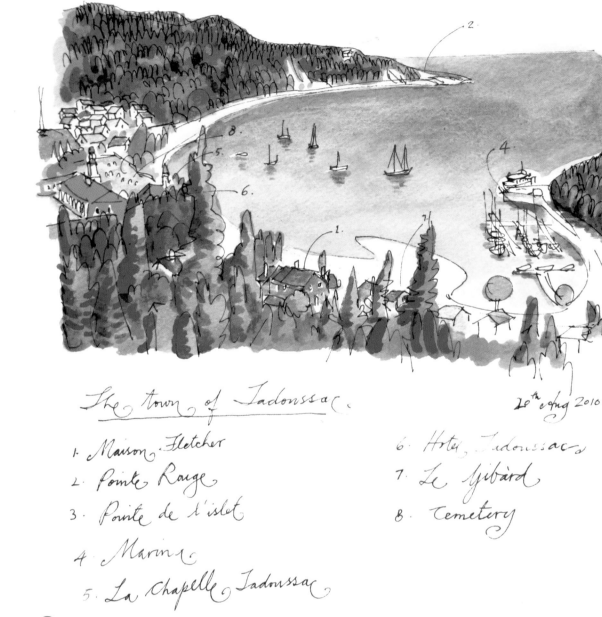

The town of Tadoussac.

20th Aug 2010

1. Maison Fletcher
2. Pointe Rouge
3. Pointe de l'islet
4. Marina
5. La Chapelle Tadoussac
6. Hôtel Tadoussac
7. Le Gibard
8. Cemetery

my Pelkan watercolors, twenty-four pigments in a box. Normally I carry three brushes: a fine, medium and large one for washes and a little container for water. I often buy large sheets of watercolor paper that I tear into the sizes I want: Arches 140-lb. (300 gsm), hot or cold press; or Saunders Waterford, something with a deckled edge. That's pretty much it. It pretty much remains the same when I travel, except for the size and format of my sketchbook.

I like doing portraits in my sketchbooks, though portrait commissions stress me out. Portraits help me connect with the person, and later they tell me about the people I hung out with during my travels. Sometimes they are caricatures. I draw what moves me. I draw anything: bottles of wine, people's faces, I love old architecture. My drawings usually have something to do with history.

My travel journals are meant to be shared so they go through quite a bit of beating, but they mean the world to me.

I keep them at home, on several bookshelves. They are important to me because they have chronicled my life over sixteen years. In that regard I consider them to be a part of my life.

Advice: Just keep a sketchbook and draw, draw, draw!

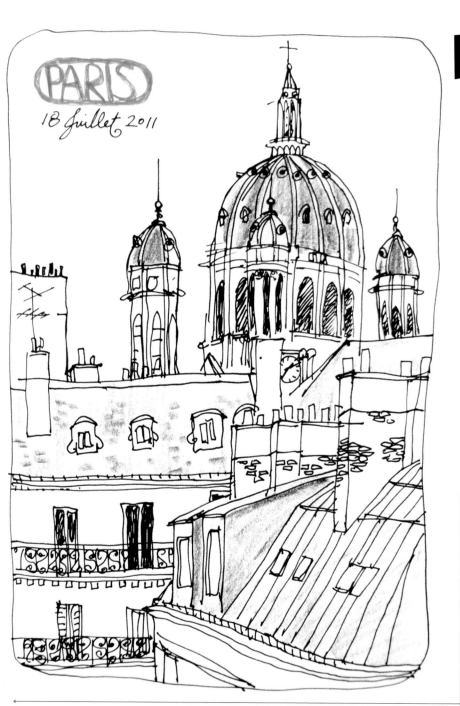

PARIS
18 Juillet 2011

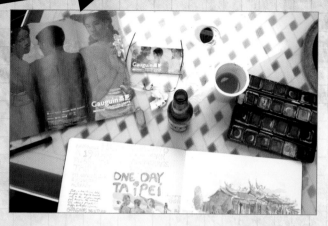

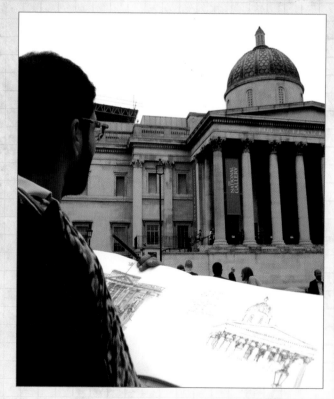

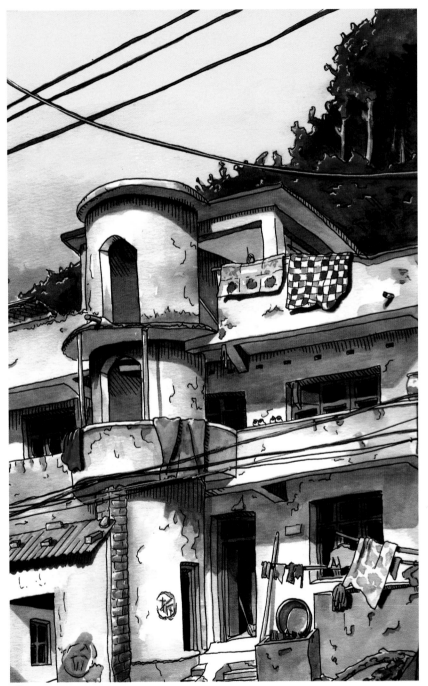
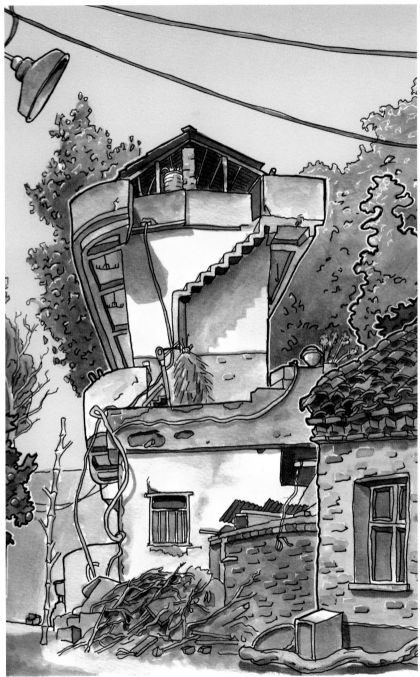

Steven B. Reddy

Steven B. Reddy began filling sketchbook journals during high school in Anchorage, Alaska. He lives in Seattle where he has been teaching elementary school for fifteen years. Steve is currently writing an illustrated travel journal of his year teaching and drawing in Southeast Asia, titled, *Laowai: Far From Home*. **stevenreddy.blogspot.com; flickr.com/photos/stevenreddy**

I've always drawn. My grandfather was a house painter with some talent, and my mother and uncle had a natural ability to make pictures. I have to credit my mom for being the most encouraging. I think she's always harbored a desire to be an artist herself, and she was always complimentary about my stuff and never made me feel guilty about all the time I spent drawing. I was a quiet, nerdy kid who spent most of my time alone drawing, reading, playing the piano, learning magic tricks and recording little radio plays about the invisible man, haunted houses, aliens, stuff like that. I made tons of little animated flip books in scratch

pads. I was a real dork.

Without disparaging my education, I feel completely self-taught. As a kid I read comics, watched Saturday cartoons and read science fiction. The covers of those pulp novels and the covers of record albums, especially from artists like Roger Dean and the British design firm Hipgnosis informed what I do more than anything I ever learned in a classroom. Then, in college I read Robert Crumb's *Mid-Life Crises* in some "best comix of the year" collection, and it blew me away. It was literature in drawings. It was so much more real and brave and personal than all the cold, abstract stuff we were

studying in college.

Later, when I took up oil painting, I learned from Todd Schorr's books about under painting a grisaille and glazing color on top. The old masters painted this way, but it was Todd's subject matter that caught my interest. How he did it came second. So now, even though I sketch in watercolor, I still do a gray ink wash version first, then "glaze" the watercolor on top of that. It's more work and takes more time, but painting in gray first helps me make sense of the overwhelming amount of data I'm looking at. Then, once I know where the darks and lights are, I can put in a little color.

I didn't start traveling until late in life. I never had the money for it, and not having traveled (except to move) as a kid, it just wasn't on my radar as something that I would do. Any extra money I ever had went toward student loans and my son. Then one year, the parents of my students pooled their resources and sent me to Oahu for ten days. My eyes were opened! I didn't want to leave. The bathtub-temperature water, the warm dry air, the lush foliage and the minimal clothing; I couldn't get enough. So I went again the following year with my son. I went to New York next and spent over a week walking

from gallery to gallery, looking at the art. Then I went with a friend on her business trip to Canada, and later the same friend and I went to Acapulco.

After the trip to New York, a friend saw *An Illustrated Life* in a bookstore and showed it to me, knowing I would like it. Although I've been keeping journals since I was fifteen, they had always been a mishmash of writing, schedules, to-do lists, kvetching—scrapbooks bulging with glued-in memorabilia. I liked sharing the books with others and was proud of how much effort went into them, but I was never too comfortable with the embarrassing immaturity and obvious mental confusion revealed in the writing. After reading *An Illustrated Life*, I got a separate book for the verbiage, and instead of saving memorabilia to paste into the book, I realized I could just draw the things I wanted to remember. In this way, my diaries became sketchbooks. I graduated from those cheap, black hardbound books with the crappy paper to spiral-bound watercolor tablets. Now I can hand anyone my books and not cringe with worry over what they'll read. I still have the embarrassing navel-gazing books, but they're safely tucked away until I can edit them into some sort of biographical novel or memoir. We'll see.

Sketching is a perfect way to approach total strangers and find out who they are and what they're up to. I just ask if I can draw what they're doing or where they live or work. People suddenly feel proud and interesting, and they almost always say yes. When people see you drawing, they are naturally curious as to what you're up to. Drawing is a universal language.

Americans tend to be blasé about seeing sketchers—or maybe they're just too respectful of personal space bubbles. But in Mexico, and especially China, crowds gather when I draw.

The most consistent challenge is finishing a drawing before someone moves their car or changes the scene. Sometimes the light changes a lot, or I need to move myself and doing so throws off the perspective.

I have no interest in drawing what other people tell me are the beautiful places to draw: mountains, rivers, flowers, animals. I agree that these things are beautiful and important, but they don't make interesting drawings. I like clutter. I love to find the patterns and details in a random collection of junk. I've drawn many times in vintage stores. If I go to the fishing harbor, I don't draw the boats, I draw the pile of unrecognizable crap on the deck of the boats. If you invite me to dinner, I'll draw (with your permission) the dirty dishes before you clear the table.

When I draw, many things that happened while I was drawing get "locked into the picture." I don't mean in a figurative sense, like, "Oh, that was a beautiful day ...," but very specific details: the

to keep the chronology. The drawings tell a story, of sorts, even if it's only a story to me. But more important, I love books. Art books, novels, textbooks. In order to go to China, I gave away everything I owned—everything except my favorite art books and, of course, my sketchbooks.

The books I grew up on as a kid had illustrations: *The Hardy Boys, Alice's Adventures in Wonderland, Robinson Crusoe, No Flying in the House, Black and Blue Magic*, the books of Beverly Cleary. They weren't picture books. The drawings were there, maybe one per chapter, to add detail and atmosphere. I think of my drawings as the illustrations for my "life novel." A lot happens between each drawing, but the drawings provide the continuity.

I try not to have too many rules. Many of the Urban Sketcher purists say a drawing must be finished on the site. I only draw from life, but I will often touch up the drawing after it's sat for a day or two; I might punch up the contrast with some more black or add some highlights with a white pen. I rarely, if ever, finish the color on-site. I'm still learning how to manage the liquids out in the field. I've spilled India ink, muddied up a page with too much color mixing, put so much water on a drawing that it buckles and won't lay flat in a scanner. It's safer to take only my pens and the paper and fuss over the drawing later, when I'm safely at my desk at home.

My drawings fill the whole page, even

conversations I had while drawing, the song I was listening to on my iPhone, the TV show that was on the background. It's weird, but I'll look back at a drawing of a cup of coffee and *Mad Men* will pop into my head. Or a glance at a drawing from a Chinese restaurant will elicit a shouted, "Laoban! Laoban!" because I heard a patron call out to the waitress while I was drawing. While doing a drawing, I'm wholly in the moment. It sounds like a

cliché, but it really is a form of meditation. It takes too much concentration to let my mind wander, so it's not a good way to brainstorm or problem solve. I can't practice my Mandarin or plan a lesson while drawing, because I'm too busy paying attention to the thing in front of me. I'm making the infinite tiny decisions about what to leave in, what to leave out, what to exaggerate, what to minimize. Can I push that thing over to

show all of the other things behind it? Can I make that part taller so it doesn't look just like that other part?

On the other hand, it's relaxing. It's not so attention demanding that you can't have an easy conversation with another sketcher, or even a friend who just wants to sit with you while you draw.

I need my drawings to be a book. Loose papers would get creased and coffee stained. Also, it's important for me

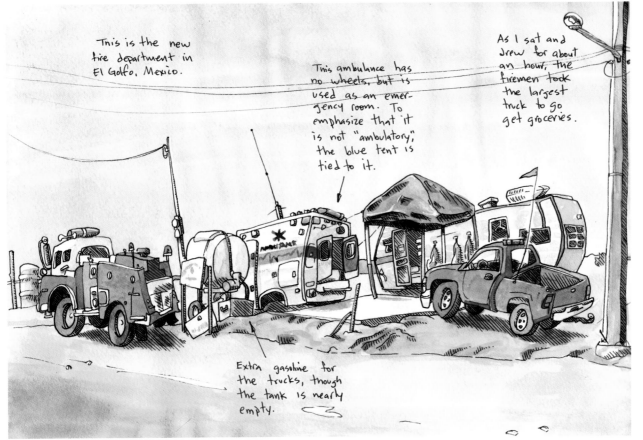

This is the new fire department in El Golfo, Mexico.

This ambulance has no wheels, but is used as an emergency room. To emphasize that it is not "ambulatory", the blue tent is tied to it.

As I sat and drew for about an hour, the firemen took the largest truck to go get groceries.

Extra gasoline for the trucks, though the tank is nearly empty.

when I start out doing what I think will be a small vignette. I can't help it. I go drawing with more trained illustrators, and I see how they refrain from filling in areas of the drawing. I understand it theoretically: Let some parts of the drawing recede so that others can come forward, choose a focal point, show restraint, put higher contrast things in the foreground, use more subtle shading for the background. But I can't do it. If I can see it, I'll draw it, so my drawings tend to fill up and

be the same all over. I even call my drawings (and paintings) "all-overs" because they are closer in composition to a Pollock than to a Norman Rockwell. I think it's because once I'm seated and in the "flow" I don't want to stop. So if there's room on the page I'll keep drawing until my knuckles are blue from the cold and I have to pee so badly I can't stand it.

My kit is very simple. I use a spiral-bound All-Media Montval 90-lb. sketchbook with fifty pages. The pages

are thick and take a lot of water, which is good because I tend to overwork my drawings with several layers of ink wash and watercolor.

I draw with a black uni-ball fine pen. (I always carry two, in case the ink runs out mid-drawing. I buy them in bulk from Staples.) I use Rapidograph waterproof, black India ink for gray washes. After years of grabbing whatever brush is cheapest, I've settled on Utrecht's white nylon sable brushes, sizes 1, 4 and 6. They

hold their points and even though I don't rinse them well, they stay really nice for a long time. That's usually my kit.

After the basic drawing is finished, I use small, twelve-color watercolor sets of whatever's handy, a Koi Pocket Field Sketch Box, and a Winsor & Newton twelve-color box. I have a Canon scanner in the States, in China I pay a local copy shop 1 yuan per scan. The scans are bad, too light and the lid never shuts all the way because of the spiral binding on my sketchbook, so I have to color correct them on my little MacBook in the dorm.

It's nice to meet with the Urban Sketchers Group after a morning drawing and pass the books around. I love when someone asks to see the book. Of course, I get most of my feedback from websites like Flickr or Urban Sketchers. My main purpose for using Facebook is to share art with other artists.

I self-published an eighty-page book on Blurb.com about wandering around and drawing in Seattle, called *Now Where Was I?* I draw at work, during staff meetings, while waiting for a haircut and even while being driven somewhere in the back of a car. If you take a sketchbook wherever you go, there's never any down time. You could whip out a quickie on an elevator ride if it was long enough. (Hey, that's a good idea for a sketch ...)

Steven Reddy

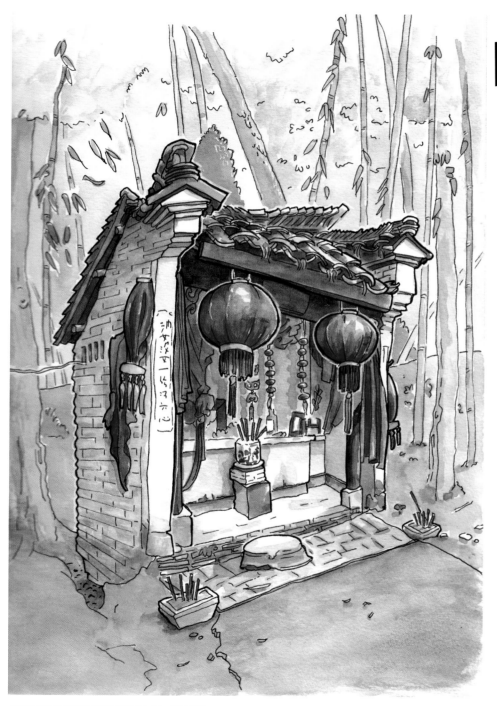

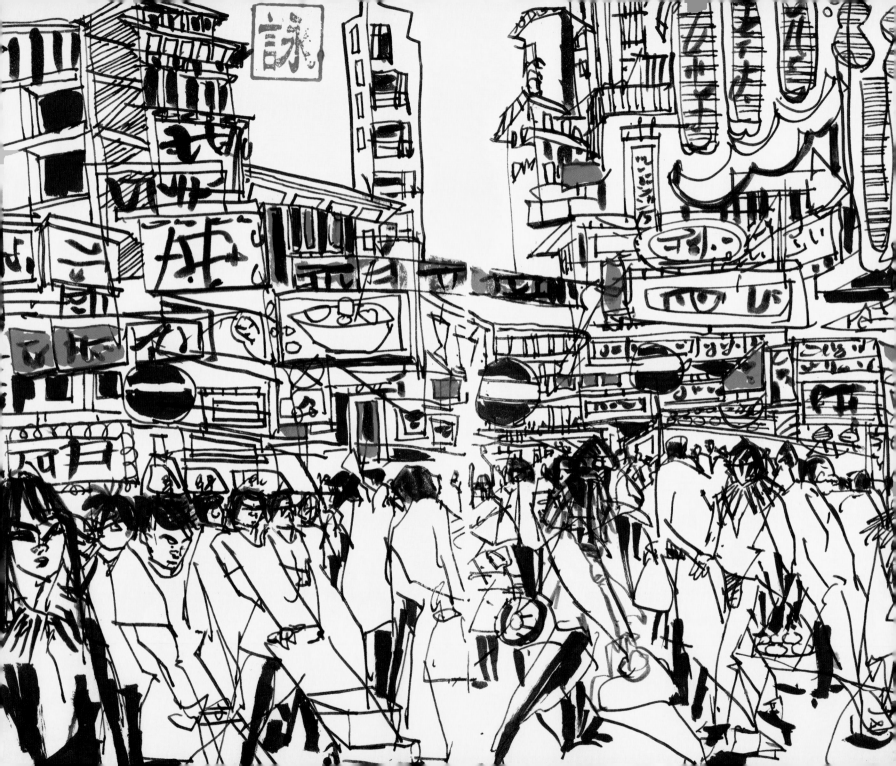

sugar cane and tracks are the toys of the BATEY.

Melanie Reim

Melanie Reim is an award-winning illustrator with a sketchbook never far from her side. Since earning her MFA in illustration from Syracuse University, she has illustrated for book publishers, advertising agencies, museums, magazines and major corporations. She is a full-time professor and the chair of the MA in Illustration program at FIT.
http://www.melaniereim.com; www.sketchbookseduction.blogspot.com/

Mine is not that unusual of a story or background, and so I often find myself thinking—as I am drawing under a palm tree, or at a voodoo ceremony, or in the middle of a medina—*How did I get here?*

Ultimately, it doesn't matter so much how I got there, it matters that I have my most favorite thing in the world to do—that I could never imagine a vacation without drawing my way through my travels and that drawing on location is a very significant part of my identity.

I grew up on Long Island. My parents were not artists, but they were artistic and encouraged creativity in and around our lives and our home. The neighborhood girls and I often conducted highly competitive coloring contests in my den. It was easy then for me to stay within the lines and I often emerged victorious. Still, I was on track to be a French major, and my art career was kind of an accident. The true story goes that, in my freshman year of high school, I was closed out of a typing class that my mom insisted I take and instead was placed in study hall. Well, that was not acceptable and I remember sitting with my mom with the guidance counselor who asked me "Do you like art?" And that's how it happened.

My high school training was very rich and supportive and I loved it—but when it came to college, I once again listened to mom and dad and opted for, not an illustration program, but an art education program. Throughout, I always kept a sketchbook and loved making observational drawings, though I did not call them that at the time. I remember how linear art excited me—and how, like so many, Norman Rockwell was the model for picture making. I now know that it was, and still is, the essence of storytelling that attracted me.

I graduated and I was not interested in teaching. I freelanced by day and studied with great draftsman by night, specifically Jack Potter and John Gundelfinger. Clearly, I was attracted to reportorial, linear artists who fed my desire to keep an observational sketchbook.

Not too long after undergrad, I earned

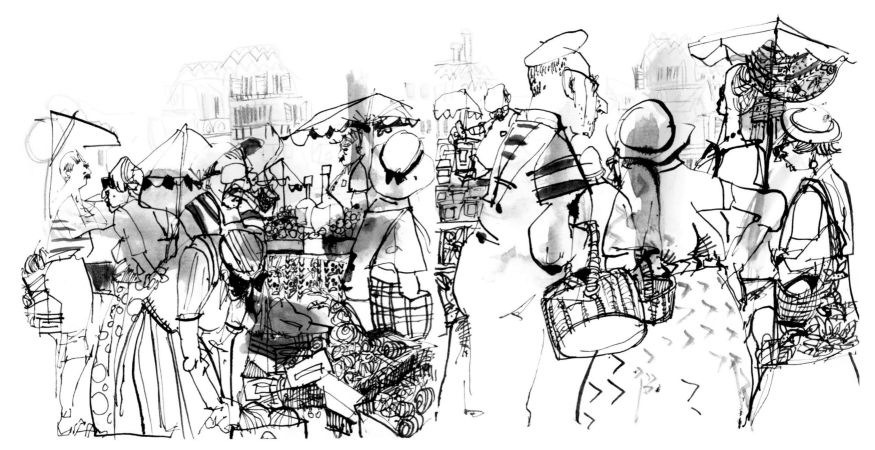

my master's of fine arts in illustration at Syracuse University. I fretted terribly the night before my interview with Murray Tinkelman—preparing my portfolio, brushing up on current events. At the end of the day, it was my sketchbook that earned me a spot. Even as I write this, I remember the drawings that he called out: one featured the front of St. Patrick's Cathedral and the other, the Plaza Hotel (as I drew it, Sid Caesar asked me what I was doing!).

In Syracuse, I met those who would shape the way that I think about drawing and forever reinforce my love for keeping a sketchbook. David Passalacqua became the most influential drawing teacher of my career. Franklin McMahon, whose class I crashed during my MFA, was the role model for how I wanted to work. Barron Storey was up to journal number fifteen when I took his class. Marshall Arisman told his stories, so vivid and vibrant, and taught

how the art of storytelling could become great pictures.

I continued to work with David for the next ten years: It was ten exciting, challenging, provocative years of working with the model, drawing on location, learning how to think and problem solve, falling in love (again) with the art of storytelling and also (re)learning about world history and art history in ways that still keep me hungry for more. It was not easy to leave the nest, but I knew it was

time, and I started to teach at the Fashion Institute of Technology, where I am now the chairperson of the MFA in Illustration program. Each and every day, I bring the lessons of my masters with me to use as tools to instill the love of drawing and of reportage to my students.

Like most professors and our so-called cushy schedule, I have acquired a travel bug. Now I must take a trip somewhere every summer or I feel sorry for myself. Before I had this luxury, I had traveled to

Europe once or twice, but since 1997, I have been making significant trips—both for my life and my art. I have had the amazing good fortune to teach for many years in the Dominican Republic. I have fallen in love with the people and the island. My sketchbooks have been with me in sugar cane fields, on deserted beaches and in the world of voodoo. I have been to Morocco several times. An old friend who was working in South Africa looked me up, and it did not take me long to make South Africa my next adventure. This is my idea of vacation! I love to be in environments where there are lots of working people, cultural rituals, costume, dance and, often, slices of life.

If I am going to a new place, I always bring a new sketchbook. I have worked with all different kinds of books. I love square sketchbooks, but my favorite is Cachet Studio, which has a spiral binder. The paper is strong and holds up to the digging that I do with my Pelikan cartridge pen—I love when I scratch and it splatters. The paper also holds up well to wash and gouache, though I primarily work in black-and-white and often use graphite as well (Ebony pencils deliver a rich black). Working in black-and-white is a habit that dates back to the days when I was studying with Dave and working with abandon in color. Oh yes, it all looked very exciting, but no one could tell what they were looking at. So I was assigned to work exclusively in line for one year: no wash, no color, not one

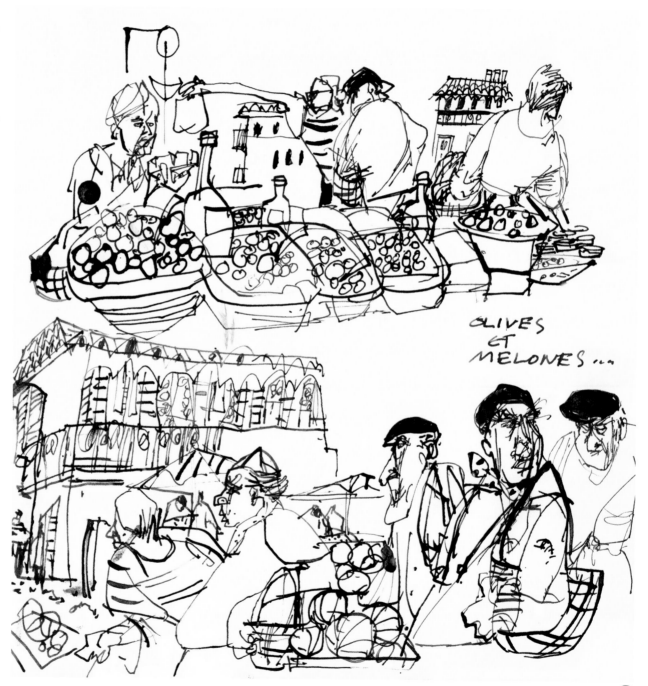

OLIVES
ET
MELONES...

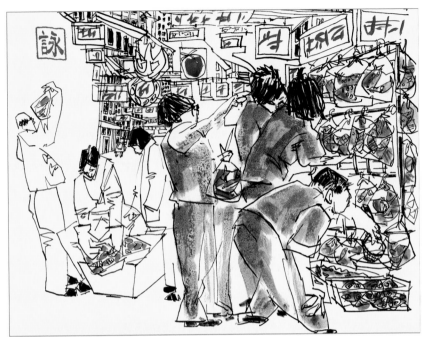

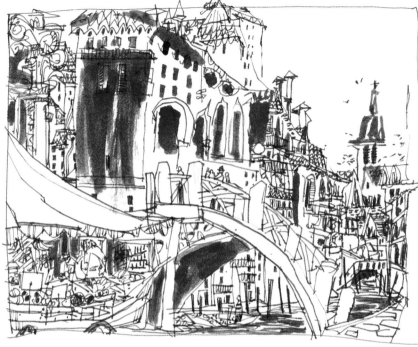

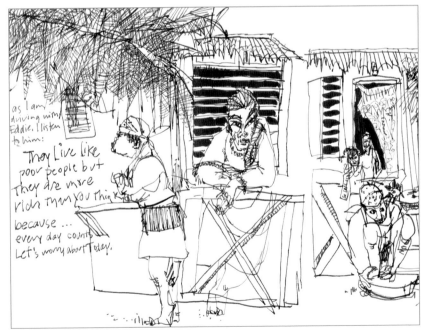

as I am driving with Eddie, I listen to him:

They Live like poor people but They are more rich than you think

because ...
every day counts
Let's worry about Today.

smudge allowed! I learned the beauty of building tone with line from Rembrandt, Delacroix, Pontormo. I learned the beauty that can be achieved with black-and-white and it feels very right to me to work this way. It was the best thing that ever happened to me—that assignment and restriction—though I drew kicking and screaming for a while about it when it first happened.

There has never been a time when I look back at my black-and-white drawings that I have not remembered the color and the impression of what surrounded me.

Drawing on location often draws a crowd, practically always piques interest, and sometimes, a critic or two. Gotta love them. They think that we artists are part of the street show. I do not mind the interest too much—and I have met some interesting characters along the way.

My sketchbooks completely and utterly inform all that I do as an illustrator. The sense of design, space and character of any environment or event is best captured for me when I insert my opinion and reaction into it. It becomes memorable, a part of an encounter that calls to mind color, smell, sound. No matter how long ago it has been since my drawing, I remember where I was, who was around me; it brings me right back.

Melanie Reim

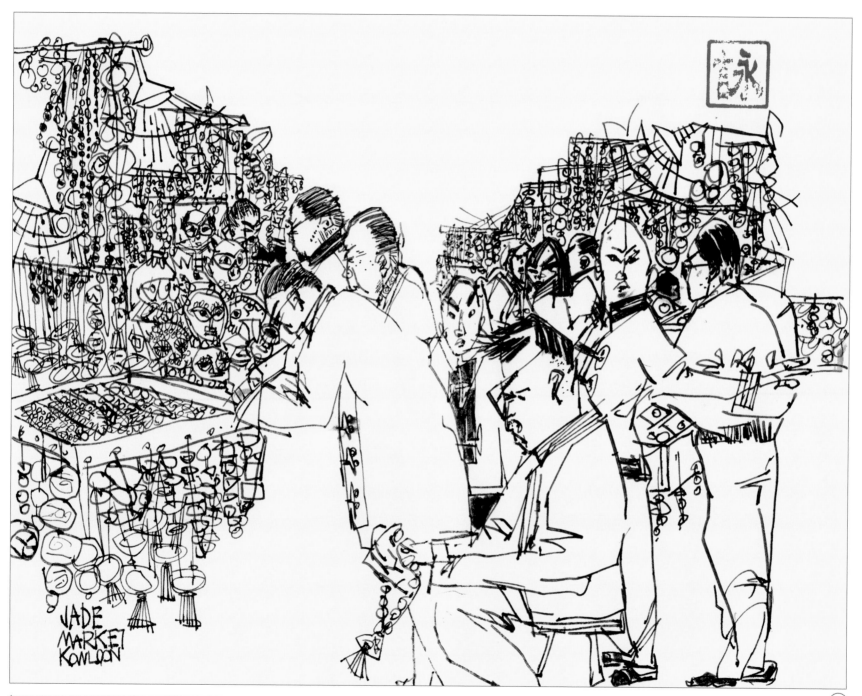

JADE
MARKET
KOWLOON

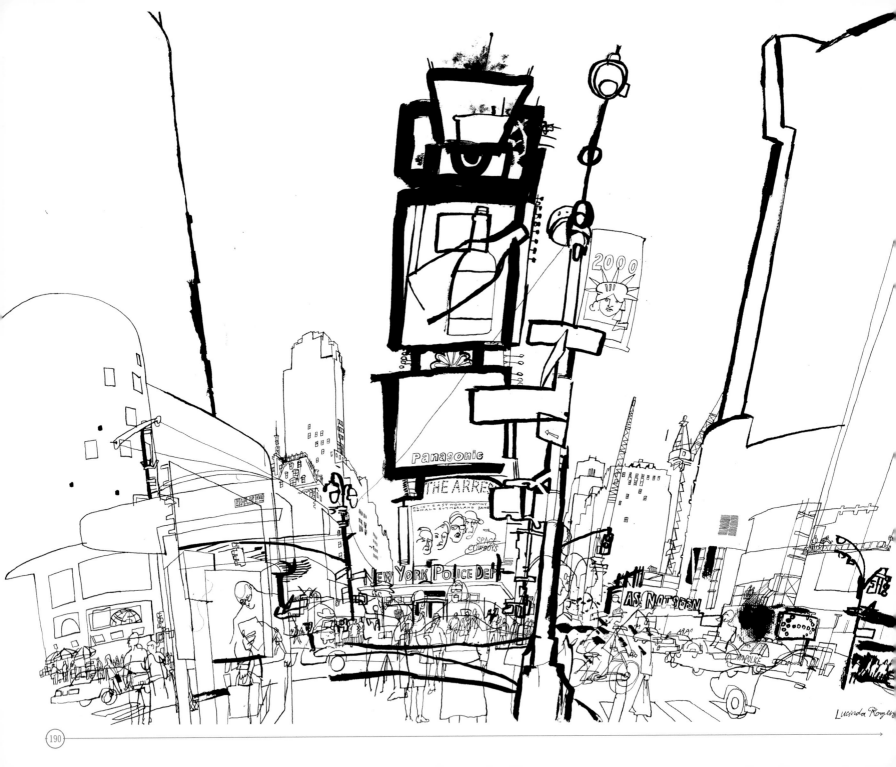

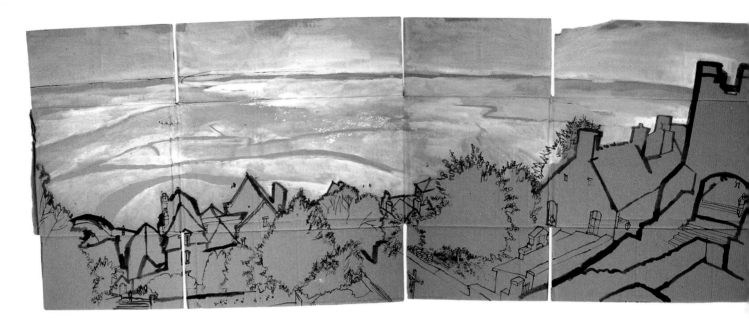

Lucinda Rogers

Lucinda Rogers is a British artist and illustrator living in London's East End and has worked for numerous publications and clients, including the major UK newspapers, *The New Yorker, The LA Times* and *Condé Nast Traveler*. Her work focuses on "reportage" and drawing on location. She currently exhibits prints and original drawings in London. **www.lucindarogers.co.uk**

My principal way of working is to draw from life, taking inspiration from what I see around me. As an illustrator I have often been sent by clients to draw interesting places, with orders to bring back the key images of a place or event. Left to my own devices, I set out with less prescriptive aims and am led by whether the subject draws me in.

I am especially attracted to cities and try to convey particular character through their buildings and scale, as well as in the often banal details (like traffic lights and signs) that distinguish places and countries. But once, sitting on the ground between rows of vines in France, I realized I liked both the absence of straight lines and the difficulty of drawing leaves.

Traveling with a sketchbook is practical, but I prefer to work on a larger scale on single sheets. I don't like the restriction of a book. My travel sketchbooks are not the ultimate summary of a trip but additions to it. They contain on-the-spot drawings, notes, overheard remarks and thumbnail sketches, i.e., reminders of subjects for larger drawings. In a way, the sketchbooks were not designed to be seen and have a more laid-back character for that reason.

As a child, I spent most of my time at home drawing and always took a sketchbook on holiday, so I got used to drawing in all sorts of places and soon recognized the desire to capture something that I saw. One year I did a large number of drawings of cows lying in a field at my great aunt's house. My family or friends would always accommodate my desire to draw, wherever we were.

In 1991, I used a journal to record a two-week trip that I took alone to Prague. Being in Prague for the first time and drawing it from scratch was a very focused way to spend each day. I also met a lot of people and absorbed the precise moment just after the Velvet Revolution. I tried to cover everything from wide views of squares and cathedrals and the great variety of architectural styles to details like wooden telephone booths, Trabants, cakes in day-glo colors, posters of Vaclav Havel, a small political meeting. I also stuck some items to the pages: bus tickets and bar receipts

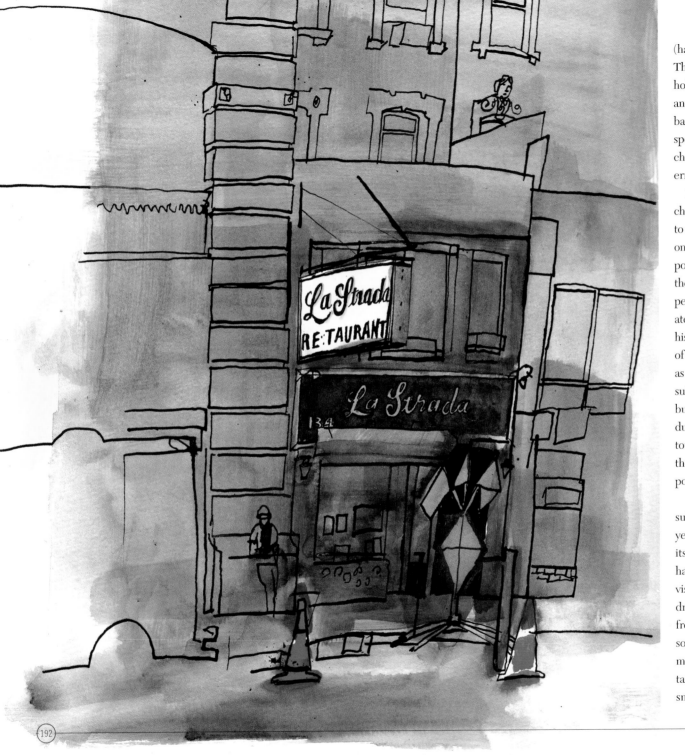

(handwritten: "one beer, two crowns"). The book, even with all that was left out, holds very strong memories of that time and place, so much so that I dread going back and seeing the way it has changed, specifically the advertising hoardings, chain stores and other trappings of western cities that Prague now has.

How or why the eye and the mind's eye choose something to draw is often hard to explain, but carrying a sketchbook gets one used to making the choice and transposing it onto paper. As with all drawing, the chosen subject then becomes more personal to the artist: a relationship is created in those moments. John Berger, in his essay "Steps Towards a Small Theory of the Visible," describes this relationship as a collaboration and suggests that the subject calls the artist, who has no choice but to follow. So drawings that are made during travel have meaning beyond the tourist experience, and to look back at them conjures much more than just a postcard-type memory.

New York has been a long-running subject of trips for more than twenty years and without the fascination with its appearance I probably would not have returned so often. On my very first visit I was overwhelmed by an urge to draw what I saw; the familiar scenes from films and photographs mixing with so many unexpected and new elements made me want to make my own interpretation. On that first short visit, I carried a small sketchbook that I filled with pencil

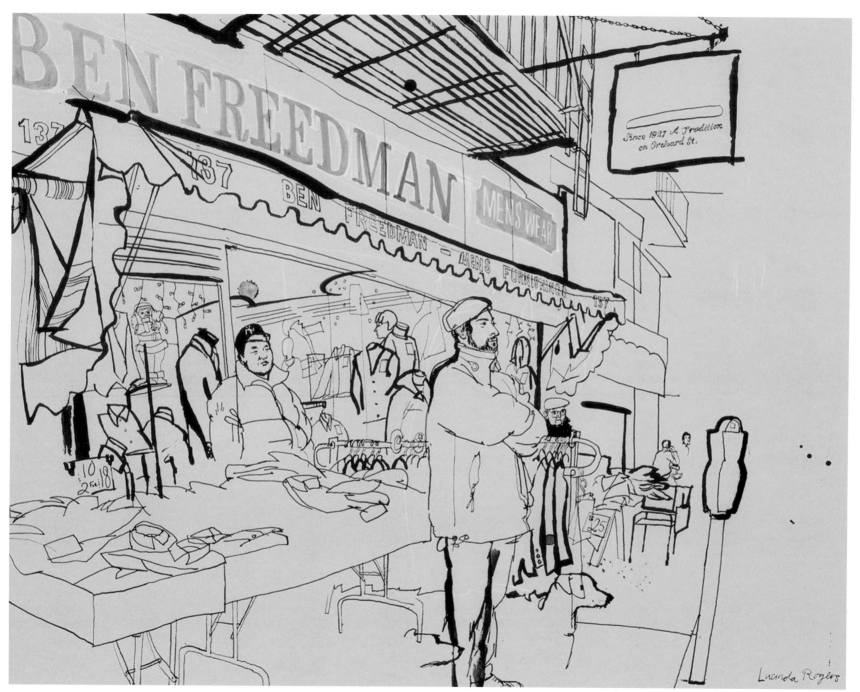

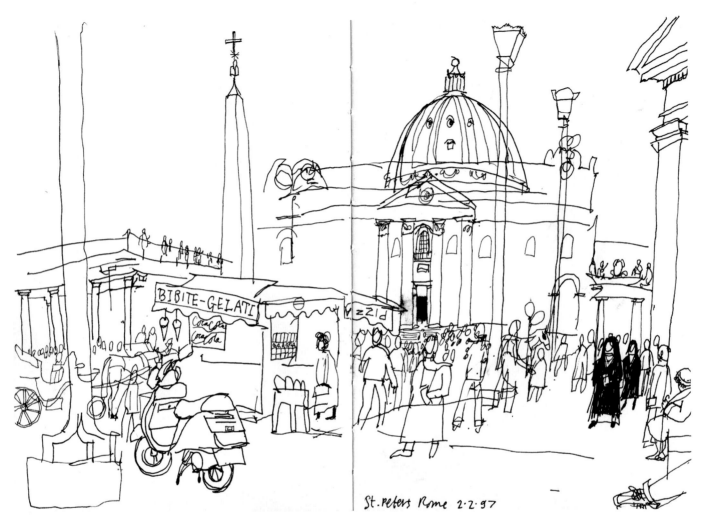

St. Peters Rome 2·2·97

drawings which, looking back, were a sort of blueprint for the work that would follow.

Sitting so often on some corner for four to eight hours makes me feel part of the profound life of a city. Brief relationships can be made with other people who occupy the same street—stallholders, shoe shiners, delivery men, sweepers, cops—and passersby who stop to look or comment. In the case of New York, I began to feel very familiar at ground level. By now I can recognize New York from fragments in photos or film clips because I am so used to staring at its windows, walls, pavement slabs and corners.

More recently I found that London, where I live, also holds some interest as a subject; it took a while for the very familiar to make enough of an impression on me to want to portray it. Once the interest was unlocked, it led to a lot of drawings and discoveries of places and people that I had not thought about before.

I continue to draw in the same vein and plan to go to new places. A travel sketchbook taken alongside is a chance to do the most immediate and spontaneous work and is something to refer back to for memories and ideas. In all my more substantial drawings, I try to keep the looseness and spirit of inquiry of a sketchbook journal.

Lucinda Rogers

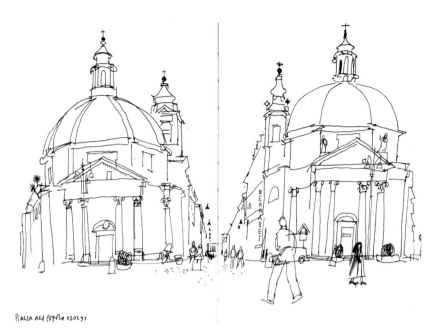

PIAZZA DEL POPOLO 020297

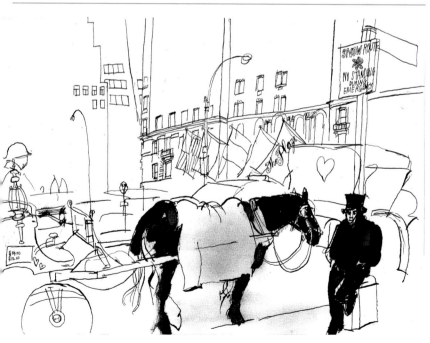

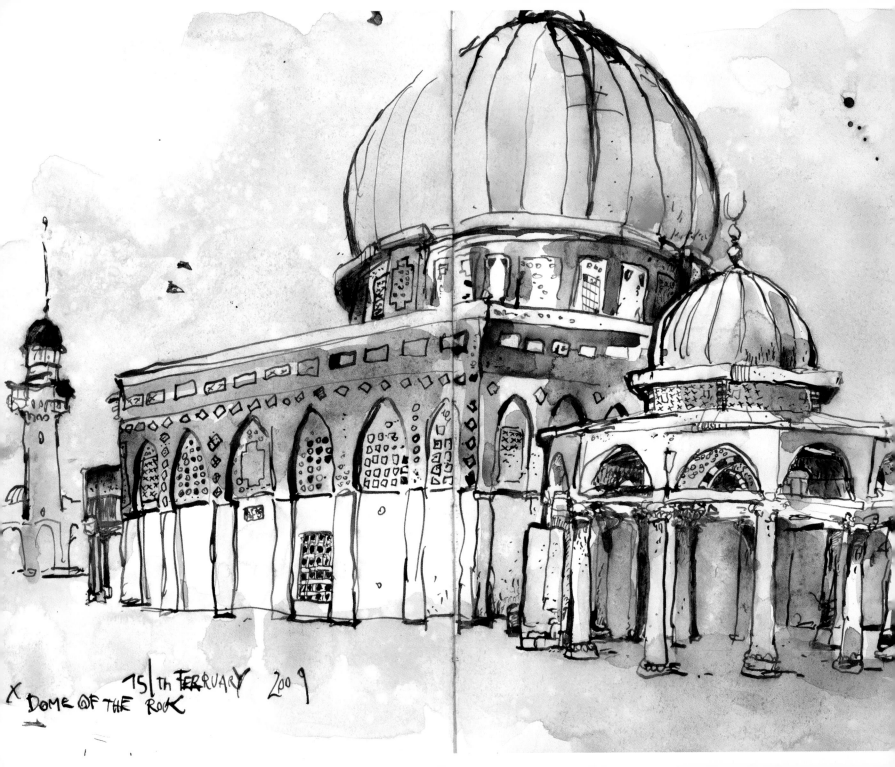

15/th FEBRUARY 2009
X DOME OF THE ROCK

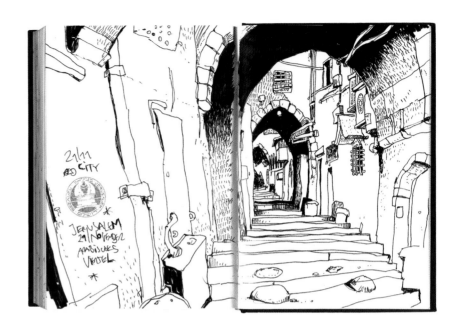

Felix Scheinberger

Felix Scheinberger was born in Frankfurt, Germany, and now lives in Berlin. He is a professor of illustration at the University of Applied Sciences in Münster. He has illustrated about fifty books and is the author of several books about drawing and illustration.
www.felixscheinberger.de

My career began in a land called boredom, a little town close to Frankfurt. Drawing was my first form of escapism. Like everybody else, I wanted to do something special: be a rock star, an artist, anything to stand out.

My drawing began intuitively. My art education was vicarious; my sister took drawing lessons and I copied everything she learned. And in school, this time was important because I learned how to bluff: Teachers never wanted anything special, there weren't any guidelines or anything similar. The only thing they wanted was hollow pathos in the spirit of the flower-power generation. This worked fine until I discovered, at seventeen, a cheap entry to pornography: Tomi Ungerer. His naked women in fantastic sexual poses left a deep impression, and as they had reached the heart of bourgeois German society, I could look at them without the shame associated with pornography. And they inspired me to draw more! At the time I was a semi-professional punk drummer. I drew record covers for our bands, and when I attended concerts, I drew the audience. When I was about nineteen, I had the inner conviction that I had to choose which path to take, drumming or drawing. And because I felt that I could express myself deeper through drawing, that's what I chose. I had flunked out of school, so I had to take an exam for gifted dropouts and was one of only two who were taken. And that's how I came to study in Hamburg with Klaus Ensikat. Since then my life is dedicated to drawing and illustration. Sixty books and more have followed.

Traveling is an integral part of my work. But I don't travel to illustrate, I illustrate to travel, and I travel to understand the world and my role in it. Spectacular journeys aren't what I am looking for. I want to depict things that mean a lot to me, and sometimes journeys don't evoke the feelings I am looking for. And I don't travel on the lookout for beauty. I look for real images, real emotions. So a journey to the Toscana just to draw terra-cotta paths seems like a waste of time. These images have been made a hundred times over.

I always have a sketchbook with me; I feel naked without one. This is especially important when traveling. One sees the world with different eyes when one is outside of one's usual environment. I can use the impressions directly for my work; different impressions become part of

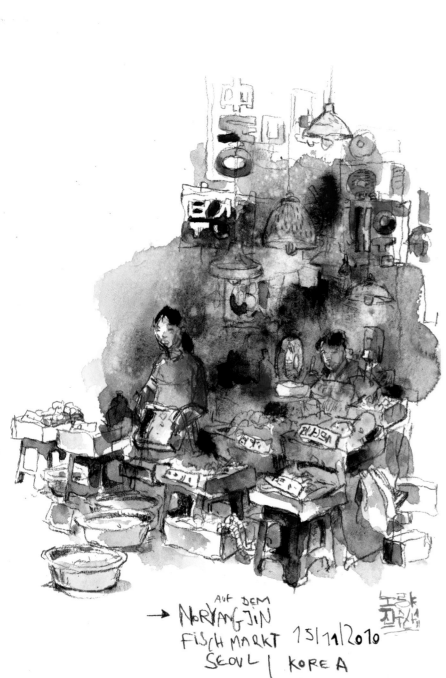

AUF DEM
→ NORYANGJIN
FISCH MARKT 15/7/2010
SEOUL | KOREA

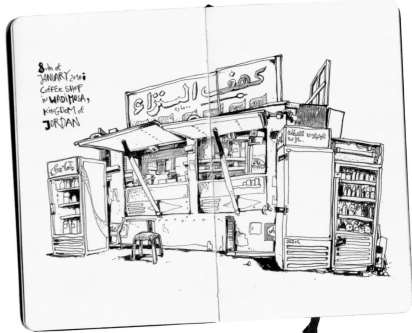

8th of JANUARY 2010
COFFEE SHOP
in WADIMUSA,
KINGDOM of
JORDAN

the reflection and drawing process. The world becomes a whole different place if you draw it. We all want to be a part in changing the world, and I see illustration as a means to this end. When I am in another country, the language, the food, the people, of course, all leave their marks in my drawings. And illustration is of course a mode of communication that is understood all over the world.

A great example comes to mind: When I taught in Israel, I was often in the Old City and drew there. An artist in the middle of the street can be a difficult experience in a culture where it isn't easy to depict humans. Once, an orthodox Jew came up to me, clearly enraged, and asked whether I had drawn him. Once I showed him my illustration, he began

discussing with me my use of color, my stroke. I was absolutely amazed. He saw that my drawing depicted authentic interest in my "object," and he felt complimented. Another experience I had included a group of religious idiots who ripped out one of the pages from my sketchbook. Here one can only see what happens when communication fails. I always tell my students that one doesn't have to care about others' critique when one is drawing, but one has to strive to be authentically interested. Not all drawings are meant for the public. One can always say one doesn't want to show the drawing, in some cases you just need good running legs. But drawing people is always a special experience. I follow my instincts and ask when I want to draw

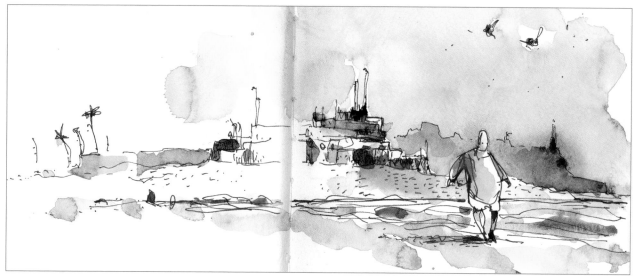

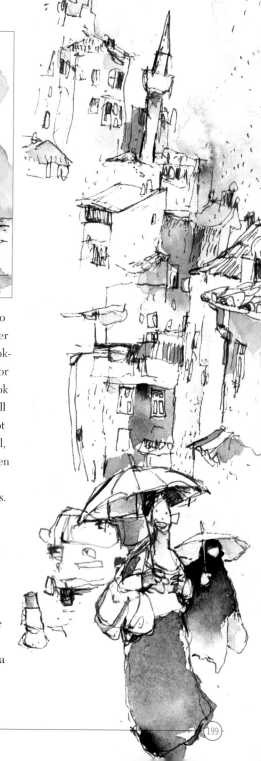

somebody. If I get a negative reaction, I also adopt different techniques of secrecy, especially when I am confronted with cultural borders. I play hide-and-seek, wear sunglasses and silly hats, things like this. But the world needs to be drawn, and people are the most important things in the world. Landscapes are different. I like drawing landscapes but take a special approach to perspectives, as if they have their own history, their own life. Crude landscapes without anything living in them are not as interesting as landscapes that tell a story through history, through ruins for example.

I never feel like a journalist. I draw because I want to reflect my surroundings wherever I am, and I want to reflect my role interacting with others. As a journalist, one usually has a job to do, one has an assignment. But I don't like working on assignment. Here's the difference: Once

I went to Istanbul with a great photographer. The assignment was to show the differences of perception between an illustrator and a photographer. While he had to wait a long time for "the right moment," I could create the moment for myself. Another time I had an assignment in Switzerland and everything was planned in great detail. I always had to be somewhere at some specific time. The publishers wanted specific motifs and other things. This had nothing to do with my kind of sketching and drawing. So I never travel to illustrate; I illustrate to travel! I need time to create time. I was once in a refugee camp for the purpose of drawing. It was a terrible experience accompanied by soldiers who kept looking into my sketchbook. The illustrations portray my own fears.

My sketchbook is my great passion and my home. When I am abroad, I have

my home with me and invite guests into my house. When I look at drawings after I come back, it sometimes feels like looking into a diary. I also use my website for this purpose. I post illustrations and look forward to reactions, but I never post all of my illustrations because some are not meant for the public. They are personal, intimate, and I keep them to myself even if their quality is awesome. I see the sketchbook as a stockpile of illustrations. I can choose whether or not I want to use them in one of my next books. But the sketchbook is first and foremost my personal work space and living space.

This personal aspect also applies to my choice of material. My sketchbooks are always small, A5 max, and I take the minimal amount of drawing materials with me, just the basics: fine liners and a small palette of watercolors. That's it.

I simply love watercolors. Markers

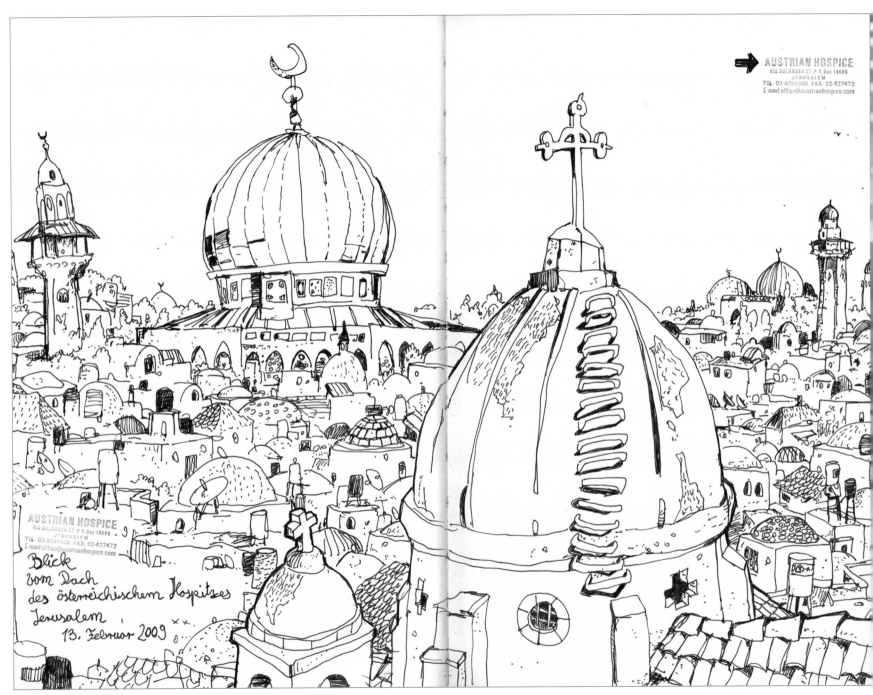

AUSTRIAN HOSPICE
VIA DOLOROSA 37, P.O.Box 18460
JERUSALEM
TEL: 02-8265800, FAX: 02-627472
E-mail:office@austrianhospice.com

AUSTRIAN HOSPICE
VIA DOLOROSA 37, P.O.Box 18460
JERUSALEM
TEL: 02-8265800, FAX: 02-627472
E-mail:office@austrianhospice.com

Blick
vom Dach
des österreichischem Hospitzes
Jerusalem
13. Februar 2009

can't compare! And one's materials can also be an expression of personal creativity. One can also use things one finds; coloring with coffee, red wine or fruit juice can be a lot of fun and the result is always unique. I also like to use things I find such as bus tickets or restaurant receipts. And my material is never expensive. I don't want to worry about making mistakes or being wasteful. I like mistakes. Some can lead you in completely new directions. It's like at home: I don't want to drink out of crystal glasses. One can easily develop a fetish for material, and I don't want to develop this fetish. One needs to be free. Sketchbooks are a way of thinking—a way of life if you want. Clients might want perfection, but my sketchbook is not driven by customers. When clients want a certain image, I don't want to Google the image and then copy it in my style. I want to experience it myself. My technique in my atelier can be a lot more stressful, and here I need to see the free work and develop my illustrations from there. The really good illustrations come from freedom, and serendipity is a great part of freedom. When publishers want illustrations, they are under pressure themselves and hand on the pressure to the artists. Nothing exceptional can grow from too much pressure.

Teaching is also a part of my life. I teach students how to work with a sketchbook and try to tell them how freedom is the basis of artistic expression. I always take my students outside to

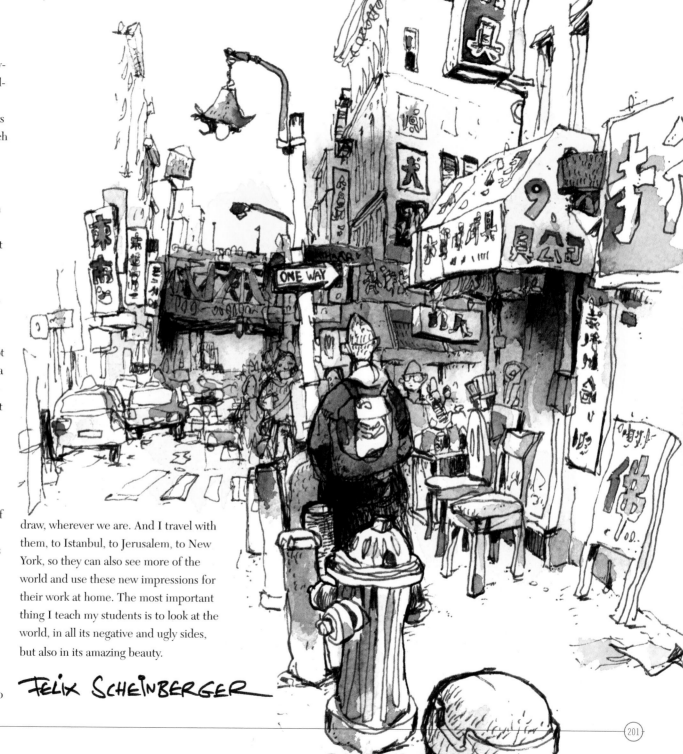

draw, wherever we are. And I travel with them, to Istanbul, to Jerusalem, to New York, so they can also see more of the world and use these new impressions for their work at home. The most important thing I teach my students is to look at the world, in all its negative and ugly sides, but also in its amazing beauty.

FELIX SCHEINBERGER

Shields Library, UC Davis

Pete April 6, 2010

Pete Scully

Pete Scully was born and brought up in the North London suburb of Burnt Oak, but he married an American girl he met in the south of France and now lives in Davis, California. He works for the University of California and has been the Davis correspondent for Urban Sketchers since its inception in 2008. **www.petescully.com**

I was born and grew up in Burnt Oak, North London. The love of travel was instilled in me early, borne of a desire to get away from Burnt Oak. I spent a lot of my childhood sitting at my bedroom window, looking out at the dull orange rooftops and the gloomy gray clouds and the damp drizzly rain, drawing for hours and hours. I knew I was incredibly lucky to be in London, and I couldn't get enough of day trips down to the Natural History Museum or riding a boat down the Thames, but I always wanted to see the world, and so I drew pictures of it.

I still have a little self-made booklet called *New York*, made out of cheap A4 paper stapled together, drawn at age seven in red ballpoint pen. It's full of mile-high skyscrapers, airplanes, the Statue of Liberty, people everywhere pointing at the sights and, of course, Big Bird (my main reference point for the city back in 1983).

I started to draw as soon as I could hold a pen, and I hold my pen in a "funny" way. At first my teachers tried to correct that, but I could write and draw faster than anyone in my class so they left me to it, and I drew and drew and drew. I was never short of felt-tip pens and always had lots of paper—my parents encouraged me to draw as much as I wanted. Drawing became my life-long friend.

One of my big regrets is that in all of the traveling I did in my late teens and early twenties, I did not carry a sketchbook with me. I often wish I could go back in time and put a sketchbook in my hand on every one of those trips I took. I wrote constantly, whole books of writing about everywhere I visited, but I can remember when I finally realized that I could better capture the feeling of a place through drawing. It was in 1998, sitting on a hillside in Prague, classical music wafting over the rooftops, when I interspersed my diary with a quick scribble of the castle overlooking the city.

I spent five weeks traveling around Europe that summer, but of all the photos I took and journals I wrote, that single drawing stands out the most in my memory. It wasn't particularly good, but that wasn't the point. A couple of years later I was on a trip to Venice and I noticed how almost every single person spent every single moment looking through their camera lens, but hardly ever with their own eyes. I remembered something one of my university professors had told me: that

Pete

people go to cities and take photos so they can look at the city when they get home, but it's better to look at it while you're there, and the best way to do so is by drawing it. With that in mind, I put the camera away and got out my guidebook. There was some blank space at the back, and so I filled it with drawings of gondolas, campaniles, masonry

and colorful houses.

After that, I drew whenever I traveled, even if it was just a scribbled page here or there in a Canson sketchbook. The point was never about creating a great drawing but about recording where I was. When you do that in words, you are limited to the vocabulary and expression of your language, but with drawings,

regardless of your individual style, the message is universal. It's a language we can all relate to.

Now I live in America—not New York, but Davis, California. My Californian wife and I emigrated here in late 2005, leaving my family, friends and football behind. It was after moving to the West Coast, with its incredible light and friendly open

attitude that I started to draw incessantly and to post my work online.

Since I left London, I have begun to realize that I see myself as in a constant state of travel. I feel the need to record on paper, in my sketchbooks, to capture the where and when that I am in. I see my new home through outsider eyes, taking immense pleasure in those things

The House of
Dr. Samuel
Johnson
17 Gough Square
London

Dr. Johnson's chair from
the Old Cock Tavern. It's very
thin! He would watch cockfights...

Hodge the Cat whose statue is outside it family

original prospectus of Johnson's dictionary (the pages are the only manuscripts!)

December 17, 2010

Anna Williams' room

She was a close friend of Dr. Johnson & lived here after an operation when last her blind...

"when a man is tired of London, he is tired of life, for there is in London all that life can afford."

uc davis, a cold sunny january

e street, davis — still sunny, less cold

1st street, davis — sunny cold but mellow

LUNCHTIME SKETCHES

pete, jan 28-09

pete, jan 29-09

pete, jan-30-2009

FINANCIAL DISTRICT

CHRONICLE

SF

Battery St. Pete 5-15-10

Kearny St.

Post St.

UNION SQUARE

Union Square, SF

VIPINS
CARDS BOOKS
STATIONERY
GIFTS

PARKER

FAX SERVICE!!

Christmas

pete
dec. 29, 2010

a fire hydrant! at heathrow airport, in dayglow orange

HEATHROW, about to board US Airways flight to Philadelphia + on to Sacramento... Bye bye Europe, for now!!

that may seem like ignorable everyday objects (fire hydrants or newspaper stands) to the local, but to me are a daily reminder that I am on "the other side of the world." On top of that, every time I go back to England I see that country more and more with traveler's eyes, wanting to sketch every postbox, every brick terrace, every old pub, all of those things that are no longer in my "every day" in California.

I like to focus on the character of any place I visit, something that represents it more than just the usual sights. I think things can generally look more interesting if they are drawn, because you get the human rather than the digital-camera version of events. To be honest, Davis appears a lot more interesting to me through drawings than through anything else. I always say, everything is interesting *if* you take an interest in it.

The point is to capture the experience of travel itself, but the temptation is to draw the sights. If you have wanted to go to Paris your entire life, do you feel like you've cheated yourself if you don't draw the Eiffel Tower at least once? Or do you focus on that cute little boulangerie hidden away behind your hotel, or the street signs, or the entrance to the Metro, or the old man sitting outside the café? All of these things say Paris, so you don't have to leave them out in favor of the sights. In my sketchbooks, though, I do try to balance them. In Lisbon I drew Rua da Bica's famous yellow tram

and sweeping view, but I also drew some empty Portuguese beer bottles littered there from the night before. Both together told the story of the place. Therefore the travel sketchbook becomes a place to tell a story about where you travel. It's not a photo album.

Having spent time really looking at, observing, capturing a place, you feel a little ownership over it. If you snapped a photo and moved on, well, it's just a photo, but with a sketch you have become part of the place. You may go back years later, and the memories that come flooding back will be the ones you captured on paper.

When deciding what to draw, I think mostly about the story I'm trying to tell. Sure, get that famous building in there, but don't leave out the newspaper box. Urban furniture is beautiful. One of the things I used to do is always make sure I have a great place to sit (or stand) first, preferably in the shade, and then decide what I can draw, but doing so limits me. These days I will draw almost anywhere, if it means getting the right view of something I want to draw. People go around me. They usually don't mind. I've been tempted to stand in the road, but I think they have laws against "jaysketching" over here.

When I travel with family or friends, I always have to carve out some drawing time. I find it harder to draw when I'm with others who aren't drawing, because I'm always anxious about the time,

at Little Prague, Davis Pete 10-8-10

at Little Prague, Davis Pete 10-8-10

Tonight I went around the Davis 2nd Friday Art About, saw some very interesting art, went to Art's Reader + started ukulele dude Gary, and then by chance caught a book-talk by former Davis mayor (!?) Michael Corbett (a bit taller than Ronnie) who is an architect + has a very interesting book full of the sort of things that interests me greatly. (not a great experience). Good night!

and it shows. Everyone who knows me understands I need to get off and sketch something for a while by myself, even for just an hour, or I might get grumpy.

My sketchbooks are very special to me, repositories of my emotions and experiences, like Tom Riddle's diary in the Harry Potter series. Bits of my soul are invested in them. I intend to look through them when I'm old and senile. I want to put them all on a shelf, but instead I keep them all in shoe boxes in the closet. I think of my sketchbooks as books that my son will read. After all, they show the world he lived in when he was born. If my drawings were all loose, I feel they would lose their cohesiveness as part of the story I am spending my life telling. I often draw frames around my sketches so that they have a graphic novel feel to them. I couldn't do that for a whole book though; it's better to mix up the styles a bit.

When out and about, I keep my sketchbook in a plastic zip-lock bag. I can't take any chances of it getting wet from rain or sprinklers or if I somehow fall in a pond.

One of my biggest rules is that my drawings must be in chronological order in my book. There are people who start their sketchbooks in the middle, or at

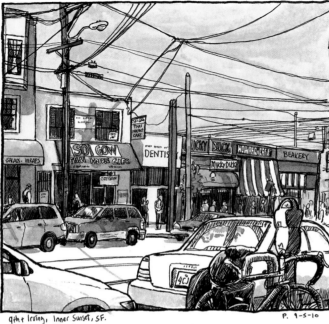

8:20 am, on the Amtrak (Capitol Corridor) P. 9-5-10

9th + Irving, Inner Sunset, SF. P. 9-5-10

Mission District, San francisco

Pete 2-2010

the back, or two pages in, but for me that presents a big psychological issue.

I love to give myself sketchbook assignments! I chose to fill one sketchbook front to back by drawing fifty fire hydrants and other pipes that come out of the ground. Every hydrant or metal pipe had to be different (it's amazing how many different breeds there are), and as I drew them I gave them personalities, names, stories. Now when I see them around town they are like old friends.

I prefer the Micron Pigma, the most reliable of all the pens I've used, though the nibs wear down relatively quickly on that watercolor paper. I always carry a variety of pens with me—far too many—

and whenever I travel I spend many more hours on my pencil case than I do on my suitcase. I usually use a H2 pencil to mark rough perspective lines, but often it's straight into pen. I focus mostly on the drawing, and then add some color with watercolor paints. I carry around a small box of Winsor & Newton Cotman Paints, and I always keep a fairly large palette in that small box. I typically use a regular brush with a little jar of water but have recently taken to the Koi Water-Brush, very handy in those situations where you don't have much room to work in, such as a crowded marketplace. I prefer to sit when I sketch, usually on a very lightweight sketching stool (from

REI) that I carry over my shoulder, but sometimes you feel closer to the street when you're sitting directly on the pavement. That's when street dust blows into your paints and gets into the sketch itself. Sometimes I will use a puddle of rainwater for my watercolors; that way I'm using local ingredients.

I also carry lots of paper napkins with me. The best ones, in my experience, are the ones from Chipotle; they do a good job soaking the water without disintegrating.

Keeping a sketchbook is about recording your world in the most personal way. I share my books online because I have been inspired by the daily online

sketch journals of others. I am not interested in being a great artist. Progress happens slowly, but if you draw consistently enough, and if you know what you like, you will eventually see your drawings improve. I love the fact that I have no idea what my drawings will look like in five year's time. Sometimes I have no idea what my drawings will look when I'm drawing them. And if you aren't sure what to draw, just step outside and draw the first thing you see. As you notice things you might like to draw, the world becomes a richer place to you.

Pete Scully

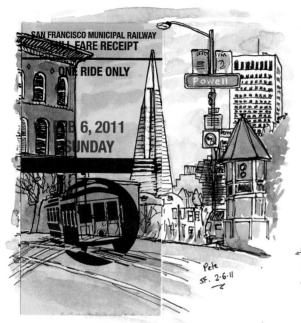

SAN FRANCISCO MUNICIPAL RAILWAY
FULL FARE RECEIPT

ONE RIDE ONLY

FEB 6, 2011
SUNDAY

Powell

Pete
SF. 2-6-11

Grace Cathedral,
Nob Hill, SF

Pete, Feb-6-2011

Fisherman's Wharf

Pete 2-21-10

LOS ANGELES

BLOCK
INTERSECTION

Breakfast
Cafe
PANTRY

@ Figueroa and 9th, Downtown LA

P. 9/11/10

The original Pantry
"Through a door which has no key you will
enter a café that has...NEVER BEEN CLOSED SINCE 1924"

@ 7th & Flower, LA

Pete 9-11-10

"Books alone are liberal and free; they give to all who ask; they emancipate all who serve them faithfully"

@ Grand + 5th

P. 9/11/10
LA City Library

Richard Sheppard

Richard Sheppard grew up in Colorado and Arizona and now lives in Healdsburg, California. Since graduating from Academy of Art University in San Francisco, he has illustrated books and theater posters, and he sketches a column called "Sense of Place" for a Sonoma County newspaper. **www.theartistontheroad.com**

When I turned twenty-one, I decided to take a break from school and move to London to explore the world and discover who I was. I had no inkling of the artist I would become. While there, I would sit for hours on rainy days and write in my journal. I went to London not only because it was a cool thing to do, but also because it was a time in my life when I had few responsibilities: no mortgages, kids or car payments. Why not travel and be free like the wind? Finishing college, I figured, would just have to wait.

When I arrived in London, I got a job as a hotel receptionist, and what I enjoyed most was meeting people from all over the world. I didn't have a clear purpose initially, but while there, I found one. I attended theater performances, frequented museums and discussed art with friends over coffee. That's when the idea of becoming an artist bubbled to the surface. I bought watercolors and started to paint but felt entirely too self-conscious. When it got down to it, I was even afraid of the word *artist* as it applied to me. But when I returned to the States, I signed up for my first art classes.

While attending the Academy of Art University in San Francisco, I had several talented and influential instructors. Howard Brodie was one. His sketchbooks and first-person accounts of world travel made a big impression on me. Man, could he draw! Since I had already caught the travel bug, I thought that traveling and sketching together like Howard did would be a dream come true. I signed up for his workshop in the hopes of learning his secrets about drawing. But he didn't focus much on the technical side of drawing and instead gave us insights on how to live life. Every day, while we were busy sketching a nude model, he would say, "Are you a sound or an echo?" He also quoted e.e. Cummings, "To be nobody but yourself in a world which is doing its best, night and day, to make you everybody else means to fight the hardest battle which any human being can fight." Although his workshop didn't give me the skills or the secrets to make drawings like his, it taught me that I was unique in the universe and to be true to myself by living life fully.

During my years attending the Academy, I learned the mechanics of drawing and sketchbooking from Barbara Bradley and Barron Storey. Both instructors

required sketchbooks and reviewed them with us regularly. I can still hear Barbara's voice telling me to first appreciate what I see and form an opinion about a subject before I begin to draw.

By the time I graduated from art school, I had not yet tried travel journaling, and the first time I attempted sketching while on vacation turned out to be a flop. My wife and I married in June 1999, and for our honeymoon, we went to Ireland. I practiced sketching from photographs for many days before the trip. But upon arriving in Ireland, I found that sketching from photographs didn't prepare me for anything other than sketching from photographs. I was too self-conscious to draw in public and ended up taking photographs the entire time. I kept telling myself that I could paint from the photographs when I returned home. It never happened. There is no substitute for learning to draw from life, out of doors. You can't fake it.

Three years ago, I started going out to sketch every weekend and became an avid outdoor sketcher. It took a while, but I was beginning to feel comfortable sketching in public environments. I sought out places where I encountered people less frequently, but at least I was out there doing what I loved.

In the summer of 2009, my dad and I discussed the possibility of traveling around Greece for three weeks. It sounded both frightening and exhilarating at the same time. Sketching in a

foreign country, in public with people around? Didn't I try this before and fail? What am I thinking? In spite of my reservations, we planned the trip and padded the itinerary with plenty of time for sketching.

Those insecurities certainly came up again once I arrived in Athens. It took me almost two full days to complete a drawing in public, but finally, on the second evening in Athens, I made myself take out my paints and sketch, in spite of the fact that there were people milling all around. I was nervous at first but by the time I finished that first sketch, I felt a sense of relief. No one laughed at me or made rude remarks. In fact, people actually seemed interested in what I was drawing. From then on, I had enough confidence to go on with my plans of sketching Greece. By the end of the trip I felt completely relaxed. I didn't care if people were watching me, I was happy to be sketching. When I returned home, I wrote a book about my travels, *The Artist on the Road: Impressions of Greece*. I included drawings from my Moleskines, spiral-bound books, watercolor blocks, even loose scraps of paper, and I published them as a travel sketchbook journal.

Sketching and writing are now a part of my day job. For the past twenty years, I've created illustrations for college textbooks, business books, cookbooks, quilting books, children's books, theater posters and more. It's a whirlwind of

subjects and media, and keeps me on my toes. But nothing compares to my love of sketchbooking. Sketching gives me a purpose and creates order out of my life's chaos.

I have at least two different sketchbooks going at all times: one for observational, out-of-doors drawing and one for conceptual drawing. Both are equally important to me as I weave my stories into both sketchbooks. I reserve my conceptual sketchbook for my eyes only. This private place is where I create drawings for a series of etchings I call "Communities." I don't worry about how these sketches look because they are not in their final form. The best ideas from this sketchbook blossom into finished, full-color etchings.

I love sketching in books but have never found one that I'm completely happy with. I prefer paper that can hold heavy watercolor washes and most can't. Hot press paper is my favorite because I like the way the paint floats on its surface, creating water effects and keeping the colors vibrant. I don't much care for spiral-bound books, but I use them anyway because the paper is better than bound books and the pad can be folded behind itself.

Before I traveled to Greece, I prepared for the trip by sketching out of doors as often as possible to test materials. That's when I designed my current kit. I use an 1/8-inch-thick Masonite board as my base with water cups

clipped to one end. I use a children's paint set, soak out the cake watercolors and replace them with Winsor & Newton pro watercolors. I don't much care for cheap brushes so I've designed a way to carry my sable brush by placing a piece of kneaded eraser in the corner of the paint set to hold my brush in place. I've been using this kit for over two years now, and it's worked well for me.

I use a simple selection of art supplies. I'm not big on experimenting with too many things, but occasionally I like to add a new color to my palette or try a new pen just to mix things up a bit. For drawing, I use a technical pencil with HB lead, and I occasionally use colored pencils, too. For ink drawing, I use Sakura Pigma Micron pens of all sizes.

I find it inspiring to travel to unfa-miliar places to sketch. I think travelers experience a place differently than some-one who knows the place intimately. I've run up against this problem sketching locally because I'm too familiar with my surroundings. But in an attempt to get beyond this familiarity of place, for my next book, *The Artist on the Road: Impressions of Wine Country*, I've decided to do all my traveling by bicycle.

So far, I'm seeing all sorts of new things and places that I would never have ex-plored if I was in a car. It provides a new perspective; what was old and familiar is new again. I believe that's one of our jobs as sketchers: to find the ordinary and make it extraordinary.

Richard Sheppard

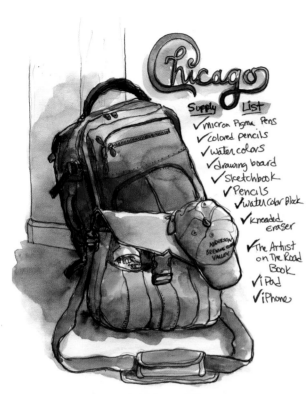

Chicago

Supply List

- ✓ micron pigma pens
- ✓ colored pencils
- ✓ water colors
- ✓ drawing board
- ✓ Sketchbook
- ✓ Pencils
- ✓ water color Block
- ✓ Kneaded eraser
- ✓ The Artist on The Road Book
- ✓ iPad
- ✓ iPhone

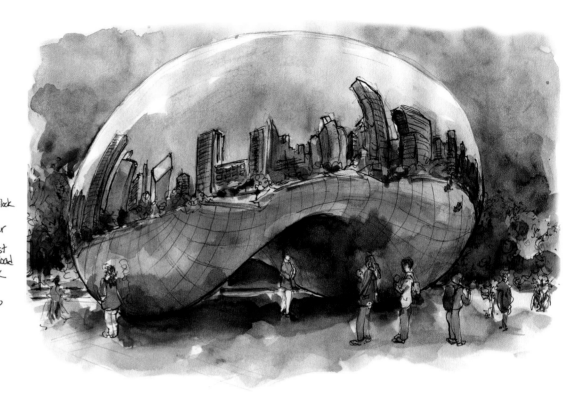

SONOMA COUNTY AIRPORT

CHARLES M. SCHULZ

SKY LOUNGE RESTAURANT

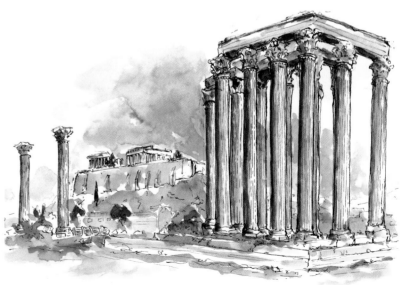

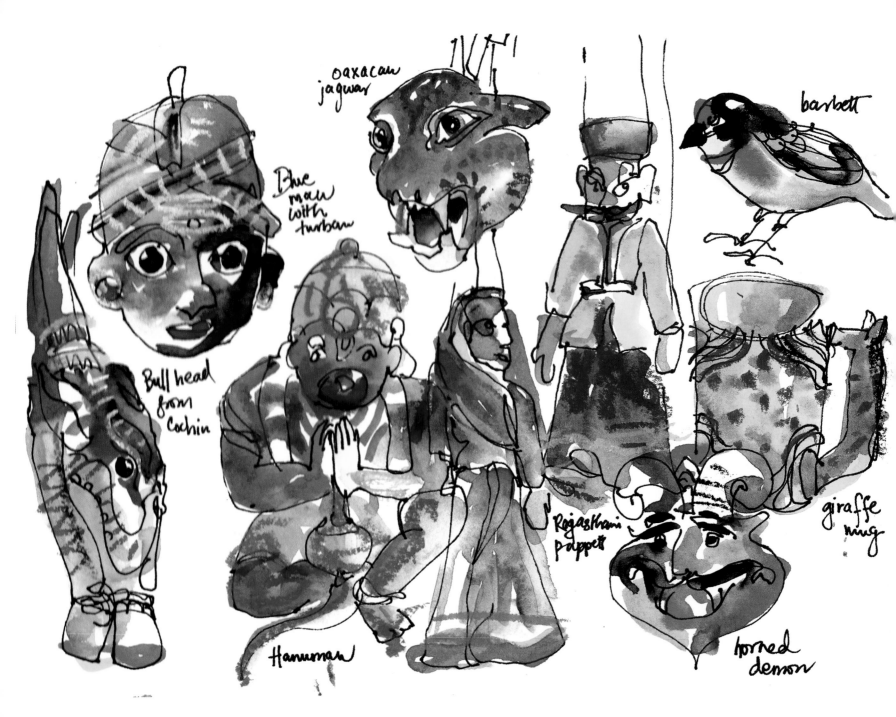

oaxacan jaguar

barbett

Blue man with turban

Bull head from Cochin

Rajasthani puppet

giraffe mug

Hanuman

horned demon

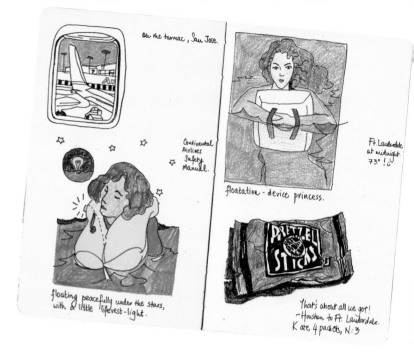

On the tarmac, San Jose.

Continental Airlines Safety Manual.

floating peacefully under the stars, with a little lifevest-light.

floatation - device princess.

Ft. Lauderdale at midnight. 73°!

PRETZEL STICKS

That's about all we got! – Houston to Ft. Lauderdale. K ate 4 packets, N: 3.

Suhita Shirodkar

Suhita Shirodkar grew up in India and now lives in sometimes-sunny Northern California. She is an art director, freelance illustrator and an obsessive sketcher and traveler. **www.sketchaway.wordpress.com**

I grew up in the city of Bombay (now Mumbai) in India, and I drew obsessively as a child. When it was time to choose what I would do in college, I just had to go on to art school, but I decided to make the "sensible choice" and chose the only kind of art I could see making a living off: graphic design. I went on to work in advertising and moved to the United States in my late twenties. I still work as an art director and live in San Jose, California. For me, graphic design started as a way to keep drawing and art in my adult life, and somewhere along the way drawing was pushed to the side. Everything I produced was born on a computer. Ironically, art school marked the beginning of a long chapter in my life during which I did not draw.

I clawed my way back to sketching eight years ago, when I spent a couple of years in New York City. Anyone who has once drawn and then stopped knows how painful it is to get back after a long break, to plod through drawing until the lines flow again. It is hard to look at those first sketches without being completely critical of them. I was almost there, starting to enjoy the process, when I dropped off again.

A few years later, when I was mother to two little kids under the age of five, I decided to give it another shot, another painful start. I had a family and worked full-time. There was practically no time for another activity in my life. Little sketches in a book I carried around were a simple way to carve out a little time to do something I loved, just for myself. Sketching in my books literally helped me maintain my sanity. And just like that, I was sketching again.

It took a trip to Oaxaca, Mexico, to truly get me back to sketching. (Sadly, that Moleskine is now missing, and all I have are low-res images of its pages.) I now know what it takes to get me excited and inspired to sketch: color, cities, chaos, high-energy scenes. Give me some combination of these and I can get lost in my book. I love the madness

of a bazaar in India, coming up from the subway in Chinatown in New York or the color of a city plaza in Mexico. The pristine, the classically beautiful—I can see how they are lovely, but they don't excite me the way city life and travel do. Give me a smelly, crowded market over rolling hills and pastures any day.

Which brings me to my big challenge with sketching. Because of my responsibilities, travel is much more the exception than the rule. Keeping at sketching when I'm not traveling is a challenge. I have noticed though, that by sketching regularly, I began to see things differently. I discovered that the lessons I'd learned through sketching while I traveled stayed with

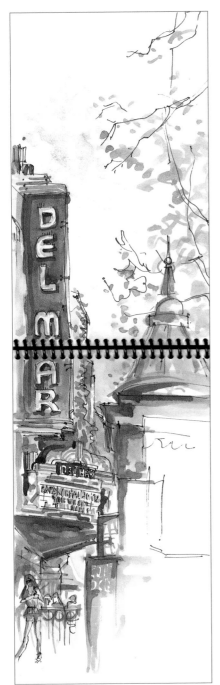

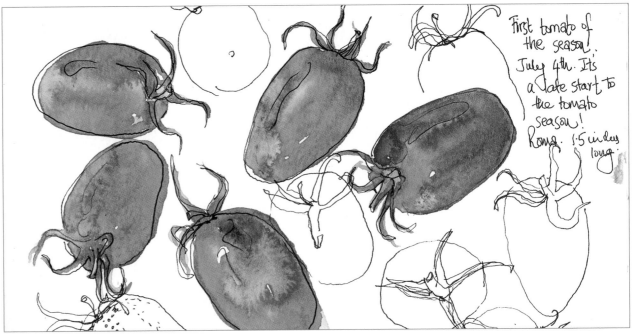

First tomato of the season! July 4th. It's a late start to the tomato season! Roma. 1.5 inches long

me: Looking closely and deeply; looking at even the everyday stuff around me with fresh eyes, as if I had never seen it before. Suddenly everything was exciting: The fire hydrant in our quiet suburban neighborhood, the garbage and recycling trucks my son obsessed over, my melon-flavored bubble tea, the coffee shop full of programmers all bent over their laptops (a very common sight in Silicon Valley) all became sketch worthy.

Does sketching like this feel the same as traveling and sketching? On the best of days, it comes close, but most of the time, nothing for me equals that magic mix of traveling to and sketching a new place. But I plan to keep drawing until I figure how to incorporate more travel in my life.

That way, I'm ready for those amazing places when I finally get there.

Sketching has changed the way I travel. My idea of a "packed day" (and yes, I love to pack as much as I can into my travel) used to be to see as much as I could in a day. Now my perfect day would involve seeing far less, but seeing it deeply through drawing. When I sketch, I get to know what I sketch well—not just its shape and color, but how the light falls on it, how it speaks to me just at that moment. In a successful sketch, I manage to capture some of those ephemeral qualities and not just a likeness of what I see.

Drawing has also broadened what I consider interesting. Before I drew, I would have been bored to tears at, say,

an aircraft museum. Neither vehicles nor wars interest me, and most exhibits in an aircraft museum involve both. But the Seattle Museum of Flight Aviation History was a fun experience with my sketchbook. My husband and two kids explored every flight simulator and aircraft. I never got beyond the first room of gorgeous vintage airplanes—such beautiful lines and color.

I'm not shy to draw in public anymore. (I was when I started out, but it soon became so limiting to be shy that I had to get over it.) And I've met the most interesting people because I sketch. There is something totally fun about setting up to sketch in a small town in India: Almost instantaneously, crowds of people appear,

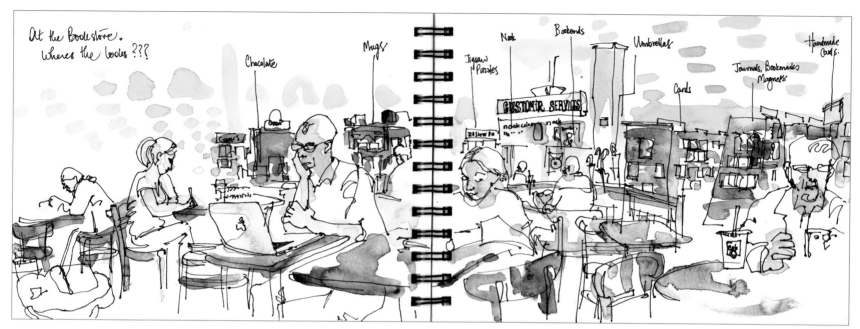

At the Bookstore.
Where the books ???

Chocolate

Mugs

Jigsaw Puzzles

Nook

Bookends

Umbrellas

Cards

Journals, Bookmarks, Magnets

Handmade Cards.

CUSTOMER SERVICE

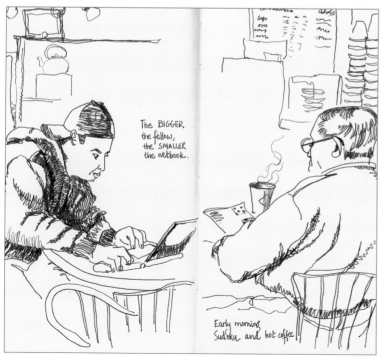

The BIGGER the fellow, the SMALLER the netbook.

Early morning Sudoku and hot coffee

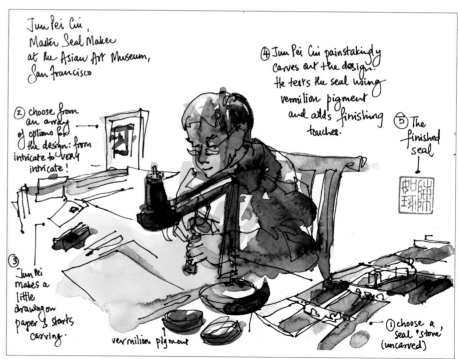

Jun Pei Cui, Master Seal Maker at the Asian Art Museum, San Francisco

④ Jun Pei Cui painstakingly carves out the design. He tests the seal using vermilion pigment and adds finishing touches.

② choose from an array of options for the design: from intricate to VERY intricate!

⑤ The finished seal

③ Jun Pei makes a little drawing on paper & starts carving.

vermilion pigment

① choose a seal "stone" (uncarved)

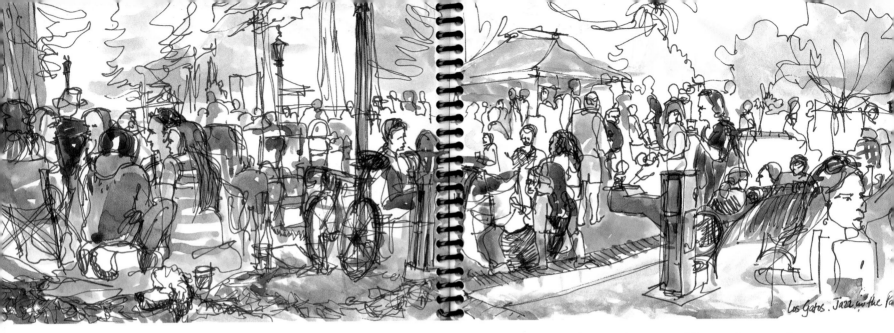

Los Gatos. Jazz in the Pa[rk]

and they stay (and comment unabashedly) through the hour that I sketch.

I rarely sketch with someone. It is, almost always, a solitary activity for me. My "sketch buddies" are virtual friends: They are the group Urban Sketchers. Discovering Urban Sketchers was a turning point in how I thought of my sketchbook. I finally found a bunch of people who, just like me, enjoyed recording from life in their sketchbooks with no other purpose for those sketches in mind. And I thought I was the only strange person who did that.

I am not loyal to a particular sketchbook brand and am always on the lookout for the perfect sketchbook. It's hard to get just the right combination of paper and size that works for how I sketch. And it does help if it's not terribly expensive, because I don't like my sketchbooks to

be too precious. If I have to consider whether it's worth starting a sketch, I probably spent too much money on my book. I started out sketching with any black pen I could find and Prismacolor pencils. But I soon moved on to watercolor. I love its fluidity and its wild do-its-own-thing nature. My sketch kit consists of a couple of books at least (so I can lay one aside to dry and quickly switch to the other and not have to wait to turn pages), Sharpie Ultra-Fine Pens (not only are they waterproof, but the ink flows almost too fast: if I ever pause, the pen makes a little blotch—which I love—and marks every pause and turn in my drawing). I go between writing more and less in my sketchbook. The more layered and dense a capture is, the less I tend to write. At that point, a spread in my books becomes like a page of writing: You can delve

into it, look in and see different things, discover interesting snippets.

My sketchbooks now fill a shelf of my bookshelf. It's great to see them build up to a body of work over the years. I like that they're not overly precious to me, but I do miss the one book I've lost. A sketchbook is now the best record you can find of a time in my life: By looking at them, you can tell what I was obsessed with, what preoccupied me, what I was trying to solve, whether I was calm or harried, what inspired me at that time. I went through an obsession with high-tension electric wires, factories and chain-link fences and with capturing the uneasy quiet and uncomfortable perfection of suburbia. It's nice to look at those books once in a while and to see what I did then compared to where I am now. They mark the passage of time and hope-

fully, record my growth as an artist.

I once heard a fellow artist say something that really stuck with me: If you truly loved doing something at age five, it was probably worth doing the rest of your life. I loved to draw as a kid, just absolutely loved it. I remember agonizing when I was three years old about how to draw four legs on an elephant and make it look real and how to draw all the people on a Ferris wheel without having them turn upside down at the top. I guess I just took a couple of decades off, but I'm back to drawing now. And I still love it like I did when I was a kid.

Suhita

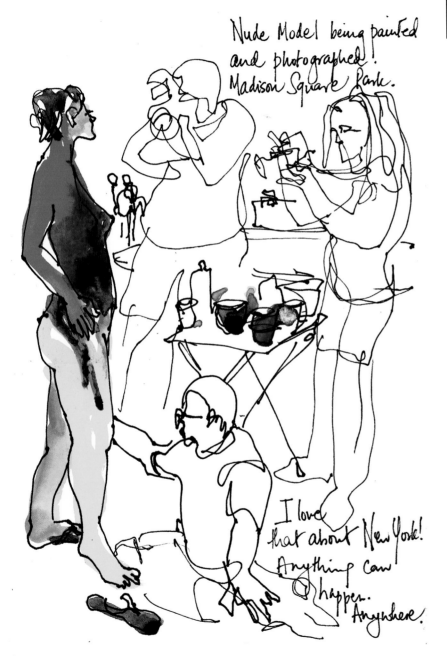

Nude Model being painted
and photographed!
Madison Square Park.

I love
that about New York!
Anything can
happen.
Anywhere.

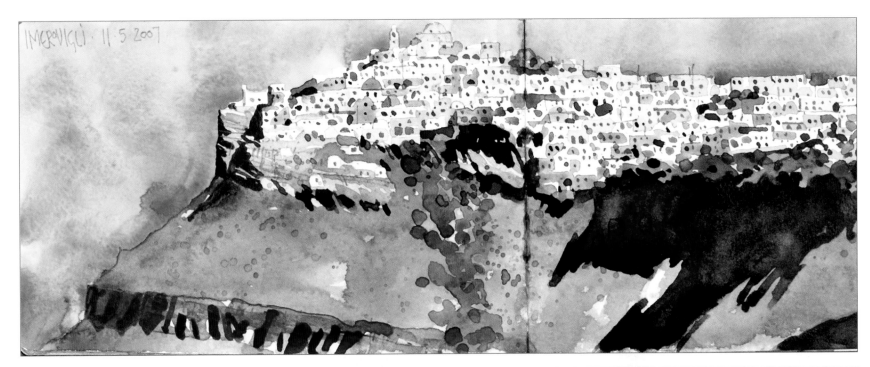

IMEROVIGLI · 11·5·2007

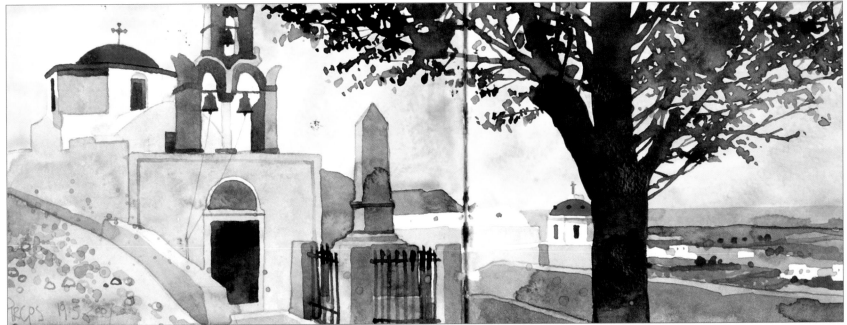

ARGOS 19·5·2007

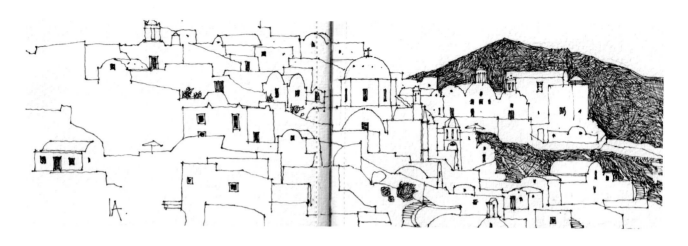

Ian Sidaway

Ian Sidaway was born in the Industrial Midlands of England; he now lives in London. He was trained as a designer and is author of over thirty books on art technique. **www.iansidaway.com; www.iansidawaydrawing.blogspot.com**

I was born in the Industrial East Midlands into a family of miners and clay workers. My passion was the great outdoors and collecting bones, birds eggs, nests and pressed flowers, and in the 1950s and early 1960s, believe me, not many working class boys did that. These are the things I would draw and I hoped to pursue that interest by working either in the Nature Conservancy or the Forestry Commission. Both required academic qualifications that were beyond me, so I went to art college as a way of entering either of these organizations through the back door, possibly as an illustrator. Once at art college, design became my metier, and after four years

of study I found myself working as a designer at an advertising agency in London, a job I disliked. There followed a period of freelancing during which time I began to paint. I guess I dropped out before I ever dropped in.

Painting became a passion, and I worked as a gardener, carpenter, builder, painter and decorator in order to subsidize making artworks. Fortunately, my father, possessed of that wonderful postwar "make do and mend" ethic, taught me much about all of these things. Gradually, success of a kind did come, and I exhibited and sold well. I drifted into portraiture for a time, then into illustrating books and magazine articles on a wide

range of subjects, including food, travel, gardening, fishing and knot tying, to name but a few. I also began to illustrate practical art books. This work taught me much about technique, and eventually I was asked to write and illustrate my own series of books that featured drawing, watercolor, oils and pastels. Over the next fourteen years, I completed thirty-two titles. I gave the publishers a complete package—text and images on film—but this project took all of my time, and making work for publication is not the same as making work to exhibit. Three years ago, I began to turn down offers from publishers and now, apart from magazine articles and product reviews, I spend my days very contentedly

producing work in the studio for competitions and exhibition, whilst listening to very loud music.

My wife and I have always traveled and I have always produced sketchbook work. I have used sketchbooks to work out ideas and compositions, as well as for straightforward observational drawing. I have done this in part because it seemed, as an artist, the right thing to do; it seemed a part of the process. However, it was not until a trip to the far north of Scotland in 2007 that something clicked. On that trip, I produced a complete volume of around thirty-five watercolors; they make up a solid, observed, self-contained record of the trip. Each page was part of the whole,

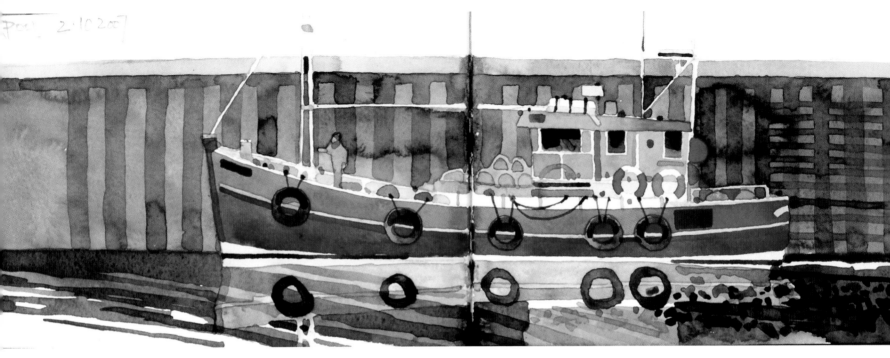

and the book was the finished article. Nothing new here, artists have been doing this for hundreds of years, but it was a breakthrough of sorts for me.

Looking at the book made me want to complete more, and I began to visually document my travels, near and far, in an attempt to produce a coherent volume of drawings or watercolors of trips made. The books are stored on shelves in the studio and are used regularly, as I often refer to them for ideas.

I am always looking for interesting images that I can potentially turn into a painting and, whilst I am ever mindful of the possibilities in any destination, it is not always my sole purpose for the visit.

I work constantly, however, on loca-

tion. The activity for me is best done in a subtle low-key way. I prefer to go unnoticed as much as possible, so I always travel light and try to use the bare minimum of equipment and materials. On occasion, I do work on a slightly larger scale but always in sketchbooks. I don't always finish the work on-site; I often complete images later in the hotel, bar, cafe, plane or train. Sketchbook paintings are often worked on at a later date in the studio. As long as the essence of the location and composition is in place and I have enough material to make the image work, I can move on. I almost always supplement drawings with digital photographs that I use as references for studio work later, but producing images

on-site makes you look much harder and I find that I can visually edit far more successfully when I have done so. Composition and design are very important to me, and I go to great lengths to make each page strong on both accounts. All of my studio paintings have their genesis in a sketchbook drawing or watercolor. It's where the idea starts.

I like to fill my books. I usually have two on the go at any one time. In one, I will work in watercolor, and in the other I make fine line drawings. I use these books for day-to-day work and for short day trips. But whenever I travel for longer periods, I try to produce a volume of drawings just from that trip. I have used many different brands of sketchbooks

over the years, but in recent times work exclusively in Moleskine watercolor sketchbooks for both watercolor work and fine line drawings. They stand up to frequent use, and I enjoy the challenge of making compositions work on the long rectangular format. Interestingly, working on this format does not translate to my studio work. Here the emphasis is on the more traditionally proportioned rectangle and the square.

I use various brands of fine liners but favor Copic Multiliners because I can replace the ink cartridge and the nib, which on the finer pens often wears down long before the ink gives out. I use a Pentel Graph Gear 1000 propelling pencil to very loosely sketch

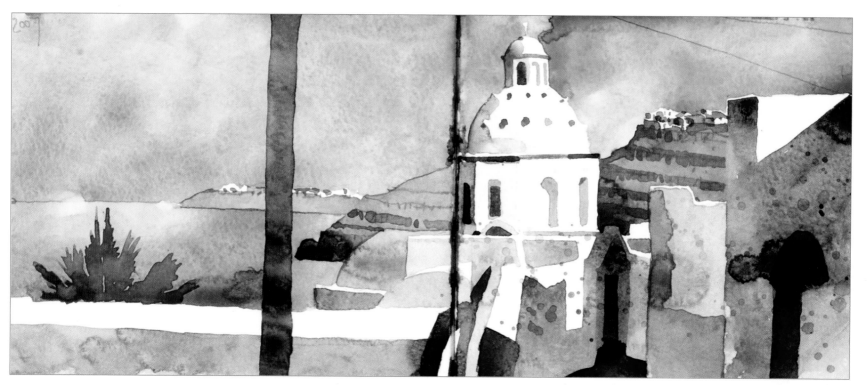

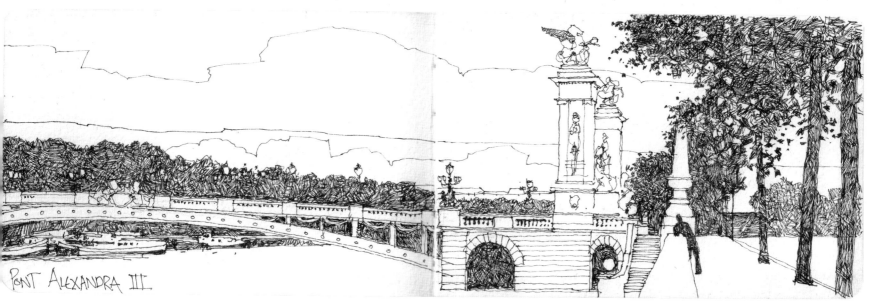

PONT ALEXANDRA III

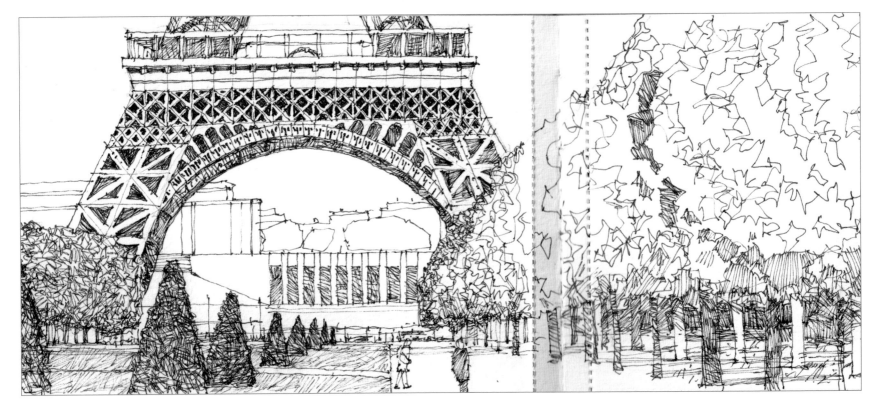

in a composition before using the fine liner. For watercolor work, I no longer work with a drawing but prefer to work directly in watercolor. I will, however, often work into a painting using graphite as it progresses. I have several Winsor & Newton watercolor boxes. For location work, I use a box containing sixteen whole pans or a smaller traveling box containing twelve half pans. I use a standard palette of colors: Cadmium Red, Alizarin Crimson, Lemon Yellow, Cadmium Yellow, Cobalt Blue, Cerulean Blue, Ultramarine, Viridian, Burnt Umber, Yellow Ochre, Payne's Grey and

Dioxazine Purple. I have a set of travel brushes, rounds and flats to which I add a small fan brush and a rigger. I use gum arabic in my watercolor mixes because it intensifies color and enables me to rewet and modify washes once they are dry. All this is carried in an old Billingham Bag, but at a push I can get most in the pockets of a jacket.

Much of the time I travel with only a small Moleskine and a few fine liners in my pocket. Only when I set out specifically to paint watercolor will I take a bag full of materials.

I tend not to write thoughts or notes in

my sketchbooks. I carry a diary and notebook for that. For me, the image tells it all. My work is not about my thoughts, hang-ups or prejudices but simply about what I see and my visual response to it and the potential to carry that forward into a studio work. Inevitably that response carries a degree of subjectivity, but the initial response is always objective. Currently my work is concerned with the rural and urban landscape, and while people do crop up in my work, they are of secondary importance. I often include them simply as a compositional device. However I will draw anything

that catches my eye in order to add variety to the book.

I have always loved the work of the so-called Norwich school, Cotman and Girtin, the watercolors of Charles Rennie Mackintosh and Paul Nash, together with the graphic works of Frank Newbold. All have documented the British landscape, and it is in that tradition that I would like to think that I follow.

Ian Sidaway

RIALTO MARKET

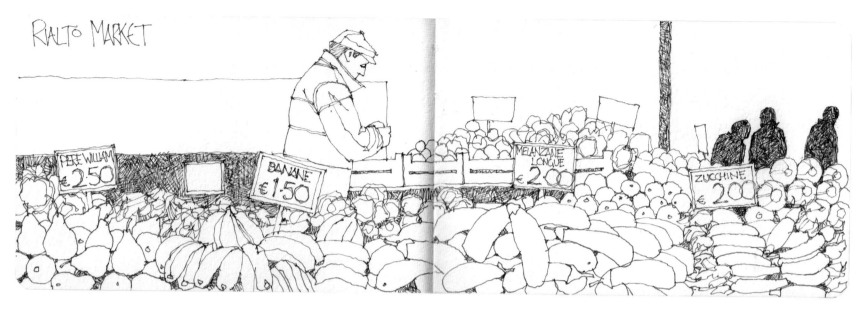

Text visible within the market illustration:
PERE WILLIAM €2.50
BANANE €1.50
MELANZANE LONGUE €2.00
ZUCCHINE €2.00

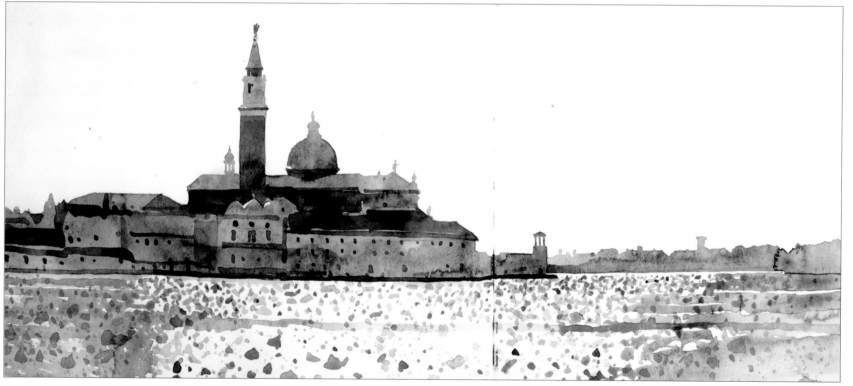

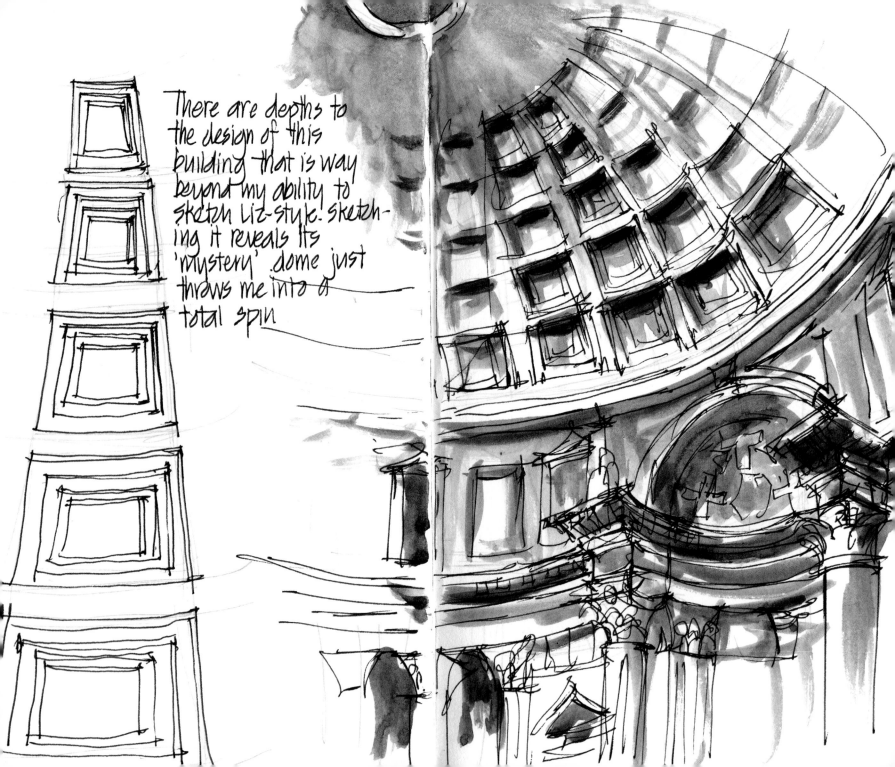

There are depths to the design of this building that is way beyond my ability to sketch Liz-style. sketching it reveals its 'mystery'. dome just throws me into a total spin

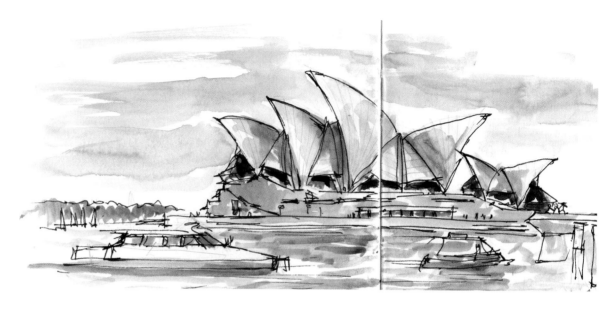

Liz Steel

Liz Steel works as an architect in Sydney, Australia and since discovering watercolors in 2007 she has not stopped sketching and painting her daily life. She has a great interest in architectural history and theory and seeks any opportunity to travel with her sketchbook. **www.lizsteel.com**

I was born in Sydney, Australia, and have lived here all my life and love it! I have always loved to draw but during high school, math was my favorite subject (a family trait), and I dropped out of art after one year because I spent six months drawing a spark plug. Although I entered my degree in architecture from a more technical basis, my love of drawing was soon rekindled, and it was during my student years that I started keeping travel journals. These early journals were mainly made up of little doodles of the funny things that happened and copious handwritten notes—and, just for the record, I am highly amused that even back then, cups of tea feature as an important event of the day.

Historically, travel and sketching have been an important part of architectural training, and this is something I longed to do but didn't know how. During the years 2000 through 2006, I went on a number of trips to Europe, and each time I took a sketchbook, which was still void of drawings when I returned home. However, as I was fascinated by the architecture I saw (being particularly interested in Renaissance and Baroque architecture), I undertook my own personal research projects on each building once I got home, sketching and notating from my photos. I really thought that it was impossible for me to have the

time or to develop the skill to sketch these buildings on location during a very rushed vacation. Yet that is what I longed to do. I was convinced that the best way to understand and learn from architecture was to draw it.

This quote from one of my favorite architects, Le Corbusier, really sums it up for me:

When one travels and works with visual things—architecture, painting or sculpture—one uses one's eyes and draws, so as to fix deep down in one's experience what is seen. Once the impression has been recorded by the pencil, it stays for good, entered, registered, inscribed.

The camera is a tool for idlers, who use a machine to do their seeing for them. To draw oneself, to trace the lines, handle the volumes, organize the surface ... all this means first to look, and then to observe and finally perhaps to discover ... and it is then that inspiration may come.

Then in January 2007, thanks to a friend, I discovered watercolor pans in a little field kit and just wanted to paint. And because my goal was to learn to use watercolor, the sketching part, for some bizarre reason, just seemed to happen.

For me, there is a very special connection between sketching and travel—when I travel I sketch better and when I sketch, the traveling experience becomes

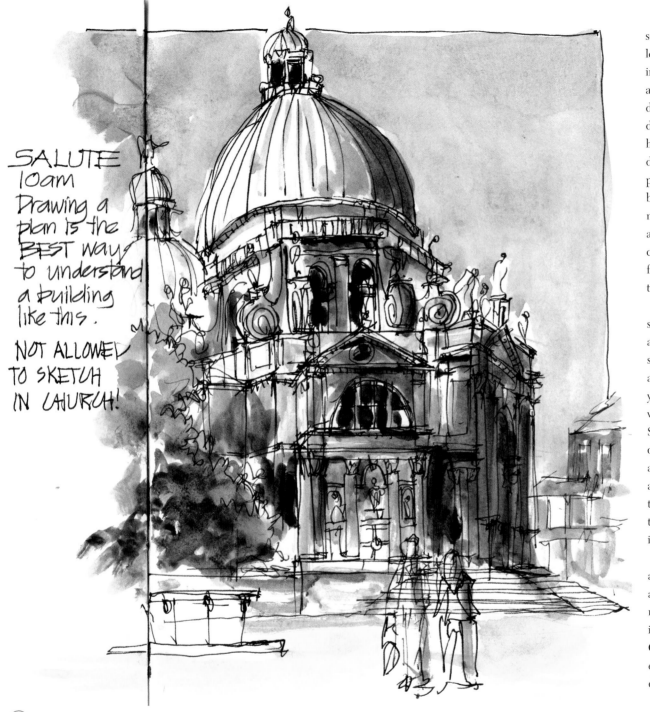

SALUTE
10am
Drawing a
plan is the
BEST way
to understand
a building
like this.

NOT ALLOWED
TO SKETCH
IN CHURCH!

so much richer. Sketching is all about learning to see and, when I travel I am inherently more aware of everything around me—everything is new and different (or strangely similar despite different locations and cultures). With heightened sensory perception and the desire to capture the moment on the page "right now," sketching seems to become easier when I am traveling. For me traveling is a license to draw anything and everything (including every single cup of tea, if I want to). It is a period of full-time exploration, and sketching is the perfect way to record this.

Because I have been working for the same firm for more than fifteen years, and thanks to Australia's wonderful system of long service leave, I have been able to take extended trips in recent years. In 2010, I had an eleven-week vacation traveling through the United States, United Kingdom and Italy. Most of this period, I traveled on my own—although I met up with many friends along the way—and was therefore able to sketch as much as I liked for an extended period of time. What an incredible experience it proved to be!

There is a great satisfaction in the achievement of traveling alone, putting all the pieces of an itinerary together and making all the decisions, and I feel that it is important to record this achievement. On my own, I am far more aware of everything around me and in continual dialogue with myself, and when I sketch

MORNING WITH JEANETTE

Drive around town + all recent buildings seen (its not a Gehry!) Got pen easily + then roam in museum.

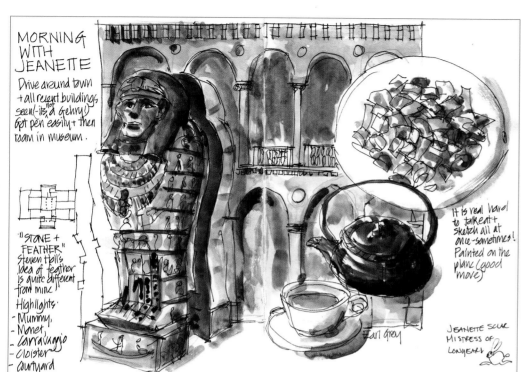

"STONE + FEATHER" Steven Holl's idea of feather is quite different from mine.

Highlights:
- Mummy,
- Monet,
- Carravaggio
- Cloister
- Courtyard

It is real hard to talk, eat + sketch all at once - sometimes! Painted on the plane (good move)

Earl Grey

JEANETTE SCLAR MISTRESS OF LONGYEAR

BREAKFAST
with Ea, Reza, Nina+ Jim (classic greeting in lobby!) To school with Melanie + Orling. Met Isabel Back to hotel + coffee with Omar + Jenn.

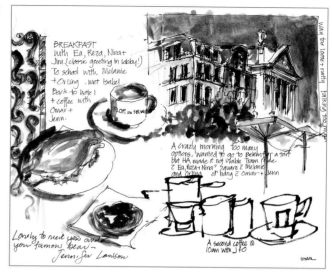

FLOR DEL SELVA

A crazy morning. Too many options. Wanted to go to Bakery for a tart but HA made it not viable. Team made 2 Ea, Reza + Nina? Square 2 Melanie and Orling. or Indry 2 Omar + Jenn.

Lovely to meet you and to you famous bear - Jennifer Lawson

A second coffee @ 10am with J + O

OMAR

North Atlantic Cod + Chips in Beer Batter, salad and Homemade Tartare Sauce

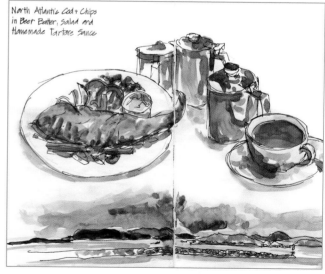

ROMAN TEA!!

namaste'y

VIA DELLA PALOMBELLA, 26 - ROMA (PANTHEON)
TEL./FAX 0668135660
E-MAIL namastey@namastey.it
www.namastey.it

HOW EXCITING! I found a TEASHOP! Girl in store confirmed that there is nowhere in Rome that you can get a proper cup of tea. of course I made a purchases.

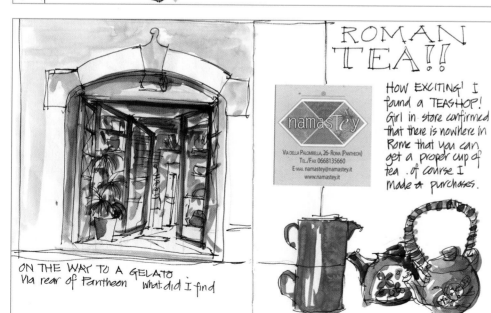

ON THE WAY TO A GELATO
Via rear of Pantheon. What did I find

IN SEARCH OF TEAPOTS...
none in Asia (surprising) but found a few in Africa!

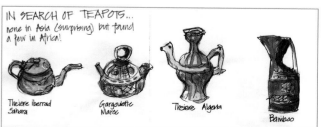

Theiere iberrad Sahara

Gargoulotte Maroc

Theiere Algeria

Bamboo

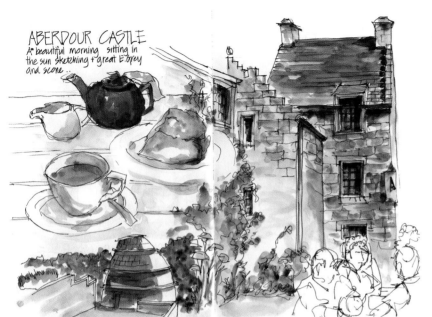

ABERDOUR CASTLE
A beautiful morning sitting in the sun sketching + great E.grey and scone...

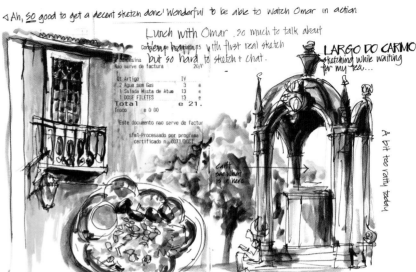

Ah, SO good to get a decent sketch done! Wonderful to be able to watch Omar in action

Lunch with Omar ...so much to talk about ...with first real sketch but so hard to sketch + chat.

Nao serve de factura 20/ro
Qt Artigo IV
2 Agua sem Gas 3 e
1 Salada Mista de Atum 13 e
1 DOSE FILETES 13 e
Total e 21.
Troco e 0 00

Este documento nao serve de factur

sfm1-Processado por programa
certificado n. 0071/DGCI

LARGO DO CARMO
sketching while waiting for my tea...

A bit too rainy today

Healthy tuna salad still have HA

An urban sketcher... YES!
Eduardo (waiting for João!)

this awareness is increased dramatically as I visually explore the scene in front of me. My sketchbook is my constant companion and the place where I share and record this dialogue. (My other companion is a wee bear called Borromini, who travels the world with me, loves meeting other artists—and being drawn by them—and features in my pages from time to time.)

Not only does my sketchbook contain this internal dialogue of what I am experiencing, it also records the incredible buzz I get out of sketching on location. The buzz comes not just from a daring sense of adventure and discovery—often I am sitting in a crazy position on the streets, discovering amazing details of a famous building/place—but even more from the sense that I have had my own very personal and unique experience and interaction with the building. In a funny way, I own it now as mine. I often add notes to explain what I am feeling at the time, but most of the time that is not really necessary because what I am feeling is expressed in my line work or my splashes of color. The fact that I can relive this experience at any time, by simply turning the pages of my book, is really very special when traveling alone.

As someone who used to travel taking lots and lots of photos and rushing to see all the must-sees at every destination, it has been quite fun to see how my approach has changed now that I am sketching. A constant battle between the tourist and the sketcher continues within me. In true Liz style, I try to do both and end up going at a ridiculous pace. But the reality is that the sketcher can just not do the same amount of sightseeing as the tourist used to. And ultimately it doesn't bother me because the places that I do get to and that I do sketch are so much more meaningful.

Apart from the intensely personal nature of sketching, it is also one of the most engaging ways to travel. When I am drawing, so many people stop to talk. Even more look over my shoulder (that sometimes annoys me), and often I get to meet some locals. Eating alone at dinner is one of the hard things about traveling alone. People look at you strangely, but if you start sketching your dinner, other patrons and the staff might notice and talk to you. I have had free food and coffee as a result, and my sketchbook often does the round of the kitchen ... collecting signatures of course. I love collecting signatures from other people. I am also trying more and more to collage ephemera into my book. It is the kaleidoscope of experiences that makes travel so enriching, and that is what I want to capture in my sketchbook.

One important part of a big overseas trip is the preparation, and I have a dedicated "Trip Prep" journal for this. It helps focus my research for both architecture and sightseeing, helps me plan

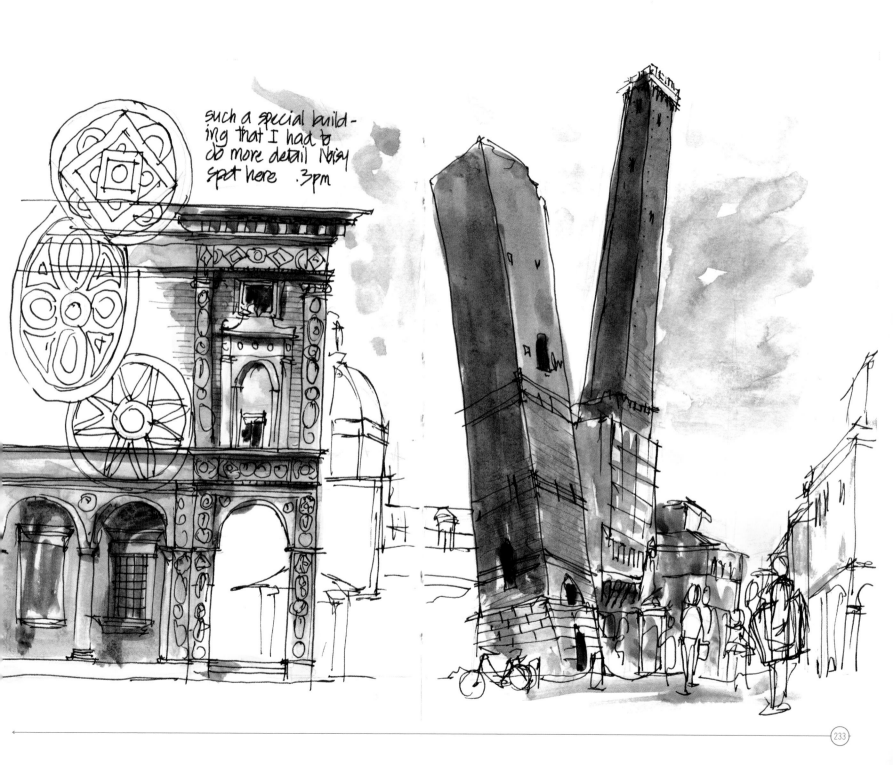

such a special build-
ing that I had to
do more detail. Noisy
spot here. 3pm

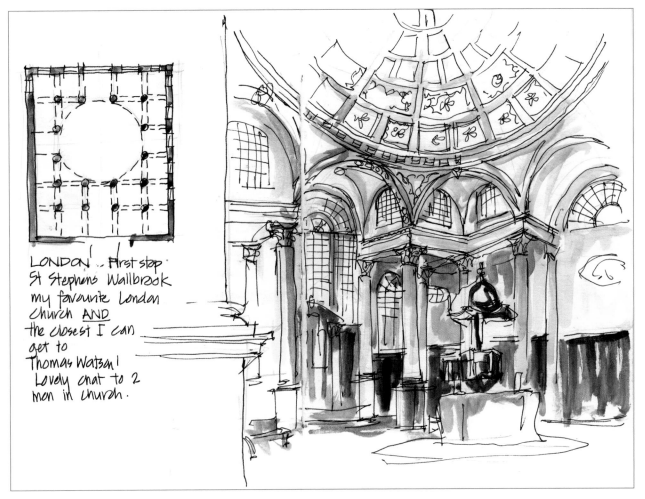

LONDON! ... First stop
St Stephens Wallbrook
my favourite London
church AND
the closest I can
get to
Thomas Watson!
Lovely chat to 2
men in church.

wouldn't allow me to paint. I also take a few wax pencils for resist and at the moment am also carrying a brown and a blue Lamy pen with more Noodler's ink (Polar Brown and Polar Blue). This will probably change again soon.

My sketchbooks have remained the same for a number of years—I use an Australian version of the Daler Rowney Ebony Sketchbook (my exact book is a Jasart Premium Sketchbook) with 150 gsm cartridge paper. It is wonderful to write in (I write a lot of text and notes in my books), but it does have limitations in regard to watercolor because it buckles a bit. But I love the buckling. I love the look and feel of well-used and filled sketchbooks. While my sketchbooks are very precious to me, and I would be devastated to lose one, the experience of sketching and the other adventures I have as a result of sketching are more important to me than the resultant sketch.

Although I started sketching daily as training for travel sketching, it has become an end in itself and I am now totally addicted to sketching my daily life. I often do this in a way that is similar to the way I approach sketching while on vacation. All you need to do is to put on your "everything is new and interesting" glasses and then it is easy to be a tourist in your own city—or even your own everyday life.

what I am going to pack and is a testing ground for the travel sketchbooks. I test colors, pens and materials, and I also consider and develop a new approach: Every sketching trip that I have taken has been an incredible journey of artistic development, so now I set myself some specific art goals before I go.

One of the things that I absolutely love about travel is putting my kit of art supplies together. It is a balance between simplifying and flexibility, as well as trying to pack light. A few things are standard and haven't changed for years—my Lamy Joy Pen with a EF nib containing Noodlers Bulletproof Black ink and my Schmincke metal tin with twenty pans of Daniel Smith, Winsor & Newton and Schmincke watercolors (I love exploring different pigments and often change colors specifically to suit my destination). These are the media I use most often, but as I am traveling and sketching more than usual, with different scenes and different situations, I have to be prepared for anything. So I pack a few things for specific occasions, such as my Pentel Pocket Brush Pen for when I have only a few moments to work or a few watercolor pencils for galleries that

Liz Steel

"That has to be Roz."
Bonnie Ellis came up to
my side and said hello...
and chatted just as I
was finishing the painting.
She is working at various
booths and activities through-
out the Fair.
She'll have her 50th wedding
Anniversary next week!
(or month?)

9.2.11
11:19. a.m. She laid down... (Calligraphy pen)

lumpy top on beak

pink crease at "lip"

3·6·11 11:44 a.m.
Penguin at Como
After just watching
the puffins for 10 mins.
I came over here. They
are right by the glass.

Roz Stendahl

After spending half her childhood outside the United States as a third-culture kid, **Roz Stendahl** continues to be a lifetime tourist even when close to home. A Minneapolis-based graphic designer and book artist, she is also amassing sketches for her life's work on invasive species: "Pigeons: I'm Only Here Because You Brought Me." **www.rozworks.com; www.rozwoundup.typepad.com**

Life is a road trip. There are sorties to gather intel: the trip to the allergist's office, the visit to the grocery store, a bike ride along the Greenway to see the wild turkeys. There are excursions lasting less than half a day to exotic locales like the zoo or a natural history museum, where you can stretch your hand muscles and make your eyes work for extended periods. And then there are full-blown expeditions lasting a day or more where the information flows in a constant stream, and you have to breathe great gulps of air to keep up. That's when all the practice on shorter trips pays off.

That's what my life is like. I always have a fanny pack or a backpack equipped with everything I need for sketching ready to go.

Travel is synonymous with journaling for me. I started journaling as a child. My mother gave me my first sketchbook to keep me occupied on a trans-Pacific trip. The habit stuck. The family never stopped traveling, and I never stopped journaling. Journaling was my job, that task I was supposed to perform to keep myself engaged.

What is important to me is not the distance traveled or even the seeing of new sights. What is important is the surveillance of what surrounds me, whether it's culture, language, architecture or people doing everyday tasks.

The gift of growing up as a third-culture kid is that everything around you calls for attention and examination. I am an explorer every moment of my life. I feel like an alien from another planet who is just trying to get her bearings by scrutinizing what everyone else is doing and processing it internally. Drawing is something that I find engages me more fully with my surroundings. If I'm traveling (near or far), drawing helps me to

look about and to focus. Next, it helps me absorb my surroundings. Drawing generates raw material for my other projects. I also find that drawing slows me down so that I can absorb more of the experience of a location. This is even true when I am traveling with companions who move quickly through an area. If I make one sketch, I feel I have seen something and actually felt a place, regardless of the finished state of that sketch; the mechanism has been turned on.

I draw when I travel for the same reason I draw all the other times I can't stop myself from drawing: because something

Ears have a lavender shading to them. And visible veins.

A group of two women with about 8 kids just stopped to talk with me. The eldest Wesley — has started keeping a nature journal. I showed him the earlier pages and told him not to stop with one drawing, as in the puffins, but keep going and then you'll hit your stride. He showed me the journal he'd just started. It had a feather marked for scale. It was great. Told them to work from life, learn to make books... the whole spiel. (sp?). His mother asked for a card (business card) and I told him to check my website and draw his pet fish every day. Hope some of it sticks! It's 2:47 now. Time to go. And this 0.1 pen is dead!

loose top lip.

Just saw some cud recalled up the throat the bank delivery system. Now down it goes.

COMO ZOO 2:08 p.m. 4.08.08

catches my eye and grabs my interest. I want to remember it; I want to savor it; I want to understand it just a little bit better; I want to acknowledge what I just saw. At the same time all of this is happening, when I'm drawing there is also a physiological change within me. I am calmer, more alert (hyperalert) and filled with wonder. Drawing activates a direct switch to my sense of wonder. I feel that to draw something or someplace

is to ask questions about that subject: How is it made? Why was it made? What does it stand for? How was it used? How does it live in these circumstances? (That last question is something I ask as I draw pigeons the world over.)

In recording those observations, I gain understanding and that understanding fosters compassion and recognition.

While I've had the opportunity to travel all over the world, a journaling journey

doesn't have to take me far from home. Every time I go to the zoo or the Bell Museum of Natural History, or sketch by myself in the Twin Cities, something funny, moving or startling happens. Someone next to me will say something that is outrageous or poignant, or simply revealing, like the woman at the zoo who said of the puffins, "This is what bit me in Norway—only different—those had red, lots of red feathers."

The statements people make always change my understanding in some way.

If I am going to a location with the express purpose of journaling, then drawing takes over. I live and breathe drawing. I'll sketch standing at the State Fair for a three-hour shift, take a thirty-minute break and sketch another three-hour shift; and repeat. I'll sketch for twenty minutes out of every hour for days or weeks as I explore a new city.

If I am traveling with friends, then the goal of the trip is to meet my sketching and observational goals without inconveniencing the people with whom I'm traveling. (I want to be included on the future trips.) To that end I am respectful of the group dynamic and the group's pace, as well as the group's interests. If we are going to stop at antiques stores so that people can browse, I'll find a piece of taxidermy and sketch it until it's time to leave. If the visit at an architectural or natural wonder has ended and I'm still sketching, I simply stop and move with the group. I'll scribble lots of notes about my thoughts, the colors I couldn't paint and the details that went undrawn.

It is important to me, when I travel with people, that I spend as much time finding out more about my companions as I do sketching and discovering the new environment. I want to discover their take on things. I want to learn their responses to the trip's events. A good portion of my time during a group travel situation is spent interviewing my travel companions.

Traveling with a journal is really no different from my daily journaling. I've got my journal in my hand. It's still a journal I've bound myself because I want to use the paper that I want to use in the size and format that I enjoy. My behavior is the same: I'm looking, I'm listening, I'm smelling, I'm sketching, I'm processing how all of what I observe does or doesn't make sense to me and my understanding of the world.

2nd one before he sat down

July 21. 06
I was at the cabin taking a break & diane called. She & her father had stopped at the motel and gotten permission to salvage. She needed me to get tools & go get what we wanted. I took the tools and went to get Jennie applesauce. No one was at the site to talk to so I drove by. The IGA only had applesauce with high fructose sugar so I went to the coop – theirs had "Vitamin C added" but when I called Jennie she said to bring it – she wasn't sure...

I was already parked so I went to get a donut for me and the gulls. But they & the geese were already sleeping on the beach! (They must have known the donut shop was down to 3 cake glazed and some filled!) I stood watching. Two middle-aged women walked right through them - scattering them... inconsiderate of the birds!

I turned and saw this bird on the chimney. I painted but it started to rain so I actually had to finish painting in the car.

Off to the motel again.

000618

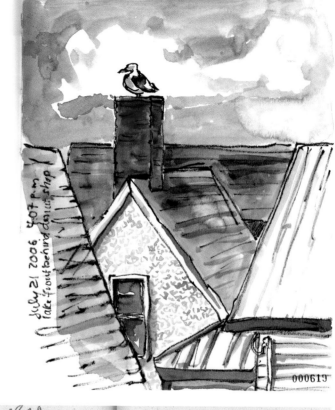

July 21 2006 4:07 p.m.
lake front behind donut shop

000619

9.01.09
4:55 p.m.
Toulouse, Old Gander
Ian Ulvin, North Branch
Two in the cage - the other keeps 'splashing' on!

8.28.10
3:06 p.m.
SC RI Reds
Chickens breeding pen
Carver County
Matthew Hektt.
Black Rooster
(brown under lower iridescent black tail feathers.)

Woman passing thought
They were some sort
of "civet" No—
Leister.

tight ear

white face
knobby
white
legs.

Huge Bow in
nose when we ued
in propell.

In brushed
out tufts.
not curls.
Brownish.

Wool down
like an
elizabethan
ruff on their
necks.

12:20 p.m.

White
legs.

Big nose.

000389

When traveling to a foreign country where there is a language barrier, I often begin the trip by using the journal as a safe zone of retreat because I can't engage with the language. This act has the delightfully perverse result of luring people to me, people who want to talk to me about what I am doing and who are willing to resort to great attempts at pantomime to communicate and connect with me.

When you travel, there will always be people who are suspicious of your sketching activity. (I like those folks. It shows they are engaged with their surroundings; they probably run their Neighborhood Watch.) You will also meet people who are proud of their community. They are thrilled that you found something about their home that captured your interest so much that you would spend time drawing it. They appreciate your expenditure of time. They will find a way to communicate with you. From them, you will learn about what life is like for them. No guidebooks or arranged tours can give you this connection—but your visual journal can.

So in a lot of ways traveling with a journal changes how I interact with the world, because if I weren't traveling with a journal those people wouldn't speak with me and I probably wouldn't know how to go about beginning a conversation with them. More important, the journal helps me bridge my own deeply ingrained cynicism. Traveling with the journal does not mean I'm turning off my panhandler radar, but having the journal does mean that I balance my openness a tad more toward the warm and friendly.

When I travel, I try to always remember that I am a guest in the world and an ambassador—of my family, my school and my country.

To anyone just beginning to journal, I would say jump right in. Take small journeys locally to build up your confidence for sketching in public. Devise a ritual and a comfortable approach that enable you to keep drawing even when people jostle around you in distant locations where the comforts of home aren't close by. Always keep your radar on and occupy your space with confidence and awareness of your surroundings.

Travel light, with compact media, in order to move quickly and suffer less wear on the body. Less fatigue will translate into longer drawing times. Drawing is, after all, an endurance sport—a marathon, not a sprint.

Wear comfortable shoes so that you can stand sketching for hours in spots where no seating exists (and so that you can run from spies).

Along with your art supplies, always carry dental floss.

And of course, eavesdrop shamelessly.

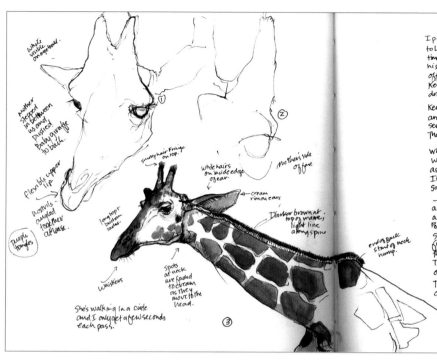

Giraffe sketch annotations (left page):

White visible on eyeball.

Mother stepped in between us and pushed baby giraffe to back.

Smoky hair fringe on top.

Flexible upper lip.

Nostrils angled together at base.

Purple tongue.

White hairs on inside edge of ear.

Mother's side of face.

Long top + bottom lashes.

Cream rim of ears.

Darker brown at top of mane, light line along spine.

End of back / start of neck hump.

Spots at neck are faded to cream as they move to the head.

Whiskers.

She's walking in a circle and I only get a few seconds each pass.

① ② ③

I picked up Ken at 10:25 (he wanted to come to Liz's sketch out before it started to get in more time.) When we arrived at Como Ken showed me his sketches for KSTP from the hearing of a sex offender (69 + petitioning for release; 80 some victims; Ken said he was very creepy and I think the drawing caught his toad like aspect.

Ken elected to stay "inside" in the new walkway area of the new entrance building and in the conservatory. I headed out to the penguins + puffins. The puffins were quiet at first but got going.

While I was sketching this giraffe two men + their wives (c. 45-55) stopped. One said, "she approves," as the mother giraffe came forward + peered at me. It did sort of look like that. Then the other man said, "I never realized how much giraffes look like _____ from stairways until I saw you draw a giraffe." I didn't hear the creature name. I'm assuming its that ambassador creature in the Natalie Portman res. I stopped sketching and said they should go to the M/A + look at the Chinese Zodiac figures. Artists made them from animals, stylized them down. (They look just like Star Wars characters.) That's what artists do whether it's in ancient China or on Lucas' Skywalker Ranch.

Taking a break from standing. I've been doing a lot of looking so I'm low on page count.

March 6. 2011
Como - Giraffes
12:47 p.m.
- Hip.

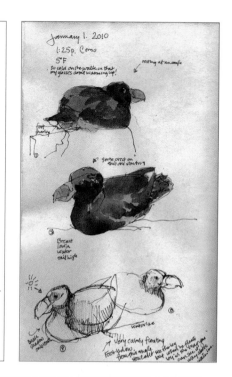

Right page (puffins/penguins):

January 1. 2010
1:25p. Como
5°F
So cold on the walk in that my glasses aren't warming up!

resting at an angle

...so you're cold on this one sketching

Breast lower + water + tail high

Breast cheeks one color

Very calmly floating.

Feet below, from this angle you can't see the webs but when it turns you can see them.

waterline

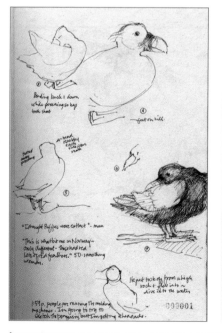

Lower left (puffins):

Bending back + down while preening so legs look short.

goat on hill

④

③

⑥

"I thought Puffins were extinct". - man

This is what bit me in Norway - only different - these had red lots of red feathers. 50-something women.

He just took off from a high rock + dove into ~ dive into the water.

1:59 p. people are running the molding machines. I'm going to try to sketch the penguins but I'm getting a headache.

000001

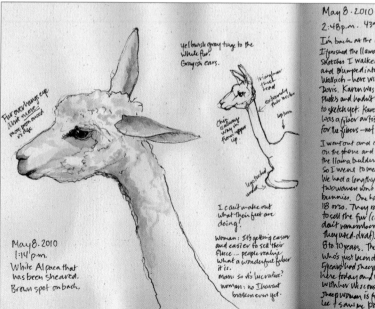

Lower middle (alpaca/llama):

Yellowish gray tinge to the white fur. Grayish ears.

Fur over brow or eye about more noise from nose + eye.

(triangular head extended from neck)

Chin is away from upper lip. lip horn

(leg tucked under)

I can't make out what their feet are doing.

Woman: It's getting easier and easier to sell their fleece... people realize what a wonderful fiber it is.

Mom: so its lucrative?

Woman: no I haven't broken even yet.

May 8. 2010
1:14 p.m.
White Alpaca that has been sheared. Brown spot on back.

Right text block:

May 8. 2010
2:48 p.m. 43°F Overcast wet

I'm back at the car. After I finished the llama + alpaca sketches I walked about and bumped into Karen Wallich - here with her friend Doris. Karen was taking photos and hadn't settled down to sketch yet. Karen's friend was a fiber artist and her for the fibers - not sketching.

I went out and called Suzanne on the phone and she was in the llama building again so I went to meet her. We had a lengthy talk with two women who raise angora bunnies. One has 13 the other 18 or so. They raise them to sell the fur (coat-fiber I don't remember the term they used-draft). They can live 8 to 10 years. The 2nd women who's just been doing it for 5 years had sheep (not bunnies) here today and was just chatting with her Wisconsin friend. The sheep woman is from Albert Lea + I saw her painting sheep

in the sheep barn and I showed her my sketches. She has Dexter cattle (small) sheep, a guard llama for her sheep, goats ... I don't remember what all. "Road Trip" I said to Suzanne. I gave the woman a card with my email, asked her to send me a note so I could write her if we were coming up that way... about 2 hours away.

Suzanne + I walked through the shop buildings. There we found a woman from you Iddho selling buffalo + yak but she said there's a guy named Hopper, west of Anoka who has yak... maybe we could go there. Suzanne and I talked about the various products and then the sketching. She got some great stuff today. A great llama print + ink. I'm pleased with some of my stuff. Good practice.

Sitting in my car. It's been so long since I've been out to Wisconsin. Soon as I'm back, every year it's over building at Stagecoach friend. Horse teacher (sign), new structure changes about fences everywhere. 3:31 p.m. I just added paint. Some white clouds showing through the gray. Some streaks greyblue - not a color I can use. The whole field is car packed with yellow and dull blues daisies - white pompoms. All the old posts + lights I remembered using them as map markers.

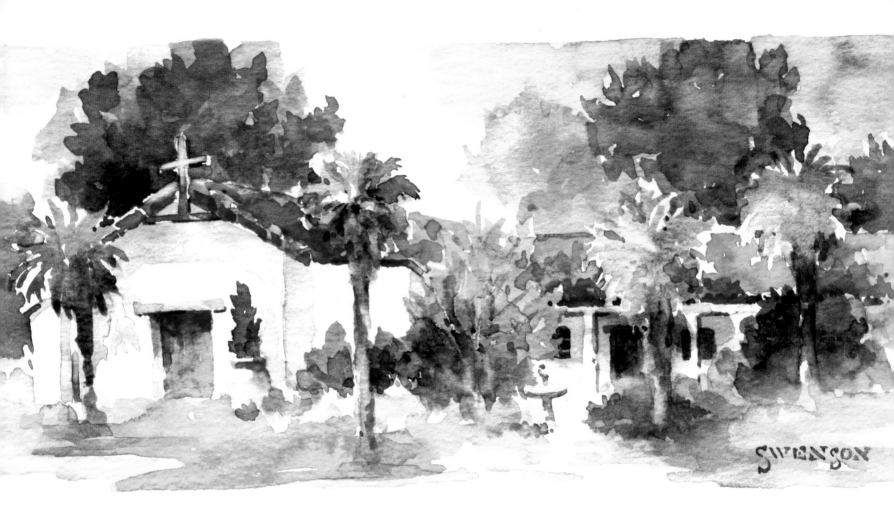

——— ∘ Mission Nuestra Senora dela Soledad ∘ ———

THIS LOVELY LITTLE MISSION IS IN A AREA SURROUNDED BY FARM LANDS. IT IS NOT IN THE CENTER OF TOWN AS WE USUALLY FIND THEM. THE FIRST THING I NOTICE IS THE BEAUTIFUL SOUND OF A GUITAR. BEHIND THE BUILDING IS THE RUINS OF THE ORIGINAL MISSION BUILT IN 1791. I FIND A UNATTENDED GRAPE VINE. THE GRAPES ARE DARK PURPLE, DUSTY & SWEET.

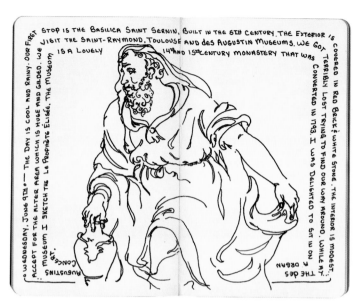

Brenda Swenson

Brenda Swenson is a Californian born and raised. She is the artist/author of two instructional books on watercolor. Her paintings and sketches have been featured in numerous magazines and books. Brenda teaches watercolor workshops nationwide and abroad.
www.SwensonsArt.net

I have vivid memories of drawing as a child. I felt something special within me whenever I drew. Art made me feel complete. All the kids knew what they wanted to be when they grew up: nurses, airline stewardesses, doctors, veterinarians. I didn't think being an artist could be a job. One day I saw a billboard. Go to school to be a professional artist. Wow, I could be an artist. Right away I told by my stepmom. "I know what I am going to be when I grow up. I am going to be an artist!" I was abruptly told that's much too difficult, and I should find something else. I was crushed. The only thing in me that felt special wasn't good enough. I was ten years old.

Throughout my school years, I took lots of art classes. When I graduated from high school, art was put on the back burner to work and raise a family. In my midtwenties I was newly remarried to a wonderful man named Mike. He recognized the creative spirit in me and nurtured it. When my youngest son started first grade, I started taking art classes at Pasadena City College. From the first day, I poured everything I had into each assignment. I wanted to prove my stepmom wrong. I was good enough! Once I exhausted all the art classes at the community college, I sought out watercolor instructors I admired. This is when I began to travel with my art supplies. The first overseas workshop was to Great Britain, next Holland ... I was hooked!

I feel a sense of adrenaline sketching from life that I do not get from a photo. I enjoy being immersed in history and culture and I welcome interaction with people. While in Florence, a very elderly couple stood and watched me. Eventually, the man made a gesture to see my sketch. He studied the page and with a smile gave an approving nod. I couldn't have received a greater compliment. In Prague, I was sketching in an open market when a little girl no more than five years old became fascinated with me. She chatted away in Russian. I couldn't understand a word. Her aunt acted as a translator for a brief moment, and then they disappeared. A short while later she reemerged with a miniature Russian nesting doll on a key

ring. She handed it to me. I admired her little treasure and returned it. I watched her smile disappear into a look of confusion. She took the little doll and stuffed it in the pocket of my sketch bag. How I wished I had a gift to give in return! The best thing I had to offer was to let her draw with me in my book. She signed her name, Evonka. In my studio is the gift she gave me along with a photo of us together. Interacting with people of all ages and cultures is one of the pleasures of sketching outdoors.

For safety purposes I don't travel or sketch alone. I have a wonderful friend and sketching buddy, Judy Schroeder. A few times a year we get out of town for the sole purpose of sketching. I have

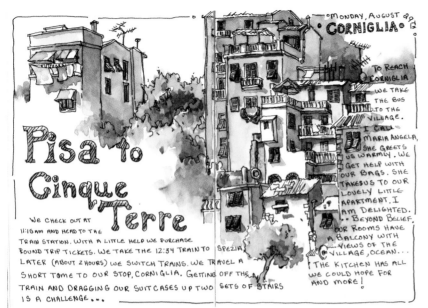

Pisa to Cinque Terre

We check out at 11:15 AM and head to the train station. With a little help we purchase round trip tickets. We take the 12:34 train to Spezia. Later (about 2 hours) we switch trains, we travel a short time to our stop, Corniglia. Getting off the train and dragging our suitcases up two sets of stairs is a challenge...

° MONDAY, AUGUST 29 °
CORNIGLIA

To reach Corniglia we take the bus into the village. I call Maria Angela, she greets us warmly. We get help with our bags. She takes us to our lovely little apartment. I am delighted. Beyond belief our rooms have a balcony with views of the village, ocean... The kitchen has all we could hope for and more!

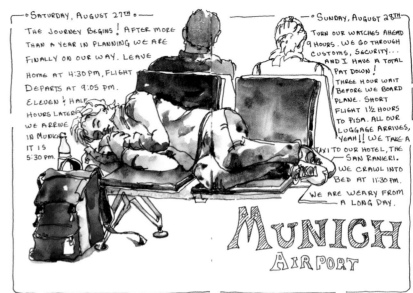

° SATURDAY, AUGUST 27TH °
The journey begins! After more than a year in planning we are finally on our way. Leave home at 4:30 PM, flight departs at 9:05 PM. Eleven & half hours later we arrive in Munich. It is 5:30 PM.

° SUNDAY, AUGUST 28TH °
Turn our watches ahead 9 hours. We go through customs, security... and I have a total pat down! Three hour wait before we board plane. Short flight 1½ hours to Pisa. All our luggage arrives, yeah!! We take a taxi to our hotel, the San Ranieri. We crawl into bed at 11:30 PM. We are weary from a long day.

MUNICH AIRPORT

WALKED TO OLD TOWN IN THE MORNING. CHECKED OUT AN ART SUPPLY STORE AND HAD COFFEE. A HUGE MOTORCYCLE RALLY CAME INTO TOWN, 100'S OF BIKES! I WORKED ON MY POSTCARDS IN THE AFTERNOON TO SEND BACK HOME.

sketched with many other people but I have never found anyone who is as driven as me, except Judy. Others have joined us only to drop out after half a day. Our styles are distinctly different but our interest in subject matter is similar. Having a sketching buddy has opened the world to me. Our sketch outings have lasted from one day to three and a half weeks.

Before I start a sketch I ask myself, *How much time is available?* If I have realistic intentions, I can very likely complete what I start. Otherwise, I will become frustrated and feel my skills are lacking, when in fact, I didn't allow enough time. When I arrive at a location, I walk around for a few minutes. This is when I get a sense of the place. When I find something that really excites me

(light, shadows or a particular view) I begin to sketch.

I always carry a camera when I travel but a photograph is easily forgotten. When I sketch I will never forget what I saw. The image is forever ingrained in my mind. I will often jot down the temperature, noises and smells. When I return home and read my notes it engages my senses (sight, sounds, smells and physical sensations). It is as if I am still there. No photo can do that for me.

Unlike my everyday sketchbooks, I feel driven to record images and words together on a page when I travel. During the day I sketch and before I go to sleep each night I write. In the beginning, I kept the first couple pages of a sketch-book for my travel notes. Now the words are an integrated part of the page. When

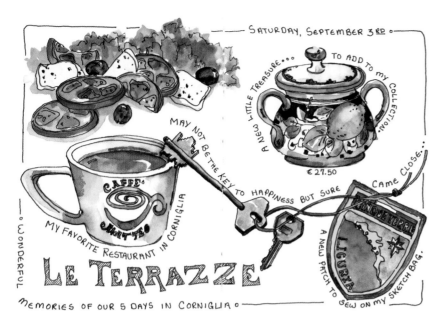

SATURDAY, SEPTEMBER 3RD

MAY NOT BE THE KEY TO HAPPINESS BUT SURE CAME CLOSE...

A NEW LITTLE TREASURE... TO ADD TO MY COLLECTION

€27.50

A NEW PATCH TO SEW ON MY SKETCH BAG.

CAFFÈ

MY FAVORITE RESTAURANT IN CORNIGLIA

WONDERFUL

LE TERRAZZE

MEMORIES OF OUR 5 DAYS IN CORNIGLIA.

I write, it is more than what I'm saying. I use words as a design element, to create borders, to tie multiple images together, to balance the page, as a heading. I am often up long past midnight to complete the writing, perhaps that is why you'll find so many typos and misspelled words.

Ultimately, I sketch for me and paint for others. I paint for national shows, galleries, commissions. My sketchbooks and travel journals are a more personal reflection of me. Within the confines of these books I challenge myself to grow and I can see tangible growth in each book. It is within the pages of the book that I am free to express myself with words and images. The pages contain the ups and downs of travel, relationships and life. No painting can do all that for me. With each new sketchbook I wonder

where the book will lead me and what lessons I will learn along the way. The first page feels a little unnerving and the last page feels a little sad ... like the end of a journey.

When I need to travel extralight I only take what will fit in my purse: Moleskine Watercolor Album (I don't understand why the company makes the watercolor books only in a landscape format and I cut the book in half to measure 8 ¼" × 5 ¼"; a small folding palette with twelve colors; Niji Waterbrush (size large); waterproof PITT pen by Faber-Castell (size M).

For my larger setup, I carry a Rigger tool bag—I've taken out some of the stitching to enlarge the pockets. I make my own spiral-bound sketchbooks with Bockingford 140-lb. watercolor paper, cut to 10" × 11". And a few pieces of

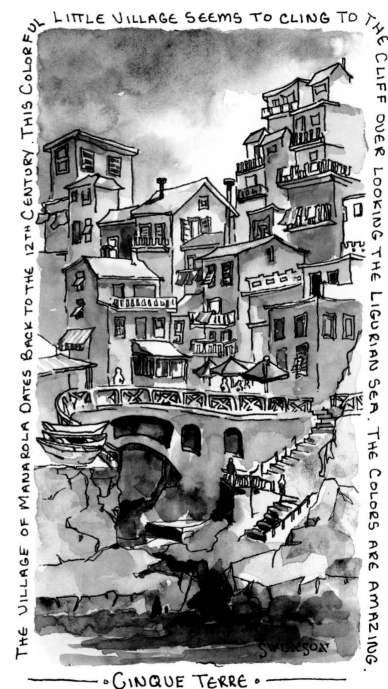

THE VILLAGE OF MANAROLA DATES BACK TO THE 12TH CENTURY. THIS COLORFUL LITTLE VILLAGE SEEMS TO CLING TO THE CLIFF OVER LOOKING THE LIGURIAN SEA. THE COLORS ARE AMAZING.

SWERSON

· CINQUE TERRE ·

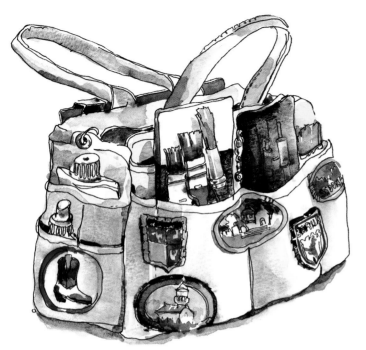

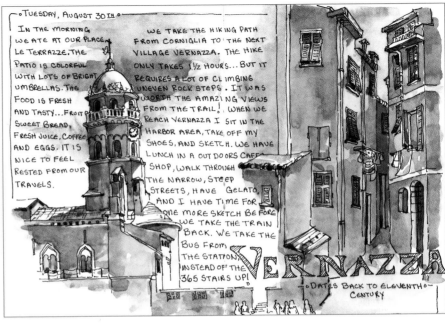

IN THE MORNING WE ATE AT OUR PLACE, LE TERRAZZE. THE PATIO IS COLORFUL WITH LOTS OF BRIGHT UMBRELLAS. THE FOOD IS FRESH AND TASTY...FRUIT, SWEET BREAD, FRESH JUICE, COFFEE AND EGGS. IT IS NICE TO FEEL RESTED FROM OUR TRAVELS.

WE TAKE THE HIKING PATH FROM CORNIGLIA TO THE NEXT VILLAGE VERNAZZA. THE HIKE ONLY TAKES 1½ HOURS...BUT IT REQUIRES A LOT OF CLIMBING UNEVEN ROCK STEPS. IT WAS WORTH THE AMAZING VIEWS FROM THE TRAIL! WHEN WE REACH VERNAZZA I SIT IN THE HARBOR AREA, TAKE OFF MY SHOES, AND SKETCH. WE HAVE LUNCH IN A OUTDOORS CAFÉ SHOP, WALK THROUGH THE NARROW, STEEP STREETS, HAVE GELATO, AND I HAVE TIME FOR ONE MORE SKETCH BEFORE WE TAKE THE TRAIN BACK. WE TAKE THE BUS FROM THE STATION INSTEAD OF THE 365 STAIRS UP!

VERNAZZA

DATES BACK TO ELEVENTH CENTURY

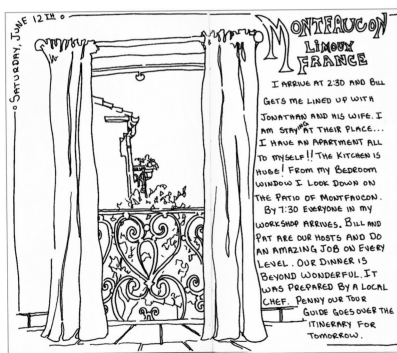

MONTFAUCON LIMOUX FRANCE

I ARRIVE AT 2:30 AND BILL GETS ME LINED UP WITH JONATHAN AND HIS WIFE. I AM STAYING AT THEIR PLACE... I HAVE AN APARTMENT ALL TO MYSELF!! THE KITCHEN IS HUGE! FROM MY BEDROOM WINDOW I LOOK DOWN ON THE PATIO OF MONTFAUCON. BY 7:30 EVERYONE IN MY WORKSHOP ARRIVES. BILL AND PAT ARE OUR HOSTS AND DO AN AMAZING JOB ON EVERY LEVEL. OUR DINNER IS BEYOND WONDERFUL. IT WAS PREPARED BY A LOCAL CHEF. PENNY OUR TOUR GUIDE GOES OVER THE ITINERARY FOR TOMORROW.

colored pastel paper (tan, crème and gray tones) called Mi-Teintes by Canson, cut to size. The paper works great with watercolor. My favorite palette is called the Palette Box. It was custom-made by Craig Young of The Watercolor Paint Box Company, in the United Kingdom. (It was a costly gift I gave myself.) I also have the Heritage Folding Palette with eighteen wells. It is lightweight and reasonably priced. Favorite paints: Holbein, Winsor & Newton, Daniel Smith and American Journey. For brushes, I use assorted rounds sizes 6 to 14, flats ¾" and 1¼", and a stiff brush for lifting. Miscellaneous items include a small digital camera, travel chair, visor, roll of paper towels, container for water, collapsible water bowl and spray bottle.

Half the joy of creating a travel journal is sharing it. Numerous times I have given a presentation titled, "An Artist Journey." The presentation is a digital slide show of my travel journals and photos from the locations. People from all walks of life are fascinated with artists and how they interpret the world.

I have more than forty sketchbooks and journals and I love these books. When I sketch, I feel freer than when I am working in my studio. Sketching feels like playtime.

SWENSON

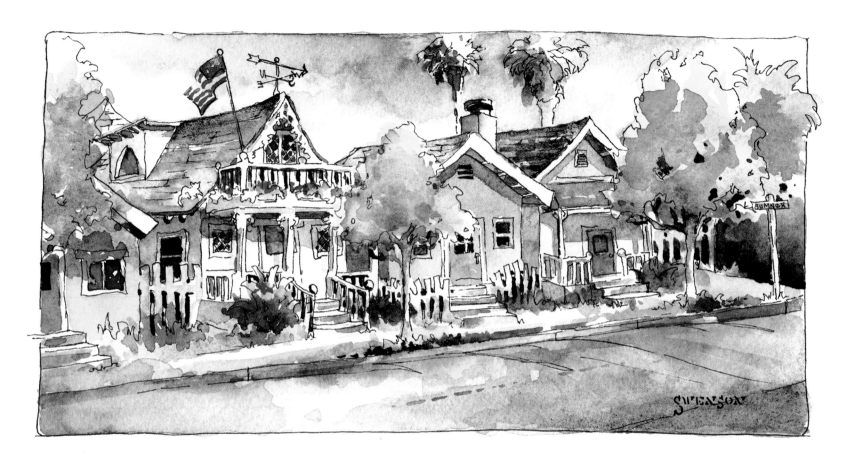

STREET IS ALIVE WITH ACTIVITY. GOLF CARTS ARE ZOOMING UP AND DOWN THE STREET! I SAW A CAT WATCHING FROM THE ROOF TOP. AFTER A WHILE HE CAME OVER AND GOT HIS EARS SCRATCHED. HOUSES ARE SO SMALL AND CLOSE TOGETHER, BUT CUTE.

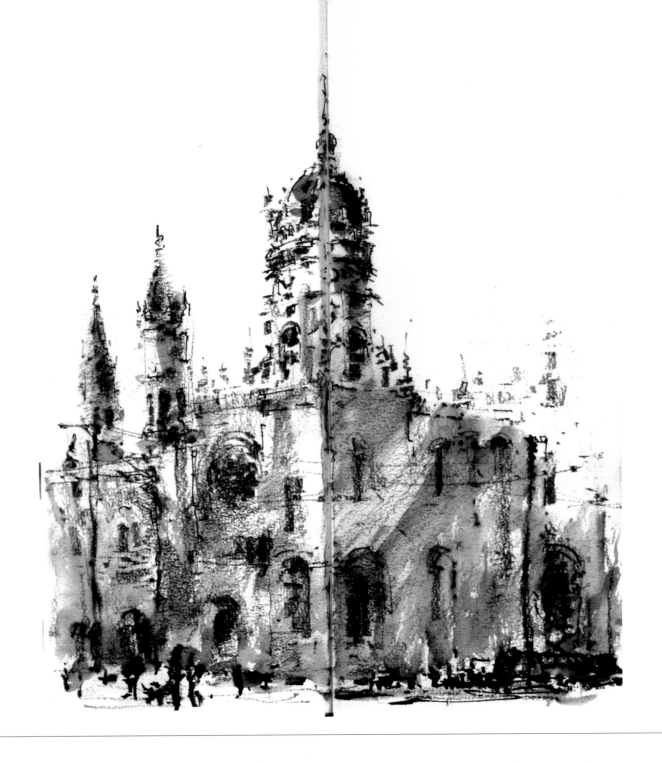

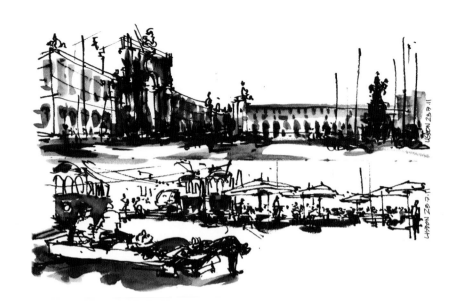

Asnee Tasnaruangrong

Asnee Tasnaruangrong lives in Bangkok, Thailand. He is one of the authors of *Architects' Sketchbooks*, published in Bangkok in 2008, a founder of Bangkok Sketchers Group and the correspondent for Bangkok with Urbansketchers.org.
www.flickr.com/atas; www.facebook.com/asnee.page

I was born and grew up in Bangkok, the capital of Thailand. Although I cannot recall having anyone in my family with artistic experience, I still remember clearly as a young boy, drawing Superman and other comic hero characters with confidence and joy. I recall the happiness of painting sessions in my kindergarten class, the smell of the wax sticks and that first drawing of an ocean liner, complete with the wave line at the base of the ship and several clouds of smoke from its many chimneys. I was good at watercolor when I was in school. I was one of those few who was outstanding in the school's art class and I was sent to a student painting competition.

At around grade seven or eight, my interest in drawing and painting had been eclipsed by a new interest in music. I spent all afternoon practicing the slide trombone so I could join the school jazz band. I could have been reunited with my love of painting and drawing at an art college, but I took up architecture instead.

Most architects are too tied up with other aspects of complex design and technical issues to enjoy drawing, sketching and paintings; and without exception, so was I. I did not have a single sketchbook until, fortunately, I retired early. I did tons of drawing, architectural sketches and three-dimensional study in the process of design and construction but never once on travel or vacation. I took up watercolor painting and pencil sketching only after my retirement, some ten years ago. And from that point on, drawing, sketching and painting are what I do for a living, not financially but for the joy of living.

My travel sketching started not in a sketchbook, but with a casual reunion with my childhood love of watercoloring. There I was, under the big bright blue sky, armed with only the urge to paint and faint recollection of a schoolboy's fun, facing the challenging beautiful sky line of Perth, where I was having a family vacation. Then I started using just pen and pencil for the first few years of sketching and, thank God, learned how to use them in an entirely different way than I had used them in the past.

I never see myself as an artist, although I am kind of delighted when other people think I am one when they see me sketching. Many people do not seem to believe me when I tell them I am sketching just for fun, not for business or as a career.

I believe strongly that sketching makes a deep mark on the sketcher, and I often

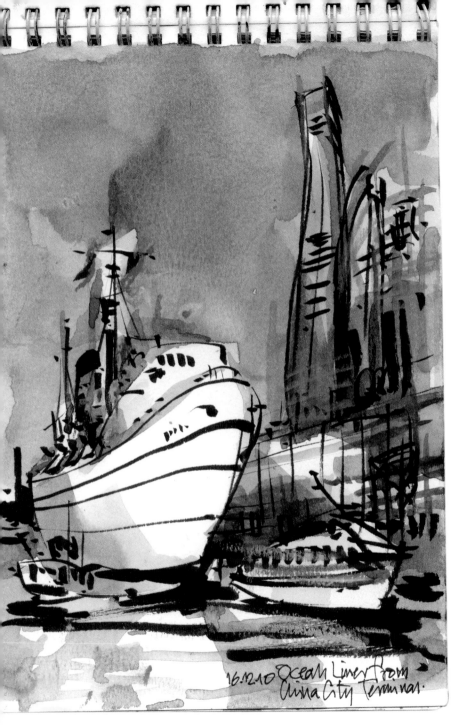

16.12.10 Ocean Liner from China City Terminal.

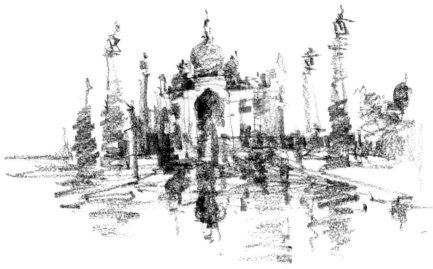

share this belief with anyone who cares to listen. In order to sketch successfully, one has to "see" and not just "look" at the subject. And, as I see the subject, I "feel" what I have seen and then I draw what I feel about the subject.

Sketching the houses I travel past every day, the corner food stalls on the street where I live or a certain section of town makes me realize the relationship I have with my past. It brings back the memories of certain events or times I spent with family at such places, dinners I had with friends at some restaurants in the mall and many other moments.

Sketching seems to work magic with my memories; it's like a hard drive storage device is to a laptop. It's the action and process of sketching that counts, I think, because I think I would still be able to feel the experience even if I lost

the sketch itself.

My sketching gear contains a few soft pencils, usually 2 and 4B by Derwent Graphic, Staedler Mars-Lumograph, Castell 9000 Faber-Castell.

I always carry a few fine line pens, the very well-established German-made Staedler pigment liner. I also use Artline drawing system pigment ink by Shachi-hata, Pigma Micron archival ink by Sakura Color Product Corp and uni-PIN fine line pigment ink, PAPER MATE ink point and the new series from Mitsubishi Pencil Co., Ltd., uni-ball Vision Needle. I recently added a variable-width ink line pen from China by the brand of Hero. Occasionally I bring along my brush pen, a black Pentel Color Brush that produces a Chinese-like brushwork of black bold lines. The ink that comes preloaded with the brush is not waterproof but its

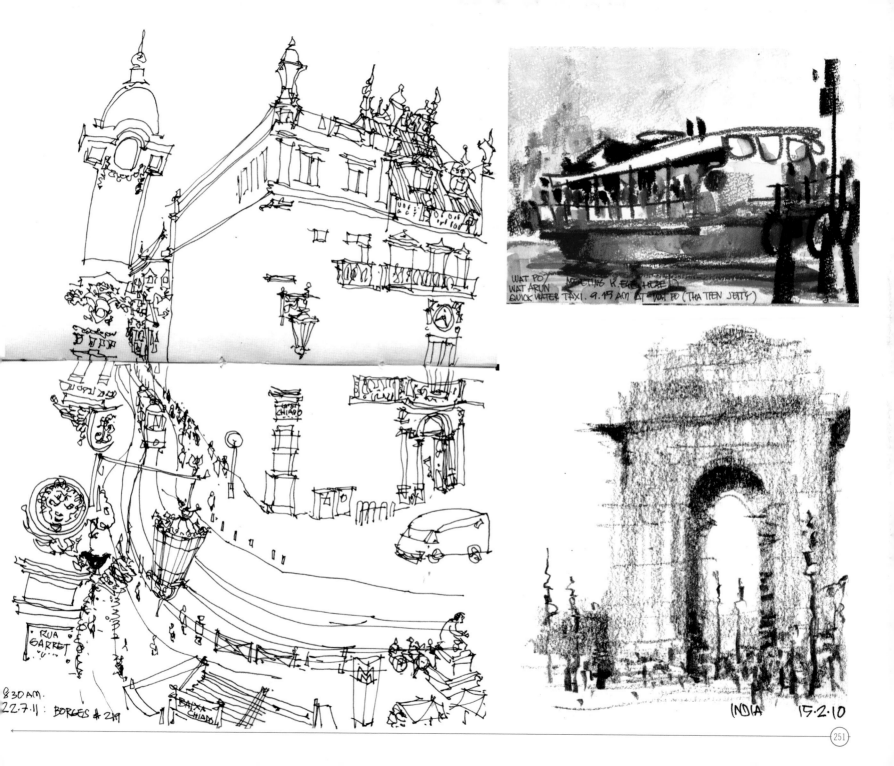

WAT PO
WAT ARUN
QUICK WATER TAXI. 9.15 AM (AT WAT PO (THA TIEN JETTY)

RUA GARRET

8.30 AM.
22.7.11 : BORGES # 219

BAIXA CHIADO

INDIA 15·2·10

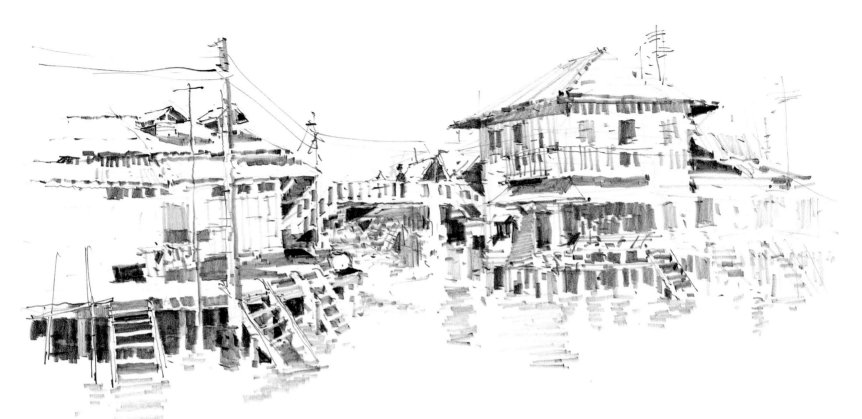

smearing property can be used effectively with care and practice. I have a twelve half pan metal sketchers' box by Winsor & Newton Cotman as well as the smaller field sketching set by Schmincke. I use various kinds of watercolor brushes, such as No. 2 and 5 Petit Gris Pur round mob brushes by Pebeo, a 1" (25 mm) Siberian Squirrel flat brush, 1" (25 mm) Pyramid filbert.

I usually mix watercolor with other types of dry media such as Sakura's oil pastels for students Cray-Pas junior artist, water soluble wax pastels NEO-COLOR II and the water-soluble lead Museum, the latter two by Caran d'Ache. Sometimes I also get a very effective result by adding soft pastel (the type used by professional pastel artists) very sparingly over dry watercolor sketches.

I think sketching has becomes part of how I react to the world, how I see and feel things around me and perhaps, more important, it is what I do to feel happier in everyday life. I don't see sketching as a diary to record my life for a later viewing or contemplation in private. My sketches are just drawings of the world the way I see it.

I think every single sketch tells a lot about itself, about its creator, about the sketcher's mood and feelings. Looking back on my own past works, I see reflections of my moods of joys and excitement and even familiar things seem to take on a new meaning. People dressed differently, buildings stared back with different expression, streets weave into a different twist, even the air gives out a different hue.

All these new and different environments not only make me feel like a schoolboy on his summer holidays, they also fill me with an appreciation of being alive for another day. To me, at this point of time after retirement, each new trip away from home, be it on a street of a foreign town or just walking up a small dirt track of a village a few hours drive from home, seems more precious than the one before. Being away from the familiarity of home gives me a different set of eyes and a near brand-new mind to observe, absorb, compare and test against all experiences and beliefs I may or may not have had before.

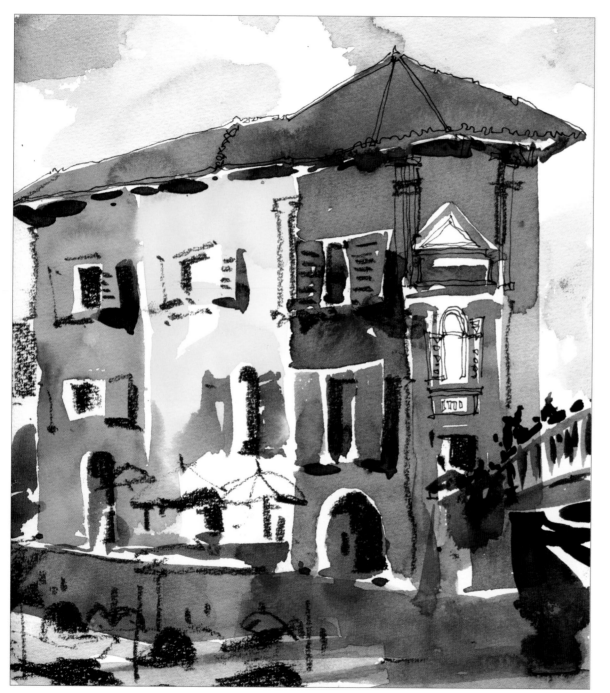

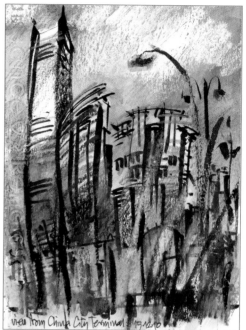

view from China City Terminal 15.12.10

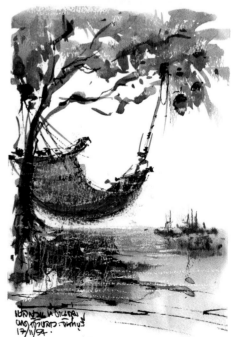

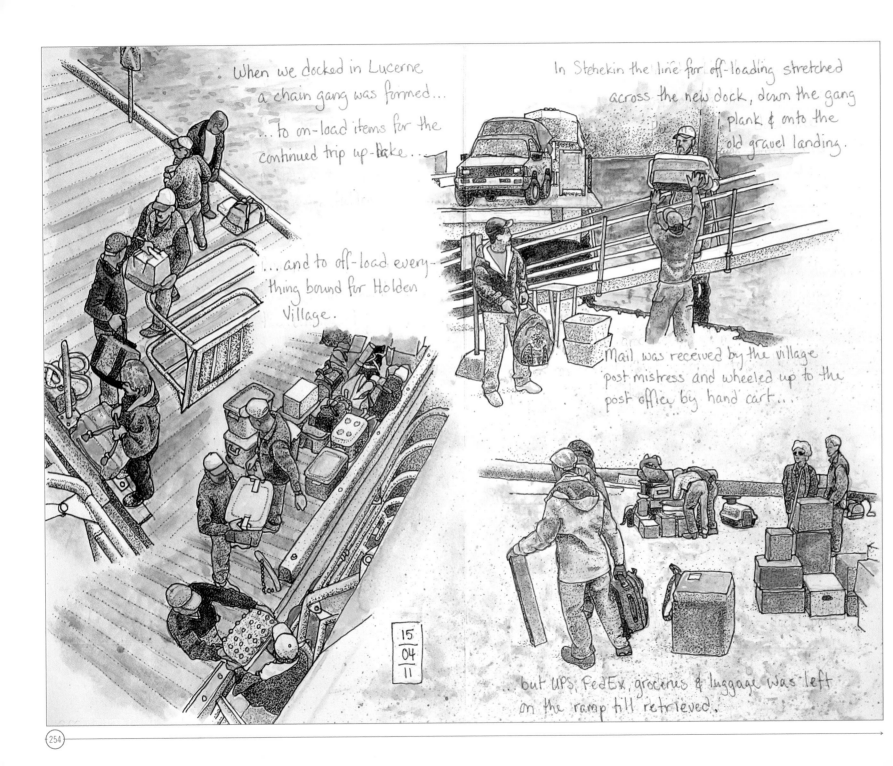

When we docked in Lucerne a chain gang was formed...

...to on-load items for the continued trip up-lake...

...and to off-load everything bound for Holden Village.

In Stehekin the line for off-loading stretched across the new dock, down the gang plank & onto the old gravel landing.

Mail was received by the village post mistress and wheeled up to the post office by hand cart...

but UPS, FedEx, groceries & luggage was left on the ramp till retrieved.

15
04
11

High water marks show graphically just how high the water will rise at "full pool."

Anything that won't fit on "the Ladies" - be it car, truck, fuel, or horses - that needs to come up-lake (or down) is barged in

Park Service barge

Earnest Ward

Earnest Ward was born in Wichita, Kansas; grew up in the U.K., Germany and Taiwan; and spent his early summers traveling across Europe, North America and Asia with his family. Earnest holds both BFA and MFA degrees and is a full-time artist, travel journalist and blogger. **www.earnestward.com; earnest ward.blogspot.com**

I grew up in an Air Force family and I like to think that my father was an enlightened product of the Great Depression—he saw the service as both an outstanding career opportunity for a poor boy from rural Mississippi and a priceless education opportunity for his children. He volunteered for every overseas assignment he could take his family on. By the time I graduated from high school, I had lived in England (twice), Germany and China (Taiwan). Of course, his pay was not extraordinary, and we couldn't afford to stay in the kind of hotels that appeal to tourists. So we spent our holidays camping our way, near and far, across Europe and Asia, traveling from one museum, cultural hot spot

or village to another and thus meeting more people from the local cultures. To a young and impressionable mind, it was all very exciting and adventurous. So much so that I swore to do the same when my own children were born.

I began drawing as soon as I could pick up a mark-making tool. I went through paper as quick as my parents would provide it. And when that ran out (as it frequently did) I drew on the walls and the fence in our back garden. This often got me in trouble but rarely deterred me. And my first "job" was selling illustrated short stories to the other kids in the neighborhood and at school.

I travel regularly, sometimes near and sometimes far. When I was very young,

in England, I used to do "run away day trips" regularly. Not to leave my parents permanently, but to see what I could see around the next bend in the road or over the next hill. The unknown was, and still is, a very magical mystery to me. My parents did not fully understand this and it sometimes led to "misunderstandings" with "less than desirable" consequences. But I was quite stubborn and reluctant to change my ways. Travel is, at least for me, life.

In an era when things all too often move too fast, drawing slows me down. It enables me to venture beyond the facile. It allows me to more fully explore and experience the moment, person, place or thing, instead of merely checking off an-

other item on an imaginary list of experiences. Today the typical point-and-shoot camera can record a very good image of any subject placed before its lens, but no details end up in a sketch until the artist first observes and becomes consciously aware of it and its nature.

The act of drawing creates both experience and memory. And the drawing also facilitates recall and shared experience. When I thumb through an old journal, I am instantly inundated with memories so fresh and alive that they feel like they just occurred. I have discovered that most of the worthwhile experiences in life are far too important not to draw.

I have lists of places I want to visit

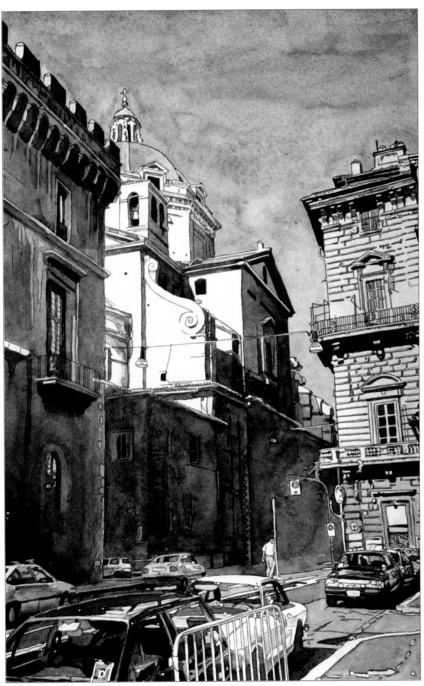

with my journals. When I plan a trip I scour the Internet and old books for details—significant and esoteric—about the people, places and things I hope to see. But, at least as important, I am also constantly on the lookout for the serendipitous—that very special gem that was totally unexpected and that makes my adventure unique. Maybe it's not so much a question of what I would have skipped had I not drawn but more what I would have missed, or forgotten, if I hadn't stopped to sketch in my journal.

I love the fact that every trip—short or long, near or far—can be a source of learning and enlightenment. I learn new things from a breathtaking vista, great cultural landmarks and from discovering a tiny new flower at my feet—or the insect that pollinates it. I revel in drawing them all. And I have found that the more carefully I draw them the more I learn about them.

I'm a dedicated "Slow Traveler" and, as such, try to strike a balance between my trip to-do list and my drawing. A few well-experienced sites—with visual documentation and some little-known facts—make for a memorable trip, and even allow for the serendipitous. (Have you noticed yet that "the unexpected" is something I treasure on my travels?) On the other hand, a schedule crammed to overflowing results in short tempers, museum fatigue and memory gaps.

When I'm traveling with my sketchbooks, I feel like the eighteenth- or nineteenth-century traveler—I feel like the journalists/correspondents/diarists who wrote home to their local papers and shared their adventures with the papers' readers.

While there's frequently a great deal of difference between my sketchbooks and my paintings or stand-alone drawings, there is rarely much difference between my travel journals and my "regular" sketchbooks. My sketchbooks are about exploration and discovery, about seeking out the unknown, unexplored and undiscovered and about documenting the experience, whether that experience occurs on the far side of the globe or around the corner from my house. My book is the confidant I share it all with.

I frequently share my journals with others. For the same reason, I think, that when I am traveling alone and experience something wonderful or sublime I think to myself, *Gee! I wish so-and-so was here to see this!* I think maybe we all have a need or desire to share things that inspire wonder and awe. I don't think my journals are like travel slides in that slides tend to be impersonal photocopies of the place without any personal notation. I love to include notes about what was happening while I was doing a drawing, historical notes and esoteric facts, the quirkier the better.

I've been around long enough to not only see and experience some truly amazing things but to also see some of them vanish. So now I record the

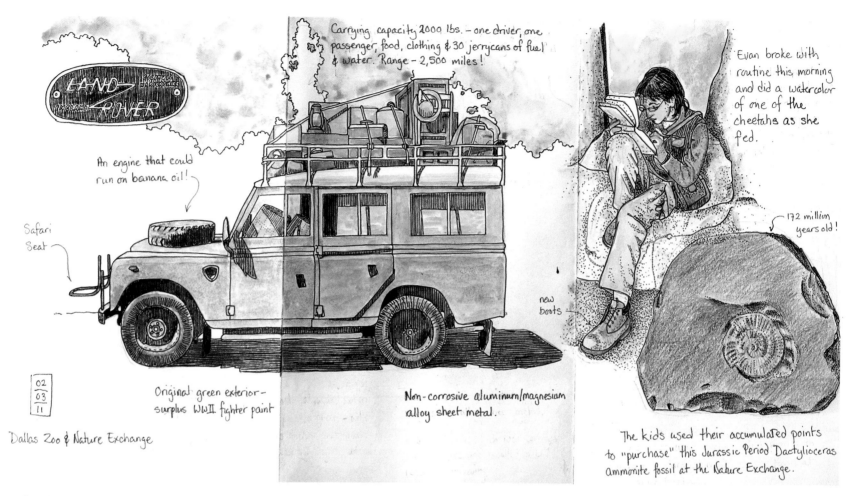

Carrying capacity 2000 lbs. — one driver, one passenger, food, clothing & 30 jerrycans of fuel & water. Range — 2,500 miles!

An engine that could run on banana oil!

Safari Seat

Original green exterior — surplus WWII fighter paint

Non-corrosive aluminum/magnesium alloy sheet metal.

02/03/11

Dallas Zoo & Nature Exchange

Evan broke with routine this morning and did a watercolor of one of the cheetahs as she fed.

172 million years old!

new boots

The kids used their accumulated points to "purchase" this Jurassic Period Dactylioceras ammonite fossil at the Nature Exchange.

wonderful people, places and things I encounter in as much detail and with as much passion as I can in hopes that doing so persuades others that these natural and cultural treasures might be worth saving. Or at worst, so that there might be a record of what once was for those to come.

I vary style as well as medium and technique—both in my travel journaling and my "regular" work—based on interest, intent and relevance to the theme or subject. I use a particular style as long as it seems best suited to a project and as long as it holds my interest. When it no longer seems the best choice, when I can no longer see the relevance, or when I lose my keenness of interest, I look for something new. I'm constantly exploring and experimenting.

Generally speaking, I don't have many rules with regards to my journals: Use archival materials whenever possible; use the same structure within a journal series. When traveling, I usually carry three to four different structures and several different media in my "possibles" bag and a watercolor block in my backpack.

I carry one or two "snapshot" sketch-books: one for dry media, one for wet, for making quick visual notations of subjects and details I want to remember. In these, composition within the page format is of little or no consequence. However, the journals that I share with others are always designed. Early on, I used tracing paper to actually lay out pages, but more recently it's become a more intuitive, relaxed production.

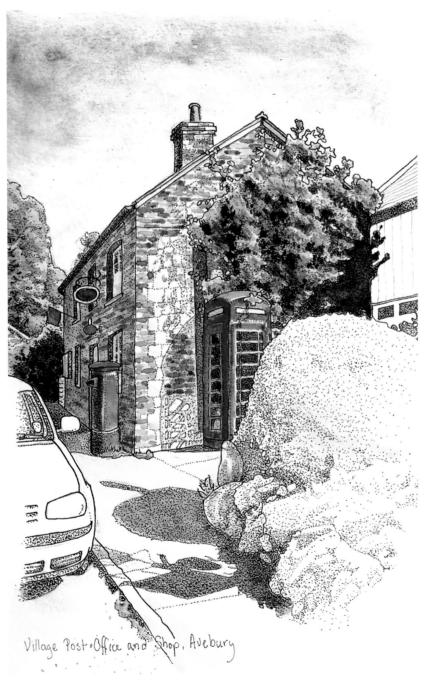

Village Post Office and Shop, Avebury

Before each trip, I like to research my destination and I compile a foundation list—sometimes covering the entire trip, sometimes just the first half—of places to go, people to meet and things to see. This becomes something like a coat hanger upon which I can hang the unexpected and unplanned experiences and discoveries of my journey. Of course, I reserve the right to disregard the itinerary and just go with the flow—and I frequently do so.

The fact that my journals take book form is very important to me. The binding protects the work from the wear and tear of being on the road and can also double as a folder for receipts, tickets and other ephemera that might eventually be integrated into the completed journal. Pages allow for the integration of time as a component of the journal—by sequencing the images in a particular chronological order—in a way that is not generally possible in a painting or stand-alone drawing.

I draw anything that I encounter, great or small, that is unique to the place and culture I am exploring. I'm particularly attracted to the differences in things of everyday life. So I like to draw a car, if it's unique to the country I'm in, or a cabin scooter or an Ape 50. Local brands and unusual products intrigue me in grocery stores, bakeries and pharmacies. Street signs and pedestrian crossings are interesting. Streetlights and trolley cables are fascinating in older cities. Unusual sport-

ing events are appealing. Working boats in small fishing villages and ferries at sea always catch my eye. Sidewalk cafes and public parks on sunny days are all good.

As a general rule, I travel with friends and family who are comfortable with slow travel and travel journaling. My wife and children are all artists in their own right and regularly join me in sketching and writing about the places we go, the things we see and the people we meet. In fact, we have become one another's extra sets of eyes, frequently pointing out to one another things that a single set of eyes might otherwise overlook. We blog together. Friends and relatives that we visit regularly have learned to expect that I will disappear from time to time to do a little independent exploring and sketching, and they are generally tolerant of my quirky, artistic "eccentricity."

I seek one-on-one interactions with local residents and am particularly interested in the personal anecdotes and stories of local cultural and natural history (the stories I can't find in the guidebooks) that they may wish to share. I sometimes draw a view over my shoulder, sometimes engage in conversation with an individual or small group, and at other times observe quietly and unobtrusively.

I always write in my sketchbooks but not always one particular sketchbook. I have a pocket sketchbook that functions as my catchall when I travel—everything goes in there, with no prioritization or

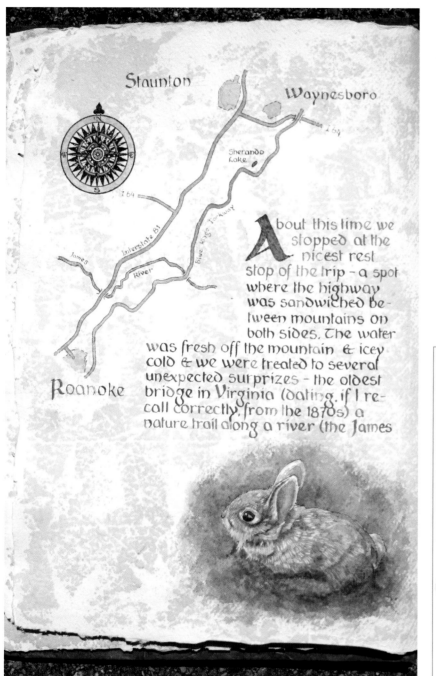

Staunton

Waynesboro

Sherando Lake

I 64

I 64

Interstate 81

Blue Ridge Parkway

James River

Roanoke

About this time we stopped at the nicest rest stop of the trip – a spot where the highway was sandwiched between mountains on both sides. The water was fresh off the mountain & icey cold & we were treated to several unexpected surprizes – the oldest bridge in Virginia (dating, if I recall correctly, from the 1870s) a nature trail along a river (the James

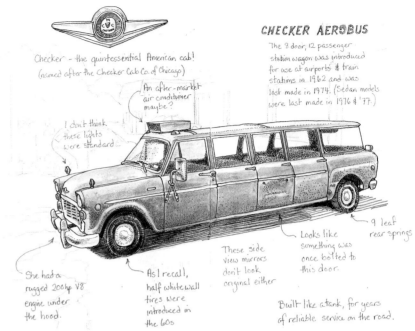

Checker – the quintessential American cab!
(named after the Checker Cab Co. of Chicago)

CHECKER AEROBUS

The 8 door, 12 passenger station wagon was introduced for use at airports & train stations in 1962 and was last made in 1974. (Sedan models were last made in 1976 & '77.)

An after-market air conditioner maybe?

I don't think these lights were standard.

She had a rugged 200hp V8 engine under the hood.

As I recall, half white wall tires were introduced in the 60s

These side view mirrors don't look original either

Looks like something was once bolted to this door.

9 leaf rear springs

Built like a tank, for years of reliable service on the road.

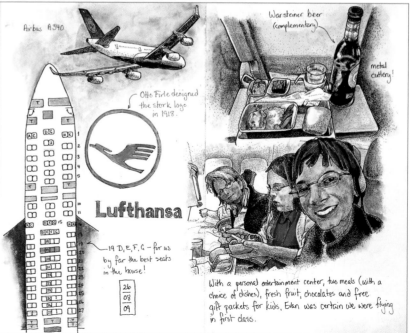

Airbus A340

Warsteiner beer (complementary)

metal cutlery!

Otto Firle designed the stork logo in 1918.

Lufthansa

19 D, E, F, G – for us by far the best seats in the house!

26
08
09

With a personal entertainment center, two meals (with a choice of dishes), fresh fruit, chocolates and free gift packets for kids, Evan was certain we were flying in first class.

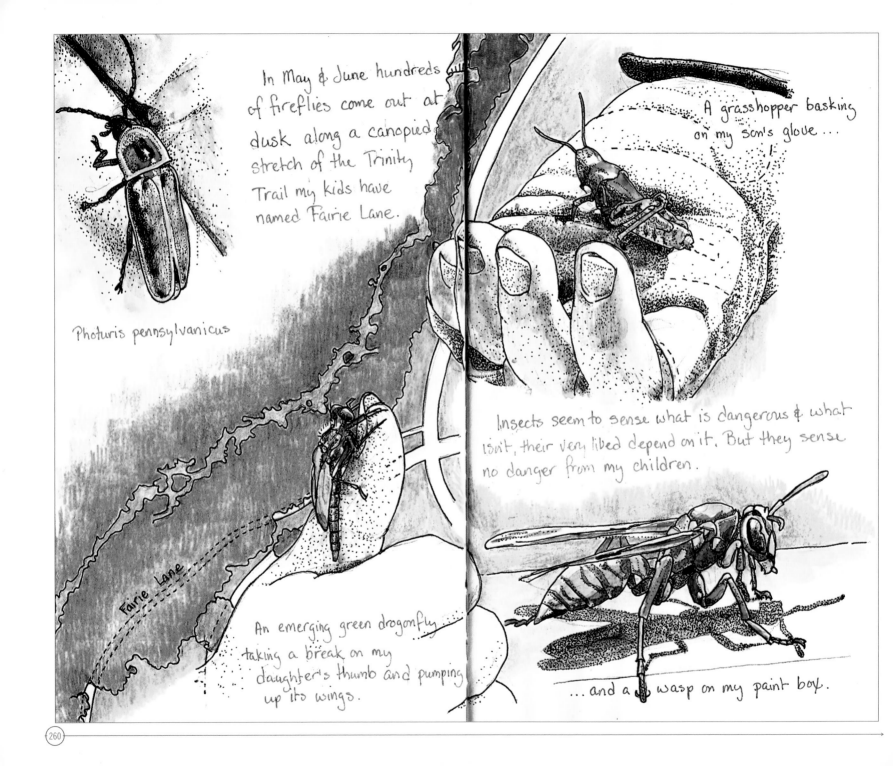

In May & June hundreds of fireflies come out at dusk along a canopied stretch of the Trinity Trail my kids have named Fairie Lane.

Photuris pennsylvanicus

Fairie Lane

An emerging green dragonfly taking a break on my daughter's thumb and pumping up its wings.

A grasshopper basking on my son's glove...

Insects seem to sense what is dangerous & what isn't, their very lives depend on it. But they sense no danger from my children.

...and a wasp on my paint box.

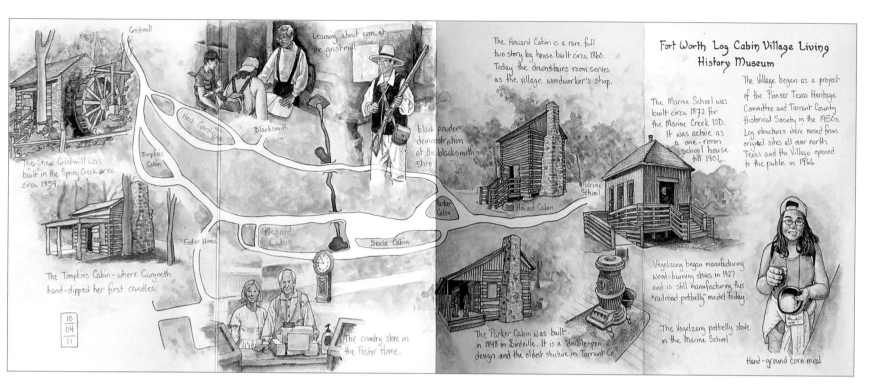

Gristmill

The Shaw Gristmill was built in the Spring Creek area circa 1854.

The Tompkins Cabin - where Gwyneth hand-dipped her first candles.

Herb Garden

Tompkins Cabin

Blacksmith

Foster Home

Pickard Cabin

Seela Cabin

Parker Cabin

Learning about corn at the gristmill!

black powder demonstration at the blacksmith's shop

10 04 11

The country store in the Foster Home.

The Howard Cabin is a rare full two story log house built circa 1860. Today the downstairs room serves as the village woodworker's shop.

Howard Cabin

Marine School

The Parker Cabin was built in 1848 in Birdville. It is a "double-pen" design and the oldest structure in Tarrant Co.

Fort Worth Log Cabin Village Living History Museum

The Marine School was built circa 1872 for the Marine Creek ISD. It was active as a one-room school house till 1906.

The Village began as a project of the Pioneer Texas Heritage Committee and Tarrant County Historical Society in the 1950s. Log structures were moved from original sites all over north Texas and the Village opened to the public in 1966.

Vogelzang began manufacturing wood-burning stoves in 1927 and is still manufacturing this "railroad potbelly" model today

The Vogelzang potbelly stove in the Marine School

Hand-ground corn meal

consideration for what might be important or not. This allows my journal ideas time to percolate and evolve before I commit a final version in my "official" journal. I also have sketchbooks that are dedicated to specific themes or subjects (old vehicles, flora, insects, for instance) and media (pen and ink, watercolor, color pencils and so on).

I have one small RTPI bag, 6" × 9" × 4", that I never leave the house without. I refer to it as my "possibles" kit. Its contents vary from time to time, as I adopt new materials and discard old. Currently it contains a tin of General brand HB graphite pencils, a tin of Sakura Micron

Pigma color pens (in size 01), a tin of Prismacolor color pencils, one or two hand magnifiers, a Moleskine Japanese album (large), a Moleskine watercolor journal (large), a mini Maglite Flashlight and my spare pair of eyeglasses.

For trips of more than a day or two, I also carry a day pack containing an Arches HP watercolor block, my twenty-four-color tin of watercolors (Winsor & Newton), water brushes (small and medium), a size 0 Petit Gris Pur mop brush, a couple of flexible nib dip pens, a pouch of black Micron pens in assorted sizes (005, 01 and 02), a small pair of binoculars, a small Fabriano Art-

ist's Journal (for the color papers) and a Coleman folding stool.

I also like to wear cargo pocketed pants when I travel, in which I carry a small Moleskine notebook with unlined pages for recording esoteric details, addresses, phone numbers and people's names; a vinyl eraser; a pen knife for sharpening my pencils (of course, if I'm traveling by air these days, I have to mail this to myself or opt to buy a new one at my destination); a Canon SX130 IS camera and a small packet of illustrated carte de visite.

I currently use Moleskine sketchbooks. I like the variety of the structures,

archival quality and heavy paper.

My advice to all: Create a small travel kit of basic tools you can carry with you every day. Never leave home without it. Draw, and write about what you draw every chance you get. No matter where you are—whether at home or abroad—look carefully for things that might take your breath away (in grand vista and tiny microcosms), and you will find them. The world is filled with awe and wonder.

Earnest Ward

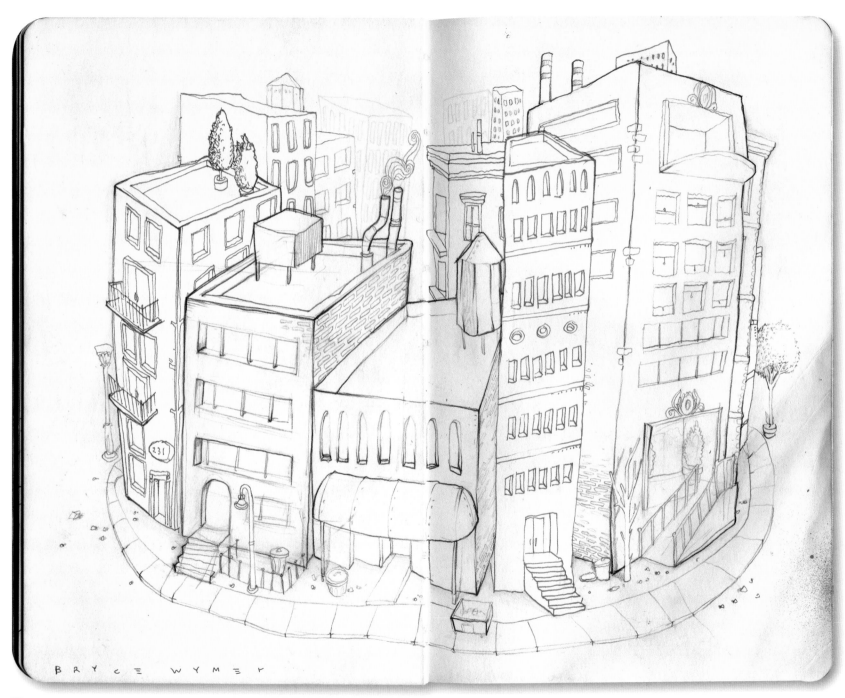

BRYCE WYMER

Bryce Wymer

Bryce Wymer was born amongst alligators, hurricanes and mosquitoes on the east coast of Florida. He is currently based in Brooklyn New York and works as a freelance creative director around the world. This title incorporates all facets of live action direction, graphic design, illustration, fine art and interactive installations. www.**brycewymer.com**

I grew up in West Palm Beach, Florida, and currently live in Brooklyn, New York.

I remember the first time I ever drew—when my mother flipped a paper place mat over at a diner and handed me a couple crayons. I believe that I fell in love with art instantly. It was an all-enveloping kind of force that took over my life. On vacations, I always drew. It was a constant part of my childhood. I remember distinctly drawing in the backseat of my parents' car until I could no longer feel my fingers. I have creative genes. Both of my grandfathers were painters/draftsmen, my mother works as interior designer and my father is a carpenter.

I studied illustration and design at Ringling College of Art and Design. I went to art school rather late (after a failed attempt at becoming a professional hardcore punk bass player). What I learned in college was invaluable, but honestly, most of the habits I currently embrace in my sketchbooks began back in middle school. To represent various aspects of my surroundings has always been a job I've felt employed to represent.

I now work as a freelance creative director all around the world. This title incorporates all facets of visual storytelling, live action direction, design, fine art, illustration and interactive installations.

I've just started a project in which once a month I go to different churches, mosques and synagogues around the United States, and I do pencil drawings of the procession.

There is a serene feeling about being in these buildings and being with the patrons. I originally thought that these drawings would be chaotic and somewhat abstract. But they came through in a very refined, rather journalistic fashion.

They are certainly some of my favorites of the last couple months.

I travel somewhere at least once or twice a month. Traveling and documenting where I have been and the people I have seen have always been an addiction to me. It tends to lie somewhere between therapeutic mark making and a real-time study of all aspects of the human condition.

So often, travelers are so mentally consumed by schedules, connections and such that they miss the beautiful and ugly aspects of their surroundings. I try my best to find these beautiful and ugly moments. I might, for instance, capture a mother discussing why gum doesn't go away like candy does to her inquisitive five year old. Or I might draw a destructively overweight businessman while he is talking on the phone about how the company was sure to take over the competition. There is something that fascinates me about people and how they react with their immediate environments.

One time I was drawing a guy on a plane from New York to Detroit, when the guy looked over and said, "Hey man, you made me look just like Bob Dylan!" He was pissed off. So I put my pen down and said, "Hey brother, when you woke up this morning you dressed like Bob Dylan!" He was so upset! The color ran from his face as he sat down and uncomfortably tried to read his copy of *Money* magazine. I finished the drawing.

BRYCE WYMER 2010

His food was Locust & wild Honey
St Josephs Parish

My style has typically three components: time, materials at hand and mood. It seems while traveling you either have a ton of time or no time at all. The last few years I have been traveling pretty light. Basically I carry just a box of microns, a few pencils and a small watercolor set. This gives me a pretty broad media range. I also bring along a small primary set of gouache, in case I need to be a little more opaque. The last couple trips I tried something a little different and brought nothing but my Moleskines. This forced me to utilize whatever was available where I am. In such cases, I tend to do a lot more collage and of course a ton of typical hotel-grade ball-point pen (an underappreciated pen by the way).

Working in a sketchbook or writing in a journal is a physical and mental exercise. It's not necessarily meant to be hung on a wall or handled with white gloves. It's one of those rare places in this world where on one page you can totally geek out and experiment with abstraction and on the next page you can work through a refined portrait where there will undoubtedly always be something wrong with the fucking nose.

BRYCE WYMER

Index

MORE GREAT TITLES FROM HOW BOOKS

An Illustrated Life

By Danny Gregory

An artist's journal is packed with sketches and captions—some rough, some polished. *An Illustrated Life* offers a sneak peak into the wildly creative imaginations of top illustrators, designers and artists from around the world through the pages of their personal visual journals. Popular visual journalist and author Danny Gregory reveals how and why keeping a consistent, visual journal leads to a more fulfilling creative life. The pages of *An Illustrated Life* are sometimes startling, sometimes endearing, but always inspiring. Whether you're an illustrator, designer, or simply someone searching for a spark, these pages will open a whole new world to you.

Creative Stuff

By David Gouveia and Christopher Elkerton

Exercise your imagination through interactive games and challenges, sharpen your brainpower with puzzles and brain teasers, and find inspiration when you need it most! This workbook will jumpstart creativity and brainstorming for visual thinkers—you know who you are! Every page will stimulate the senses and get those creative juices flowing fast and furious.

 For more news, tips and articles, follow us at Twitter.com/HOWbrand

 For behind-the-scenes information and special offers, become a fan at Facebook.com/HOWmagazine

 For visual inspiration, follow us at Pinterest.com/HOWbrand